P9-DZP-174

GAY DIRECTORS, GAY FILMS?

EMANUEL LEVY

GAY DIRECTORS GAY FILMS?

Pedro Almodóvar, Terence Davies, Todd Haynes,
Gus Van Sant, John Waters

COLUMBIA UNIVERSITY PRESS

NEW YORK

Columbia University Press
Publishers Since 1893
New York Chichester, West Sussex
cup.columbia.edu
Copyright © 2015 Columbia University Press

Library of Congress Cataloging-in-Publication Data
Levy, Emanuel, 1947–
Gay directors, gay films? : Pedro Almodóvar, Terence Davies, Todd
Haynes, Gus Van Sant, John Waters / Emanuel Levy.
pages cm
Includes bibliographical references and index.
ISBN 978-0-231-15276-1 (cloth : alk. paper) —
ISBN 978-0-231-15277-8 (pbk. : alk. paper) —
ISBN 978-0-231-52653-1 (ebook)
1. Homosexuality in motion pictures. 2. Gay motion picture producers
and directors—United States. 3. Gay motion picture producers
and directors—Europe. I. Title.
PN1995.9.H55L48 2015
791.43'653—dc23
2015006484

Columbia University Press books are printed on permanent
and durable acid-free paper.
This book is printed on paper with recycled content.
Printed in the United States of America

c 10 9 8 7 6 5 4 3 2 1

Cover Design: Jordan Wannemacher

References to websites (URLs) were accurate at the time of writing.
Neither the author nor Columbia University Press is responsible for URLs
that may have expired or changed since the manuscript was prepared.

In Memory of Rob Remley
Love of My Life

CONTENTS

Preface ix
Acknowledgments xi
Introduction xiii

1 PEDRO ALMODÓVAR: SPAIN'S
ENFANT TERRIBLE 1

2 TERENCE DAVIES: SUBJECTIVE MEMOIRIST 118

3 TODD HAYNES:
DECONSTRUCTIVE QUEER CINEMA 160

4 GUS VAN SANT: POET OF LOST AND ALIENATED YOUTH 200

5 JOHN WATERS: QUEER AS TRASH AND CAMP 268

CONCLUSION: GAY DIRECTORS—WHO'S LOOKING
AND HOW? 325

Notes 341
Select Bibliography 353
Index 363

PREFACE

THOUGH IT'S my ninth book, *Gay Directors, Gay Films?* is my first truly personal work—for a number of reasons. First and foremost, it's written in honor of my late companion, Rob Remley, who passed away on September 27, 2011. A former Merce Cunningham dancer and a top executive in the film industry (Sony, New Line, Time/Warner), Rob was an extraordinary man in many different ways. Having spent thirty-one years of happiness and fulfillment together, I cannot think of another individual who has influenced my career and shaped my life more significantly than Rob. My loss and grief are indescribable, and rather than engaging in therapy (as most of my friends recommended), I decided to channel my sorrow into writing a tribute book for Rob that would reflect in spirit and in essence the kinds of informal and spontaneous discussions that we used to have after seeing films, dances, and other art forms. Incidentally, we seldom disagreed about the quality or impact of a film; it was always a matter of the extent or degree to which we liked or responded to a particular film.

Second, the book is personal due to its subject matter. I have written comprehensive biographies of two major Hollywood directors: *George Cukor: Master of Elegance* (1993) examines George Cukor (1899–1983), who was openly gay (sort of living an open secret life),

and *Vincente Minnelli: Hollywood's Dark Dreamer* (2009) considers Vincente Minnelli (1903–1986), who was a latent homosexual, opting for heterosexual marriage and children (he was married four times and had two daughters). One goal of these books was to elevate the stature of two extremely gifted filmmakers whose critical standing and reputation had suffered, albeit in different ways, due to their sexual orientation.

Third, *Gay Directors, Gay Films?* is the first book in which I subject myself to self-criticism, paying attention to how my sexual orientation and social background as a white, gay, upper-middle-class male influences, directly and indirectly, consciously and subconsciously, the ways I read films made by openly gay directors. In this, I follow the lead of gay theories, which no longer limit themselves to the analysis of overtly homosexual images but embrace other aspects and images of film that may be "gayer" or "queerer" in meaning than the explicitly gay ones.

In the early 1970s, while spending a summer in Paris, my relatives enrolled me in a course offered by one of the colleges of the Sorbonne. The charismatic teacher of that course, which was devoted to French literature, exposed me to a perspective called *explication du texte*, in which she analyzed according to different yardsticks classic novels by Flaubert, Zola, and others. I have always wanted to apply tenets of this approach to my scholarship and decided to do it in writing *Gay Directors, Gay Films?*

Finally, more than any of my previous books, *Gay Directors, Gay Films?* has benefited from my dual academic background in social sciences as well as cultural and film studies. The book's key organizational principle is career, which is more of a sociological than a uniquely filmic concept. And though I apply the notions of worldview and sensibility to the realm of film, the concepts themselves are broad, deriving from philosophy, history, and other fields. The following text also integrates the duality of my career as a full-time professor and a full-time film critic (*Variety, Screen International*), a career inspired by my great Columbia teacher and mentor, Andrew Sarris.

ACKNOWLEDGMENTS

THIS BOOK, as noted in the preface, owes its entire existence to my late companion, Rob Remley. My vivid memories of the lively and lovely experience of seeing these movies with him have nourished and sustained me in some tough and hard times.

I have enjoyed tremendously attending the world premieres of many of the movies, and interviewing the five directors who made them, at various press conferences and events at the Cannes, Sundance, and Toronto Film Festivals, or in more intimate forums, such as the Hollywood Foreign Press Association.

To the best of my knowledge, there have been three or four books in English about Almodóvar (many more in Spanish and French). I especially learned from the expertise of Paul Julian Smith and Mark Allinson, who published their volumes over a decade ago, thus covering only half of Almodóvar's output. Robert James Parish is the first and sole biographer of Gus Van Sant; his informative volume was printed over 15 years ago. John Waters has written several personal books, and I benefited from the 1992 volume that John G. Ives wrote based on lengthy interviews with the director. There are no biographies or comprehensive books about Terence Davies or Todd Haynes, but several scholars have done exemplary analyses of some of their

films, particularly Michael Koresko and Leonard Quart in Davies's case, and Justin Wyatt in Haynes's.

Many colleagues and friends have contributed to the research and writing of the various drafts. I would like to thank in particular Thomas Doherty, Pamela Griffin, Molly Haskell, Fred Katz, Bill Shepard, Ed Sikov, Edward Turk, David Van Leer, all distinguished critics and scholars. Though I did not set out to write an auteurist volume about gay directors, during the process it became clear that my book could not have existed without Andrew Sarris's seminal criticism and pioneering book of 1968.

Over the past three decades, I have shown many gay-themed features in various film classes at Wellesley College, Columbia, New School for Social Research, ASU, UCLA, and NYU. The students of these schools have helped immeasurably in shaping my ideas and focusing my views with their bright comments and challenging criticism.

Much gratitude goes to three of my loyal research and media assistants, Jeff Farr, Beth A. Mooney, Lisa Plinski, and especially Ariel Adler. Valerie Todesco, who was born in Spain, helped me with translations of Spanish dialogue (and slang) in Almodóvar's films. My friend and HFPA colleague Jorge Camara, who hails from Mexico, improved the quality and accuracy of the language.

I would like to thank the personnel of the Margaret Herrick Library of the Academy of Motion Picture Arts and Sciences, particularly its director Linda Maer, Barbara Hale of the Special Collections, and the friendly librarian Sondra Archer.

Finally, I have benefited immensely from the methodical work and continuous support—and remarkable patience—of the entire team at Columbia University Press, beginning with its gracious director Jennifer Crewe, and continuing with Associate Editor Kathryn Schell and Senior Manuscript Editor Roy Thomas, Editorial Services Manager Ben Kolstad and others at Cenveo. My very first book, *The Habima—Israel's National Theater*, was published by Columbia University Press, so in many ways *Gay Directors, Gay Films?* is sort of a coming home (*Volver*, to borrow the title of Almodóvar's 2006 film).

INTRODUCTION

THE INTRIGUING notions of a distinctly gay gaze and a uniquely gay sensibility, and their reflection in the work of openly gay directors, have not been thoroughly explored in the fields of cinema and culture studies. *Gay Directors, Gay Films?* deals with one central issue: the effects of sexual orientation on the career, film output, and sensibility of five homosexual directors. They are, in alphabetical order, Pedro Almodóvar, Terence Davies, Todd Haynes, Gus Van Sant, and John Waters. I aim to show that these directors have perceived and expressed their sexual (and other) identities as outsiders in highly complex and varied ways. While sexual orientation and being an outsider are essential in understanding the oeuvre of the five directors, they may be more crucial in the beginning (first decade) of their careers. Moreover, the impact of these attributes may differ from one director to another and from one phase to another within the career of the same director.

My book examines five talented and relatively well-known directors by placing their films and their careers in the sociopolitical, ideological, and economic settings in which they have lived and worked. All five directors were born after World War II and thus belong (more or less) to the same age cohort. At 69, Davies is the oldest, and Haynes, 53, is the youngest. In between, there are Van Sant, 62; Almodóvar, 65;

and Waters, 68. They are directors who began their screen careers at more or less the same time, in the 1970s and 1980s.

In comparing the work of this quintet, three of whom are American (Waters, Van Sant, and Haynes) and two of whom are European (Spaniard Almodóvar and Briton Davies), I explore the impact of sexual orientation and status as outsider on the kinds of films that they have made. Is there a distinctly gay mode of looking at the world? Do gay directors make specifically gay-themed films that are targeted at mostly gay audiences? Do we define a film as gay by its explicit contents (text) and/or by its implicit meanings (subtext)? Is there congruence or tension between the film's narrative and themes and its visual style and tone? These are some of the intriguing theoretical and pragmatic questions that have guided me.

The book's comparative framework, contrasting the career and oeuvre of five directors in one volume, offers readers a broader context within which they can place an individual director and a particular film. I don't know of any books that have dealt with the significant questions of how gay directors choose their subject matter, the various influences (filmic, intellectual, literary) on their pictures, the ease with which they move from one feature to the next, the evolution of their filmic sensibility, and the consistency of their visual style. Do their careers follow a linear model of evolution, show evidence of ups and downs (and ups), or are they defined by repetition and refinement of similar narrative strategies and stylistic devices?

Centering on five directors whose careers continue to evolve, often in unpredictable ways, *Gay Directors, Gay Films?* offers an exciting research site for an account spanning four decades, from the early 1970s to the present. The book examines the sensibility of directors who are perceived as outsiders from the perspective of mainstream culture. It explores how these directors have channeled their sexual energies, anxieties, and identities into the creation of idiosyncratic film art through the specific shape and form of their gaze.

I aim to show how the directors' status as outsiders has led to the creation of innovative thematic and aesthetic paradigms. For example, the significance of Almodóvar's background as a gay man, and as the product of a particular historical generation, on the creation of a joyous, revisionist, and ironic sensibility. Similarly, one

cannot understand the work of a postmodern director like Haynes without placing it in the context of the New Queer Cinema, of which he was both a founder and a beneficiary. In discussing five important filmmakers, I intend to add a piece of knowledge to the already rich puzzle of the filmmaking process and of cinema as a complex institution.

Vito Russo's seminal book, *The Celluloid Closet*, prompted a new look at film history.[1] His politicized historical survey (which served as the basis for a 1995 documentary of the same title) led to the rediscovery of forgotten films and to a fresher, more critical examination of gay directors, such as George Cukor, James Whale, and Mitchell Leisen, all of whom worked successfully within the studio system. In the past, what was interesting about gay filmmakers was their ability to infuse their texts with a gay sensibility while making genre pictures for mainstream audiences under the control of the studio system, without necessarily disclosing in public their sexual orientation and lifestyle. Hence, James Whale is best known for his horror movies, George Cukor for his poignant social comedies, Vincente Minnelli for his lush musicals and vivid melodramas, Irvin Rapper for his women's pictures, and Mitchell Leisen for his savvy screwball comedies.

In contrast, this book's gay directors live and work in different sociopolitical conditions: They do not have to conceal their sexual orientation any more. It is therefore relevant to ask to what extent their openness has allowed them greater freedom in choosing material, including explicitly gay texts that go beyond issues of coming out or the representation of gay and lesbian characters.

In dealing with the careers of gay directors, I have benefited from developments in psychoanalytic, feminist, gay, and queer theories. Centering on issues of gender and desire, *Gay Directors, Gay Films?* explores the concepts of sexual identities and sexual practices in the work of these directors. Identity is perceived as a flexible narrative, not just a label, of a subject's particular location within larger social structures. Artists, like all individuals, possess various (often dual and contradictory) identities that traverse their subjective experiences with the broader outside world. These multiple identities, of which the sexual is just one, offer complex connections among self, culture, and society. The psychoanalytic approach assumes that films

reflect and play on the socially established interpretation of sexual difference that controls visual images and ways of looking. Laura Mulvey's work and Jacques Lacan's psychoanalysis have demonstrated the ways in which the conscious, subconscious, and unconscious of patriarchal society have structured the contents and forms of dominant cinema.[2]

The presumably "established" categories of sex, gender, and sexuality are brought to a "crisis point" by exposing their limitations as analytic terms. In doing so, I draw on recent developments in theories that take an interdisciplinary approach to sexuality by disrupting conventional assumptions. Queer studies have invited impassioned, sometimes angry, resistance to "normalization." They have rejected simplistic, mainstream heterosexual codes by submitting their social and sexual conventions to a more rigorous analysis, aiming to expose incoherence, ambiguity, and instability. Sexuality is analyzed as a fluid, mobile, and permeable concept that embraces a wide range of positions within institutional formations.[3]

For decades, sexual pleasure and erotic desire have been largely conceived as "universal forces of nature," basic instincts that transcend history, but gay and queer studies have problematized these concepts by seeing them as the products of language, history, politics, and culture. *Gay Directors, Gay Films?* aims to clarify the role of race, gender, politics, and nationality in determining the various configurations, both normative and deviant. Moreover, in distinguishing between sexual identities and sexual practices, queer studies have encouraged a more detailed study of desire, pleasure, and self-knowledge.

Gay Directors, Gay Films? adds an interesting but so far missing panel to the historiography of cinema by highlighting the contribution of five gay directors. The book deconstructs the narratives of these directors in terms of themes, both overt and covert, raising such questions as to what extent their films have shown radical positions on gender, desire, and sexuality? Thus, in addition to context, the concepts of text and subtext (denotation and connotation in film studies) are crucial to the book, because the meanings imbued in gay-themed films, or in straight-themed films made by gay directors, may be manifest to some viewers but latent to others.

My book draws on the traditions of other minority movements, such as the feminist and the black movements, which necessarily have been concerned with issues of gender, desire, identity, and sexuality. These movements have established meaningful links between the personal and the political, between the private and the public. Moving beyond conventional readings, *Gay Directors, Gay Films?* examines specific elements, such as romantic yearning, erotic desire, sexual identity, and sexual performance. It asks, To what extent have gay directors expressed their worldview through different kinds of narratives, characters, and visual styles? Do gay directors create alternate/alternative ways of seeing the world, and are these subcultural or countercultural? Are these visions radical and subversive (antiestablishment) in dealing with issues of masculinity and femininity? Some films may be totally subversive, whereas others may contain subversive moments within narratives that are otherwise more conventional. The book explores how subversive images—such as graphic sex scenes in Almodóvar's work—are treated, contained (or not), and articulated (or not) within the totality of the work. *Gay Directors, Gay Films?* explores other pertinent or prevalent issues— namely, whether gay directors tend to elevate style over content, or whether they tend to succumb to camp strategies and/or expect viewers to perceive artifice as an integral attribute of their work.

Film theory scholar Edward Branigan has noted that point of view (POV) involves a "condition of consciousness."[4] The screen represents various states of mind that guide viewers' responses through mise-en-scènes, organization of space, and orchestration of visual and aural elements. Subjective point of view and articulation of space are treated thoroughly in my book. How do gay filmmakers construct narrative worlds that allow specific ways of entry—involvement and engagement—into their narratives? How and why do they encourage viewers to relate to—empathize or sympathize with—their characters?

The work of the five filmmakers is examined in relation to the ideology, politics, and culture of their respective societies. All five directors have shown some disregard of thematic, ideological, and stylistic conventions. They have refused, in one way or another, to apologize for their distinctive approaches as far as gay images and sexual politics are concerned.

Throughout the book, beginning with its title, I am using the broader term of *gay* rather than *queer* for both thematic and historical reasons. The New Queer Cinema is a label created and applied to films of the early 1990s. With the exception of Haynes (who is both a founder and a product of this broadly defined and loose movement), the other directors began their careers before queer cinema (or queer studies, for that matter) was established, both within and beyond the academic world.

Gay Directors, Gay Films? is written in a popular style as a general interest book. In an effort to reach a broader audience that goes beyond the academic milieu, the jargon of cinema studies is reduced to a minimum. Most of my friends are avid moviegoers, and even the scholars among them often complain that there is no middle ground. There seems to be either popular film journalism or rigorous scholarly work written in a manner that only film studies experts can understand. Thus, I perceive the ideal readers of my book as open-minded individuals who love nonconventional and nontraditional films (largely independent and art-house films—but not limited to those spheres) and who want to know more about the process of their making in terms of narrative, ideological, stylistic, and visual aspects.

Each chapter in the book is devoted to a single director. The chapter begins with a general description of the director's distinguishable personality, followed by an examination of his early life and interest in film. The career of each director is divided into phases. To demonstrate how the directors choose subject matter and move from one project to another, the films of each director are discussed chronologically. This approach enables readers to decide for themselves issues of evolution, progress, and diversity in the case of each director. My interpretation aims to illuminate each particular film vis-à-vis other works by the same director and vis-à-vis similar works by other directors—what is known in film studies as intertextuality.

The book's essential information derives from close readings of seventy films and detailed analyses of the directors' careers from their beginnings up to the present. I had watched most of the films upon their initial theatrical release and then revisited them for the book, examining in the process the extent to which I have changed my reactions to them. As a senior critic for *Variety* and then as chief critic for

Screen International, I have reviewed about two dozen of these films at their world premieres, often at the Cannes, Sundance, and Toronto Film Festivals. A large portion of the data is based on my interviews with the five directors over the past three decades, either at festivals or when they promoted the release of their pictures in the United States.

The merits of some of the films have been acknowledged by awards from the New York Film Critics Circle, the Los Angeles Film Critics Association, and the National Society of Film Critics. I am particularly gratified that Almodóvar's *All About My Mother* won Best Picture from the Los Angeles Film Critics Association while I was the president of that group (1997–2000). The film then went on to win both a Golden Globe and an Oscar for Best Foreign Language Film.

The book examines all the feature films made by the five directors, regardless of their relative commercial appeal and artistic merit. Most of the films have been shown theatrically by the specialty units of the Hollywood studios (Sony Pictures Classics, Fox Searchlight, Focus Features). Thus, their exhibition went beyond film festivals and niche markets. The book attempts to explain the differential appeal of these films, including the box-office failure of interesting movies—such as Van Sant's *Elephant*—that deserved greater public recognition.

A major goal of *Gay Directors, Gay Films?* is to enliven the discussion of what constitutes a specifically gay film and how we define gay sensibility. However, I am by no means suggesting that the directors' sexual orientation is the only (or primary) factor in their creative endeavors. The impact of sexual orientation on a director's career and output may be relative, differing from one career phase to another and from one picture to the next. Nor am I suggesting that films made by gay directors are necessarily defined by a unified or monolithic orientation.

There is no one way to look at, discuss, analyze, appreciate, and enjoy films. My reading of films in this book may not be conventional but it is a legitimate one, standing alongside other kinds of readings based on different perspectives.[5] I easily could have dissected the films and interpreted the directors who have made them from another theoretical perspective. But I hope that the discussions in my book will induce readers to catch some good films they have missed or to see familiar films again in a different light.

GAY DIRECTORS, GAY FILMS?

1

PEDRO ALMODÓVAR

Spain's Enfant Terrible

O VER THE past three decades, Pedro Almodóvar has established himself as one of the most artistically ambitious and commercially successful filmmakers, not just in Spain or in Europe but also all over the world. Highly prolific, he has made nineteen features in thirty-four years. There is a pattern to his method. He spends a whole year writing and shooting a film and then, upon release, another year traveling and promoting it at film festivals and in various countries, with the United States a major destination on his tour.

Almodóvar has been described, at various points in his career, as a Mediterranean Rainer Werner Fassbinder (or Fassbinder with a sense of humor), a more naïve and less morbid David Lynch, an urban Woody Allen without the neurotic Jewish angst, and a stylish Martin Scorsese without the Catholic guilt.[1] But none of these labels does justice to his rich oeuvre or idiosyncratic vision. For starters, in almost every interview I have conducted with him, he goes out of his way to stress that his work is dark but not sick, that there is angst in it but no guilt, that it is serious but also humorous. He claims that he is very Spanish because his value system is defined by intuition, spontaneity, and chaos, but that his work has universal meaning.

Almodóvar has evolved from an entertaining "bad boy" in the 1980s to a respected world-class filmmaker in the late 1990s, a status he has been able to maintain. He began his career as a provocateur and sensationalist, making erotically charged films about sexually transgressive themes. But he gradually developed into one of the world's finest filmmakers, whose works are multi-nuanced, meticulously made, and elegantly shot. Blessed with inspired verve and bold audacity, he has challenged social stereotypes in Spanish culture as well as sexual taboos in world cinema. In his best work, the seductive visual style and acute social conscience converge into features that are dramatically compelling and commercially appealing.

Early on, Almodóvar's work was dismissed as too zany, too kitschy, or too campy by critics who failed to notice that the jokes and the triviality are just the surface of explorations of more serious concerns. Indeed, the comedic and farcical touches make his darker dramas about sexual politics and various abuses more tolerable to watch. Nonetheless, some critics have continued to apply the labels of "cinema of surfaces" and "cinema of excess" to his work.

Almodóvar's films have evoked diverse, even contradictory, reactions because they display divergent tonality and ambiguous morality, offering spectators different kinds of pleasures, from the visceral and voyeuristic to the more emotionally grave and radically transformative. In most of his films, the director has relied on a wide range of characters and on a large ensemble of actors, a strategy that enriches his films and reflects his belief that ensembles are more democratic than single-star texts. Having a large group of characters as his basic narrative unit and carrier of meanings also functions as a safety valve, because it allows the viewers—male and female, straight and gay—to empathize and/or to sympathize with at least some of them. In contrast, in most of Gus Van Sant's and Todd Haynes's films the narrative centers on one or a few individuals.

Despite the dark tone and noirish sensibility of many of his films, Almodóvar is at heart an optimistic director. He is, in fact, the most upbeat and the least cynical of this book's five filmmakers. This derives from the particular circumstances in which he grew up: "The characters in my films utterly break with the past, which is to say, most of them are apolitical. We are constructing a new past for

ourselves, because we don't like the one we had."[2] Despite his increasing age and growing experience, his future-oriented credo has not wavered: "Individuals must always improve or strive to improve on their reality, no matter what that reality is."[3] (Terence Davies has expressed the same philosophy; see chapter 2.)

Almodóvar's work goes beyond well-constructed narratives, showing multilayered meaning and skillful mise-en-scène, even when the texts rely on excessive design and lurid costumes. His oeuvre defies the theory that old narratives and classic genres—screwball comedy, noir crime, woman's melodrama—are no longer functional (that is, useful) in our postmodern world. In fact, his films are very much revisionist genre pictures to which he applies a novel, postmodern strategy. He likes to destabilize codes of traditional genres by combining their elements: "I mix all the genres. You can say my films are melodramas, comedies, tragicomedies, because I put everything together, and even change genres within the same sequence, and very quickly."[4]

For Almodóvar, every element of life, including biological and human anatomy, is subject to change. Bodies, minds, hearts, and souls are not as fixed or stable as they might appear on the surface. His narratives permit boundary confusions of sex, gender, and identity. In his deliriously complicated plots, the characters are able to—and often do—change their bodies and identities with incredible speed, fluidity, and elasticity.

The key concepts in Almodóvar's work are passion, desire, sexuality (or rather sexualities), pleasure, and happiness. When his film *Bad Education* came out in 2004—the same year that Mel Gibson's controversial religious epic *The Passion of the Christ* was released—he explained: "I am the anti–Mel Gibson director. My movie is about the power of faith, and so is his film, but I am in the opposite place from him. My goal as a writer is to have empathy for all characters. In all my films, I have a tendency to redeem my characters. It is very Catholic—redemption is one of the most appealing parts of the religion. Sadly, I am not a believer in Catholicism, but the priest is probably my favorite character in *Bad Education*."[5]

Almodóvar's output is richly dense with references to other films, TV soap operas and ads, pop culture, music, and literature. Intertextual connections and allusions are crucial to his work, as Marsha

Kinder pointed out, because "they counteract the potentially dehumanizing effects of his grotesque humor."[6] He uses self-consciousness and artifice effectively to undermine Hollywood's seemingly "naturalistic" or "realistic" cinema, as do Haynes and John Waters (albeit in different ways). Almodóvar's work is self-reflexive: "I use cinema in a very active way, never as a pastiche or homage, because for me, a film is something that once I have seen it, it has become part of my experience. I put these movies in the middle of my films, and they become part of the story, but never in the sense of being a cinephile like Tarantino or Spielberg or De Palma."[7] He elaborated: "All the influences on me and all the references in my films are spontaneous and visual. I don't make any tributes. I'm a very naïve spectator. I can't learn from the movies that I love—they become part of my life and my movies without quotation marks."[8]

Steeped in pop culture lore of the past, particularly Hollywood of the studio system, Almodóvar, like Fassbinder, could not have evolved into the major and particular artist he has become without his knowledge of American filmmakers, from A-grade directors like Alfred Hitchcock, Howard Hawks, Douglas Sirk, Billy Wilder, and Vincente Minnelli to B-level directors like Frank Tashlin, Hamer, and even Waters. His seemingly absurd narratives blend kitsch, fantasy, and humor, resulting in explorations of human feelings of the deepest kind. As he told me: "I find the clichés of popular culture both very funny and very alive. I like to play with them, to create a narrative angle that makes them part of my movies as they are part of my life."[9]

Although Almodóvar's films show consistent concern with social issues (domination, oppression, rape, homophobia, transgendering, physical disability, and mental illness), there is a remarkable lack of political agendas. The outrageous, the perverse, the deviant, and the incongruous are displayed in his oeuvre as normal and existing states of being. Refusing to take a moral stance against any issue, he is a nonjudgmental director. His mise-en-scène is stylized and theatrical, but it is firmly grounded in his visual energy and impressive ability to change tone from scene to scene—and often within the same scene. Significantly, unlike Waters, Almodóvar has never celebrated bad taste or gross tackiness for its own sake. Nor has he made camp

movies just for the sake of being camp. With the exception of one or two films, there is no deliberate violation of taste or crass vulgarity in his features.

EARLY LIFE AND CAREER BEGINNING

When compared to the other filmmakers in this book, Almodóvar is, like Davies, a product of the working class—and a rural one at that—whereas Van Sant and Haynes are the products of upper-middle-class parents. Lacking formal education, Almodóvar is an autodidact, whereas Van Sant and Haynes are graduates of film and art schools.

Almodóvar was born on September 25, 1949, in the sleepy little village of Calzada de Calatraya in La Mancha. He has used his regional background in only a few films—most notably, *The Flower of My Secret* (1995) and especially *Volver* (2006). Most of his films are set in Madrid and, to a lesser extent, in Barcelona. The young Almodóvar was not suited to provincial life, as he later recalled: "I felt at home as an astronaut in King Arthur's court."[10] His grandfather was a winemaker, and his father worked as a bookkeeper at a gas station. He said: "My family, like that of Sole and Raimunda in *Volver*, is a migrant family which came from the village to La Mancha in search of prosperity. My sisters have continued to cultivate the culture of our mother. I moved away from home very young and became an inveterate urbanite. When I returned to the habits and customs of La Mancha in *Volver*, I had to ask my sisters to be my guides."[11]

The lay sister of the village, whom Almodóvar met through his older sister, thought that he would make a "good priest" and so helped place him in the Salesian Fathers Catholic School. A victim of sexual abuse in various Catholic schools, Almodóvar avoided discussing the issue, first confronting it in his movies *Dark Habits* and *Bad Education*. Years later he elaborated: "It was a shame because sex should be discovered naturally, and not brutally, suddenly. For two or three years, I could not be alone, out of pure fear."[12]

Almodóvar has explained the main value of living in La Mancha: "It allowed me to discover what I did not want to be. Everything I do is the opposite of the upbringing I received, and yet I am from there

and belong there, and in *The Flower of My Secret*, I became conscious of that for the first time."[13] In his boyhood, he read much more than his classmates, which, to use his own words, "was odd and inspired the same rejection that I now inspire in some critics. I wasn't a normal child, because during recess I'd rather talk about Ava Gardner than play ball."[14] (A photo of Gardner in *Matador* serves as a cultural reference as well as an indication of the hero's superiority over his ignorant student, who doesn't know who she is.) He also painted and watched movies, such as *Peyton Place* and melodramas starring Elizabeth Taylor (*Giant*) and Natalie Wood (*Splendor in the Grass*). He loved movies based on the plays of Tennessee Williams, particularly *Cat on a Hot Tin Roof* and *Suddenly, Last Summer* (both, incidentally, starring Taylor).

The sexual segregation that prevailed in his own family had long-lasting effects on Almodóvar's value system. For one thing, he always felt closer to his mother, Francisca, than his father, Antonio, a typical Spanish patriarch who could barely read or write and worked hard in various manual jobs to support his children—Pedro, his two sisters, and Agustín, his younger brother. Almodóvar recalls an image of unalloyed power: his father, home after a long day's work, sitting in an armchair, "like a god," expecting his wife and daughters to wait on him "like slaves."[15] He was not a bad man, just uneducated and set in his ways. (He died of lung cancer in September 1980, the very week that Almodóvar premiered his first feature, *Pepi, Luci, Bom*.)

The river was always a place for familial and communal celebrations, as he later observed nostalgically:

> Undoubtedly, the river is what I miss most from my childhood. My mother used to take me with her when she went to wash clothes there, because I was very little and she had no one with whom to leave me. I would sit near my mother and put my hand in the water, trying to stroke the fish that answered the call of the fortuitously ecological soap the women used back then, which they made themselves. The women would sing while they were washing, which is why I've always liked female choirs. My mother used to sing a song about gleaners who would greet the dawn working in the fields and singing like joyful little birds.[16]

Years later Almodóvar would sing fragments of these songs to the composer of *Volver*, Alberto Iglesias, only to be told that it was actually a song from the operetta *La rosa del azafrán*. It was also by the river where, a few years later, he discovered his own sexuality and lost his virginity, though he has never disclosed details about those circumstances.

At the age of sixteen, upon completing his *bachillerao*, Almodóvar moved to Madrid, defying his father's wish that he get an office job in the region. "I came to a small apartment that my parents had bought, so at least I was assured of having a roof over my head, but I couldn't afford formal schooling."[17] Instead, he worked as a clerk at the National Telephone Company between 1970 and 1980. He didn't hate his day job as much as Davies did his before becoming a full-time director. This job enabled Almodóvar to save some of his salary to buy a Super 8 camera.

Almodóvar took an active part in the city's emerging artistic underground—manifest in *La Comedia Madrileña* and *La Movida Madrileña* (Madrid Upsurge)—and specifically in the localized comedy and rock 'n' roll scenes, performing with his own band. He became a central figure of *La Movida*, whose elements would serve as subjects of his earlier films. The changes were first reflected not in theater, cinema, or literature but on the streets: "All the color, all the liberation, all the humor, you first found in how people were living."[18] He elaborated: "Madrid was the most modern center in the world. If you wanted to, you could find the Shah's son, Dali, and the Pope."[19]

As he later recalled: "My first films coincided with a moment of absolute vital explosion in the city. Madrid in the late 1970s was probably the most joyful, the most fun, the most permissive city in the world. It was really the rebirth of the city after such horrible period of the Franco regime. If there was something characteristic about the culture of Madrid that I belonged to, it was the night life. That was my university, and also the university of many of my generation."[20]

In those years, Almodóvar acted with an avant-garde theater group, *Los Goliardos*, and also wrote comic strips and stories in some underground papers. In 1981, he published a short novel, *Fuego en las entrañas* (*Fire in the Bowels*). He also published his parodist observations under the pseudonym of Patty Diphusa (a fictitious international

porn star). A pun name in Spanish, *patidifusa* derives from *patidifu-sion*, which translates into "bewildered" or "astounded." It is the feminine form of an adjective that suggests being both aghast and nonplussed. These texts were collected as *Patty Diphusa y otros textos*, translated as *The Patty Diphusa Stories and Other Writings*, and published in London in 1992.

In 1974, Almodóvar shot his first short, *Dos putas, o, historia de amor que termina en boda* (*Two Whores, or a Love Story That Ends in a Wedding*), followed by *La caída de Sódoma* (*The Fall of Sodom*) later in 1974, *Sexo va, sexo viene* (*Sex Comes and Goes*) in 1977, and the Super 8 *Folle, folle, folleme, Tim* (*Fuck, Fuck, Fuck Me, Tim*) in 1978. He made his feature debut in 1980 with *Pepi, Luci, Bom y otras chicas del montón* (*Pepi, Luci, Bom and Other Girls on the Heap*), a 16mm film that was later blown up to 35mm.

Artistic influences on Almodóvar's work have been varied, including classic American melodramas and comedies as well as Spanish black comedies of the 1950s by directors Fernan Gomez and Luis García Berlanga. He was flattered when critics described him as Gabriel García Márquez, crossed with Andy Warhol, crossed with John Waters, crossed with Virginia Woolf. He particularly liked the association with Márquez because of his self-perception as a writer, consumed by the passion to tell stories. Márquez has described storytelling as *bendita manía* (blessed madness), a concept that aptly describes Almodóvar's passion as a creative storyteller, experimenting with complex, multilayered narratives. In Almodóvar's case, writing is not only an exacting gift but also—to paraphrase another hero of his, Truman Capote—a self-declared need to overcome aloneness and loneliness.

Almodóvar said he was happy to be in the company of Luis Buñuel, the great Spanish director who, for most of his career, worked in exile. His films—even the good ones—lack Buñuel's subtlety, delicacy, and light touch, but his narratives, like Buñuel's, are suffused with surreal, illogical, and irrational elements. However, unlike Buñuel's films, which found little or no support in Spain, forcing him into exile (in Mexico and then France), Almodóvar has benefited from a new global cinematic order. Buñuel's best movies were made in Paris, helping him secure a place in the international film circuits (prime

among which were festivals like Cannes). In contrast, as Mark Allinson has pointed out, Almodóvar has had it both ways: in Spain, he has enjoyed greater freedom than any of his contemporaries, and abroad he has become the chief embodiment of the new Spanish culture.[21]

Of Hollywood filmmakers, Almodóvar has acknowledged his debt to Hitchcock, Tashlin, Sirk, and especially Wilder: "If I have to choose one master or model, I would choose Wilder. He represents exactly what I wanted to do."[22] When pressed to define which Wilder he adores, he says: "All of them. I like Wilder of *Sunset Boulevard* and Wilder of *The Apartment*, Wilder of *Double Indemnity* and Wilder of *One, Two, Three.*"[23] Almodóvar's sensibility, like Wilder's, is both comic and morbid, offering a satirical look at a world that also includes fetishistic and voyeuristic elements. His films deliberately steer clear of conventional logic or morality, and beneath their frenzied surfaces, they touch on social problems, violence, disability, sexual abuse, rape (in more than half of his films), women's liberation, and so on.

Almodóvar attributes his strong psychological currents to Hitchcock, a figure he has wished to emulate in his rich narratives as well as his elegant visual style and subtle mise-en-scène. He has been obsessed, like Hitchcock, with the physical and emotional life of objects. Typewriters, telephones, answering machines, microphones, kitchen knives, guns, and even blenders abound in his work. In some of his films—say, *Law of Desire* and *The Flower of My Secret*—the typewriter actually functions as a major character, alongside the human figures. Also taking a cue from Hitchcock (and Scorsese), he has been enamored of the color red in all of its hues, a color he has used to signify passion, danger, risk, murder, blood, and death.

Almodóvar was one of the freshest voices of the 1980s, a child prodigy of a news Spanish cohort, determined to throw out the country's past. His thematic flamboyance and moral relativism are by-products of Spanish culture under Franco's repressive regime. He has shown emotional affinity with the confusions, anxieties, and desires of young people who came of age in Spain right after Franco's death in 1975. Almodóvar benefited from the cinematic scenes of Spain and Europe of the early 1980s. It is not a coincidence that he achieved international fame and cult status when Spanish cinema

was at low ebb. In the early 1980s, Spanish films amounted to less than one-fifth of an ever-shrinking domestic market. His appearance signaled a new wave, a new pride in a Spanish national cinema, which began to undergo significant changes after Franco. When Almodóvar began his career, Spain's most famous director was Carlos Saura. Nearly twenty years older, Saura, considered to be the most "Spanish" of Spanish filmmakers, belongs to a different social generation. He is known for making intensely measured and psychologically reflective films infused with the innate secrecy and repressed sexuality of an artist raised under tyranny. Many of his films have celebrated national folklore, particularly music and dance, as evident in his unofficial trilogy: *Bodas de sangre* (*Blood Wedding*) (1981), *Carmen* (1983), and the colorful rendition of Manuel de Falla's *El amor brujo* (*The Bewitched Love*) (1986).

The right film artist at the right time at the right place, Almodóvar also profited from the dearth of new and exciting European directors. He flourished in an era in which Ingmar Bergman, Michelangelo Antonioni, Federico Fellini, Jean-Luc Godard, and Bernardo Bertolucci were all in decline or totally inactive. Other major figures, such as Pier Paolo Pasolini, François Truffaut, Fassbinder, Krzysztof Kieslowski, and Andrei Tarkovsky, had died prematurely, at the heights of their creativity.[24] Almodóvar was the most pulpy figure of world cinema of the 1980s, a decade before the Hong Kong–based Wong Kar-Wai became a cult figure in the United States (largely through the efforts of Quentin Tarantino, who himself burst on the scene in 1992 with his splashy debut, *Reservoir Dogs*). In addition to pumping new blood into Spanish cinema, Almodóvar created a new sensibility in international film, which became widely imitated all over the world.

Almodóvar's view of camp sensibility differs from that of Waters (see chapter 5): "Camp makes you look at our human situation with irony," he says.

> It's much more interesting to take camp out of a gay context and use it to talk about anything, everything, but to do that, you must show how much you love it, how much you enjoy camp. Otherwise you look like you're just making fun. In camp, you sympathize with lack of power, like the pathos of sentimental songs. This is kitsch, and

you are conscious that it is, but that consciousness is full of irony, never criticism. You cannot take camp out of its original context if you feel like an intellectual using this element of theirs. To use it outside, you have to celebrate it, to make an orgy of camp. Anyway, it's a sensibility. Either you have it or you don't.[25]

Critical and satirical yet always humanist, Almodóvar's work is free of judgment or moralizing. He has created characters whose sexuality is fluid and whose identity is confused—heterosexual, homosexual, bisexual, transsexual, and transgender people. His work has also explored the redemptive power of love, a notion he has consciously taken from Hitchcock. Love, in all of its complications and forms—romantic, erotic, obsessive, and self-destructive—features prominently in his work. The director, like his characters, doesn't pretend to fully understand love. But for him, love is its own goal and its own justification—mysterious, transcendent, and fatalistic. Love answers to nothing and nobody. Extolling Spanish fatalism, he has made titillating and daring features, in which sex and death are inextricably linked: "I love characters that are crazy in love and will give their life to passion, even if they have to burn in hell."[26] Passion is the key concept due to the fact that "society is preoccupied with controlling passion, because it is disequilibrium, but for the individual it is undeniably the only mother that gives sense to life."[27]

Almodóvar's narratives are personal because he, like Waters and Haynes, has always conceived and almost always written his own scenarios, affording himself a strong measure of artistic control over his work. Despite many offers, he has resisted going Hollywood, though once or twice he was almost tempted. He loved gay writer Michael Cunningham's Pulitzer Prize–winning novel, *The Hours*, which, in 2002, was made into a passable but not great film by gay British director Stephen Daldry.

Opting to work in Spain, Almodóvar has enjoyed a most fruitful teaming with his younger brother, Agustín, who is the producer of his films.[28] Moreover, as a director, he has relied on a skillful crew of collaborators, especially production designers and composers, and a terrific troupe of actors—most notably, Carmen Maura, Marisa Paredes, Penélope Cruz, and Antonio Banderas.

What saves Almodóvar's films from potential mean-spiritedness and negativism is the tension between his characters' street-smart cleverness and grim living situations and their use of humor in the most devastating situations: "I always use humor, even in the most dramatic moments, and it's a direct effect of my spontaneity, which is precisely what sometimes shocks and surprises everyone else. I don't know if my humor takes away from the intensity of a certain moment, but the fact is that my humor surfaces this way, spontaneously."[29] Beneath the jokes and lurid touches, however, there's a revisionist strategy, a distinctive POV. As he elaborated: "The main difference between directors is their private morality. I think one auteur is different from another because he has his own morality. When I say morality, I don't mean ethics. It's just a private point of view that you can see in films by Buñuel and Hitchcock, and you know exactly that it belongs to Buñuel or Hitchcock, because it's just their special way of thinking and representing the world."[30] (Waters has expressed the same belief in similar words.)

I propose to distinguish four phases in Almodóvar's evolving career, which are more or less divided by decades.[31] In the first phase, from 1980 to 1989, his work was excessively garish, outlandishly inventive, and joyously irrepressible. For me, the highlights of this phase are *What Have I Done to Deserve This?* in 1984 and *Women on the Verge of a Nervous Breakdown*, his first acknowledged masterpiece, in 1988. The second, weaker phase begins in 1990 with the controversial *Tie Me Up! Tie Me Down!* and ends in 1998 with his most restrained and conventional melodrama, *The Flower of My Secret*, which is populated by middle-aged and middle-class characters and thus is the exception to the norm. The third, most accomplished phase begins in 1999 with the masterpiece *All About My Mother* and continues through 2006 with three other masterworks, *Bad Education, Talk to Her*, and *Volver*. The fourth phase, which finds the director at his most stylishly elegant but also in his darkest mood, begins with *Broken Embraces* (2009) and includes *The Skin I Live In* (2011). It is still too early to tell whether his latest (and arguably weakest) feature, *I'm So Excited* (2013), represents the beginning of a new phase (hopefully not).

PHASE ONE: FLAMBOYANT BAD BOY

Almodóvar's earliest work was quirky and insouciant, a result of how the vibrant Madrid shaped his screen narratives and characters. This was manifest in the culture of the streets, with their colorful people, coffee shops, taxi cabs, night clubs and their nonstop music. When I first met the director in New York in 1984, he was wearing a flashy outfit with strawberry-colored loafers and carrying a red plastic briefcase. His early films were marked by the intrusion of wild and crazy humor that often relieved the melodramatic tension. Those caustic, irreverent, shocking comedies made him a favorite of international art-house cinema. Representing idiosyncratic themes, his authorial voice revealed the moral and sexual chaos that lies just beneath the surface of "normal life." This is one reason why he has proclaimed admiration for Lynch's *Blue Velvet*, released in 1986 and arguably his masterpiece.

Almodóvar's camp melodramas, which depicted new characters in Spanish cinema—homosexuals, transvestites, transsexuals—were steeped in the liberal culture of the post-Franco era. Speaking for a new generation that rejected Spain's past, he was committed to the pursuit of immediate and visceral pleasure. As he said: "I never speak of Franco. The stories unfold as though he had never existed, because for people who are 15 or 20 years old today, all of their points of reference, their traumas, the specters of their past are unrelated to the dictatorship."[32] Indeed, there are only a few mentions of the Civil War in his work, and then usually with minor figures. In *High Heels*, for example, the secretary of the protagonist-singer Becky is the daughter of a Catalan doctor who went into exile during that time. Almodóvar's postmodern sensibility reflected the spirit of those youths known as *pasotas*, "those who could not care less."[33] There was a real joy in telling stories and entertaining audiences with dazzling send-ups and irreverent antics. He saturates the screen with primary colors—particularly hot red but also blue and yellow. His films add layer upon layer of narrative strands until the mixture curdles into incredibly zany farce, not to mention outrageous imagery. Like Waters, he is a director who set out to tickle himself and the public. Remarkably, he

has accomplished that without violating his principles, which begin and end with commitment to artistic freedom and celebration of joy.

Almodóvar says he is in disagreement with Spain's contemporary young generation over one issue: "Young people now are very preoccupied with the marketplace, which is natural. But I remember in the early 1980s, everything we did was for pleasure, because we liked to, for the joy of doing it. Now young people are not doing that, and it is a pity. Because when you are starting out, that is when you need to do exactly what you want, with no responsibility."[34]

Visually influenced by Frank Tashlin, Almodóvar's 1980s films exhibit cartoonish abandon and deliberate delirium. Tashlin began his career in the 1930s as a cartoonist, creating a syndicated comic strip. Later, as a film director, his background became evident in the inventiveness and the frenzy of his farces and in the exaggerated tone of his parodies. He directed Jerry Lewis and made risqué romps featuring the cartoonish, big-breasted Jayne Mansfield: *The Girl Can't Help It* and *Will Success Spoil Rock Hunter?* Almodóvar saw Tashlin's work as the vanguard of a modern style in screen comedy. Ultimately, though, Tashlin's influence was ephemeral and mostly in the visual department. Unlike Tashlin, Almodóvar has made the artificial world both more seductive and more realistic in the sense that his characters are grounded in recognizable social contexts. Almodóvar added to Tashlin's approach a strong dose of Freudian psychology, dealing with the subconscious and the unconscious of his characters—the ways in which they feel, behave, and make love.

* * *

Almodóvar showed promise in his feature debut, *Pepi, Luci, Bom and Other Girls on the Heap* (*Pepi, Luci, Bom y otras chicas del montón*), a parody about patriarchy, machismo, traditional marriage, lesbianism, and sadomasochistic relationships. This 1980 movie is a send-up of everything and anything that's related to sexuality except for one issue that matters the most to the director and about which he would never joke: female friendship, the most recurrent theme in his pictures.

Initially, the triangle of women at the center of this zany comedy could not be more different in age, class, personality, and lifestyle. Pepi (Carmen Maura) is in her twenties and spoiled, Luci (Eva Siva) is a victimized housewife in her forties, and Bom (Alaska, born Olvido Gara Jova) is a punk musician who is only fifteen. Early on, Pepi is visited by a policeman (Félix Rotaeta) who has spotted her marijuana plant from his flat. She tries to buy his silence by offering oral sex, but he rapes her, thus destroying her hope of keeping her virginity for the best "bidder." Eager for revenge, Pepi asks her friends to beat up the policeman, but by mistake, they attack his twin brother.

Pepi befriends the policeman's docile wife, Luci, whom she introduces to the punk Bom. Luci's masochism and Bom's sadism complement each other, and the two women become instant lovers. When Bom first meets Luci, she says, "Fortysomething and soft, just as I like them." Their sadomasochistic relationship is a parody of patriarchal stereotypes. Forced to work when her father stops sending money, Pepi sets up an ad agency, designing commercials for multipurpose underwear and other eccentric items. Pepi's ads are a spoof of traditional gender roles: girls are not expected to fart on dates, or wet their pants, or flaunt their dildos. One of Pepi's most popular products is a doll that sweats and menstruates. Pepi also begins to write a script and shoot a video about Luci and Bom's lesbian affair.

Bom, the aggressive teenage singer, plays with a punk group named Bomitoni. Their parties draw gay men who are fond of a competition game called *Erecciones generals* (General Erections). Almodóvar parodies female beauty parades, watched by voyeuristic males, by putting the male organ on display, thus inverting the male gaze that prevails in traditional cinema. Women, no longer passive sex objects, are allowed to gaze at—and enjoy—men's genitalia. A voyeuristic male funds the frivolity, which he observes while cavorting with his wife, who is bearded.

Pepi, Luci, Bom is one of the few Almodóvar films in which the female characters are deliberately constructed as types. Luci is the submissive housewife who cannot (and perhaps does not want to) change her ways. Her social relationships are driven by the dynamics of sadomasochism. Early on, she tells Pepi, "I need a firm hand," confessing that she had married her policeman husband not out of love

but out of hope to be mistreated: "I thought that if I married him, he would treat me like a bitch." And, sure enough, he does.

Determined to make his wayward wife, Luci, pay for her misbehavior, the policeman abducts her. Fully embracing macho culture, he reasserts his patriarchal rule in every interaction. He silences Luci by saying firmly, "Shut up. This is not women's business." He questions her about her whereabouts, demanding to know if she had gone out to a bar. He puts down her behavior as a groupie: "You know quite well that I won't have any of that business of liberated women." Luci parodies her husband's sexual mores, stating that she is "a victim of the wave of eroticism which is invading society." When the policeman calls a colleague to find out if there are legal means to force his wife back home, his friend tells him, "If it came to court, we would have every feminist in the country on our backs."

The film satirizes dominant-subordinate relationships through the grotesque exaggeration of abusers and victims. Luci complains to Bom that she (Bom) does not treat her badly enough. When Luci returns to her husband, after being bruised by him and sent to the hospital, it's not because of his authority but because of her perverse pleasure in masochism and her enjoyment of brutality. Luci is fully aware that life with her husband will continue to be abusive and never change.

Referring to herself as a rich heiress, Pepi is supported by her father, a faceless figure that simply serves a function in the story. When he stops sending money, she seeks gainful employment for the first time in her life. Once she gets a job, she forgets all about her biological family. Moreover, Pepi (like her screen sister Pepa in *Women on the Verge of a Nervous Breakdown,* also played by Maura) is so busy that she has little time to appreciate her home.

After Franco's death, Spain became an increasingly materialistic society, and this movie shows it. As critic Paul Smith noted, money is the great social and sexual divide. Pepi is prepared to sell her virginity for 60,000 pesetas. Going to see a potential client, she tells Bom, "My capitalist lives around here." Her friends, Toni and Moncho, sleep with older men, and they are not worried about selling their bodies.

Pepi sets up her own ad agency, and the ad for Bragas Ponte is inserted. Her commercial for antiflatulence knickers shows the

product's other uses: as urine-absorbing knickers and as a dildo when rolled up. The parody becomes more ridiculous and exaggerated in each of the ad's three sections. The ad states: "*Hagas lo que hagas, ponte bragas*" ("Whatever you do, put your knickers on"). After seeing Pepi's àd, Bom remarks that she wishes the urine-absorbing underwear were for real.

When Bom feels lost without Luci, the ever-resourceful Pepi comes up with a solution. Bom should move in with her as her bodyguard, and she should start singing boleros. In the final shot, which suggests a more optimistic future, Pepi and Bom, dressed in lurid pink tights and sporting poodle-like coiffures, walk across a motorway. Holding hands, they promise each other a better life. Pepi says: "A new life is dawning ahead of you," to which Bom replies, "Ahead of you, too." "That's what I am hoping," states Pepi. Self-sufficient now, the women are not dependent on men to achieve happiness. The resolution presents friendship as a nobler value than romantic love or sexual fulfillment, be it heterosexual or homosexual.

Almodóvar has said: "Men deserve to be deceived by women. I love the idea of a girl deceiving her husband with a girlfriend. It's an image which I find attractive and which forms part of the secret autonomy of women."[35] In this film, he takes an ultraliberal look at the post-Franco pop culture. Compared with future films, there is less concern with social or political themes and more celebration of freedom in the radical break from the long totalitarian tradition. Amateurish and grotesque in both the positive and the negative sense of the terms—which is why it has been compared to Waters's "Trash Trilogy"—*Pepi, Luci, Bom* is a satire of women, who have played submissive roles for so long that they have reached the dangerous point of internalizing their victimization.

With its cheerful sense of trash and gross sex gags that recall (though vaguely) the early Waters work and its attacks on the government and the mass media, *Pepi, Luci, Bom* sees authority figures as more perverse and corrupt than their normal subjects or even dissidents. Deliberately punky, consciously cartoonish, and unabashedly gay in viewpoint, *Pepi, Luci, Bom* is the first and only Almodóvar movie that justifies the label of kitsch and one his few films to be shown in midnight screenings and become a cult movie.

Tashlin's influence is manifest throughout the picture. After the cartoon titles, accompanied by a trashy pop song from Little Nell (known as a bit player in *The Rocky Horror Picture Show*), Pepi is introduced sitting on cushions and pasting stickers of Superman into an album. Cartoonish irony also prevails in the casting. Pepi is supposed to be young and virginal, but she is played by Maura, who was already thirty at the time. Some of the intertitles are also cartoonish, as the one describing Pepi as "Thirsty for revenge." Clichés and empty slogans are deliberately inserted in the form of ideological declarations about feminism, politics, pornography, and so on. Luci's husband says, "Spain is going to the dogs with so much democracy," without fully understanding his own statement.

Neither the film's professionals nor its civilians play according to norms of decency—or any norms. Lacking a sense of ethics, the policeman who discovers Pepi's marijuana expects sexual favors in return for silence. For her part, Pepi takes his compliance for granted when she lifts her shirt, which predictably provokes his sexual response. Moreover, the policeman doesn't investigate his brother's attack through the proper channels. He tries to enact revenge on Pepi for his wife's transformation, wondering why there is no law to force his errant wife to return home. A sexual predator, he tries to seduce his wife's best friend, Charo. And when another policeman, who serves under him, steals Pepi's magazines in front of him, he takes no action.

Biological families are absent in Pepi's and Bom's lives, and there are no mothers in this film: Luci may be one of the few married women in Almodóvar's work who has no children. To compensate for this lack, the characters look outside their blood ties for meaningful relationships. *Pepi, Luci, Bom* is at its best as a celebration of female camaraderie, especially when family relationships are nonexistent or dysfunctional. The central relationship is Pepi and Bom's friendship, not the sexual affair of Luci and Bom. "I wanted to make a film about autonomous women," Almodóvar said, "women who are owners of their bodies and minds, who do without men, who make use of men. But I didn't want to make a feminist film either, but rather one that's really outside morality."[36]

At one point, Luci says, "I think women have to find their true selves." And, indeed, the women are at their most natural and spontaneous when there are no men around. Pepi cooks Bom's favorite dish, *bacalao al pil-pil*, and when they meet, they giggle spontaneously and chitchat freely about this and that. Bom's relationship with Luci becomes Pepi's film project. Their intimacy stands in sharp contrast to the cold ambience in Luci's home when she is with her husband. The women learn to be as aggressive as men by necessity. Determined not to become a victim, Pepi takes revenge on the policeman who raped her with sadistic pleasure: "Give him a good beating," she says, as she watches her friend beating Juan (who's, of course, the wrong man). Bom carries photos of nude women, and Luci delights in lesbian sadomasochistic comics.

In contrast, the males are softer and more tender than the usual. The painters who share their house have interests that are more characteristic of women; they read celeb magazines and collect folkloric figures and images of royal families. Pepi's friend (Assumpta Serna, who would star in *Matador*) goes out with a boyfriend who is good-looking but mute. The drag queen Roxy, played by Fabio McNamara, is cast as the Avon Lady, decked out in blonde wig, black beret, and glitter miniskirt. He gives a long monologue about the virtues of face masks made out of fruit salad. Like the other characters, he is capable of silly, irrational behavior, seen here when he ambushes an innocent postman. Roxy exudes scandalous sexuality and effeminacy—"I'm hysterical," he says, using the feminine adjective.

Depicting sexual and scatological taboos, which challenge acceptable (bourgeois) taste, *Pepi, Luci, Bom* shows the director's penchant for excess, his need to shock viewers with ultrafrank dialogue and biological and sexual acts considered to be "degrading" by mainstream society. More significantly, this film anticipates Almodóvar's subsequent career, in which he further explores the themes of female friendship and the impossibility of having a romantic love that's stable and mutually satisfying.

Placing his film within a broader context, Almodóvar makes references to literature, pop culture, and cinema. Playing a nameless role, simply known as "actress," Julieta Serrano (who would play the

Mother Superior in Almodóvar's next film, *Dark Habits*, and a crazy wife in *Women on the Verge of a Nervous Breakdown*) runs after a child outside El Bo nightclub at 3 A.M. in the morning dressed as Scarlett O'Hara from *Gone with the Wind*. Tennessee Williams's famous play *Cat on a Hot Tin Roof* is referenced when the wife teases her repressed homosexual husband. The closeted homosexual is hopelessly married to the squealing, bearded Cristina Pascual, who thinks he is upset because his best friend has come out as gay. Her husband's repression has turned him into a man who buys sex and gets voyeuristic pleasure by watching the members on parade in the General Erections contest. Almodóvar is borrowing here from Williams's scene in which Maggie the Cat (Elizabeth Taylor), during an argument with her alcoholic and reluctant husband-lover Brick (Paul Newman), accuses him of being upset due to the fact that his best friend had killed himself because he was gay.

Pepi, Luci, Bom played at the San Sebastian Festival and received theatrical release in Spain in 1980, but it was shown a full decade later in the United States. The script was written as early as 1977, but there were problems with financial backing. The director shot on weekends over a period of eighteen months. It took three years to make the film, a time crucial in Spain's politics, during which the first general elections since the Civil War took place.

From the very beginning, Almodóvar's cinema was a cinema of extremis. There has always been thematic, verbal, or visual excess in his work. No act of perversion or form of deviance is outside of his realm. There are literally no borders, no boundaries, no limitations to his creative imagination. There are always elements—images, sounds, props—that are not fully contained by the unifying forces of the narrative. His texts do not wholly exhaust their powerful and vivid images, which create playful puzzles that go beyond this unity. His films do not even try to make all the physical elements part of smooth cues. In many of his films, there are dramatic and emotional moments that are not necessarily or adequately motivated and props and images that carry interest beyond their function in the narrative, such as repeated close-ups, decorative patterns, discordant sounds, and shifts between color and black-and-white, all of which potentially cause perceptual shocks. His films offer rich perceptual

fields, dense structures that encourage the viewers to keenly observe and to absorb.

The scholar Steven Heath has claimed that excess arises from the conflict between the images' materiality and the unifying structures within which they are contained.[37] But excess in film doesn't necessarily weaken the overall meaning or emotional impact of the larger structure. While classical Hollywood cinema typically strives to minimize excess, postmodern films do not try to provide motivation for every element in them; they leave potentially excessive elements more noticeable. These elements—single shots, brief scenes, words or sentences—may have no narrative function or may provide little causal material, but they linger in memory, often creating a stronger impression than the more functional elements. In Almodóvar's work, these dissident moments (linguistic, thematic, and stylistic) do not necessarily disrupt or subvert the movie's intentional effect because ultimately his narratives are defined by shapely structures and clear closures.

* * *

Excessive elements in the narrative, visuals, and sounds also dominate *Labyrinth of Passion* (*Laberinto de pasiones*), Almodóvar's second film, made in 1982 but released in the United States in 1990, after the commercial success of the 1988 *Women on the Verge of a Nervous Breakdown*. A screwball comedy about Madrid's newly invigorated lifestyle, *Labyrinth of Passion* is marked by an outrageous plot with unexpected twists and turns. A tracking shot of the local bar depicts the director's favorite screen characters: drug dealers, addicts, drag queens, trendy urban youths, and so on. On a more serious level, the film offers a critique of the dominant culture's concepts of erotic desire, romantic love, patriarchy, and homosexuality.

The great Argentinean actress Cecilia Roth plays Sexilia (Sexi for short), a carefree nymphomaniac whose father (Luis Ciges) is a world-renowned fertility specialist. Hoping to exorcise her fear of sunlight (which she associates with her father), Sexi consults a therapist who determines that the source of the problem is her incestuous attraction to her father. The therapist then confesses her own attraction

to the father, whose patients include the aristocratic Toraya (Helga Liné), former wife of the deposed ruler of Tiran. Toraya, in turn, has set her eyes on Riza Niro (Imanol Arias), her gay stepson, and is now desperately searching for him in Madrid.

Committed to hedonism, Riza just wants to cruise the gay bars and straight discos incognito, but he has difficulty maintaining a low profile, let alone anonymity. Reading *El País*, Riza focuses on three stories, shown by Almodóvar as inserts à la Hitchcock. The first depicts the flight of Tiran's emperor to Paraguay, the second concerns a Spanish bio-gynecologist who experiments with canaries, and the third is an ad for porn star Patty Diphusa, which is, of course, Almodóvar's name for the character he had created for the magazine *La Luna*. There are scandalous reports about Riza's activities, especially after he goes to bed with Sadec (the young Antonio Banderas), and soon revolutionary student-terrorists plan to kidnap him.

In the first scene, based on parallel montage, Almodóvar establishes the links between the lead characters. Both Riza and Sexi are wearing dark glasses to conceal their eyes as they stare intensely at their objects of desire, focusing on the same parts of the body, crotches and butts of anonymous men strolling down the street. The only difference between the homosexual and the heterosexual is that Riza tries to conceal his mideastern origins by dressing like a European man, whereas Sexi seems more comfy as a punk. Riza meets Sexi at a night club called Carolina, in which both Fabio de Miguel, in drag, and Almodóvar himself, in fishnet stockings, perform the song "Suck It to Me." The film's second performed song, which is lip-synched by Riza, is tellingly called "Big Bargain." Predictably, Riza and Sexi immediately fall madly in love, and also predictably, the course of their love is not smooth—it never is in Almodóvar's work.

One issue in the film, and in all of Almodóvar's work, is introduced in the first sequence, the fluid and fractured nature of identities. *Labyrinth of Passion* offers erotic possibilities that go beyond permissible behavior and conventional labels of gay and straight. Almodóvar deals with incest, drugs, orgies, and other shocking habits, demonstrating skill in treating offensive material with vivid, cartoonish abandon, which tends to make it less offensive. He pairs couples that are older and younger, fat and thin, beautiful and homely, gay and

straight and then breaks them up according to whimsical plans, paying little attention to conventions of age and physical appearance. In the end, the optimistic message is delivered with sharp satirical bite.

Consider the scene in which a drag queen, whose chest seems bloodily butchered, looks at the nasty drill hovering over him before saying, "I deserve it, I'm so bad, I'm wicked," while a photographer takes pictures of the sight. Or the middle-aged laundry proprietor who takes sexual potency infusions before tying up and raping his own daughter—albeit with tenderness. When she's not secretly squirting the tea of her lusting father with sex-diminishing drops, the girl is busy tending to her weak fingernails and dry lips.

There seems to be no underlying logic to the convoluted narrative, suitably titled *Labyrinth of Passion*, other than the goal of subverting accepted norms. How else to explain the love between the gay son of an exiled Mideast emperor and Sexi's nymphomaniac. Or Sexi's unusual declaration of passion to Riza: "I went to an orgy, and I couldn't stop thinking of you." In the first part of the narrative, the attraction between Riza and Sexi seems random and arbitrary, and her ability to convert him into a happy heterosexual is inexplicable because he is overtly gay. But through a revelatory flashback to their childhood, Almodóvar tries to show the depth of their emotional bond and the reason for their fateful reunion as a couple. As I'll show, most of the characters in Almodóvar's films have already "met," or at least encountered each other in the past (often in public spaces), before they actually meet in the present, turning their emotional and romantic connections into an almost preordained fate.[38] In *Labyrinth of Passion*, the protagonists have met as children, and similar situations prevail in *Matador*, in which the two would-be lovers first encounter each other in public at a bullfight, and in *Bad Education*, in which some of the characters have met as boys in a Catholic school.

It is noteworthy that *Labyrinth of Passion* is the only Almodóvar film in which a homosexual (Riza) turns out to be a bisexual "converted" into a well-adjusted heterosexual through a woman's love. I suspect that this kind of coda would not have been built into his later, more mature narratives. When the movie played in the United States, most critics pointed out that this kind of resolution is "atypical" and "uncharacteristic" of the director.[39] Even so,

despite the "straight happy" ending, what lingers in my memory is the film's outrageous depiction of incest and deviance: the images of stepmother Toraya sleeping with her gay stepson Riza, and of Queti, the girl raped by her father, being transformed by plastic surgery into Sexi, which enables her to consummate her obsession with Sexi's father.

In making *Labyrinth of Passion*, a movie firmly grounded in the present, Almodóvar has acknowledged the influence of Richard Lester's Beatles films, *Help* and *A Hard Day's Night*, au courant visceral and spontaneous chronicles of Swinging London as it was happening in the mid-1960s. (Most movies usually lag behind the zeitgeist because of the lengthy time involved in making them.) For reasons both artistic and economic (to save money), the director composed and performed (as a leather-jacketed drag queen) the soundtrack, inspired by the live concerts and recordings of his group, Almodóvar y McNamara.

Labyrinth of Passion shows the diverse inhabitants of Madrid's street culture—hustlers, exiled princes, transvestite punks, crazy nymphomaniacs, angry terrorists—all trying to get sexual gratification, even if it's for a fleeing moment. Although all the characters are driven by their libidos, it is the men, especially the fathers, who are severely flawed and experience sexual crises of one sort or another. Sexi's father, Doctor de la Penas, finds sex repugnant, and Queti's widowed father is an impotent who deals with his loneliness by taking aphrodisiacs and engaging in incest.

Context is crucial: the tale occurs after the end of Franco's authoritarian regime and before the onset of the AIDS era. With its young characters, *Labyrinth of Passion* is targeted at Spain's young viewers, those who were not old enough to vote in Spain's first general elections and who were also indifferent to politics. This phenomenon is referred to *pastotismo*, which means "political apathy and indifference." Contrasted with Almodóvar's future assured works, *Labyrinth of Passion* is not a major work, but at the time it was made, the movie contained enough poignant and outrageous moments to shockingly entertain its viewers.

* * *

It was only a matter of time before Almodóvar, a product and victim of rigid Catholic education, turned his critical attention to the Spanish church, and, indeed, his third feature, *Dark Habits*, from 1983, is a ferocious attack on institutionalized religion. Although expected to be an outrageous satire of convent life, *Dark Habits* is more of a melodrama—and one of the most linear in the director's output. Thematically, like other of his films, *Dark Habits* is more about obsessive romanticism, which expectedly turns into doomed love and violent death.

The tale is set against a climate of denial and repression, two of Almodóvar's most consistent targets. The Spanish title, *Entre tinieblas*, refers to a Catholic ritual. Tenebrae are the days before Good Friday, when candles are extinguished in church, an act implying the socioreligious processes of sacrifice and redemption. Yolanda (Cristina Sánchez Pascual) is a cabaret singer who witnesses the imminent death of her lover after a drug overdose. Like other males in the director's work, the boyfriend is gruff and unsympathetic. Desperate to escape the police, Yolanda recalls a visit from the local convent's nuns who claimed to be her admirers. The function of the order, named the Humble Redeemers, is to serve as shelter for "fallen women," like Yolanda. Upon arrival, Yolanda is greeted by the Mother Superior (Julieta Serrano), only to realize that she is the only resident. All the nuns—Sister Manure (Marisa Paredes), Sister Damned (Carmen Maura), Sister Snake (Lina Canalejas), and Sister Sewer Rat (Chus Lampreave)—give Yolanda a warm welcome. Predictably, they turn out to be a bunch of eccentrics: Sister Damned likes pet tigers, Sister Manure bakes LSD cakes, and Sister Sewer Rat writes soft-core romans à clef.

The Mother Superior becomes obsessed with Yolanda, and the two embark on a romantic bliss induced by drug abuse. But later on, Yolanda decides to change her ways, working hard to put her life back together. Withdrawal for Yolanda is a painful catharsis, but cathartic nonetheless, but for the Mother Superior, it is a public confirmation of sinful life. Lusting for sex and drugs has made Mother Superior worse than the women she is supposed to help. Meanwhile, the convent is falling apart and is threatened with closure, when Marquesa (Mari Carrilo), the liberated and greedy widow of a fascist, informs

Mother Superior that she will no longer provide financial backing for the convent, instead using the money for her selfish pleasures. Desperate, Mother Superior thinks that drug trafficking would help her to maintain the convent's independence.

In theory, the combination of Almodóvar and convent suggests a sacrilegious farce or high camp, in the vein of American playwright Christopher Durang's witty spoof *Sister Mary Ignatius Explains It All for You*. Yet in most scenes, *Dark Habits* is a rather quiet, even tender melodrama. Though hedonism prevails in the Humble Redeemers community, the director focuses on the dynamics of his characters' relationships.

The Mother Superior's love for Yolanda pays homage to *La Religieuse*, a novel written by French author Denis Diderot circa 1780 but not published until 1796, after his death. (Francis Birrell's English translation is titled *The Nun* or *Memoirs of a Nun*.[40]) Almodóvar relished the novel's origins, not as a literary work but as an elaborate practical joke, aimed at luring back to Paris the Marquis de Croismare, Diderot's companion. The novel consists of letters purporting to be from a nun named Suzanne, who implores the Marquis to help her renounce her vows, describing an intolerable life in a convent to which she has been sent against her will. Diderot later revised the letters into a novel, drawing attention both to the cruelty of forcing young women into convents and to the corruption among the clergy. When Diderot publicly admitted his role in the ruse, the Marquis is said to have laughed, as he had behaved with genuine compassion in his willingness to help the imaginary Suzanne. Almodóvar is not as interested in delivering anticlerical messages as was the great Buñuel, who was also inspired by Diderot in such harsh antireligious films as *Viridiana*.

Dark Habits has no major male characters, reaffirming Almodóvar's commitment to femme-driven cinema. But there is no negative portrayal of the few males that exist. For example, the worst things that the Chaplain (Manuel Zarzo), who significantly has no name, does in the story are to smoke while extolling Cecil Beaton's fabulous costumes in George Cukor's 1964 Oscar-winning musical, *My Fair Lady*, and to give the church's statues a polish, with the assistance of Sister Viper, his secret lover.

Like most of Almodóvar's personae, the characters in *Dark Habits* are driven by subversive instincts. For him, the greatest sin in life is not deviance or crime but the denial of desire and feeling. *Dark Habits* tries to balance its characters' subversive impulses with their need for spiritual redemption. It is "in the imperfect creatures that God finds all His greatness," the Mother Superior says, ironically serving as the director's spokesperson. Almodovar's critique is not so much of religion as it is of rigid and authoritarian institutions (including the church), which suppress individualism and obliterate human desire.

Denying that *Dark Habits* was meant to send an anticlerical message, Almodóvar claimed that he just wanted to point out the absolute autonomy of the nuns, whose authority is not restricted by any norms. "I didn't want to shock, and it's not scandal I'm looking for." Moreover, for him, *Dark Habits* was a "Christmas film, because it follows exactly the doctrine that in order to save sinners, you have to become one of them."[41] Thus, the director's fans, expecting a serio-comic critique of the church and its practitioners, were disappointed with what was shown on-screen.

Dark Habits is the first film in which Almodóvar showed visual progress. There are long tracking shots in which the camera follows the Mother Superior down the chapel's aisles, placing her in a broader perspective. Or the high angle shots, which call attention to the women's claustrophobia and their minor stature against the foreboding structure. The color red, a visual motif of the director, is prominent throughout the picture, from the first frames, in which Yolanda's red fingernails are observed as she relishes using scissors to cut her boyfriend from the photos she is signing for the admiring nuns. And red continues to be prominent: Merchese, a woman running from the police who used to stay at the convent, and the young drug dealer who visit the Mother Superior are both dressed in red, in contrast to the convent's drab colors. In one scene, there's a sharp cut from Yolanda's red fingernails, as she holds the nuns' visiting card, to a scarlet lipstick trace on a black-and-white photo to an extreme close-up of the Marquesa (trained as a make-up artist) applying red lipstick. It is noteworthy that there's hardly an Almodóvar film that doesn't contain a scene showing women, no matter how oppressed

or depressed, using make-up—specifically, hot red lipstick—in an effort to look better for others and feel better about themselves.

The film's novelty resides in the exploration of taboo issues, such as lesbianism, fetishism, and voyeurism, all in a female-dominated context. "My only sin is to love you too much," says the Mother Superior upon meeting Yolanda. The Mother Superior displays in her room photos of such "famous sinners" as the French Brigitte Bardot and the American Marilyn Monroe, two international sex icons of the 1950s. When the Mother Superior is visited by the young Merche (Cecilia Roth), a former inmate on the run from the police, she stoops to replace Merchese's shoes as the latter is taken to prison.

The movie ends with Yolanda and some of the other nuns deserting the Mother Superior. As Sister Manure cradles the Mother Superior in her arms, the camera pulls out of the window, leaving the two women enclosed in a frame within a frame. This scene may pay an ironic tribute to Sirk's device of framing his heroines behind closed windows or doors in order to suggest their emotional stagnation and physical imprisonment in their own homes.

Reflecting his own class, Almodóvar's features have focused sympathetically on the plight of contemporary working-class women. However, although he puts women front and center, he doesn't follow feminist ideology or any other rigid political platform. By challenging established sex and gender roles, he has contested Spain's long-prevailing stereotypes of sexual politics—machismo men on the one hand and long-suffering women on the other. In this process, he has helped to abolish, within and without cinema, Spain's reactionary past, defined by rigid patriarchy and sexual segregation. He has been seeking truth in travesty through uncompromising explorations of universal matters like sex, love, and happiness.

Almodóvar has placed strong females center stage and weak males on the periphery, or altogether offstage. He doesn't identify with women, as has been suggested by some critics, but he claims to feel strong affinity with them: "I write better for women than for men, who are dramatically boring to me. I am better able to incorporate my talent for wackiness in female than male characters."[42] As a result, there are far fewer males than females in his work. Early on, the director expressed his motto: "I'm aware that my liking of the private life of

women may still be a reflection of machismo. But I hope not. Because I'm really interested in women and their world, not just when they go to gossip in the bathroom, but at all times. I believe I'm one of the least machista men in the world, and one of the most authentically feminist."[43]

Almodóvar's films have shown both the ordinary elements in the extraordinary lives of women and the extraordinary aspects of women's ordinary existence. The excess and eccentricity are accepted by him as natural and normal states of being, not as special phenomena that call for explanation. Like other gay directors, he has questioned what society considers normal and devious, normative and deviant. He has portrayed the sensational aspects of everyday life and has broken filmic taboos and social codes with remarkable ease. The real, external worlds of his characters are integrated with their internal worlds in texts that are unusually complex and complicated.

* * *

Dark Habits did not stir major controversy, and to Almodóvar's disappointment, it did not create the expected sensation. Those reactions occurred in 1984 with his fourth film, the outrageous black comedy *What Have I Done to Deserve This?* (¿*Qué he hecho yo para merecer esto!*), the turning point of his rapidly evolving career. Among other things, as his best work to date, it put him on the international map as a major talent to watch. After premiering to sold-out crowds as part of the New Directors/New Films series, cosponsored by the New York Film Festival and the Film Department of the Museum of Modern Art, *What Have I Done* became the director's first picture to be released theatrically in the United States. He could not have been happier because the film's successful run led to the release of his three earlier films. It didn't matter much that they all got mixed reviews, compared to the rapturous reception for *What Have I Done*.

One of Almodóvar's more realistic features, *What Have I Done*, is a working-class absurdist comedy in which most of the action unfolds within recognizable settings. The pre-credit sequence reveals a Madrid square as a film crew passes by, while a middle-aged woman is seen in the background. The camera moves in on the woman—Gloria

(Carmen Maura), a downtrodden housewife—as she looks back at the crew members, who are nailing signs to be used in their movie. Gloria struggles to make ends meet with various cleaning jobs, in addition to the regular, exhausting work in her own home. On her knees scrubbing the floor, Gloria looks up, facing the Kendo students in their costumes as they practice sharp moves with their clubs at the martial arts academy. The next shot places Gloria and the students together in the same frame, indicating that their paths will inevitably crisscross. In this shot, the students are in the foreground, and Gloria in the background, but in the course of the tale, the students disappear and she occupies center stage. The scene ends with Gloria imitating the blows made by the players, using her mop as a substitute for a martial club.

Love starved and sexually frustrated, Gloria gets excited by the sight of muscular men playing at Kendo. Later on, while stealing something from a cabinet, she unexpectedly encounters a handsome man in the gym's showers. Facing him straight on, she sized-him up and down, including his genitals. Almodóvar allots her the kind of gaze that typically privilege men when they size up women. Teasing her, the man winks at her and suggests that she comes over. During their attempted sexual act, under the shower head, Gloria remains fully clothed, while the man is naked. The man, who happens to be a policeman, tries to get a hard-on but, as we learn later, is impotent. The irony is not lost on Almodóvar that this archetypal male, a symbol of political power and sexual potency, fails to perform, not to mention that he has a small, flaccid penis.[44] Disappointed and frustrated, Gloria picks up the phallic-shaped Kendo and performs solo (for the viewers). The practice proves useful when, later on, she uses the same assertive position to kill her husband in the kitchen.

Gloria lives with her macho husband, Antonio (Ángel de Andrés López), a cab driver; their two sons; and her mother-in-law in a shabby apartment by the Madrid motorway. Antonio, who had worked in Germany, still longs for his former employer-mistress, Ingrid Muller (Katia Loritz), and spends his time listening on the radio to the German singer Lotte Von Mossel. His services for Ingrid involved copying letters that Lotte had allegedly received from Hitler himself. Antonio

casually mentions this fact to a client in his taxi, a writer named Luca, and the latter suggests that they forge Hitler's diaries for big profits.

Addicted to sedatives, Gloria, who has been sniffing laundry detergent and glue, goes to a pharmacy to get the drug No-Doz. But the pharmacist—a big, chubby woman with peroxided blonde hair and big stilt-like eyes—denies her request. The pharmacist treats Gloria with contempt, which is the way Almodóvar had scripted the role. But during the shoot, the director extended the character's role after casting a real pharmacist he had just met. Incidentally, pharmacists abound in his work and they are usually portrayed in a negative way, denying services, needs, or pleasures (if it's recreational drugs) to their clients (see *All About My Mother*).

Desperate to find money to pay the bills and put food on the table, Gloria is forced to take extra jobs as a cleaning woman for the writer Luca and his brother Pedro. While she struggles with her own problems, her sons must learn their own survival strategies. The elder son, Toni (Juan Martinez), is a high school student who deals in drugs, while the younger one, Miguel (Miguel Ángel Herranz), sleeps around with older men, including the father of his friend Raul. When Gloria confronts Miguel about his sexual escapades, the boy's response is firm and strong: "I'm the master of my own body." But it's Gloria who has the final word, telling Miguel that his lovers should feed his body, not just enjoy it.

Miguel's homosexuality is not easily accepted by his brother, Toni, and in a parodic critique, Almodóvar shows how Toni attempts to "cure" his brother by trying to get him laid by Cristal (Verónica Forqué, who would later play the title role in the director's *Kika*), their friendly prostitute neighbor who dreams of going to Las Vegas and becoming an actress. This scene also alludes to Minnelli's 1956 melodrama, the controversial *Tea and Sympathy*, in which a sensitive boy (John Kerr) is pressured to see a prostitute to fend off accusations by his classmates that he is a "sissy." As I'll show, in the 2002 *Far from Heaven*, Haynes also criticizes society's phony beliefs and pressures to "cure" men of their homosexuality by forcing them to see a doctor and get treated. In this picture, Almodóvar satirizes Pedro, the psychiatrist who is supposed to treat and cure the impotent man, but who is presented as a weakling of a professional who has more

problems than his patient. He's dysfunctional and unable to come to terms with his abandonment by his girlfriend.

In a poignant scene that's both heartbreaking and funny, Gloria "sells" Miguel to a pedophile, a nameless character referred to as the dentist (Javier Gurruchaga), after shrewdly negotiating his duties and her benefits off screen (behind closed doors). The dentist is intentionally constructed by Almodóvar as a caricature of the predatory effeminate pedophile who agrees to all of Gloria's and Miguel's conditions. However, it is only after the dentist promises access to video, hi-fi, and to pay for his art classes that Miguel consents to move in, claiming assertively, "no one controls me."

The defeated Gloria returns home to find her husband all excited after getting a call from Ingrid Muller, who, under pressure from Luca, had decided to pay Antonio a surprise visit. Overhearing Antonio on the phone precipitates yet another vocal argument, and when Antonio slaps Gloria across the face, she attacks him with a leg of ham, putting to use the moves she had learned from the Kendo students. Hitting his neck on the sink, Antonio instantly dies. (A similar murder, in which a daughter accidentally kills her father in the kitchen, occurs in *Volver.*)

Strangely, after the murder, Gloria, a woman on the verge of nervous breakdown, continues to behave normally, as if nothing bad or extraordinary has happened. To establish an alibi, she goes upstairs to visit Cristal, and she brings the prostitute to her flat to witness Antonio's corpse, expressing bewilderment at the circumstances of his mysterious death. Surprisingly for the viewers (but not for Almodóvar), the police investigation doesn't find any person guilty. Here again the director employs his usual portrayal of policemen as ineffective and ineffectual (see *Women on the Verge of a Nervous Breakdown*).

Gloria watches forlornly as elder son Toni leaves with his paternal grandmother (Almodóvar's regular, Chus Lampreave) for her rural village so that he can work the land. Obsessed with death, the grandmother likes to talk about this issue, informing friends of those who have passed away lately. (The director explores more fully the mores and culture of death, a recurrent theme in his work, in *Volver.*) What's a desperate housewife to do? Gloria walks back and

forth restlessly in her apartment. She then leans over the balcony as if considering suicide.

But this is an Almodóvar picture, which means that the women are resilient—not for nothing is the heroine named Gloria. Out of the blue, as in a fairy tale in which the prodigal son returns home, an unexpected savior arrives. Miguel reappears, claiming he had gotten bored with the older dentist. Still missing his father, Miguel asks: "Did Dad miss me?"—only to be disappointed by his mother's short response: "He was so busy he didn't even realize you were gone, but *I* missed you!" "I know about father, and I am here to stay. This house needs a man!" Miguel proudly proclaims, while rushing into Gloria's arms. The film ends satisfyingly as a coming-of-age tale when Miguel shows new maturity and strong determination to take care of his mother. His return is depicted as a warrior home from the hill, a reference to Minnelli's 1960 family melodrama *Home from the Hill*, for which Almodóvar has professed admiration. Minnelli's film also depicts a two-generation family, in which the estranged patriarchal husband (Robert Mitchum) is concerned with the masculinity of (and lack of it in) his two sons: his elder bastard son (George Peppard) and his younger, sensitive "mama's boy" (George Hamilton).

In this offbeat comedy, Gloria is a working-class woman "ruined" (*ajada*, in Spanish) by physical labor. Her oppression and subordination suggest that sexual liberation and gender equality can be most effectively achieved through struggle, which often calls for extreme action like criminal conduct. Suiting the fable's feminist nature, most of Gloria's actions are invisible to the men on-screen. When she is not cooking, washing laundry, and scrubbing the floor (all solitary activities), Gloria is socializing with her female neighbors, Juani, the single mother, Cristal, the hooker-wannabe actress, even Patricia, the wife of her employer, although she is initially antagonistic.

Though statistically the film contains more males than females, ultimately, none of the males, except for Miguel, matters much. One by one, Almodóvar critiques the men and then disposes of them—literally or figuratively. Take for example two of Cristal's clients. The first is an older man who seems excited by sadomasochism, asking his hostess to dress as a dominatrix; the poor woman, lacking whips, runs to Gloria to borrow a stick. The second farcical portrayal is that

of an exhibitionist who performs a striptease for Cristal and Gloria, who is dragged into the act as a spectator. The two women are bored to death as he removes item after item, asking them not to go by his slim torso or slender legs but instead to concentrate on his alleged "horse's dong" of a cock, which we never see; Almodóvar would not privilege him with a shot. Later on, during intercourse, he talks and talks while Cristal fakes yet another orgasm (while looking at her nails) and the restless and bored Gloria indicates that she needs to go back to her chores.

The irony is not lost that, ultimately, the strongest male figure in the film is a young gay man. Though he is the younger brother in the film, Miguel serves as alter ego for Almodóvar, older in real life than his brother-producer, Agustín. Early on, Miguel states that he would like to be a filmmaker. Like Almodóvar, Miguel is a precocious and eager boy. One main reason he willingly goes to the dentist is to acquire free lessons in art. Like Almodóvar, Miguel is sophisticated, mature, and knowledgeable in issues of art and life—more so than his older brother. Miguel is Gloria's favorite son in the way that Toni is his father's pride. Named after his father, Toni models himself after his irresponsible dad, all the way down to developing skills for forgery. That said, both siblings need a male role model and, on some level, engage in a rivalry (a futile one, as it turns out) to get their father's attention and emotional support.

The concluding reconciliation between mother and son and the reaffirmation of their union are now based on greater mutual respect. This coda underscores the deep understanding and bonding that often prevail between women and gay men in Almodóvar's work, based on their shared recognition of suffering from the tyranny of patriarchy in all its sociosexual manifestations.

The text gets richer and more universal in meaning by including another secondary character, a girl named Vanessa (Sonia Hohmann), who's abused by her own mother, Juani, a nasty and bitter divorcee. To retaliate against her mother's physical abuse, Vanessa develops special skills, telekinetic powers, in what is a clear reference to Brian De Palma's 1976 cult horror film *Carrie*. Vanessa retaliates against her domineering mother by stopping the elevator midway, or breaking a valuable vase of flowers. When Gloria is left alone, after her two sons

leave, she continues to express her maternal instincts by becoming a surrogate mother to Vanessa. The two women bond, and in a scene of magical realism, Vanessa uses her skills to remove the old paint off the walls and replace it with new, clean and vivid wallpaper.

Technically, *What Have I Done* is crude and its production values are raw, a combined result of the low budget and Almodóvar's relative lack of experience. But the shabby look is congruent with the tale's squalid context and the social class of its protagonists. *What Have I Done* is still the director's least stylized or camp film, unfolding within a particular historical milieu afflicted with the problems of urban, working-class life: dense population, overcrowded apartments, unemployment (especially for women), rampant illiteracy, rising divorce rates, juvenile delinquency, crime, and drug trafficking. But Almodóvar would not let the viewers forget that it is essentially a comedy, laced with elements of humor and satire and occasionally even camp. Like other animals in the director's work (tigers, chickens), the lizard, found by the grandmother in the park and brought home to the already cramped apartment, offers some good jokes— and scares. Searching for a name for the lizard, she says she likes cupcakes (which she keeps locked up), the cemetery, and money, and so the lizard is named Money. The lizard later becomes the only (bloody) witness to Gloria's killing of her husband, but accidentally the cops smash the animal and throw it out of the window, thus relieving Gloria of her guilt.

As the downtrodden, illiterate housewife, Maura, Almodóvar's muse and dominant actress during the 1980s, renders an outstanding performance, making Gloria's trials, tribulations, and escapades compelling as well as entertaining. It's simply impossible to imagine this picture without her presence, and Almodóvar dresses her in such a way (wearing for the most part green shirts and dresses) and grants her sufficient close-ups to ensure that she always stands out in the ensemble-driven tale.

* * *

Matador and *Law of Desire*—the follow-ups to *What Have I Done to Deserve This?*—could not have been more different. Sultry and erotic,

perverse and anarchic, they are gender-bender features reflecting directly the liberalization of Spanish culture and Almodóvar's strong resolve to test the limits of what's tolerable in terms of on-screen eroticism.

The plot of the *Matador* (1986), one of my favorite Almodóvar films, contains every form of deviance: abuse, rape, murder, mutilation, suicide, and even necrophilia. But the thematic and visual treatment of these crimes is so inventive and excessive (by design) that they become less offensive than they would have been if contained in another narrative or filmed by another director. The distinctions between self-eroticism and eroticism, homosexuality and hetero-sexuality, and femininity and masculinity are explored in a boldly stylized, almost abstract way. The director combines intense emotion-alism, seductive eroticism, and cool irony, while playing with viewers' expectations of narrative development and satisfying closure.

The beautiful heroine María Cardenal (Assumpta Serna) is a crimi-nal lawyer who develops a morbid attraction for former matador Diego (Nacho Martínez) after seeing him gored in the ring (he's, of course, hit in the groin). The disabled matador is now teaching preci-sion killing at a bullfighting academy, though he continues to long for danger, blood, and violence years after his career tragically ended. For sexual stimulation, Diego watches horror movies, depicted in shocking yet funny, disturbing yet pleasing ways. Sitting in front of his TV set, Diego masturbates to a montage of images of cheap slasher flicks.

One of Diego's naïve students, Ángel (Antonio Banderas), who tries to prove he is a "real" man and not queer, takes his admiration of Diego to an extreme by trying to rape Diego's girlfriend, Eva (Eva Cobo). Turning himself in, Ángel admits to a string of murders in which all the victims have been speared toro-style. Sent to prison, Ángel is rep-resented by none other than María, whose personal agenda is to meet her heartthrob, Diego. The police inspector (Eusebio Poncela) who follows the case believes that Ángel is innocent. Visiting Diego's acad-emy, the inspector stares intensely at the leotard-clad students—their crotches are seen in close-up from his subjective point of view.

As in his other films, Almodóvar provides links between eroti-cism and violence, ecstasy and death. Dressed in a cape and sporting

sleek, pulled-back black hair, María picks up a man on the street, and they go to an empty office. During hot lovemaking, she removes a pin from her hair and plunges it into his neck, instantly killing him. Intercut with this scene are parallel shots in which Diego teaches his students specific techniques for thrusting a sword into a bull. In *Matador*, the director was able to apply his dramaturgical theory: "I want the characters to live in a universe that belongs only to them, as if they were alone in a world where pain becomes the only protagonist in their life."[45] When Diego and María finally meet, she tries to kill him by sticking her hairpin in his neck, a gesture she had used on all of her victims. Diego prevents her, and the duo, both shocked and impressed with each other, fall in love.

In its broad structure, the plot sounds like a trashy soap opera. But if the motives behind the actions aren't explored, it's because Almodóvar deems them irrelevant. What matters to him is not what people say but what they do, in and out of bed. Concrete conduct is a more reliable expression of feelings than verbal declarations of love. Setting the stage for wilder and more hilarious flights of imagination, he places the viewers in a space where camp, pornography, stylization, and lyricism converge or conflict—depending on viewers' subjective perceptions.

The characters in *Matador* pursue kinkier-than-normal frills and thrills. Eccentric characters, lead and supporting, abound. When Ángel reports at the police station, the female officer says after sizing him up, "Some girls get all the luck." Almodóvar himself has a cameo as the effeminate director of a fashion show devoted to bullfight couture. "I told you not to shoot up in the dressing rooms," he yells at one of his models.

As noted, in the first scene, Diego excites himself with grisly horror videos. Later, while in bed, Diego is aroused by his girlfriend, Eva, only after she pretends to be a corpse. Not interested in normalcy, Almodóvar aims for excess, pushing the narrative to edgy lunacy—"the end of the line," to borrow a popular line from the 1944 noir melodrama *Double Indemnity*, by Wilder, one of the director's heroes. Almodóvar and his co-scribe, Jesús Ferrero (it's the first scenario not written solo), draw their characters with conviction. The choice of profession (matador) justifies the film's focus on surface

appearances, as bullfighting is very much about lavish costumes and public performance. (Just watch the preparations made by the female matador in *Talk to Her.*) With relish and gusto, *Matador* addresses the deviant and perverse in human behavior. There's no denying the pleasure that the director, his characters (who also serve as spectators in the plot), and the film's viewers derive from exploiting (in both senses of the term) cinema's potential for extreme eroticism.

After Bertolucci, who made the seminal and sexually scandalous *Last Tango in Paris* in 1972, only two European directors, Almodóvar in the 1980s and Lars von Trier in the 1990s (and recently in the two-installment *Nymphomaniac*), brought back to the big screen the "forbidden" subjects of sex, sexuality, and sexual politics, topics that are seldom dealt with (if at all) with such honesty in Hollywood movies of any era. None of the influential directors of the New American Cinema—Arthur Penn, Woody Allen, Robert Altman, Francis Ford Coppola, Oliver Stone, Steven Spielberg, Martin Scorsese—has ever depicted those issues on-screen in a manner even close to the candid and graphic approach of Almodóvar.

Almodóvar's achievement is remarkable, considering that his movies were made at the height of the AIDS epidemic and the surrounding anxieties and homophobia. He has placed special emphasis on the libidinal pleasures of the human body and its sexual organs. His characters are driven by a relentless, obsessive pursuit not of power, status, or money but of pleasure, though in his universe, there is no pain without pleasure and no pleasure without pain.

Obsessed with desire, sex, and death, María and Diego represent a match made in heaven—literally and figuratively. They plan to kill each other in one ultimate fantastical ecstasy. Diego's girlfriend Eva, who overhears the plan, alerts the police, who pursue the lovers to María's country retreat, but, alas, they're too late. The lovers find their violent passion and death mirrored and inspired by Gregory Peck and Jennifer Jones in King Vidor's 1946 excessive Western melodrama *Duel in the Sun*, which they had previously watched in a movie house where they landed by "accident" when Diego chased after María.

In the final scene, Diego and María enact their greatest erotic fantasy. Spreading out a cape in front of the fireplace, they sprinkle it with rose petals as the giddy camera pans over their naked bodies,

offering unusual visual pleasure. Diego holds a red rose in his teeth, with which he caresses María's vagina and nipples. Diego penetrates María, and she plunges a hairpin into his neck, forcing him to look at her up close and personal before she shoots herself in the mouth. The lovers fulfill their ultimate experience of sexual pleasure through death. The ceremonial ritual of their final ecstasy evokes in the viewer contradictory reactions of discomfort and disbelief but also of peculiar attraction and even laughter. The scene also suggests the fine line between soft-core and hard-core pornography. Though the movie shows only female genitalia, it is replete with phallic imagery, such as long and narrow objects (the sharp sword, the thorny rose, the lethal hairpin, the pointed gun). The last scene is profoundly disturbing, and yet it offers logical closure to the illogical narrative.

Gender distinctions, like the traditional definitions of masculinity and femininity, are revisited and contested. María is more sexually aggressive than all the men in the film combined. In one of the film's most sexually graphic scenes, María undresses an anonymous man, pulls him to the bed by his own belt, sits on him while still dressed in a tight corset, removes the jeweled hairpin from her hair (designed in a phallic coiffure), and sticks it with passion into his neck. María's orgasm is thus one-sided, achieved with a corpse! In another revelatory scene, when María heads to the men's bathroom, Diego protests: "This is the men's lavatory. Didn't you see the sign?" María responds with chilly contempt, "Don't put your faith in appearances." The inevitable gap between appearances and reality is a motif running through all of Almodóvar's work. He presents María as a caricature of patriarchy, reflecting the need of insecure men for domination.

What is most striking about *Matador* is how ambiguous the text is when looked at beyond its visual surfaces and guilty pleasures. This may explain why the film was misunderstood upon initial release, both in Spain and in the United States. For example, early on, Ángel follows his neighbor Eva down the street. It is a nocturnal scene with the street lamps providing dark shadows, but the light is sufficient to observe that Ángel is wearing a red sweater and Eva a pink jacket. In his assault, Ángel tears Eva's panties and climaxes quickly, clearly a parody of straight males' tendency to engage in selfish sex and premature ejaculation. The rape is motivated not by erotic desire

but by psychological anxiety and sexual panic. Ángel is trying to prove to himself and to Diego that he is straight—Diego had earlier asked Ángel if he likes girls. Almodóvar turns Ángel into a sensitive male when he apologizes to Eva after the assault. While moving away from him, Eva trips and injures herself, and the very sight of blood causes the squeamish Ángel to faint.

Significantly, of all the figures, the police officer is the only sexless or asexual character, the one man who does not engage in any sexual conduct. He rejects the overtures of a female psychiatrist who is hitting on him. Almodóvar constructed him as "sober, skeptical, and dispassionate," but allowed him to engage in voyeurism.[46] He named Banderas's character Ángel to suggest that he is pure, naïve, and innocent (he knows nothing about women). Judged by his appearance and insecure demeanor, no one believes Ángel when he claims to be the wanted serial rapist and murderer. At the police station, Ángel, in an act of sexual self-assertion, states: "I've come to report a rape." The police inspector asks: "Have you been raped?" "No," says Ángel, "I was the rapist!" Still unconvinced, the policeman persists: "Are you sure?" As a boy-man, Ángel mediates between the sexual and oversexed Diego and the sexless-asexual police inspector. And there are enough clues to suggest that the officer might be a latent homosexual.

In *Matador*, heterosexuality is also criticized and, in at least one scene, compared to necrophilia. When Diego is in bed with Eva, he instructs her to "play dead" before penetrating her and reaching an orgasm. This scene, combined with the one depicting Diego's auto-eroticism, presents an unfavorable portrait of heterosexuality. The characters display narcissism, making love to themselves, whether they masturbate in solitude or climax in couplings. The sexual encounters and orgasms are subjective and one-sided, initiated by and more gratifying for only one of the partners.

This is reversed in the last, lethal scene, which clarifies the link between eroticism and death, indicating Almodóvar's belief in the impossibility of long-enduring romantic love—death is the necessary and only outcome of extreme passion. The formation of new couples, based on mutual respect, is the exception to the rule, and more often than not it prevails among heterosexuals rather than

homosexuals, as would be the case of *Tie Me Up! Tie Me Down!* and *The Flower of My Secret*.

* * *

Having dealt with straight sexuality in *Matador*, Almodóvar followed up with a similarly erotic thriller set in a specifically gay milieu and dealing with the varieties and vagaries of homosexual love. Made in 1987, *Law of Desire* (*La ley del deseo*) boasts a more complex narrative and more intriguing characters than those of *Matador*, but to me, it's a less enjoyable and less coherent movie. Largely acclaimed after its world premiere at the 1987 Berlin Film Festival, where it played to enthusiastic response, *Law of Desire* became the first Almodóvar film to be sold right away worldwide.

A self-conscious director, Almodóvar said:

> I focused *What Have I Done* on the Mother figure, and I'm focusing on the Brothers now. I didn't know what type of fraternity to opt for men when I started writing the screenplay. Given my temper, I turned for reference to Warren Beatty and Barbara Loden in *Splendor in the Grass*. I've always been sensitive to stories of siblings, even in those with a good main love story, my interest was always on the siblings. Pablo and Tina are the type of siblings working in show business. Like Vivien Leigh and Kim Hunter, they are attracted to the same man (in *A Streetcar Named Desire*). And like Harry Dean Stanton and Dean Stockwell (in *Paris, Texas*), they support one another when necessary.[47]

One of Almodóvar's few explicitly gay melodramas, in which most characters are gay, the film contains fully developed characters with distinctive personalities. *Law of Desire* is also one of his more personal films because the protagonist, Pablo Quintero, is a successful director who makes shocking films bearing such bizarre titles as *The Paradigm of the Mussel*. Publicly, Almodóvar has acknowledged that only two or three of the plot's elements draw on his life, such as the scene in which Tina, Pablo's transsexual sister (Carmen Maura), confronts the choirmaster who had abused her as a boy. (Almodóvar

would return to this issue in *Bad Education.*) For him, the more significant fact was the exploration of erotic desires, expressed in different ways by the tale's male characters. "This is a movie about guys," Almodóvar proudly declared, "from now on nobody can accuse me of only directing women."[48]

Almodóvar has famously said that his ultimate goal is "to reach audiences directly through their hearts, their minds—and their genitals." This is clearly achieved in *Law of Desire*, an exhilarating erotic thriller whose title could describe each one of Almodóvar's works as well as his entire oeuvre. Moreover, his production company, overseen by his producer-brother, Agustín, is named El Deseo, meaning Desire Unlimited.

In the opening scene, one of the most sexually graphic in Almodóvar's work, an authoritative voice instructs a gorgeous-looking boy to strip, go to the mirror, and kiss himself. The voice belongs to Pablo (Eusebio Poncela), who then commands the boy to rub his crotch, take off his underwear, caress himself, and masturbate to completion. The brief shot ends with a close-up of the cash money paid to the performer. As tricky and manipulative as this scene is, other scenes and images are imbued with more erotic meanings without being necessarily gay. New theories no longer limit themselves to the analysis of overtly homosexual images. Critic Paul Burston pointed out that the film's performance of gender and inappropriate acting styles are "by far queerer" than the explicitly sexual opening scene.[49]

At a party after the premiere of his new picture, Pablo meets Antonio (Antonio Banderas), a handsome, closeted gay, who becomes obsessed with him. They go home, and the provincial, easily impressionable Antonio experiences anal sex for the first time. In fact, after seeing one of Pablo's movies, Antonio rushes to the men's room and begins to masturbate while reciting the same words he had heard on-screen, "Fuck me, fuck me" (which paraphrases the title of one of Almodóvar's shorts). First showing Antonio from the back in a medium shot, the director then cuts from a shot of the boy's tight jeans to a close-up of his red lips. He may be using Antonio's character to suggest the immediate and visceral influence of movies, their seductively dangerous appeal. Antonio's particular social background is used as an explanation for his psychotic behavior.

He is the product of a rigid politician of a father and a conservative mother. The mother, who's of German origin, is perpetually worried about her husband discovering Antonio's homosexuality and, later, finding out about Antonio's involvement in the death of Juan, Pablo's blue-collar lover.

Pablo parts with Juan (Miguel Molina), who's heading south for the summer. Unhappy with his life and burdened with confused sexuality, Juan needs some time to contemplate his future. Almodóvar conveys the complex, one-sided nature of love when Pablo tells Juan: "It is not your fault if you don't love me, and it's not my fault if I love you." The narcissistic Pablo insists that Juan send him love letters. The plan is to write the letters by himself and then have Juan sign them and mail them back to him. In a touching moment, the two men undress, spending their last night together quietly, while the soundtrack plays the iconic French chanson "Ne me quitte pas" ("Don't Leave Me") by Jacques Brel. That iconic song is again played when Tina feels abandoned by her lover.

As always in Almodóvar's tales, when couples first meet, they engage in steamy sex, as if the director is in a hurry to entrap and captivate his spectators, especially his gay fans. For Pablo, sex with Antonio means just a lusty one-night stand, but Antonio misunderstands his intentions. He wants to have a long-term relationship, and he gets dangerously jealous when ignored or disrespected. Upon learning of Juan's existence, the jealous Antonio tries to rape Juan and then kills him, throwing him off a cliff. Driving south to see his dead lover, Pablo confronts Antonio, and they argue ferociously before the devastated Pablo drives off. Pursued by the police, Pablo gets injured in a car crash, and in the next scene, he wakes up in the hospital suffering from amnesia. The police suspect both Tina and Pablo of the murder, and only a sympathetic doctor keeps them at bay.

A parallel and more engaging dramatic story involves Tina, who is a struggling actress. In the film's most shocking scene, Tina visits Pablo at the hospital and makes a typical Almodóvarian confession. Born as a boy, Tina had undergone a sex-change operation in order to experience a full relationship with their father. After she ran away with their father, he left her for another woman turning Tina into a bitter, man-hating individual. Tina is now responsible

for raising a teenage girl named Ada, whose mother (played by famed Spanish transsexual actress-singer Bibí Andersen) is seldom at home.

Never a bashful or discrete director, Almodóvar piles one bizarre strand atop another. Tina announces she has found a new lover, and to Pablo's dismay, it turns out to be Antonio. Regaining his memory, Pablo observes with alarm how Antonio manipulates Tina. Worried that Antonio might harm Tina, he calls the police. Taking Tina hostage, Antonio will let her go if Pablo will talk to him. The stunned Pablo agrees, and the story accelerates to its tragic finale when the couple experiences tender moments for the first time, after which Antonio shoots himself.

At first glance, the thematic transition from *Matador* and *What Have I Done* to *Law of Desire* seems too sharp and radical, but a closer look reveals that in *Matador*, one subplot concerns the relationship between powerful mentor and disturbed student, and in *What Have I Done*, the tale centers on two vastly different brothers, engaged in sibling rivalry. Thus, it is not a stretch to claim that *Law of Desire* revisits the issues of fraternity and bonding between older and younger men. That the younger man in both *Matador* and *Law of Desire* is played by Antonio Banderas provides a further link between the tales.

Upon release, *Law of Desire* was attacked by both right-wing and left-wing critics—for different reasons. Some reviewers were upset by what they considered a politically incorrect depiction of sex during the height of the AIDS crisis. When Pablo and Antonio are having sex for the first time, the latter asks the director whether his promiscuity has made him vulnerable to sexually transmitted diseases. Denying the charge, Pablo gets irritated. However, when he penetrates Antonio upon the latter's request, Almodóvar shows Pablo using lubricant but not condoms, which led to charges of promoting "unsafe" sex. Almodóvar claimed defiantly that he was highly aware of the health crisis but defended the scene due to its specific context and particular characters. Moreover, the director felt that the critics were more upset by the dialogue: "Men, especially straight ones, cannot tolerate hearing a man asking another man, 'fuck me.'"[50] (Van Sant said the same thing when he directed *My Own Private Idaho*.)

Almodóvar was "more nervous shooting the film's sex scenes than his actors." None of the actors was gay, which made it easier for him "because then the performers act and represent; they are not reliving."[51] In general, the director has viewed his work not as mimetic but as stylized and redemptive. He felt that in this particular scene, instead of obeying the dictates of reality, he was relieving the spectators of that reality by conjuring it away, by turning it into an excessive fantasy.

Similar logic guided the casting of Maura, based on Almodóvar's idea that "a real woman would represent a transsexual more poignantly."[52] For him, the real desire in the film is personified by Tina, not by the gay men. The goal was "to make Tina and the whole film look fresh and natural and these straight people proved so natural about their bodies, they had no shame about their physicality, no sense of something unnatural or prohibited. And after the first half an hour, the audience forgets that the lovers are men; they accept it as a love story. That's a big change in Spain and really healthy."[53] Thematically, the film stresses Tina's betrayal by all the people around her, especially the two men she had really loved: the priest, who was her spiritual father-mentor, and her biological father, who took her to Morocco, forced her to have a sex-change operation, and then abandoned her. It makes things worse that Tina is later deserted by her lesbian lover and is left alone to take care of her lover's daughter, Ada.

Some of the men try to forget the past—but not Tina, who's haunted by memories and inevitable burdens of the past on the present. When the priest urges Tina to forget their affair, Tina cannot, because all she has now is memories. Similarly, when Pablo suffers from amnesia, Tina insists on maintaining the past and their filial bonding. "Your amnesia deprives me of memory," she says, pointing to an album of old photos when they were happy boys, a gesture that reduces both of them to tears.

That older gay men can—and do—play surrogate fathers-brothers to their younger lovers is manifest in two scenes, both involving Pablo, in which Almodóvar evokes the religious image of *Madonna and La Pieta*. In the first, Pablo carries his lover Juan to the bedroom on their last, chaste night as one would carry a child. And in the end,

after the psychotic Antonio shoots himself, Pablo holds him in his arms as a baby, again evoking the famous religious iconography. *Law of Desire* is a dark *amour fou*, where passionate love leads to death, but it is also a portrait of gay men who, despite promiscuity, can still be tender and sensitive. Juan leaves Pablo because he feels that he cannot love him as the narcissistic Pablo wants and needs to be loved.

Almodóvar has singled out the hose sequence—where Tina, hot, bothered, and frustrated, shouts at a street cleaner to drench her—as one that's more erotic than the intercourse between the men because the scene is "very physical" and "I made her giant on screen. It's a great release, something I've always dreamed of doing."[54] In an earlier scene, charged by a policeman with "not being a woman," Tina knocks him down with a punch that would make macho men proud. The inspiration for the wet scene came from Fellini's 1960 masterpiece, *La Dolce Vita*, when the lush and iconic Anita Ekberg jumps fully clothed into Rome's famous Fontana de Trevi.

Almodóvar was particularly proud of the privileged moment, in which Tina, Ada and even the police look up with wonder at the window of the apartment where Pablo and Antonio have sex for the final time. He staged it as a "ritual with music," making it "surprising and magical,"[55] claiming that his visual inspiration came from Spielberg's 1977 sci-fi masterpiece, *Close Encounters of the Third Kind*, in which all the characters look up with awesome silence at the UFO.

Banderas, in his pre-Hollywood era, prompted headlines in movie and gossip magazines due to the explicit masturbation scene and the "gay kiss," reportedly the first seen explicitly in Spanish history. *Law of Desire* shows stylish elegance and more assured filmmaking, two attributes that would mark the rest of Almodóvar's endeavor, reaching their height in *Broken Embraces* and *The Skin I Live In*.

Law of Desire may be more significant as an experiment in storytelling than as an explicitly gay feature. It's a companion piece to *Matador*, as both forced the director "to know how I would get along in a masculine universe." To meet the challenge, he chose opposing stylistic strategies: *Matador* is "abstract and unreal, like a fable or legend," whereas *Law of Desire* is "concrete, evoking the absolute desire for passion in a life that's very routine."[56]

At the end, in what is a variation of *amour fou*, Pablo reacts to the suicide of Antonio, whom he has learned to love in spite of himself and despite the circumstances, by throwing the typewriter out of the window. Sure enough, the typewriter lands in another of Almodóvar's favorite locales, the trash container, where it explodes into flames. Why blame the typewriter? Why accord it so many close-ups? Because the director treats the object as a major character, capable of binding together as well as separating individuals in unpredictable but always intriguing ways. (A similar motif recurs in his autobiographical work *Bad Education* and in the noir melodrama *Broken Embraces.*)

WOMEN ON THE VERGE OF A NERVOUS BREAKDOWN: FIRST MASTERPIECE

With the exception of *Law of Desire*, *Talk to Her* and *Bad Education*, there are not many men in Almodóvar's films. At times, there are no men at all, and if there are, the men are on the periphery. The heterosexual males are usually one-dimensional and treated as disposable objects, often violently killed by women in brutal acts of murder. In contrast, the female characters are finely nuanced and complex in terms of motivation, psychology, and conduct. The director celebrates women because, as he has said time and again, "women are the ones who run the whole gamut."[57] What's consistent about his oeuvre is the indefatigable and incorrigible optimism of his heroines, despite their unhappy situation. He believes that women are much closer to their emotions than men. Women are more concerned with—and more willing to be embarrassed and undignified in—their pursuit of love, which for him is the highest goal. But women need men, especially for sex, which makes them more vulnerable and dependable on men than they wish to be.

The crucial turning point in Almodóvar's career occurred in 1988, with the release of *Women on the Verge of a Nervous Breakdown* (*Mujeres al borde de un ataque de nervios*), which established his status on an international scale, not to mention the fact that the movie became the biggest box-office hit in Spain to date. Since then, he has been the most famous and recognized Spanish director in the world,

surpassing in popularity his elders (Carlos Saura, Victor Erice) and contemporaries (Bigas Luna, Fernando Trueba). *Women on the Verge of a Nervous Breakdown*, Almodóvar's first acknowledged master-piece, is a sexy romp about obsessive love in all its shapes and forms. The elements of gaiety, melodrama, and hysterics are merged effec-tively, resulting in his most satisfying work to date. It was named best foreign film by the New York Film Critics Circle, and Almodóvar was named best young director at the European Film Awards. The film also won best screenplay at the Venice Film Festival, where it had received its world premiere.

With *Women on the Verge*, Almodóvar consolidated his reputa-tion as a world-class moviemaker, demonstrating ease at inventing stunning visual gags and fluent (if also bizarre) social interactions. Thematically, as strange as it may sound, the film is inspired by Jean Cocteau's classic monologue *The Human Voice*, filmed by Roberto Rosselini in 1948 under the title *L'Amore* with Anna Magnani and still done as a theater piece. Almodóvar has said that "nothing remains of the original, except for the essence of an abandoned, shattered woman, sitting on a couch, next to a telephone and a suitcase filled with memories, waiting for her lover to pick it up."[58]

The hot color palette of red and pink dominates the entire film from the opening credits to the closing ones. The telephone, which is repeatedly thrown, broken, and repaired (by various men) is red, and with the exception of one or two blue outfits, Pepa parades in and out of her penthouse in various red shirts, skirts, and shoes. Flushed with bright lights and cartoonish hues, the movie pays homage to the visual strategy of Tashlin, among others. Almodóvar has also acknowledged that for his film he tried to adopt the frantic pace and zany absurdities of Hollywood screwball comedies, such as Hawks's *Bringing Up Baby* and *His Girl Friday*.

Based on missed connections and both peculiar and funny coin-cidences, the narrative is triggered by a single event. Iván (Fernando Guillén), a desirable middle-aged married man, abruptly abandons his longtime mistress, Pepa (Carmen Maura), unaware that she is pregnant with his child. Desperate, Pepa frantically tries to track down her elusive lover, first via hysterical phone messages and then via more personal and dangerous pursuits. Finally, she encounters

him in person at the airport, where she ironically saves his life. Pepa's search unfolds as a road movie, replete with loopy drives and chases by any form of transportation—taxicabs (always driven by the same blond and jolly driver), cars, and even motorcycles.

In the course of her pursuit, Pepa meets the women in Iván's life, including his crazy wife, Lucía (Julieta Serrano), by whom he has fathered a now-grown-up son, Carlos (Antonio Banderas). That Carlos is shy and insecure is reflected in the way he looks (he wears eyeglasses) and moves (he walks slowly) and in his gentle naïveté with women. The tale's female antagonists are initially anonymous to each other. Lucía first spots Pepa placing a message on the door of their apartment. The jealous wife then removes the message and throws it into the garbage can, with Pepa secretly observing. Rest assured that this piece of paper would turn up later in the plot, when a garbage collector reads it. Almodóvar also pays a personal tribute to Hitchcock's *Rear Window* when Pepa sits on a street bench and observes the windows of Iván's building, zeroing in on a young woman who does her exercise routines, just as Miss Torso did in Hitchcock's 1954 classic.

Pepa—like Gloria in *What Have I Done to Deserve This?* though belonging to a different social class—is distraught and depressed to the point of contemplating suicide (with the emphasis on contemplating). As punishment and revenge, Pepa prepares a batch of gazpacho laced with barbiturates, which is meant for Iván—"I'm sick of being good," she says, setting the stage for revenge. Observed in close-up, Pepa chops the hot red and ripe tomatoes with a sharp knife, giving herself a minor cut. In a moment of revelation, she takes one pill for herself and dumps the rest of the package into the uniquely Spanish drink. Assuming a life of its own, the gazpacho then becomes a key to some strange, unexpected events. Because *Women on the Verge* is structured as a farce, it is anticipated that all the "wrong" individuals, and not Iván, will drink the gazpacho at one point or another.

Looking for a change, Pepa puts her apartment up for rent. Let the parade begin: soon all kinds of bizarre people show up at the luxurious flat. When she is around, Pepa functions as the hostess, at one point even entertaining two policemen. Not surprisingly, they

prove to be stupid and ineffectual, drinking the gazpacho and falling asleep when they are most needed. When Pepa is not around, which is half of the time, other guests assume the role of host, with varying degrees of success. The bell rings and doors are opened and closed with frequent regularity and sharp precision, as are the norms of bedroom farces.

Pepa's penthouse and large terrace are introduced as the day dawns on a polluted Madrid, accompanied by her voice-over narration. Though an urban dweller, Pepa has fulfilled her desire to live in the country, so to speak. She has palm trees with birds; a little yard with hens, which refuse to "behave" when she talks to them; a cock that crows; and several rabbits. Every element of this urban farm is designed with cheerfully perverse taste that's slightly kitschy—but not in an offensive way. Pepa enjoys watering her plants with a long hose and feeding and socializing with her family of animals on the rare occasion when she's alone.

Like the dichotomies in the narrative, Pepa's space is defined by a series of binary oppositions: country and city, upper and lower class, men and women, husbands and wives, fathers and sons, spouses and mistresses, older and younger, authority figures and ordinary civilians. The movie belongs to a genre described by Almodóvar as *alta comedia*, or "high comedy," defined as a "comedy of manners characterized by anti-naturalism: The sets are deliberately artificial, the performances and dialogues excessively rapid, and the deepest human ambitions treated in an abstract, almost synthetic manner."[59]

In the opening act, a voice-over is heard in a black-and-white scene that shows an older man surrounded by many women. It's Pepa's voice narrating a monochromatic dream, which reflects her anxieties over Iván's betrayals. The women in the dream, clad in different dresses, walk toward Iván, noticed or unnoticed by him, in a parade that recalls sequences in Fellini's *8½*, made in 1963 and also shot in black-and-white. The black-and-white dream both parallels and reaffirms the reality of Pepa's life, albeit in color. This sequence is a prime example of Almodóvar's penchant for the "trick beginning"—namely, a premonition of an event that will happen later, such as the slasher footage at the beginning of *Matador* or the steamy sex scenes in *Law of Desire* and *Broken Embraces* (discussed in the last section of the chapter).

Lighting a cigarette, Pepa sets her bed on fire by accident. Staring into the flames, she seems strangely excited, even thrilled by the sight, as if wishing for bigger catastrophe. However, snapping out of her fantasy, she throws her cigarette into the fire and goes for the hose. Eccentric and crazy as Pepa is, she is not stupid. Almodóvar's women can be dreamers and losers—but only for a while, and only up to a point. Eventually, they all get up on their solid feet and wear their sexy high heels (the title of Almodóvar's 1995 picture). Pauline Kael was the first American critic to note that it is "no small thing" for these women to look good and to get recognition and affirmation that they look good.[60]

The film's initial reel has an unsettled rhythm, defined by sudden shifts in the plot's many locales and personas. There are at least ten speaking characters, all fully developed. Pepa is first seen passive and asleep, and the ensuing tale is about her waking up and getting in touch with her inner feelings by gaining self-awareness. Almodóvar's femmes may be flighty, spontaneous, tempestuous, and driven to momentary madness, but ultimately they are pragmatic and sane, motivated by common sense rather than intellect and fueled by a newly formed female friendship or community.

The aging Iván and the younger (but not young) Pepa both work in the film industry. Pepa is doing some commercials (a funny one about detergent is seen on a TV in the film), but her main job is dubbing. Iván and Pepa provide the Spanish voices for Sterling Hayden and Joan Crawford in Nicholas Ray's 1954 cult Western *Johnny Guitar*, which Almodóvar, like many other cinephiles, greatly admires. The dubbing sequences are as crucial as the movie chosen for them to dub. Each addresses only the microphone—there is lack of reciprocity because they are not physically present at the same time. Moreover, the dialogue offers an ironic commentary on their own "relationship" when Hayden's Johnny is begging Crawford's Vienna to "deceive" him—that is, to tell him that she loves him as much as he loves her. This phrase is ironic, as Hayden almost always played "macho" roles (*Asphalt Jungle, The Killing*) and *Johnny Guitar* was the exception to the norm, casting him in a more vulnerable role. More significantly, in *Women on the Verge*, it is the female, Pepa, who's desperate to know whether Iván loves her as much as she loves him—or

loves her at all, as Iván plans to leave town for a vacation with his latest mistress.

Pepa, the film's protagonist, is contrasted with two women. First, there is her weepy friend Candela (María Barranco), who is wearing an ultra-mini blue skirt and earrings in the shape of espresso machines. In her big scene, delivered in tears that make us laugh, Candela tells of her affair with a Shiite terrorist who had used her apartment as a meeting place. She now fears that the police will arrest her as a crime accessory, perhaps even a conspirator. Candela is seen, just like Pepa earlier, packing the belongings of her (unseen) terrorist lover in a suitcase, which she buries in a public dumpster. In contrast, Pepa's suitcase, containing Iván's possessions and love letters to her goes from one hand to another, again obeying the rules of the farce genre. At the end, the suitcase lands in a public dumpster and is conveniently retrieved by Iván's current lover, who "just happens" to be sitting nearby in her car.

The second contrast is offered by Marisa, played by the iconic star Rossy de Palma, known for her cubist face—her extraordinary long and crooked nose—which gives her a distinctive look. Dressed in sensual red, like several of the other women, Marisa first turns up at Pepa's apartment with her boyfriend, Carlos, who "just happens" to be Iván's son. When Marisa, among others, drinks the gazpacho intended for Iván, she falls into a sleep that induces a wet erotic dream in which she experiences her first orgasm ever. This is Almodóvar's satiric stab at men who brag about sexual prowess—here it takes a surreal reverie for a virginal girl to have her first climax. Meanwhile, the virginal Carlos courts Candela before she falls asleep in his arms; the way he caresses her breasts suggests that he has never done it before and lacks any knowledge or experience of sex.

Almodóvar's description of the setting illustrates his theory of happiness, his utopian manifesto: "Society has now adapted itself to individuals, and all their social and professional needs have been met."[61] For him, the most significant human goal is to be happy—or unhappy—with the person you love. Love is a sacred value and the highest goal in life. Sex in his movies could be both dreamy (and dream-like) and realistic, exciting and messy, fulfilling and dangerous. It is an activity and a performance carried out in complete

abandonment and total immersion, to the exclusion of other interests. However, as an all-encompassing act, sex is often humiliating in its obsessive pursuit, and hot sex can be dangerous and risky to the point of death, as it is in *Matador* and *Law of Desire*.

Though Iván offers the dramatic connection among the characters, he is shown only in brief glimpses, walking down the street, making a call from a phone booth, hiding from his crazy wife, or recording in a studio. Almodóvar reduces Iván's presence to a voice talking to a microphone in a close-up. An aging, dwindling Lothario, he is deliberately an underdeveloped character, a philandering husband blessed with an erotic voice that proves alluring to women. He is really fully seen, and given some dialogue, in the last sequence, set at the airport, when he is about to depart for a vacation with his younger mistress.

In the preceding scene, there is a seriocomic confrontation between Pepa and Iván's wife, Lucía. Both are holding a glass of gazpacho, but knowing its contents, they refuse to drink it. Breaking the impasse, Lucía throws the gazpacho in Pepa's face and runs out. At gunpoint, Lucía forces a punkish motorcyclist who "just happens" to be outside the building to take her to the airport. Fearing the potential consequences, Pepa rushes to the airport in a taxicab (again the same one). A chase scene with shoot-outs ensues, in a satire of Hollywood's notorious chase scenes. At the terminal, just when Lucía is about to shoot Iván, who's standing on line with his mistress, Pepa saves his life by pushing a luggage cart at the mad wife before fainting herself. Spotting Pepa, now in the role of his lifesaver, Iván rushes toward her, holding her in his arms while apologizing for his behavior. But, alas, it's too late. Finally sober and in control of her emotions, Pepa realizes that Iván is really not worthy of her love. Iván, and by implication all men, is a big liar and phony performer.

The discussion of this film began with an analysis of Pepa's space and should conclude by suggesting that initially the penthouse is just a place but doesn't qualify as a home. For most of the story, the apartment is just a physical site that Pepa leaves and returns to, only to leave again. Before each departure, she makes sure to change her dresses carefully and apply make-up properly. Throughout the tale, Pepa's space is visited or invaded by her *amigas* and strangers

(Candela, the police, the couple looking to rent it, Iván's wife). Crucial to the film's meaning is Pepa's journey of self-discovery: the realization that the penthouse is her home and, as such, should serve as a place of stability and happiness.

For every death in Almodóvar's films, there's birth; for every terminated relationship, a new one is formed. In the last shot of *Women on the Verge*, all the invaders and guests have left except Marisa. Both women have been deluded by their relationships with men, who emotionally, no matter their age, are still boys. There is no chemistry or meaningful rapport between Marisa and Carlos; they look more like siblings or classmates than lovers. In the very last image, the two women toast their new friendship.

In celebrating female camaraderie, Almodóvar reaffirms the endings of such classic Hollywood melodramas as *Old Acquaintance*, in which Bette Davis and Miriam Hopkins, initially rivals and then best friends, have a drink in front of the fireplace. Gay director George Cukor chose the same closure for the 1981 *Rich and Famous*, his loose remake of the 1943 Warner Brothers melodrama, with Candice Bergen and Jacqueline Bisset. Almodóvar would again reference that scene in his 1995 film, *The Flower of My Secret*.

Again proving he is a great actors' director, Almodóvar coaxed superb performances out of his large, uniformly skillful cast. Maura, an Almodóvar regular and consummate farceuse, brings out with remarkable energy and authenticity the pathos and the tragic but also the joyous elements of a farcical melodrama about a dejected woman. It is not a coincidence that most of this picture's stars, including Maura, de Palma, and especially Banderas, went on to become major stars of Spanish and international cinema.

PHASE TWO: MATURE MELODRAMAS

Wearing his outrageousness effortlessly, Almodóvar is still able to upset and to shock, after three decades, as was evident in the 2011 *The Skin I Live In*, his creepiest work. However, as he grew older and more mature, he also started, by his own admission, "to look deeper inside myself,"[62] which led him to expand the range of his subjects and focus

on their emotions. As he told A. O. Scott: "I think that emotions have always been present in my films, but I'm conscious of a change, of almost deciding that I will focus solely on emotion and take away as much of anything extraneous to them as I can. I now deal with a completely open heart."[63]

In 1990, *Tie Me Up! Tie Me Down!* (*¡Átame!*) had the misfortune of being released after Almodóvar's most appealing and commercial picture, *Women on the Verge of a Nervous Breakdown*, which, among other accolades, was nominated for the Best Foreign Language Film Oscar. The winner, however, was the Danish film *Pelle the Conqueror*, starring Max von Sydow. Almodóvar's follow-up became his most controversial film to date after its distributor, Miramax, appealed in court its initial rating by the Motion Picture Association of America. Put in perspective, however, most critics consider *Tie Me Up!* to be a bold but not entirely satisfying work in the director's large and impressive output.

Tie Me Up! begins as a hostage melodrama, but after a series of unpredictable events, it turns into a wildly bizarre love story. The film moves at a deliberate pace and with disrupted momentum toward a sentimental ending that evokes a mixed reaction of both laugher and disbelief. Continuing Almodóvar's exploration of a female-dominated world, *Tie Me Up!* depicts a clique of women in a milieu in which, initially, men have only temporary presence. The mother of the two central sisters—played by Francisca Caballero (Almodóvar's real-life mother)—is a matriarch, but there's no information about her late husband. Her two daughters, Marina and Lola, are career-oriented, working in the film industry. Marina is a single, strong, vibrant woman, capable of standing up to all kinds of men, including her older and sleazy director (in the movie-within-a-movie). Her sister, Lola, has a daughter, but there's no husband or man in her life.

By placing the story in a heterosexual milieu, Almodóvar might have tried to broaden the appeal of his work beyond the art-film and gay-film circuits. Although the movie was Spain's top-grossing picture that year, it was not very popular in the United States, not only because of the NC-17 rating but also because of the divisive critical response.[64] It would take another decade for Almodóvar to enter into

the mainstream with two melodramas: *All About My Mother*, in 1999, and its follow-up, *Talk to Her*, in 2002.

"I'll never love you . . . ever!" the sexy Marina (Victoria Abril) tells the love-struck Ricky (Antonio Banderas) while being handcuffed to a bed. In Almodóvar's world, the way to conquer a woman's body and heart doesn't exclude forced captivity and physical abuse—at least initially. Who is Ricky as a character? The director has constructed him as an immature man who has nothing in life—and therefore nothing to lose. He has to work at getting everything he has or desires—including love. In a sense, he has only the night, the day, and the vitality of an animal—just like the flamenco singers say in their song. Orphaned at three, Ricky has spent most of his life in orphanages and mental institutions. When Ricky is let out, he has high hopes for his newly gained freedom.

Marina, the film's heroine, is a "B" movie actress making cheap slasher films and trying to adjust to her recent success after years in the porn industry, not to mention dealing with a drug problem. Ricky had slept with Marina once during an escape from a mental ward, and now he's determined to marry her. Ever since that glorious night, Ricky has been thinking of Marina. Determined to win back her affection, Ricky shows up unexpectedly at the studio where Marina is shooting her latest horror flick.

When first seen, Ricky, in tight blue jeans and hot red sweater, is at a psychiatric hospital trying to fix something with a screwdriver, which is just one of many phallic objects that serve as symbolic reminders of the relative sexual impotency of the male characters. Called to the hospital office, he is interviewed by its stern female director, who projects an authoritative tone even as she is chain-smoking. Interrogated about his plans, Ricky claims he wants to get married and have children—to live like a "normal" person. The hospital director then cuts him off abruptly: "You are not a normal person." And on at least one level, *Tie Me Up!* goes on to show the fine line Ricky is navigating between "normal" and "abnormal" life.

Quite expectedly, Almodóvar immediately subvert notions of normalcy and social order. Going to the window, the hospital director turns the shades up, and the light comes in. Standing behind her is Ricky, who, as a gesture of gratitude for what she has done for him,

begins to kiss her. The pragmatic director turns the blinds down, and they have sex (offscreen). Like all the other women in the film, she cannot resist Ricky's appeal, a combination of charming child-ishness and sexual animalism. Almodóvar describes him as a child-man—with the smile of an innocent child and the eyes of a tiger. For many people, the tiger stands in for the male principle, but for Almodóvar, "it was more the presence of the irrational, which is just as natural and believable."[65] The hospital director joins other professional women in Almodóvar's films, such as the lawyer in *Matador*, who compromise their ethics for immediate sexual gratification.

Ricky boasts a hustler's mentality; he is used to working hard and even paying for everything that he needs or owns. With a big smile on his face and macho braggadocio, Ricky leaves the hospital and joins the masses walking on a busy Madrid street. But he always stands out, even in the lonely, anonymous crowds. Stopping at a candy store, managed by a young woman who also looks at him in a sexual way, Ricky gets a red, heart-shaped box of chocolates, for which he under-pays, before hopping on a bus whose color is, of course, red.

Sneaking into the studio, Ricky heads into Marina's dressing room and smells the underwear that we had observed her removing earlier. He places the chocolates in her purse, steals some cash from another dress, picks up a pair of handcuffs from her desk, and dons a long rock-star wig. After standing in front of the mirror playing an air guitar, he walks out to the set incognito, sort of a spy-voyeur. Ricky is dismayed to see the film's older director, Máximo Espejo (veteran actor Francisco Rabal), hitting so blatantly on his leading lady. The movie-within-a-movie scenes are observed from the POV of Ricky, who feels that this is his last chance to rescue Marina from the clutches of the sleazy director and claim her as his own grand amour.

In a parody of male voyeurism and potency, Máximo, a victim of stroke, is seated in an electric wheelchair, restlessly moving around the set, while always keeping an eye—gazing—on Marina. In what may be an inside joke, he is asked to choose between two knives (phallic symbols) to be used in the horror flick that he directs, and he predictably opts for the longer, sharper knife. Talking to Marina while seated in a wheelchair, Máximo's staring eyes are at the level of her crotch. Marina is used to being the object of male gaze by her

director, crew members, spectators, and now Ricky. But she can also hold her own in a male-dominated milieu. She tells Máximo to stop staring at her "that way," and the director says that he is not looking at her—he's just admiring her. (It sounds better in Spanish: "No te miro, te admiro.") Marina then coolly observes that she has no use for such admiration. This doesn't deter Máximo, who continues to stare intensely. When he is denied attention or when Marina is absent from the set, in frustration, he circles around and around in his wheelchair—going nowhere. Back home, the dirty old man watches Marina's former porn videos, including a scene of anal intercourse shown in extreme close-up, on his big TV screen.

After completing the last scene, Marina goes home to change for the postshoot party. Taking a luxurious bath, she begins playing with a toy in a semierotic mode. The electronic male-shaped toy approaches her slowly, flipping its legs until it penetrates into her. With a big smile on her face, Marina removes the toy and places it on her breasts. Suddenly, Ricky bursts into Marina's apartment and knocks her to the floor while she's kicking and screaming. In the next scene, she wakes up with a terrible headache that no painkillers can help (we know she's addicted to strong drugs). Holding Marina captive in her own apartment, Ricky tries to convince her that she does love him, that he is good for her, that they have a future as one big happy family. But all of his persistent wooing and manipulative attempts end in failure.

Shocked by his confession and still in pain, Marina persuades Ricky to take her to the doctor. Unable to get the drugs she needs at the pharmacy, Ricky decides to get them on the black market. Not knowing his place, he attacks the drug dealer (played by Rossy de Palma), a tough dyke on a motorcycle. In retaliation, the cyclist later asks her groupies to beat Ricky, which leaves him unconscious. While he is gone, Marina finds a way to get out of her chains but not out of the apartment. When Ricky returns home wounded and bleeding, Marina is both touched and upset. Now it's her turn to tend to his needs. As the plots thickens, the kidnapper and hostage engage in a bizarre role-playing, sort of a parody of bourgeois marriage, including breakfasts served in bed, domestic arguments in the bathroom, and trips to the doctor, with Marina handcuffed and Ricky holding

a knife. When Marina tries to escape, Ricky ties her up, albeit ten-derly—Almodóvar goes out of his way to show that Ricky is using the "softest" rope available.

Ricky's beating is a turning point in the relationship. Gradually, Marina begins to understand his devotion to her, and her feelings toward him soften. For the first time, they make love that's passionate and mutually satisfying. Meanwhile, Marina's sister, Lola, is worried about her and makes periodic trips to her apartment, leaving notes under the door, which Ricky destroys. As a precautionary measure, Ricky moves Marina to another, more lavish apartment that belongs to his neighbor.

In the end, when Marina gets a chance to escape, she makes the choice to stay. She no longer needs or wants to be rescued. The very last image depicts a newly formed family, a triangle composed of Marina, Ricky, and Lola. Significantly, Lola is in the driver's seat, Marina in the passenger's seat, and Ricky in the back. Driving off into the distance, the trio sings aloud Gloria Gaynor's popular disco hit "I Will Survive."

Thematically, *Tie Me Up!* echoes some of the issues in William Wyler's 1965 *The Collector*, based on John Fowles's novel and starring Terence Stamp as the kidnapper and Samantha Eggar as the captive. And, in turn, Almodóvar's movie might have influenced *Boxing Helena*, the controversial 1993 indie about forced love from Jennifer Lynch, better known as David Lynch's daughter. For Almodóvar, *Tie Me Up!* is a story of "how a man attempts to construct a love story in the same way as he might be studying for a degree or diploma—by means of effort, will power, and persistence."[66] But underlying the film are some more philosophical concerns: Can passion be planned? Can it be forced upon another person?

Some reviewers criticized the notions of forced love and the sado-masochism in *Tie Me Up!* and several feminist critics were downright offended. Questions were raised about the film's outrageous title, which was found to be disturbing in its depiction of romantic yearn-ing, even if it took place in a heterosexual milieu. Other critics didn't like the film's uncertain tone: some scenes are boisterous and hilari-ous as befits a farce, whereas others are serious and dramatic in deal-ing with the anguished pain caused by a fatalistic love.

Responding to criticism at home and abroad (the picture's world premiere at the Berlin Film Festival drew a mixed response), Almodóvar rationalized:

> The moment when Marina says, "Tie me up," is the moment when she realizes she cannot live without love. At the same time, she sees that she's accepting with love a whole lot of things she doesn't desire—the knowledge that Ricky is a little crazy and that the world they're going to live in together is a hostile one. She cannot live without this passion, but at the same time, she has to accept everything that goes with it. In my movie, the heroine doesn't say, "I love you." She says, "Tie me up!"[67]

As noted earlier, Almodóvar has played a significant role in international cinema. He was responsible for the revival of Spanish arthouse cinema. As a result of his work, foreign audiences have come to expect Spanish art cinema to display graphic eroticism, zany comedy, eccentric humor, and stylish elegance. Luna's scandalous film *The Ages of Lulu* (*Las edades de Lulú*)—which came out the same year as Almodóvar's *Tie Me Up!*—could not have been made without Almodóvar's pioneering features. Luna's film concerns the sexual awakening of a young woman, whose curiosity leads her to involvement in dangerous sexual experimentation in Madrid's gay scene, including S&M clubs. Ángela Molina, who was originally cast in the lead, withdrew upon learning of the film's explicit sex scenes. In one of his first roles, the young Javier Bardem plays a small role of a corrupt gay man, and María Barranco won the Goya Award for playing a transsexual prostitute. In several countries, scenes were cut from this sexually bold movie, which is also replete with erotic images, including an S&M orgy at a gay club and an opening scene in which Lulú is baptized as a baby, because it exposed her genitalia. Luna's 1992 sex comedy *Jamón Jamón,* which is replete with casual heterosexism, could not have been made without Almodóvar's preparatory work. There are images in this picture that could have been seen in Almodóvar's features—crotch shots of trainee matadors, scenes in the women's lavatories—vividly conveyed with flashy camera angles and saturated colors.

* * *

From a strange melodrama about *amour fou*, Almodóvar moved to a relatively more conventional woman's picture about intergenerational love. In *High Heels* (1991), he changed genre and tone. Though framed as a murder mystery, this movie is essentially a melodrama about the rivalry between mother and daughter. Once again, the movie divided critics. Some claimed that the tale was old-fashioned in its stereotypical depiction of a neurotic career woman who becomes a self-sacrificing mother—sort of a Spanish Mildred Pierce.[68] But others praised the movie for putting center stage not one but two strong females—and again relegating the males to the periphery.

In interviews, Almodóvar pointed out that the Spanish title, *Tacones lejanos*, actually means the noise of high heels coming from afar—sort of *Distant Heels*, inspired by titles of Hollywood Westerns like *Distant Drums*. For him, the essence of the melodrama was a showdown or a gunfight between a mother and her daughter.

Reteaming with Victoria Abril, Almodóvar cast her as a TV presenter named Rebeca, a woman anxiously awaiting the arrival of her star mother, Becky (Marisa Paredes), whom she has not seen since childhood. Becky is also eager to rekindle the relationship with her daughter after fifteen years of estrangement. Diagnosed with an incurable heart condition, Becky's time might be limited—"an animal that sees its cycle as finished" in Almodóvar's words. Insecure, obsessed, and desperate to emulate her mother, Rebeca has even married one of her mother's old lovers, Manuel (Feodor Atkine), who no longer loves her; he foolishly attempts to restart an old affair with Becky. Not wasting any time, Rebeca has impromptu sex with Letal, a transvestite whose show includes, among other acts, an impersonation of Becky.

As mother and daughter begin making up for lost time, Manuel is suddenly found dead at his home. After making the quintessential Almodóvarian confession, revealing that she had an affair with her son-in-law, Becky returns to Madrid. Rebeca goes public, telling the whole nation of her husband's death. She is imprisoned, but despite incriminating evidence, the investigating judge is determined to prove her innocence. The judge arranges for Becky to see

her daughter, and Rebeca denies killing Manuel but confesses to her mother of killing Becky's second husband. As a child (seen in flashbacks), Rebeca had overheard her stepfather deny Becky's wish to go to Mexico for a film. To grant her mother freedom, Rebeca swapped his pills, which caused a lethal overdose.

Rebeca's confession proves too much for Becky's already weak heart, and her condition worsens. Meanwhile, Rebeca discovers that she is pregnant with Letal's child, and the judge releases her from prison. Rebeca goes to see Letal's drag performance, and in his dressing room, she discovers that he is actually the judge himself; Letal is just one of his masks. Claiming that dressing up is no more than an investigative strategy, Letal then asks for Rebeca's hand. While considering his offer, Rebeca watches a TV broadcast that reports Becky's sudden heart attack. Rushing to the hospital, Rebeca confesses to her mother of murdering Manuel. Becky decides to take the blame so that her daughter will go free, and once the sacrifice is made, she dies more peacefully.

High Heels owes its existence to Ingmar Bergman's 1978 *Autumn Sonata*, an intense family drama about a successful concert pianist (Ingrid Bergman) who goes to visit her daughter (Liv Ullmann), whom she has not seen for years. The mother is guilt-ridden, and the daughter is bitterly resentful of years of neglect, not to mention the burden of taking care of her chronically ill sister. It is impossible not to view Ingrid Bergman's movie role in autobiographical terms: as is well known, in 1949, Ingrid left her husband and daughter (Pia Lindstrom) to work for Italian director Roberto Rossellini, whom she later married and had children with. Like other directors, Almodóvar has professed admiration for *Autumn Sonata*, the first and only film that Bergman the director and Bergman the actress made together, which sadly marked the latter's last big-screen performance, for which she received the New York Film Critics Circle Award and her eighth Oscar nomination.

High Heels was also inspired by the 1959 *Imitation of Life*, Sirk's last American movie, which was his most commercially popular and also his most influential, largely due to its heightened stylization. *Imitation of Life* centers on a beautiful white actress, Lora Meredith (Lana Turner at her most glamorous), who is a neglectful mother. Lora

cohabits with her self-sacrificing black housekeeper, Annie Johnson (Juanita Moore), who is the biological mother of her black daughter, Sarah Jane (Susan Kohner), and the surrogate mother of Lora's white daughter, Suzie (Sandra Dee). Lora's dilemmas are typical of the Hollywood woman's melodrama: career versus family, professional success versus personal life, public fame versus personal love. In childhood, the two girls are treated as equals by Lora and Annie, but there are already interracial tensions when Sarah Jane refuses to play with a black doll. As the girls become adolescents, the conflicts increase when Sarah Jane tries to pass as white. Caught, she is brutally beaten by her white boyfriend (heartthrob Troy Donahue), and her self-denial ultimately causes the death of her grieving mother.

The similarities and differences between Sirk's and Almodóvar's films are telling. *High Heels*, unlike *Imitation of Life*, shows no concern with social class or race. In *High Heels*, Becky escapes to Mexico to pursue her career, abandoning her daughter. Her daughter, Rebeca, is married to her boss at the TV station, but they have no children. In *Imitation of Life*, unbeknownst to her insensitive mother, but fully recognized by the black housekeeper, Annie, the teenager Suzie falls in love with her mother's lover, Steve Archer (John Gavin). However, *Imitation of Life* is a 1950s American melodrama, so Suzie is attracted to Steve, but she doesn't "dare" to sleep with him. In contrast, for Almodóvar, it is natural and no big deal that mother and daughter sleep with the same man. When Rebeca confesses to her mother that she is responsible for the deaths of her stepfather and husband, Becky just says, in a typically Almodóvarian cool comedic mode, "You must find another way of settling your differences with me." Finally, both Sirk and Almodóvar are concerned with stylish elegance and the ability to deal with serious issues in seemingly crass material, without condescending to any of the characters.

There is, however, one significant difference between Sirk and Almodóvar, as the latter himself pointed out: "I love Douglas Sirk, but I can't make a Sirk film because I'm not upset over those old issues of morality; I just use them."[69] Almodóvar repeated his philosophy of melodramas in a later interview with me: "I like big, intense melodramas, but I can't actually make them because my point of view is amoral. I don't believe in *Imitation of Life* and *Splendor in the Grass*

underlying morality, which is the basis for Hollywood melodramas of that era. In my films, 'bad girls' like Susan Kohner or Natalie Wood are not bad at all; you can look at them and enjoy them because there is no judgment."[70]

American viewers failed to see the extra-filmic significance of the casting, but Spanish and Latin viewers did. The real-life father of Miguel Bosé (who plays the dual role of Judge Dominguez/Femme and Letal/Hugo) was a famous bullfighter, Luis Miguel Dominguin, who, among other things, was one of Hollywood star Ava Gardner's lovers when she lived in Spain. Miguel's mother, Lucia Bosé, was Miss Italy and went on to pursue a successful acting career in films by Fellini, Antonioni, and Buñuel. Up until *High Heels*, younger Spaniards, especially girls, admired Miguel as a popular rock star, and Almodóvar relished changing his image by dressing him in drag, perceiving him as a "mutant," a very tall man wearing very high heels.

<p style="text-align:center">✳ ✳ ✳</p>

Having done a serious-trashy woman's melodrama, which was met with mixed critical response, Almodóvar was ready to revisit two of his most recurring themes, deviant sexuality and morbid death, in a joyous farce. The result was the 1993 *Kika*, centering, for a change, on the troubled relationship between a stepfather and his stepson. Both men are enamored of Kika (Verónica Forqué), a Madrid make-up artist—and one of the most optimistic and upbeat characters in Almodóvar's oeuvre. Kika is good-natured to a fault, which doesn't help when she becomes involved in two criminal schemes. One scheme revolves around her lesbian maid Juana (Rossy de Palma) and the latter's disturbed brother, Pablo (Santiago Lajusticia), ex-boxer and porn star. The other deals with the stepson Ramón and his novelist stepfather, Nicholas (played by American actor Peter Coyote).

The plot begins with the arrival of the young and handsome photographer Ramón (Alex Casanovas, in a role similar to those that Antonio Banderas had played) at the home of his mother (Charo López) just in time to hear gunfire. It seems that she has killed herself, after shooting and wounding her husband, Nicholas. The beautician Kika relates how she had first met Nicholas when she made him

up for a TV interview. Nicholas now asks Kika to apply make-up to Ramón, who had presumably died of a heart attack. Kika begins her work, endlessly rambling, but she feels that something is wrong—Ramón's skin is too warm for a dead man. When she alerts Nicholas, he dismisses it as nonsense. But the intuitive Kika proves to be right when, suddenly, Ramón opens his eyes.

Almodóvar cuts to Madrid, when Nicholas, having spent time abroad, is met at the train station by Ramón. The color design chosen for both men is noticeable: the macho Nicholas is in a white and blue shirt, young and romantic Ramón in a white shirt with red stripes. The relations between stepfather and stepson are strained, to say the least. Ramón asks Kika to marry him, but she is doubtful, having already slept with Nicholas and also concerned with Ramón's voyeuristic nature.

In a parallel subplot, Nicholas is approached by Ramón's former lover, Andrea Caracortada (Victoria Abril), who hosts a morbid TV reality show called *The Worst of the Day*. One of the show's episodes tells the story of a rapist and prison escapee, who happens to be Pablo, the brother of Ramón's maid Juana. Pablo rapes Kika, unaware that he is being filmed by the voyeuristic and spying Ramón. Less traumatized by the brutal rape than by its public transmission on Andrea's TV show, Kika leaves Ramón.

Influenced by the movie *The Prowler* (directed by Joseph Losey), a noir tale in which a bad cop (Van Heflin) seduces a vulnerable married woman (Evelyn Keyes), Almodóvar emphasizes the subplot of Ramón's suspicion that it is his stepfather who murdered his mother. Ramón decides to confront Nicholas but has an attack, and Nicholas assumes he's dead. By that time, Andrea has figured out that Nicholas is the actual murderer, and when she challenges him, they end up killing each other.

Almodóvar's tenth feature benefited from the biggest budget he had worked with; it was the second coproduction of his company El Deseo (Desire L.T.D.) and France's Ciby 2000, which may account for the polished technical values and lavish costume design. Except for the maid, who's clad in the same outfit, the other characters, especially Ramón, change shirts in every scene. Most of the gear is in red, or red and white, in various patterns.

As a follow-up to *High Heels*, which was not as well received or as successful as *Women on the Verge of a Nervous Breakdown*, Almodóvar must have felt the pressure to deliver a more commercial film, which resulted in a narrative in which the various strands do not converge smoothly and whose tone is not farcical enough, as is required by this particular genre. The movie makes allusions to two seminal films of the 1960s, Hitchcock's *Psycho* (1960) and Antonioni's first English-speaking feature, *Blow-Up* (1966). But, ultimately, these references don't offer the poignant parallels or ironic commentaries that prevail in Almodóvar's other self-reflexive pictures.

The stylish credit sequence shows in black-and-white and then in color a spotlight, a keyhole, and a camera shutter, signaling that *Kika* would deal with voyeurism, both male and female, and shady family secrets, past and present. All the characters in *Kika* live a double life: in addition to embodying individuals grounded in particular locales, they fictionalize their own lives or those of others. Andrea, the film's most mysterious and least engaging character, roams the streets of Madrid on her motorcycle, searching for (and surely finding) authentic crime scenes in all kinds of places, including the cemetery. Looking ridiculous, like an alien in a sci-fi movie, Andrea sports a black uniform, equipped with a camera on her helmet and flashing lights placed on her chest that from afar look like exposed breasts.

The voyeuristic photographer Ramón may be seen as Almodóvar's version of David Hemmings in *Blow-Up*. Ramón is obsessed with recording every piece of reality, from models (early on) to his own sex with Kika, a prolonged graphic scene in which he shoots Kika as she performs fellatio on him. Ramón then asks Kika to film him as he penetrates her, and the poor girl obliges, though she never stops talking during sex. Almodóvar lifts a whole sequence out of *Blow-Up*, showing Ramón sitting on top of his model, arousing her and himself with his phallic camera, just as Hemmings did with the model Verushka in the 1966 picture.

Almodóvar misfires in the central set-piece, in which Pablo, the criminal who escapes from prison, invades Kika's flat. Before raping Kika, Pablo complains to his sister that he has grown tired of screwing gay men (*maricones*) in prison. Using a peel of mandarin, Pablo begins caressing the crotch of the sleeping beauty before assaulting

her sexually in a lengthy and excessive sequence. Kika tries to protest and resist her rape, but to no avail, as Pablo pulls a knife and continues his assault. Pablo's sister, Juana, gagged and bound by him to a chair in the kitchen, moves herself to the room and sits by the bed, watching with horror Pablo's hard work at reaching a climax. Ironically, the rape is finally interrupted by an act of voyeurism from a neighbor who calls the police. Andrea has manipulated a mysterious voyeur to hand her the video of the rape.

By now, Almodóvar's low opinion of the police (and authority figures) is well established. In this film, there are two inept policemen (one tall, the other short) who invade Kika's apartment. They untie the maid, but they seem unable to remove Pablo, who's still inside Kika. The sequence ends with the couple being dragged together out of bed. Rushing to the terrace, Pablo, still aroused, continues to masturbate and finally climaxes. His cum lands on the cheek of Andrea, who simply removes it with a nonchalant gesture; nothing bothers or shocks her. The scene is meant to be comic, but instead it drags on and on. The director's parody of men, as perpetually horny and obsessed with orgasms, becomes too blatant.

The cum shot in Almodóvar's 1993 picture may have inspired Todd Solondz's black comedy *Happiness*, in which Philip Seymour Hoffman jerks off to completion, as well as the Farrelly brothers' wonderful romantic comedy *There's Something About Mary*, in which Ben Stiller's sperm lands on Cameron Diaz's hair. Both American movies were made in 1998, which prompted one of my students to write a paper titled "The Year of the Cum Shot."

Some of the more personal notes in *Kika* also miss their mark. Like Scorsese, Almodóvar has cast his mother in a number of films, and in *Kika*, his mother plays a TV presenter who interviews Nicholas about his latest novel and future plans. Significantly, the interview ends with her saying, "Nothing compares to Spain." And, by extension, nothing compares to Almodóvar. Despite the horrors that Kika has witnessed, including the double murders of Nicholas and Andrea, she remains hopelessly and hopefully upbeat. In the very last scene, Kika hits the road in her red sports car. Shortly thereafter, she opens the door and her heart (with her body to follow?) to a young hitchhiker in what seems to be the beginning of yet another amorous adventure.

Almodóvar's humorous treatment of rape in *Kika* was criticized by reviewers who could not understand his obsession with sexual assault. *Kika* was the director's third consecutive feature facing charges of misogyny and exploitation.[71] It is hard to tell whether or not this line of criticism had any impact on Almodóvar, as rape would feature prominently in several of his future pictures. Nonetheless, his subsequent features became more dramatic than satirical, more serious and less tinged with black humor.

* * *

Enamored of the stupendous Marisa Paredes, arguably one of the best actresses working in world cinema today, Almodóvar built a whole "woman's picture" around her in *The Flower of My Secret* (*La flor de mi secreto*). It's a film that some critics (not I) consider to be Almodóvar's first truly "mature" work because it's devoid of visual excess and outlandish humor and the heroine is more mature and complex than Kika or Marina.

Paredes plays Leo Macías, a middle-aged novelist trapped in a bad marriage to Paco (Imanol Arias), a NATO official working in Brussels for the Bosnian peacekeeping force. The first sequence is highly symbolic. Leo, wearing with love the boots that Paco had given her, can't remove them because they are too tight. She rushes out to the streets and asks a homeless man to do it for money, but he cannot either, and both are drenched by water from a nearby pool. Desperate and wet, she arrives at the office of her psychologist friend Betty (Carme Elias), who is finally able to remove the boots. Like her playful director, Leo is a self-conscious heroine, a lovelorn romance novelist who describes her romantic predicament in terms of the plot of Wilder's 1960 Oscar winner, *The Apartment*. Deep down, however, Leo knows that what's serious is not that her boots are too tight but rather that the man who used to take them off for her—Paco—is not there. In phone conversations with Paco, she tells him that every day she wears an item that he has bought her—and removed (for sex?). Leo (whose name means "I read" in Spanish) shares her marital discord with the seemingly more rational and pragmatic Betty, who then recommends that she contact her publisher friend Ángel (Juan Echanove), editor

of the "Culture" section of *El Pais*. Leo obeys, and after their meeting, Ángel commissions her to write a literary column. Excited, Leo calls Paco to share her news, but he cuts her short, attributing her contentment to the influence of alcohol; Leo does have a drinking problem.

Eager to see her handsome husband after a long time, Leo is burning with desire for the kind of sex that Maggie was desperate for in Tennessee Williams's *Cat on a Hot Tin Roof*. Preparing herself for the meeting, Leo wears a sexy red dress and helps make Paco's favorite dish, paella. But, alas, the meeting turns out to be disastrous from the second that Paco arrives. Cold and detached, he announces that he has only two hours (instead of the promised full day), needs his clothes ironed, and is very hungry. Leo has given her housekeeper, Blanca, the day off so that they can be alone. But nothing she does pleases Paco, and everything she says irritates him.

It is one rejection after another. When Paco takes a shower, the yearning Leo stares at his body through the glass door, but when he notices her, he turns to the other side. Helping him to dry up, she kneels down, burying her face in his crotch, only to be pushed away. Paco complains that the paella is too cold, but he won't let her reheat it in the microwave. Dressing up quickly in his uniform, Paco is in a hurry to leave, despite Leo's protest that he has not even given her the promised two hours. In one of the tale's saddest scenes, she sits at her bed, opening up to Paco, who stands behind her. We observe how Paco leaves the room, while Leo continues to relate her unconditional love for him, unaware that she is talking to herself. Then, realizing she has been talking to the walls, Leo rushes after Paco and finally confronts him with a direct and burning question: Does their marriage hold any future? Paco coolly confirms her worst fears by saying, "None."

Along with her "serious" unpublished work, Leo has written bestselling romances, using the pseudonym of Amanda Gris, but she now feels incapable of delivering the upbeat plots required by her contract. Drinking heavily, she has begun writing grim novels about accidents and murders, and her editors get angry at her for departing from her previously satisfying, if predictable, stories. No doubt Leo's productivity is affected by her loneliness and sterile marriage. Contemplating suicide, like other Almodóvar heroines, Leo empties

a bottle of pills. However, when she hears her mother's voice on the answering machine, Leo vomits the pills. Rushing out, Leo runs into Ángel, who kindly takes her back to his flat to recover. The next day Ángel reveals that he has disclosed her secret—her identity as the famous writer.

Leo visits her perpetually anxious sister, Rosa (Rossy de Palma), who lives with their querulous and hypochondriac mother (Chus Lampreave). The sequences between Rosa and their mother provide the only comic relief in a film that's otherwise straight, serious, and a bit dull. Almodóvar has said that Chus is his "cinematic mother"—"an actress who understands me perfectly." As a result, he kept giving her more lines just minutes before shooting her scenes.[72] Demonstrating his belief in gender-bending, he modeled the on-screen mother on his own birth father, who had cancer and decided to return to his village to die in the same room in which he had been born.

The long-suffering Rosa is married to a man (unseen) who's out of work and has a drug problem. Feeling out of place in Madrid, the mother longs to go back to her native village. She endlessly complains about being starved and treated like a dog, unable to take a nap in the afternoon. "I cannot do anything to please your sister," she tells Leo, who's clearly her favorite daughter. "When I doze off, she is waking me, 'Get up, get up.' Christ, what does she want me to do, aerobics?" The mother shows contempt for Rosa's taste in furniture, which she describes as that of a gypsy. For her part, the exasperated Rosa complains that their mother is so out of it that she cannot distinguish between skinheads and yuppies. More annoying is the mother's insistence on taking laxatives on a daily basis because "she wants to shit all the time."

Things become unbearable, and the mother calls Leo—this is the call that saves Leo's life—to say that she has made up her mind to leave. Defeated and exhausted, Leo accompanies her mother, and they are greeted with the expected warm response from the villagers. Once Leo begins to recover, she sits among the women (mostly widows), who are studiously knitting. She asks them to sing traditional folksongs, and showing female solidarity that empowers Leo, they all sing, which makes Leo relax and smile for the first time in years.

In a separate, less engaging subplot, Leo's loyal housekeeper, Blanca (Manuela Vargas), is visited by her son Antonio (Joaquín Cortés), who persuades her to resume her career as a flamenco dancer. Needing money for the show, Antonio retrieves a manuscript that Leo had dumped in the garbage, after it was dismissed by the publishers, and also steals her earrings. Meanwhile, the distraught Betty confides in Leo in the requisite Almodóvarian confession that she and Paco have been seeing each other.

Back in Madrid, Leo and Ángel attend a flamenco performance by Blanca and Antonio, after which Ángel avows his love. At midnight, Antonio shows up at Leo's and admits he stole her things in order to finance the show. Handsome but much younger than Leo, Antonio treats her like a desirable woman, willing to "do anything" to repent for his sins. In a shrewd piece of casting, Almodóvar assigned the role of Antonio to Cortés, then a teenage sex symbol and a popular flamenco dancer. Leo accepts Antonio's apology but resists his advances after verbal flirtation. Though vulnerable and tempted, Leo knows the line between proper and improper conduct for a woman her age. In the end, freed from any obligations, Leo can rebuild a new, healthier life.

The Flower of My Secret is the only Almodóvar picture in which there is no sex at all! Restraint is the name of the game in every aspect of the production, including the acting. The director instructed Paredes to focus on "the economy of gesture," to do "as little acting as possible." In the scene in which she comes back to life in the bathtub (after vomiting the pills), he wanted her to look like one of the living dead. In the last scene, Leo and Ángel have a toast on New Year's Eve. Sitting in front of the fireplace, Ángel tells Leo that they are recreating the last scene from Cukor's *Rich and Famous* (1981), in which the two old rivals, played by Jacqueline Bisset and Candice Bergen, behaved in the same way. Almodóvar has said that he intended Ángel to undergo a process of feminization, to the point where at the end he and Leo become sort of two female writers. For him, turning Ángel into Leo's best girlfriend is "a very positive process,"[73] but for me, it's one of the reasons the new bond lacks tension and the movie is a bit boring.

✳ ✳ ✳

Live Flesh (*Carne trémula*), Almodóvar's twelfth film, is the most interesting of his mature melodramas. This 1997 movie is perhaps more significant for the director's allotting equally strong roles for male and female actors and for his treatment of serious, relatively unexplored issues, such as disability, in addition to his recurrent explorations of love and desire. As a result, he was praised by most critics for breaking new ground in his restrained approach to characterization and in his construction of a shapely narrative.

Live Flesh is also significant as the first Almodóvar film to feature Penélope Cruz, who would become a major player in his repertory company. Cruz was then mostly known for playing the pregnant girl in *Jamón Jamón*, made in 1992 by Almodóvar's rival Luna (who passed away in 2013). The film's cast is interesting for its inclusion of inexperienced actors, such as Cruz and the young Javier Bardem (who would become an Oscar-winning actor and appear as the villain in the Bond picture *Skyfall*), as well as world-renowned actors, such as Francesca Neri and Ángela Molina, who brought rich cultural associations to their roles.

For this film, Almodóvar bought the rights to Ruth Rendell's book, which is set in London, only to throw it away, like Hitchcock used to do to the source materials of his films. "When I set out to adapt something, I don't respect anything," he told me in an interview, "and I gave the same advice when they wanted to change the protagonist of *Women on the Verge of a Nervous Breakdown* from a white woman to a black one who's younger (Jane Fonda, who was interested in a Hollywood remake, felt that she was too old to play a pregnant woman, the American counterpart of Pepa in the Spanish film).[74] The script, which deviates from the novel, was co-penned by Almodóvar and Ray Loriga, a younger writer who was hired to assure greater authenticity and also establish a stronger connection with Spain's younger audiences, as Almodóvar was nearing the age of fifty.

The tale begins and ends with a birth, reaffirming the director's view that for every death, there is a new life. *Live Flesh* again demonstrates Almodóvar's use of binary oppositions. In the first chapter, set in 1970, Victor, the son of an unmarried prostitute (Cruz), is born on a bus during a state of national emergency. In the symmetrical ending,

set in 1990, Elena and Victor, the newly formed couple, are about to have a child, also on the streets of Madrid, just like Victor's birth two decades ago.

The story takes place at the present time, when the twenty-year-old Victor (Liberto Rabal) is working as a pizza delivery boy. Victor is excited about his prospective date with Elena (Francesca Neri), but she turns him down. Like most of Almodóvar's determined and horny males, Victor, unfazed, breaks into Elena's apartment. In the argument that ensues, Elena fires a shot, but no one is injured. Two policemen arrive at the scene of the crime after the gunshot is reported, and in a panic, Victor takes Elena hostage. Sancho, the elder, drunkard policeman, tries to grab the gun. Another shot is fired, this time injuring the younger policeman, David (Javier Bardem), leading to Victor's imprisonment, accused of causing David's paralysis.

After he is released from prison, Victor seeks revenge against David and Elena, who are now married. Victor works as a volunteer in a shelter for homeless children, which "happens" to be run by Elena. Victor's stalking of Elena angers David, who warns him to stop—or else. Victor then meets Sancho's mistreated wife, Clara (Ángela Molina), and they begin an affair. Clara reveals that it was Sancho who pulled the trigger because of her affair with David. Feeling responsible for his false imprisonment, Elena softens toward Victor and goes to bed with him. After confessing her betrayal, Clara flees, but the jealous Sancho tracks her down, and they end up killing each other.

In the pre-credit sequence, Victor the baby is presented in a mischievous black-and-white parody of the NoDo and via newsreels from the Franco era. The first sequence introduces the main characters in their typical locales. The drug-addicted Elena is waiting for her dealer in a lavishly decorated apartment while Buñuel's *The Criminal Life of Archibaldo de la Cruz* is playing on the TV. The two policemen, David and Sancho, are seen patrolling the streets of Madrid. Reversing age-related stereotypes, David, the younger, is rational and serious, whereas Sancho, the older, is volatile and alcoholic. Clara, Sancho's brutalized wife, is seen on her terrace tending her plants, just like Pepa did in *Women on the Verge*.

Victor, who begins as Elena's ignorant sex partner, seeks access to her apartment, feeling she had used him for sex and then dumped him. Once again, Almodóvar contests sociosexual stereotypes by showing women as sexual aggressors and men as their more submissive partners. In the book, Victor is a psychotic serial rapist, but Almodóvar presents him as a more multi-nuanced character. Victor is played by the rising star Liberto Rabal, cast in the kind of role that Antonio Banderas used to play, an innocent adolescent (*Women on the Verge*) or a sexy and disturbed youth (*Tie Me Up!*).

Influenced perhaps by Hitchcock's 1943 masterpiece, *Shadow of a Doubt*, the doubling principle is put into effect: there are two cops, two shootings, two deaths, two births, even two voice-over narrations. The tale begins on Christmas with Franco's minister Manuel Fraga suspending the few civil liberties that prevailed under the dictator. And it closes symmetrically on Christmas, two decades later, with Victor's voice-over about how Spaniards stopped being afraid. The birth, which could be read as Almodóvar's version of The Nativity, also has political dimensions, as it occurs toward the end of the Franco regime.

In Rendel's book, the handicapped man is sexually impotent, having been traumatized, like Norman Bates in *Psycho*, by witnessing a primal scene between his parents. But Almodóvar changes that: in a bathroom scene, David makes love to Elena through oral sex. For Almodóvar, a steady, satisfying sexual bond between the physically abled and the disabled is not an insurmountable problem.[75]

Male frontal nudity is still the biggest taboo in cinema. Banderas had never consented to frontal nudity in Almodóvar's films, not even in the 2011 *The Skin I Live In*. And in the 2004 *Bad Education*, Mexican sex symbol Gael García Bernal (who, in *Y tu mamá también*, directed by Alfonso Cuarón, is seen masturbating with a peer) agreed to appear in tight white underwear while emerging out of a pool, but not fully naked, or seen engaged in anal intercourse. Rabal, Spain's sex icon at the time, however, did consent, and he is briefly shown nude against smoky flames, when he gets out of the shower to extinguish a fire in the kitchen. As critic Paul Smith has noted, there is no particular dramatic reason for Rabal's nakedness, other than perhaps to please Almodóvar's core audience of gay and other curious viewers. Liberto is the grandson of the veteran actor Francisco Rabal,

who had appeared in Buñuel's 1961 masterpiece, *Viridiana*, a shrewd piece of casting that adds extra-filmic resonance.

As played by Francesca Neri, the famous Italian actress, Elena goes through radical transformation from a junkie to a loyal wife to a social worker. Clara, the abused wife seeking sex outside her loveless marriage, is played by Ángela Molina, who had appeared in Buñuel's last film, *That Obscure Object of Desire*, as a foil to Carole Bouquet, who played the same character. As I will show, Buñuel's 1977 film, in which the two actresses played the same part, inspired the casting strategy of Haynes in *I'm Not There*. Other actors also bring rich cultural baggage associated with Buñuel. Molina is remembered by many from Buñuel's anticlerical *The Criminal Life of Archibaldo de la Cruz* (1955), whose narrative, just like *Live Flesh*, deals with the issue of taking responsibility for a killing; as noted, a scene from that picture is seen on Elena's TV screen.

The narrative's organizational principle is based on circularity. The story begins and ends on the high holiday of Christmas, signifying birth and renewal. The two lovers begin their interaction in casual sex but end up living together twenty years later. Victor, the baby born on a bus, becomes a father, and Elena becomes a mother who, like Victor's mother, gives birth in public.

Masculinity is portrayed in revisionist, varied, and deeper ways than has been the norm in the work of Almodóvar, who would continue to explore other dimensions of manhood in *Talk to Her*. Tough, brutal males, such as Sancho, are contrasted with sensitive and tender ones like David. Moreover, in this film, the men, just like the women, are capable of changing their behavior to accommodate their partners. One of the most moving scenes depicts David's entrance into his car, which involves folding and stowing his wheelchair. Almodóvar shows respect in portraying the everyday lives of disabled people. The film benefits immensely from the fact that, as the disabled David, Bardem renders a remarkable performance of dignity and restraint.

The existence of mutually satisfying love is rare in Almodóvar's work. *Live Flesh* represents a point of departure, even though Almodóvar insists that reciprocal love is possible only when the individuals involved are willing to take responsibility for their actions.

In this film, real love materializes when Victor and Elena search and find, in a series of Almodóvarian confessions, the truth about the shootings, which have affected all the characters. In placing his domestic melodrama against a specific political context, the director indicates the importance of Spain's shift from dictatorship to democracy. Despite the death of one couple, the happy ending for the other one emphasizes the movie's ultimately upbeat tone. Victor and Elena, like Spain, are better human beings at the tale's conclusion, (re)starting a relationship based on mutual respect.

PHASE THREE: MASTERPIECES

Announcing Almodóvar's newly gained maturity, and continuing his boundless creativity, *All About My Mother* is the first in a series of four great films made between 1999 and 2006, representing the best phase of his career. *All About My Mother*, still my personal favorite of his films, is one of his universally acknowledged masterpieces and also one of his most commercially profitable films.

A summation work, *All About My Mother* (*Todo sobre mi madre*) is a fiercely emotional yet unsentimental movie representing thematic, visual, and tonal synthesis of Almodóvar's entire work. It is his first film to be shown at the prestigious Cannes Film Festival, where most of his works would premiere in the future. For this accomplished film, he won the Cannes Best Director Award, though many critics thought he should have won the Palme d'Or. *All About My Mother* was his second picture to be nominated for the Best Foreign Language Film Oscar and his first one to win. When the director got the Golden Globe Award for this film, he said it was like having an orgasm, but he likened winning the Oscar to experiencing "multiple orgasms."

Arguably his warmest film, *All About My Mother* represents a loving tribute to women in their various shapes, ages, classes, and professions. On the surface a woman's melodrama, the movie covers the entire range of emotions: loss, grief, reconciliation, camaraderie, and redemption. It depicts a circle of women who confront with forceful courage all kinds of ills: terminal disease (AIDS), desertion by husbands and lovers, old age and dementia, unplanned pregnancy, and

death. Well balanced, the film mixes elements of comedy and drama, sentiment and humanity in equal measure, all contained in a multi-layered narrative of extraordinary cohesiveness and emotional power. Critic Paul Smith noted that, if the plot is too melodramatic and the setting too theatrical, the characters and performances are decidedly not—they are grounded in realistic contexts. There is no surface glamour, despite the theatricality. The close-ups of the characters— the mother-nurse Manuela, the aging diva Huma, the terminally ill nun Rosa, the dying transsexual Lola, the drug-addicted lesbian Nina— reveal wrinkled faces of women who have gone through a painful life, allowing themselves to look downtrodden.

The opening credits appear and dissolve as the camera pans over medical objects, drips and dials in the primary colors of blue, red, and yellow, colors that will serve as the film's visual codes, again signaling issues of life and death, birth and demise. The tale is dominated by women—many women. The heroine, Manuela (Cecilia Roth, the Argentinean actress who had starred in *Labyrinth of Passion*), is a single mother living in Madrid with her only son, Esteban (Eloy Azorín). On his seventeenth birthday, Manuela takes him to see a production of Tennessee Williams's *A Streetcar Named Desire*, starring the famous star Huma Rojo (Marisa Paredes). Manuela confesses to Esteban that she had once played Stella to his father's Stanley Kowalski in Williams's play—so we anticipate this information to come back later in the plot, as it does. The play's legendary last scene, when Blanche is taken away after descent into madness, is repeated several times, though each time a different actress is playing Stella.

For most of her adulthood, Manuela has lived a life of quiet desperation, replete with lies—small and big lies—to herself and to others. Manuela, who has told Esteban that his father had died before he was born, promises to tell him more about his lineage after the show. Sadly, this never happens due to a fatal car accident. On a fateful rainy night, Huma and her co-star and lover Nina (Candela Peña) enter a taxi after the show. Running after them for an autograph, Esteban is hit by the taxi. The devastated Manuela, who witnesses the accident, is a nurse who organizes seminars to counsel relatives of prospective organ donors. Having decided to donate Esteban's body, she violates the rules and takes a trip to meet (incognito) the recipient

of her son's organs. Almodóvar inserts a close-up of the chest of the middle-aged recipient when he gets out of the hospital, blessed with Esteban's young heart.

After the tragedy, Manuela tries to bring together the disparate and unfinished elements of her life. Honoring Esteban's last wish to find his father, who's also named Esteban, she returns, after eighteen years away, to her hometown of Barcelona to seek him out. The boy's father is a transsexual, Lola the Pioneer (Toni Cantó), who doesn't know he has a child because Manuela had never told him. Manuela later relates how Esteban became Lola in Paris, when he got "a pair of breasts much bigger than mine."

Manuela is now looking for Esteban-Lola in the marginal milieu of a sleazy pick-up site where dirty older men cruise hustlers and prostitutes, both male and female. Upon arrival (by taxi, Almodóvar's favorite mode of transport), Manuela encounters La Agrado (Antonia San Juan), a battered transsexual beaten up in the open fields by a frustrated customer. La Agrado has big fake breasts and a huge real cock (more about it later). She turns out to be Manuela's old friend from their Barcelona days. She is named La Agrado because, as she explains, "I always agree."

Two decades earlier La Agrado lived with Manuela and Esteban's father before the latter had a sex-change operation. La Agrado complains to Manuela that she had taken in the sickly, HIV-positive Lola, but the ungrateful Lola ran off with her money and possessions. Through La Agrado, Manuela meets Sister Rosa (Penélope Cruz), a nun bound for missionary service in El Salvador. Manuela then becomes a personal assistant to Huma, the stage actress whom her son had admired. She helps Huma manage her life, which includes controlling Nina, her tempestuous, drug-addicted younger lover, who periodically abandons her. Deciding to change her life, La Agrado goes to see Sister Rosa for counseling. She learns, however, that it's Sister Rosa who needs help— Rosa now carries the HIV virus after sleeping with Lola. Though initially resistant, Manuela nurses Sister Rosa through her pregnancy, the birth of her child, and eventually her death (at childbirth). In the climax, Manuela confronts Lola, the dying transsexual and her son's father. In the happy ending, Manuela brings up the baby boy, also named Esteban, who succeeds in defeating the lethal HIV virus.

Like other Almodóvar features, this film deals with the binary oppositions of procreation and death, creativity and stagnation, individual and community, self-sacrifice and social redemption, and love and loneliness. As in most of his films, for every death, there's new life: Esteban's heart beats within another man. Lola transmits the virus to Rosa, but her baby miraculously recovers. Esteban never sees the photo of his father, but his father (Lola) sees the photos of his dead son (by Manuela) and learns of the existence of his other son (by Rosa).

Structurally, unlike *Live Flesh*, which was circular, the story unfolds in linear mode, using only a few flashbacks. In the first, Manuela recalls the performance of *A Streetcar Named Desire*, which she had seen with her son on the night he was killed. The second and third flashbacks are inserted when Manuela tells Huma about her son and Huma recalls vividly that rainy night when she got a glimpse of the boy through the taxi's window.

Consistent with Almodóvar's worldview, in the end, the show, just like life itself, must go on. La Agrado, the "chick with a dick," takes to the stage after a performance of *Streetcar* is canceled—Huma and Nina are both hospitalized after a fight. Proving that any woman has some acting skills, the likable La Agrado gives the audience a choice to leave or to stay, and several leave. Performing his/her own life story as a transsexual endowed with both male and female parts, La Agrado takes equal pride in her natural big penis and her fake big breasts. "A woman is authentic only insofar as she resembles her dream of herself," she proudly exclaims. Each of his/her body parts has a price in the marketplace, except for her penis, which is a vital part for procreation as well as an object of pleasure.

Despite the occurrence of tragic events, humor prevails in the most devastating situations, as when Sister Rosa suddenly proclaims, "Prada is perfect for nuns," or when Huma discloses, "I have not had one of those [penises] in a long time," or when La Agrado performs onstage, describing each of her organs. Unity is brought to the narrative by a single character, the dying Lola, who has affected and infected all of the women, albeit in different ways. There is a price to be paid, however, and before dying, Lola sums up her life in one sentence: "I was always excessive, and now I am very tired."

Almodóvar brings together the diverse characters in masterful two-shots. In the first act, mother and son are in the same frame, whether watching Bette Davis on TV or watching Huma performing onstage. Making a special dinner for her son on the night before his birthday, Manuela is rushed by Esteban to the living room, as *All About Eve* is about to begin playing on TV. They always change titles, Esteban complains. In Spanish, the movie is retitled *Eve desnuda*, which literally translates into *Naked Eve*, à la Goya's painting *Maya desnuda*. Eagerly waiting for midnight, Manuela enters his room with her personal birthday gift, a book by Truman Capote. Reduced to childhood, when she used to tuck him in bed, Esteban asks his mother to read aloud. Densely self-referential, *All About My Mother* alludes to works by other directors and playwrights. Manuela is reading aloud to her son from Capote's book: "When God hands you a gift, he also hands you a whip, and the whip is intended solely for self-flagellation." Capote's often-quoted line becomes a running motif of Almodóvar's text.

Manuela shares the screen with each of the characters—Huma, Rosa, La Agrado, and even Rosa's mother, who is initially antagonistic. But significantly, Manuela doesn't share the same space in the crucial reunion with her ex-husband. Almodóvar cuts sharply between the two, who lost touch decades ago and can never occupy the same frame and universe again. With Esteban's imminent death, Manuela is spared of taking care of yet another individual, but if she needed to, she would have.

On the one hand, *All About My Mother* is a glossy melodrama, modeled partly on Sirk's visual splendor, epitomized in *All That Heaven Allows*, *Written on the Wind*, and *Imitation of Life*—all 1950s Hollywood films that Almodóvar admires. However, unlike the detached and ironic tone of Sirk's works, the tone of Almodóvar's film is lyrical, warm, meditative, and decidedly nonironic and noncynical. And although the latter celebrates the work of American writers and directors (Truman Capote, Tennessee Williams, Joseph L. Mankiewicz), he never lets the viewers forget that he is still a Spanish director. *All About My Mother* concludes with a specific reference to Spain's indigenous culture, showing Huma again fully committed to her calling, the theater. She is now rehearsing the part of the rigid matriarch in Federico García Lorca's best-known play, *Blood Wedding*. (As noted, Saura made a film of this play in 1981.)

Several scenes are set in the theater, a prevalent domain of melodrama as a distinct genre, and Almodóvar's use of this particular milieu is strategic. The most crucial scenes take place backstage, in the dressing rooms, and they are played for earnest rather than for satirical points, as is the case of the actress Lora (played by Lana Turner) in Sirk's *Imitation of Life*, a title that Almodóvar would never use because for him there's no such thing. Almodóvar also cites his own pictures. Like *The Flower of My Secret*, this movie centers on one woman, Manuela, mourning the loss of her only son, whom she had raised alone. The movie's theater scenes of *A Streetcar Named Desire* include the one in which Blanche DuBois is carried out of the Kowalski house after recycling the legendary line, "I've always depended on the kindness of strangers." These allusions to life, onstage and off, recall those of Cocteau's monologue *The Human Voice*, which Rossellini had filmed with Anna Magnani, in Almodóvar's film *Law of Desire*.

At one point or another, each of the female protagonists is dependent on the kindness of a stranger—always a female in Almodovar's work—to borrow from Williams's play. This is manifest in the random encounters, accidental meetings, spontaneous friendships, and unexpected needs that are ultimately met by and through female camaraderie. The dubbed inserts of the Bette Davis–Celeste Holme sequence from the 1950 Oscar-winning *All About Eve* parallel the Joan Crawford–Sterling Hayden clips from *Johnny Guitar* in Almodóvar's *Women on the Verge of a Nervous Breakdown*. However, unlike the treacherous and greedy Eve Harrington in *All About Eve*, Manuela is a good-hearted and generous-to-a-fault femme who would never betray or deny the needs of other women. Unlike Blanche DuBois in *A Streetcar Named Desire*, Almodóvar's heroines may slip and "lose it" for a while, but they never really descend into madness (or commit suicide), surviving with stoicism and humor.

Stylistically, too, there are references to and parallels between *All About My Mother* and other Almodóvar pictures. La Agrado's defiant claim, "I am authentic," recalls that made by the maid Juana in *Kika*. Showing remarkable facility in constructing seamlessly cohesive narratives, the director is equally at ease with Prada and Truman Capote, Tennessee Williams and Lorca. As Paul Smith observed, he fuses pop culture and high culture, stylized aesthetics and genuine feeling,

fake silicone breasts and real penises, and performance onstage and necessary acting offstage.

This film celebrates women qua women, viewing them all as performers. *All About My Mother* is dedicated to Almodóvar's mother, who passed away shortly after the shoot was over, and to all the actresses who have played actresses on the stage or in film, including Bette Davis, Gena Rowlands, and Romy Schneider. Manuela, who had once performed in *A Streetcar Named Desire* opposite her then husband, becomes an understudy—by necessity, not by calculated design. She represents the actress in all women, including the women in the director's personal life. He said in an interview: "My initial idea was to make a film about the acting abilities of certain people who aren't actors. As a child, I remember seeing this quality among the women in my family. They pretended much better than the men. Through their lies, they were able to avoid more than one tragedy."[76] As is clear by now, for the director, gender roles are performatively constituted, and as such, they need to be played inwardly and outwardly, serving the crucial function of revisionist, antihegemonic representation.[77]

Early on, Almodóvar became known as an actor's director, one who spends a lot of time with his performers, based on his philosophy that "actors are the life of the cinema, everything is transmitted by them. Lighting, mise-en-scène, and all the rest are important, though nothing compared to the actors."[78] The richest, most subtle acting to be found in the work of the five directors considered in this book is found in the films of Almodóvar because of his perception of actors as "the special effects of my films." Known for his rigorous mise-en-scène, in which the actors (not objects or décor) are central, he has paid attention to the minute details of acting, guiding his performers in terms of voice, facial expression, gestures, body position, and body movement. He loves actors because, as he has said time and again, "It's impossible for them to lie to me when I'm directing them. I ask the actors to be completely naked in their emotions."[79] He recounts, "I work very hard on how the actors express the dialogue, how they walk and talk. When they pick up an object, I want it to be very physical—not obvious but definite."[80] Like the British director Mike Leigh (*Secrets & Lies*), he aims for the acting to feel fresh and spontaneous, though all the dialogue is rehearsed and scripted before

shooting begins: "Nothing happens for the first time in front of the camera. We've always rehearsed it before."[81]

* * *

Addressing the charge of many critics that his cinema is essentially female-driven, Almodóvar decided to focus his next feature on men— two, in fact, and straight. *Talk to Her* (*Hable con ella*), made in 2002, is considered by many critics (not by me) to be Almodóvar's most serious and emotional work, a dramatic feature that's extremely risky due to its subject matter and narrative form and style. The film's critical status was reflected by its nominations for the Best Director and the Best Original Screenplay Oscars, winning in the latter category. Showing the director's humanism at its fullest, this fourteenth feature is an intimate exploration of friendship between two heterosexual men brought together under unusual but strangely similar circumstances.

Stylistically, there are similarities between Almodóvar's last two works. *All About My Mother* ends with a theater curtain opening to reveal a darkened stage, and *Talk to Her* begins with the same curtain. The characters in *All About My Mother* are professional actresses and other women who play out their lives, on- and offstage. Similarly, *Talk to Her* is about narrators who recount their own lives, men who can (and would) talk to whomever is willing to listen, as most of the time there is no live audience for their performances.

A curtain of salmon-colored roses and gold fringing is pulled back to reveal one of German choreographer Pina Bausch's signature dances, *Café Müller*, a tension-ridden piece, in which the stage is filled with wooden chairs and tables, while two women, eyes closed and arms extended, are moving to the music of Henry Purcell's *The Fairy Queen*. Among the spectators are the film's protagonists, two men sitting next to each other by chance. Benigno (Javier Cámara) is a young, chubby nurse in his late twenties, and Marco (Darío Grandinetti) is a more masculine-looking and handsome writer in his early forties. The dance is so moving that Marco starts to cry. Benigno can see the gleam of the other man's tears in the darkness of the stalls. He would like to tell Marco that he, too, is moved by the spectacle, but for now, he doesn't dare. In this scene, playing with viewers'

expectations, Almodóvar contests gender-induced stereotypes, such as the notions that ballet is a "feminine" art form, that women like dance more than men, and that male spectators are not supposed to show overt emotions in public ("boys don't cry"). In the course of the narrative, the director will blend the attributes that each man initially stands for: Marco's emotional, tearful identification (expected of tragedy) with what he sees onstage and Benigno's more distanced and observational approach (expected of comedy) to the dance.

Benigno's apartment overlooks a dance studio run by Katerina (American actress Geraldine Chaplin, daughter of Charlie). Day after day, Benigno is voyeuristically watching one of Katerina's students, Alicia (Leonor Watling), eventually becoming infatuated and then fatally obsessed with her. Early on, Benigno follows Alicia down the street, and when she drops her purse, he is quick to give it back to her. Almodóvar's movies abound with coincidence of this kind, in which the characters first encounter each other without actually meeting or speaking to each other.[82] They meet again when Alicia is admitted to El Bosque, the clinic where Benigno works, after a car accident leaves her in a coma. Given her condition, Alicia is unaware that the man who gives her extra attention and erotic massages is none other than Benigno. Going beyond his duties as a nurse, Benigno spends a lot of time caring for a woman he is deeply in love with but has barely met. He volunteers to take over nightly shifts when his female colleague has domestic problems and needs to be replaced. Some of the staff members notice, first with curiosity and then with alarm, how he caresses her thighs, going higher and higher, or how he sensitively washes her body (including her bleeding vagina) with a white towel that turns red.

Meanwhile, Marco is assigned to interview Lydia (Rosario Flores), a well-known bullfighter whose on-the-rocks romance with the noted toreador El Niño de Valencia (Adolfo Fernández) has made the tabloids. Marco first notices Lydia on TV while he exercises. She is being interviewed by an aggressive female anchor that literally won't let her go until she opens up about El Niño, who walked out on her. Intrigued, Marco requests to do an in-depth profile of Lydia for the Sunday section of *El Pais*. Their first encounter, during a trip to Madrid, doesn't go well, and she is reluctant to collaborate. However,

when Lydia runs hysterically out of her house after seeing a snake and the gentlemanly Marco kills the snake, she becomes considerably softer, and soon they fall in love. Marco treats Lydia kindly, and she responds to his attention. Unfortunately, during a bullfight that he attends, Lydia is gored, and her coma also sends her to El Bosque.

Months later the two men meet again at the clinic. Marco walks by Alicia's room, staring curiously through the half-opened door as she lies naked and gets treated by Benigno. The second time he engages in voyeurism, Marco is caught gazing by Benigno, who invites him in. Finally gathering his courage, Benigno approaches Marco, telling him exactly how and when they met. Benigno recalls every small detail, including the tears in Marco's eyes, although Marco doesn't remember a thing about their first chance encounter.

This conversation serves as the "beginning of a beautiful friendship," to quote Humphrey Bogart's declaration to Claude Rains at the end of *Casablanca*. It's an intense friendship between two men, containing some tensions on Benigno's part but devoid of explicit homoerotic overtones. Marco is a sensitive, romantic, sensual male, capable of crying on more than one occasion, whereas Benigno's sexuality is more troubled and complicated. Living with his mother (and taking care of all of her needs, including doing her hair and make-up), initially he comes across as a mama's boy, claiming to be a sexual virgin despite his age. When Benigno visits a psychiatrist, who happens to be Alicia's father, he states a preference for men rather than women, but we never see him engage in any encounter—social or sexual—with other men. When the psychiatrist insists on knowing if he has a partner, Benigno simply says, "More or less." At first, Almodóvar constructs him as a type, an effeminate male, with a manner of speaking and gestures to match, who knows how to aestheticize his female patient. Gradually, he is revealed to be mentally disturbed, capable of raping Alicia while she is in a coma, an act for which he is sent to prison.

Unlike other Almodóvar films, *Talk to Her* does not show the rape, but it is implied that there may have been several rapes. While in jail, Benigno, who is not allowed to communicate with his colleagues, is eager to know if Alicia has given birth. Later, learning that the baby was born dead, Benigno realizes that his only way to escape his fate

is to commit suicide, and he informs Marco of his intention. Rushing to the jail, the alarmed Marco arrives too late.

Most of the narrative depicts how, during a period of suspended time inside the clinic's walls, the lives of four characters flow in various directions—past, present, and future—pushing the quartet toward an unknown destiny, while keeping the viewers in a state of anticipation and suspense. The names of the four characters must bear some significance: the first couple is A (Alicia) and B (Benigno), and the second couple is L (Lydia) and M (Marco). The goal of the text is to get rid of B and L so that A and M (amour?) will be able to form a new couple, free of past constraints and looking ahead to a brighter future. Thus, Lydia dies and Benigno commits suicide (not uncommon for Almodóvar's obsessive lovers, as seen in *Labyrinth of Passion*, among other films).

The film's boldest stroke is the insertion of a seven-minute, black-and-white silent film titled *The Shrinking Man*, which Almodóvar shot specifically for the movie. Breaking narrative continuity is always a dangerous act for a filmmaker—and is especially so here, as the sequence is tragic-comic in tone, describing a tiny man climbing, entering, and disappearing into a huge vagina. Almodóvar said that he did it to hide something that was going on in the story but the spectators should not see. For him, this kind of silence, which is the film's leitmotif, is a mechanism that protects both his characters and his viewers.

Almodóvar brings the physical aspect of the relationship between the two men to a closure in a brief but touching scene set at the cemetery. Visiting Benigno's grave, the grieving Marco leaves the hairpin that Benigno had stolen from Alicia and cherished all his life. The hairpin belongs to the director's large gallery of physical objects that are infused with symbolic meanings (see Matador).

Talk to Her is a quiet, poignant meditation about aloneness and loneliness and the long convalescence from wounds provoked by passion. In a session with his psychiatrist, Benigno declares, "I'm not alone anymore," and from his subjective POV, he is not, due to his passion for Alicia and the full-time job of tending to her needs and misperceiving her desires. Though the relationship is one-sided, Benigno tells Marco: "My relationship with Alicia is better than the

relationship of many married couples I know." Almodóvar has said that he wanted to show that "for utopian love to exist, only one person is necessary, and that that peculiar passion is sufficient in moving the relationship forward."[83]

It is also a film about the varied and shifting nature of communication between couples, from the explicitly verbal to the sexually gestural to the scary and ominous silence. The movie shows how monologues delivered to a silent (noncommunicative or physically disabled) partner can be just as effective as actual dialogues, even (and especially) if they substitute for live interaction. Almodóvar dissects the notion of silence as an "eloquence of the body," providing, much like Ingmar Bergman, a reflection about film as the ideal medium for conveying rich human relationships in minute detail. He shows how film can bring time to a standstill, affecting the lives of those who are telling, the narrators, and those who are listening, the characters in the film and the spectators in the movie theater.

Like other Almodóvar works, *Talk to Her* concerns the joy of narrativity and narration, the use of words as weapons against solitude, illness, insanity, and death, all of which recur in this picture—and in the rest of the director's oeuvre. You might say that the characters' lifestyle of solitude borders on madness. But there is also sensitivity and tenderness in these experiences, although they are not readily noticeable and thus do not deviate much from ordinary states of normalcy. Self-reflexive, *Talk to Her* comments on the film medium's unique properties, capturing the essence of monologues and dialogues, especially when they are shot in close-ups. Benigno and Marco develop a powerful bond in their deep love for—and shared devotion to—women who cannot talk back (even when they open their eyes) or return their affection. Here, too, Almodóvar contests Western values of masculinity and femininity—specifically, the notion of males as "men of few words" and females as "nonstop talkers."

In defiance of mainstream cinema, Almodóvar shows women to be capable of initiating contact, verbal and sexual, with men who are sensitive. The film's last scene is particularly evocative, both fateful and coincidental. It stresses the symmetry and circularity of the text, which begins and concludes with a performance piece and shows how the chains of a haunting, unhealthy past can be broken.

Almodóvar has acknowledged that of the four characters, Alicia is the least developed—by design: "I know very little about Alicia. Only what is seen in the film. At times, the writer knows the characters' past and their future, far beyond the ending of the film. In this case, I have the same information as the spectator."[84] Marco and Alicia meet during the intermission of Pina Bausch's *Masurca Fogo*. It is the first time that each is aware of the other's presence, though they had actually met before. Alicia was in a coma when Marco first saw her in the hospital. Later Alicia is not conscious that Marco is staring at her through the window, just as Benigno had, after Marco moved into Benigno's apartment while the latter was in jail.

During intermission, Alicia recognizes Marco as the man seated just two rows in front of her; there's one empty chair in the row that divides them. In the lobby, they sit on matching red couches. Alicia stares at him, as if expecting a look back from him. She holds his gaze as he collects himself and sits on a sofa. Initiating talk for the first time, Alicia asks, "Are you all right?" "Yes," Marco says and then quickly adds, "I don't know," indicating his fragile state and lack of self-confidence. "I'm much better now," Marco says in a whisper, almost to himself.

Alicia, after four years in a coma and confined to bed, is like a magical creature, an angel moving freely and talking. Her gaze suggests strong desire to interact with Marco. She and Marco finally occupy the same space, to which they belong physically and emotionally. Almodóvar accords each a close-up before slowly panning, rather than cutting, as they look at each other intensely.

With this picture, Almodóvar finally showed his remaining detractors his transformation from a rude boy into a sophisticated interpreter of modern melodramas, still retaining a gleeful capacity to affront conventional mores. Like other works, for every death, there's birth, here in the shape of couple formation. Alicia and Benigno's bond must be terminated so that she can form a new bond with a more suitable male, Marco.

On one level, the film is a cautious warning of relationships in which the one partner who loves carries his passion to an extreme. "It's a horrible situation, full of anxieties and problems, when only one person loves,"[85] Almodóvar has said. Ultimately, though, *Talk*

to Her is meant to be an ode to the platonic love between two men, unfolding in a tale that is, by turns, strange, comic, tragic, and creepy. Thus, in spite of its admittedly perverse elements, the film is touching and poignant, finding humor in the most grotesque situations and rays of hope in the most devastated conditions.

* * *

It was only a matter of time before Almodóvar revisited a traumatic chapter of his past with a more detached perspective. Again changing gears, Almodóvar's next feature, *Bad Education* (*La mala educación*), released in 2004, was his most autobiographical film. As he observed: "I had to make *Bad Education*. I had to get it out of my system before it became a destructive obsession."[86] *Bad Education* is my fourth favorite Almodóvar film, after *All About My Mother*, *Women on the Verge of a Nervous Breakdown*, and *Matador*.

Almodóvar dug deeper than usual into his own past and psyche, making *Bad Education* harsher, darker, and more bitter than his two previous works, the accessible and enjoyable *All About My Mother* and *Talk to Her*. Past and present collide in complex and unexpected ways in this personal meditation about the dual power of love to liberate and to enslave, to inspire and to destroy. Occupying a significant place in his already rich oeuvre, *Bad Education* ranks as one of his strongest films, based on a multilayered script that took over a decade to write. As expected, it was not as commercially successful as the prize-winning *Talk to Her* and *All About My Mother*, but it is a more ambitious film, bringing together strands of his gay films of the 1980s with those of his more intimate and introspective melodramas of the 1990s.

Though drawing on personal experience, Almodóvar insisted that *Bad Education* is not completely autobiographical. Its origins go back to his *Law of Desire*. In that 1986 picture, Tina (played by Carmen Maura) goes into the church at the school where she had studied as a boy. A priest playing the organ in the choir asks for her identity, and she confesses that she had been a pupil at the school and that he (the priest) had been in love with her. But Almodóvar is not interested in settling scores with priests who continue to "bad-educate"

boys like him. He has empirical evidence on his side: sex scandals have afflicted the Catholic Church over the past decade, damaging severely its reputation. In an interview, he disclosed: "The church doesn't interest me, not even as an adversary. If I needed to take revenge, I wouldn't have waited forty years to do so."[87] Although he attacks the corruption and hypocrisy of the Catholic Church, that's not what the movie is about.

Spanning seventeen years, the saga begins in 1964 and ends in 1980, with one crucial interval in 1977. Though a large part of the story is set in Madrid, the movie is not a reflection on *La Movida* of the early 1980s. What interests Almodóvar about that specific historic moment is the explosion of freedom, as opposed to the repression and obscurantism that prevailed in the 1960s, when he was growing up.

Despite some humor, *Bad Education* is a quintessential film noir—as dark as they come. It blends noir and crime elements in an erotic melodrama laced with personal memoirs, which again explores the issues of desire, obsession, and death. Thematically, in previous films, Almodóvar was inspired by, and borrowed from, Williams, Sirk, and Mankiewicz. In this picture, however, he goes deep inside the noir territory, mixing elements of such melodramas as *Leave Her to Heaven*; dark, excessive, and incestuous stories like *Mildred Pierce*; and obsessive romances like *Laura*. Like American film noir, *Bad Education* draws heavily on the hard-boiled literary tradition, defined by its crime-thriller elements and critique of societal mores. More specifically, *Bad Education* pays tribute to Wilder's *Double Indemnity* and to Hitchcock's *Vertigo*. Like those classics, *Bad Education* is about obsessive love, illicit affairs, double-dealing, and scandalous revelations. The opening credits pay homage to Saul Bass (who did many striking title sequences for Hitchcock and Preminger), and the loud, discordant score of Alberto Iglesias is very much in the spirit of Bernard Herrmann's thunderous scores for Hitchcock—specifically, *Psycho*.

Set in 1980 Madrid, the first act finds Enrique (Fele Martínez), a gay director, with no idea or inspiration for his next feature. Out of the blue, he's visited by Ignacio (Mexican actor Gael García Bernal), a handsome youth claiming to be his old classmate and first love. Ignacio, who now goes by the name of Ángel, says he is pursuing

an acting career. He hands Enrique a story titled *The Visit*, an allusion perhaps to Friedrich Dürrenmatt's famous play *The Visit of the Old Lady*—later filmed as *The Visit*, starring Ingrid Bergman and Anthony Quinn—a tragic comedy about a wealthy woman who offers the people of her hometown a fortune if they execute the man who had jilted her years back.

Ignacio's tale is inspired by their childhood experiences, when they were abused by the school principal, Father Manolo, and by Ignacio's subsequent life as Zahara, a drug-addicted transvestite. *Bad Education* might have been called Almodóvar's *Secrets & Lies*, though bearing different meanings than Leigh's acclaimed 1996 picture. Appearances are deceiving, and when it comes to identity, nothing is what it seems to be on the surface. As soon as we form an opinion of a character in *Bad Education*, Almodóvar presents a challenging twist, such as the revelation that Ignacio has a "mysterious" younger brother, Juan.

The childhood episodes display a lyrical, dreamy quality—especially noticeable in an idyllic scene out in the country with the boys relaxing and swimming. Ignacio is singing upon request Audrey Hepburn's theme song, *Moon River*, from Blake Edwards's 1961 *Breakfast at Tiffany's*, based on Capote's most famous novel. That novel and film are admired by Almodóvar, who had made a significant reference to Capote in *All About My Mother*. Father Manolo is genuinely in love with the angelic Ignacio, and his cruel decision to separate him from Enrique is driven by obsessive jealousy.

Structurally, *Bad Education* displays one of the director's most intricately woven plots. The movie unfolds as a labyrinth, with layers on top of layers, strands interfacing with other strands. It is a masterful work, in which symmetry works—but often in reverse. The organizational principle of the text is that of the triad. *Bad Education* is the story of three triangles: the trio of the two pupils (Ignacio and Enrique) and their school principal, the trio of the two brothers (Ignacio and Juan) and Mr. Berenguer, and, finally, the trio of the director, actor (Angel), and Mr. Berenguer.

A visitor who calls himself Mr. Berenguer and intrudes into Enrique's set turns out to be Father Manolo himself, dressed in civilian clothes. It has been seventeen years since the last time they had

met, when Manolo had expelled him from school. Now, it's Enrique, as director, who expels Manolo-Berenguer from his office. However, when Manolo offers information about Ignacio's death and Ángel's identity, Enrique becomes intrigued, driven by the same curiosity that had led him to work with Ángel.

The metaphor of crocodiles, shown earlier in the film, comes full circle, making its meaning clearer. While listening to Manolo's story, Enrique begins to feel like the woman who threw herself into a pool of crocodiles and was hugged by them while they ate her. (In this motif, Almodóvar might have been inspired by Eve Arden's witty one-liner about crocodiles in the 1945 crime noir melodrama *Mildred Pierce*.)

Almodóvar borrows from the noir genre the elements of desire, deception, fatalism, double identity, and crime. But if in American noir the femme fatale is a female, in *Bad Education*, it's a male, Juan. He is an enfant terrible who combines in his sultry and soulless nature elements from the roles played by Barbara Stanwyck, Jane Greer, and Jean Simmons, to mention some of Hollywood's famous femme fatales and black widows. The scene in which Berenguer and Juan go to Valencia's Museum of Giant Creatures to plan a murder pays explicit tribute to the supermarket scene in *Double Indemnity*, in which Stanwyck (in blonde wig and dark glasses) and Fred Mac-Murray plan to murder her husband. It may also allude to the famous aquarium scene between Orson Welles and Rita Hayworth in Welles's 1948 quintessential noir, *The Lady from Shanghai*.

Almodóvar uses the screen as a reflective mirror for the protagonists and the spectators. When Juan and Mr. Berenguer go to the movies after committing murder, the theater they choose "happens" to be showing two French noirs: Renoir's *The Human Beast* and Marcel Carne's *Therese Raquin*. These movies involve situations similar to those surrounding the men who are watching them. Leaving the theater, the devastated Berenguer complains, "It's as if all the films were talking about us." He is not kidding; they were![88]

Fiction and reality continue to interface up to the end. When Berenguer visits Enrique's set, he sees himself as Father Manolo in front of the camera—it's a film about him, written by one pupil (Ignacio) and directed by another (Enrique). Berenguer is thus forced to

contemplate his own past as it's narrated and thus deconstructed by his former pupils-victims.

The density in *Bad Education* is manifest in the text's multiple layers, based on the duality, duplicity, and mirrors that inform what is seen by the characters. There are at least three narrative layers: The first is the "real story"; the second is the story told by Ignacio in his short story (inspired by the "real story"); and the third is the story Enrique is adapting from the short story, now visualized as a film. Like many American noirs, the "double" and role reversal motifs are expressed in the portraiture of desire. The passion Father Manolo feels for the boy and his abusive power turn him into an executioner. However, years later, when Manolo calls himself Mr. Berenguer and falls in love with Juan, the wrong man, he is the one who becomes the victim. The handsome and versatile actor Garcia Bernal (currently in Jon Stewart's *Rosewater*) does a remarkable job in impersonating three characters: Ignacio, Juan, and Ángel.

For me, *Bad Education* is a stronger, more personal, and more significant work than the universally acclaimed *Talk to Her*. It received a rapturous response when it played at the Cannes Film Festival, as the first Spanish film ever to open this prestigious international event. Almodóvar was aware that the film's subject would limit its potential commercial appeal. Indeed, after a series of hugely successful pictures, *Bad Education* performed only moderately at the U.S. box office.[89]

* * *

Though stylistically different, thematically *Volver* belongs to the same universe as *All About My Mother*, centering on a group of victimized but resilient women who have (almost) no use for men in their lives. Three generations of women have survived with strength, audacity, and vitality various disasters, some caused by Mother Nature (gusting winds, ferocious fires) and others by many deaths, both natural and executions.

The film is set in a lively working-class neighborhood where immigrants from various Spanish provinces share with other groups the harsh realities of daily living and occasionally their fantasies and

dreams. In *Volver*, Almodóvar contests the prevailing clichés about "Black" Spain, offering instead the opposite, a "White" Spain, in which communal life still prevails as a spontaneous, supportive, and life-affirming experience.

Volver could be described as a cross between *Mildred Pierce* and *Arsenic and Old Lace*, infused with elements of Almodóvar's own *What Have I Done to Deserve This?* The film's strong female protagonist takes over a restaurant (just like Mildred) and makes a successful business out of it after her daughter kills her indifferent, parasitical, and abusive husband. Unlike Mildred, though, she does not go back to conventional domesticity at the end.

The heroine, Raimunda (Penélope Cruz, in an Oscar-nominated turn), is married to an unemployed laborer with whom she has raised a teenage daughter (Yohana Cobo). Over the years, she has remained close to her sister Soledad, nicknamed Sole (Lola Dueñas), who makes her living as a hairdresser, operating an illegal beauty parlor in her home. Their mother Irene (Carmen Maura), who was believed to have died in a fire along with her husband, suddenly appears as a living ghost. As such, she begins to interact with Sole, then with her grand-daughter, and finally with Raimunda. Strong and stubborn, mother Irene still has unresolved issues with Raimunda, who had moved to Madrid and neglected her, and she also needs to settle some matters with her village neighbor Agustina (Blanca Portillo) regarding the lat-ter's dead mother.

In terms of genre, *Volver* is neither surreal nor comedic, though it has elements of both. It shows how the living and the dead coexist without any tension or discord, resulting in situations that are both hilarious and emotional. *Volver* is essentially a film about the culture of death in La Mancha, where people practice death-related rituals with admirable naturalness. Almodóvar contemplates the mysteri-ous but real ways in which the dead continue to influence the living. The seriousness with which the residents treat the rites honoring the dead suggests that the dead may be buried in the ground but they never really die, in the sense that they never disappear from their sur-vivors' existence—in both real and symbolic ways.

The first scene, set on a sunny and windy day, depicts cheerful women at the cemetery, cleaning the tombstones of their families.

The buried are mostly husbands, and Almodóvar makes a point of indicating that the women tend to live longer than men. But in Raimunda's case, the deceased are parents, soon to be joined by her husband, Paco, who, significantly, would not get a proper ceremony or burial. All of her life, Raimunda has believed that her parents were devoted to each other and died together, tightly embraced to the bitter end, in a lethal fire. We later learn that Raimunda's father, just like her husband, Paco, was an adulterer who cheated with their neighbor, Agustina's mother. Moreover, the fire was no accident, as everybody assumed, but the police (always ineffectual in Almodóvar's films) never suspected that it was a deliberate act, a crime committed by Raimunda's mother. Never subjected to real investigation, Irene disappears quietly and then just as quietly returns to the village as a ghost.

The first reel concerns the domestic life of the hard-working Raimunda, waiting on her lazy brute of a husband. Sitting in front of the TV, he watches soccer and guzzles one beer after another, creepily watching his daughter's crotch as she sits with her legs spread in a natural way. Later on, Paco stares at his daughter through the half-open door while she undresses. In bed, trying to make love to Raimunda, she rejects him—"Don't be a pest." "Don't call me a pest," the macho man charges back, and the submissive Raimunda feels obligated to apologize, fearing his temper. Insensitive to Raimunda's mood—she's worried about her sickly Aunt Paula, who lives by herself—and lack of energy to make love, Paco begins to excite himself while lying behind her. Almodóvar stops the music and concentrates on the natural sounds of the masturbation, shot from the POV of Raimunda, who's appalled and horrified.

While Raimunda is absent at work, the drunkard husband makes a pass at his daughter, telling her it's all right because "You're not really my daughter." The girl, frightened and shocked, defends herself with a kitchen knife, seen earlier in a close-up when Raimunda was washing the dishes. Upon learning the truth, Raimunda protects the girl and creates an alibi—"Remember, I killed him," she says, and the two engage in cleaning up the blood and wrapping the body, in what may be a tribute to the lengthy scene in *Psycho*, in which Norman Bates cleans up the bloody mess and buries Marion's corpse and

her car in the nearby swamps. For the time being, Raimunda deposits Paco's corpse in the deep freeze of a restaurant owned by her friendly neighbor Emilio, who had asked her to supervise the business while he was taking a trip to Barcelona.

The restaurant serves as the major site in the second reel, when a film crew working in the region needs daily lunches. Pragmatic and with no signs of panic or hysteria, Raimunda promises to serve lunch to a crew of thirty later that day, at 4 P.M. to be precise. In just several hours, she rushes to the marketplace and borrows money and food from neighbors and passers-by—all women (including a hooker), of course—who gladly come to her rescue. The film director is one of the four males in *Volver*, and the most positive character. Almodóvar may be paying tribute to himself and/or to other male artists, who are expected to be more sensitive to the needs of all others, especially women.

Volver is the most extreme of Almodóvar's films in terms of depicting complete solidarity among women, who have no use for men, not even as sex objects. There is not a single woman who's happily married or attached; the teenage daughter is also deprived of a boyfriend. There are also no couples to be seen around. All the femmes live sexless lives; having repressed their libidos, they channel their anxieties and energies into rich family and community life. Almodóvar even refrains from showing the growing affection between Raimunda and the film director, who frequents her restaurant. There is exchange of simpatico looks, of some open and inviting smiles, but that's about it. For now, Raimunda lives a sexless life—she is done with relationships, though clearly she enjoys the attention paid to her by the courteous director. As soon as she notices his gaze, Raimunda takes better care of herself, applying hot lipstick and flaunting a cleavage that gets deeper and deeper, exposing her beautiful breasts.

For Almodóvar, the most difficult thing about *Volver* was writing the script, perhaps because he decided to tell the story chronologically with no insertion of flashbacks, a characteristic device. (We never see the fatal fire or the adulterous affair.) Overall, though, it was a joyous experience, especially after *Bad Education*, which he described as "absolute hell." "I had forgotten what it was like to shoot

without having the feeling of being on the edge of the abyss. This time I suffered less; in fact, I didn't suffer at all."[90]

Displaying one of the shortest and most significant titles of Almodóvar's films, *Volver* is also one of few films to use the original Spanish in all foreign theatrical markets. Bearing many meanings, *Volver* translates into "to come back," "to return," "to come home," and "to repeat," all of which apply to—and are valid with—the text. *Volver* includes several acts of coming back. It represents Almodóvar's return to comedy, his return to a distinctly female world, and his return to La Mancha ("this is my most strictly Manchean film"), to its language, customs, patios, and streets. Moreover, after seventeen years of separation, he worked again with Carmen Maura, his muse and dominant actress in the 1980s. Other regular actresses, such as Penélope Cruz, Lola Dueñas, and Chus Lampreave, were cast in *Volver*, lending a sense of continuity, on-screen and off.

Volver also signaled a return to maternity as the essential source of human life and as the origin of fiction. More specifically, the film pays tribute to Almodóvar's mother, the most influential figure of his life. He has said that "coming back to La Mancha is always like coming back to the maternal breast."[91] During the writing and shooting, he asked his mother to be physically present on the set—he needed her to be around. He later said, "My mother hasn't appeared to me, though I felt her presence closer than ever."[92]

Almodóvar claims that he has never fully understood the notion of death. This put him in a distressing situation when faced with the fast passage of time in his own life. The ghost of the mother who "appears" to her daughters is a recurrent phenomenon in his village. As he recalled: "I grew up hearing stories of apparitions, and this fiction has produced serenity in me such as I haven't felt for a long time."[93] His innate restlessness has acted as a stimulus. With *Volver*, he believes he has recovered "part of my patience" and "a sense of my balance." With this film, "I have gone through a painless mourning (like that of Agustina, the neighbor). I have filled a vacuum, I have said goodbye to my youth, to which I had not yet really said goodbye and needed to."[94]

Volver honors the rites practiced in Almodóvar's village, based on the myths that the dead never really vanish. The director has said that

he always envied the naturalness with which his neighbors talked about the dead, cultivating their memories, carefully tending their graves on a regular basis, and so on. Like the film's Agustina, many neighbors look after, and periodically visit, their pre-assigned graves while they are still alive. It was the first time, Almodóvar said, that "I could look at death without fear. I'm starting to get the idea that death exists."[95] Despite being a nonbeliever, he brings Maura's character (Irene) from the other world and makes her talk about heaven, hell, and purgatory. "I'm not the first one to discover that the other world is here. We all have hell, heaven or purgatory, they are inside us. Jean-Paul Sartre put it better than me in his essays and plays (*No Exit*, for example)."[96]

Raimunda, looking for a place to bury her husband, decides to do it on the banks of the river where they had first met as innocent children. Time never stands still in Almodóvar's movies. Rivers, like transports, tunnels, bridges, and passageways, prevail in his work (like the boys singing and swimming at the river in *Bad Education*), serving as potent metaphors for the transience of time, just as they did in Sirk's films. In Sirk's *Written on the Wind*, there is a flashback to the younger characters of Dorothy Malone and Rock Hudson, having a picnic by the river and engraving on a tree the heart symbol of their love. Malone returns to this romantically pure site as a woman, her nymphomania and obsession with Hudson partly blamed on his sexual rejection of her. In *Volver*, assisted by the village's prostitute, Regina, Raimunda digs a hole and buries Paco by the river. She later returns to the scene with her mother and daughter, telling the latter that this was Paco's favorite site. She makes an engraving on an ancient tree, just like Malone did, but instead of a heart, she lists Paco's dates of birth and death.

A dramatic comedy, *Volver* defies realism in its portrayal of local customs in favor of what Almodóvar has described as surreal naturalism: "I've always mixed genres. For me, it's something natural. The idea of including a ghost in the plot is a comic one, particularly if you treat it in a realistic way. Sole's attempts to hide the ghost of her mother from her sister, or the way in which she introduces her to her clients, as a dumb Russian, are essentially comedic."[97] Although the events in Raimunda's house (her husband's death) are terrible, the

way she conceals the crime and the way she gets rid of Paco's corpse (first freezing him in a cooler) create situations that are comic. Moving between divergent genres and opposing tones, often in a matter of seconds, one of Almodóvar's signatures, calls for a more naturalistic interpretation of life, a strategy that makes the most ludicrous situations slightly more plausible and bearable—occasionally even funny. The other "realistic" element in *Volver*, apart from the recognizable setting, is the troupe of reliable actresses, who are all in top form—"in a state of grace,"[98] to quote the director.

Almodóvar pays tribute to the positive parts of Spain that he had experienced as a child—especially to supportive neighbors, unmarried or widowed women who live alone and take care of their neighbors. This also was the director's personal acknowledgment of the final years of his own mother, who was helped by her closest neighbors and served as inspiration for the composite character of Agustina. One of the film's memorable moments finds Agustina alone on an empty and dusty road, forlornly watching as Sole's car disappears in a long shot into the horizon. It conveys the notion of rural solitude, ordinary life stripped of any adornment.

Cruz has shown (from her screen debut in Luna's *Jamón, Jamón*) that she is more forceful playing working-class characters. In *Live Flesh*, she played an uncouth hooker who goes into labor and gives birth on a bus. She appeared in only the first eight minutes of the film, but she made such an impression that she was remembered for the rest of the tale. In *All About My Mother*, she was memorable as the resilient yet sensitive nun named after a flower, Rosa. In *Volver*, her Raimunda belongs to the same type of woman that Maura had played in *What Have I Done to Deserve This?*: a force of nature, undaunted by any man—or any obstacle. But unlike Maura's Gloria, Cruz's Raimunda is a woman who can be furious one moment and defenselessly fragile a moment later. Her disarming vulnerability and the speed with which she could get in touch with her innermoset feelings surprised Almodóvar.[99]

Watching how Cruz's beautiful brown eyes suddenly fill with tears was an indelible sight. Almodóvar noticed how at times the tears spill over like a torrent or how in other sequences they fill her eyes without ever spilling over. Witnessing what he described as "balance of tears

within imbalance of crying" was thrilling, indicating Cruz's contribution to the overall emotional impact of *Volver*.[100] For Cruz's wardrobe, Almodóvar and his costume designer decided on straight skirts and cardigans because they are classic garments, feminine and popular in any decade. The wardrobe was meant to channel the young and voluptuous Sophia Loren in her pre-Hollywood career, when she played sexy simpletons like a Neapolitan fish-seller. To approximate Loren's sensual and lush look, Cruz wears a similar hairdo, dresses with deep cleavage, and uses extra pads to make her backside appear bigger and rounder.

Many viewers were happy to see Maura back in Almodóvar's work, two decades after a falling out. The lyrics of a song by Latin American singer Chavela Vargas—"You always go back to the old places where you loved life"—apply to his reliable cast (Vargas's songs had accompanied crucial scenes in *Live Flesh*). There is a long sequence in *Volver*, almost a monologue, in which Maura's ghostlike character explains to her daughter the reasons for her death and for her return. It took a whole night to shoot this sequence, but it was rewarding. The director said that he cried each and every time he revised the text for this scene.[101] He later admitted with self-deprecating humor that his conduct was not original. The inspiration for his emotionalism derived from Kathleen Turner's persona in *Romancing the Stone*, an author of kitschy romantic novels who cries whenever she is writing.[102]

Just like *All About My Mother*, *Volver* represents a lovely portrait of women. The group includes the grandmother, Irene, who comes back; her two daughters, Raimunda and Sole; her granddaughter, Paula; and Aunt Paula, who still lives in the village. The ensemble also includes Agustina, the neighbor who knows the family's hidden secrets. Agustina is a woman who as soon as she gets up taps on Aunt Paula's window and doesn't let up until Paula answers. When Aunt Paula dies, Agustina opens her home to the corpse in order to give it a proper wake until the nieces arrive. She has the ability to convert the mourning for her neighbors into mourning for her own mother, who had disappeared years ago. Agustina behaves as if she is an integral member of Raimunda's family. An opposite type of neighbor, who hates his neighbors and transmits his hatred from generation to generation, also exists in the film, and not surprisingly, he is a male.

Confessions—Almodóvarian style—dominate the last reel. As we expected and suspected, Paco is not the daughter's birth father, though he has raised her as his own. Thus, Raimunda, sexually abused by her own father, is both the mother and the sister of her daughter, just as Faye Dunaway revealed in the notorious, much imitated dramatic climax of Roman Polanski's *Chinatown* ("she's my daughter, she is my sister...").

The final chapters center on Agustina, now suffering from terminal cancer and determined to find out what had happened to her mother—it's her last wish. (Thematically, *Volver* could have been easily called *All About Her Mother*.) Having performed invaluable duties in caring for Aunt Paula until the latter's death, Agustina feels she is entitled to the same honorable treatment from Irene and Raimunda.

The very last scene is extremely touching, even by Almodóvar's high standards. Irene takes care of the dying Agustina, administering the injection needed to relieve her of pain and perhaps helping her die quietly and peacefully in her own bed, before she is "returned" to the grave she had already prepared for herself. Irene is watching TV, allowing Almodóvar to pay tribute to another great actress in a quintessential maternal role: Anna Magnani in Luchino Visconti's 1951 comedy, *Bellissima*. A force of nature, Magnani plays Maddalena, the overbearing stage mother of a daughter who has no talent. Standing in front of the mirror, Maddalena is combing her hair, and at one point, it feels as if she is staring directly in Irene's eyes. Irene turns off the TV and engages in the film's last dialogue, which offers a more ambiguous closure than is the norm for Almodóvar. Though unclear whether Agustina is dying in a case of euthanasia, she tells Irene, "That's our business." To which Irene responds, "That's right. And nobody else's." Having redeemed herself and having reached rapprochement with her alienated daughter Raimunda, Irene closes the door, and the screen turns black before the end credits begin to roll down.

A film about a family of women, *Volver* is also made by a family of female actors, both reel (on-screen) and real (offscreen). On this picture, Almodóvar's sisters served as his advisors when he shot scenes in La Mancha and Madrid. They made sure that the sites of the hair salon where they work, the kitchen where they prepare meals, the

bathrooms, and even the cleaning materials are all authentic. Then there is the presence of two quintessential actresses of Almodóvar's troupe, a generation apart, Maura and Cruz, with the former passing the torch to the latter, echoing the relationship between Divine and Ricki Lake in John Waters's *Hairspray* (see chapter 5).

Almodóvar is much more of a "woman's director" than Cukor (*The Women*, for example, not to mention numerous films with Katharine Hepburn, Joan Crawford, Norma Shearer, and Greta Garbo), albeit without the pejorative meaning of that label in the case of Cukor. Historically, women feature more prominently in the works of Antonioni (the intimate collaborations with Monica Vitti, Jeanne Moreau, and others) and Hitchcock (about half of his fifty-three narratives are about women, and several are named after women). Yet neither Antonioni nor Hitchcock has ever been described as a woman's director, largely due to the fact that they were heterosexuals. Almodóvar has earned the title of *The Man Who Loves Women* much more than Truffaut, to paraphrase the title of one of the famous French director's films. For that matter, Truffaut's *Love on the Run* would also apply to at least half of Almodóvar's oeuvre.

The most recurrent motif of Almodóvar's work is the celebration of women—a diversity of women, past and present, working class and middle class, young and old, and urban or rural. This was his reaction against the prevalent Hollywood genre of the buddy film, with its focus on male adventures and male camaraderie. "I am becoming a specialist in women," he has said. "I listen to their conversations in buses and subways. I show myself through them. For me, men are too inflexible. They are condemned to play their Spanish macho role."

Even hard-core feminist critics would have to acknowledge Almodóvar's genuine affection for women and his empathetic understanding of them. The director believes that women, no matter their age or class, are closer to, and in more direct touch with, their feelings than are men. Women in his works begin as oppressed and subjugated victims before they turn into avengers. They often end up victorious over pain and grief, invariably caused by men, who tend to be betrayers, abusers, and oppressors. He has repeatedly observed: "I enjoy the complicity that exists between women. Women have been able to give themselves up unashamedly to friendship for cultural

reasons, because they have been condemned to live out their private life in secret and that private life has only been revealed to female friends."[103] What humanizes all of Almodóvar's women (even the tough ones) and makes them more vulnerable is their need to feel and look desirable. Thus, there are numerous close-ups in his films of women keeping themselves up, primping, applying hot red lipstick, lifting breasts tucked under tight bras (if they wear bras). His femmes never forget the importance of deep cleavage and high heels to their physical looks, morale, and impact on men. The desire to look desirable is one of the most significant motifs in his work.

PHASE FOUR: ELEGANT STYLIST

After experiencing unparalleled success for a decade with four consecutive masterpieces, *Broken Embraces* (*Los abrazos rotos*), from 2009, had a lesser impact on viewers because it was more impressive visually than narratively. Though showing that Almodóvar is a distinctive stylist, the film treads water rather than breaking new ground. The feature displays the director's control over every aspect of the production, but this time it also shows the deliberate work involved in the textual construction. Despite elaborate mise-en-scène and a rich color palette, *Broken Embraces* feels less like an original feature and more like yet another take on the noir melodrama, a genre overused in cinema over the last two decades.

Almodóvar's most expensive movie to date, *Broken Embraces* revisits old themes that have intrigued him for decades. The movie combines his three favorite genres: *amour fou*, crime noir, and seriocomedy, a mixture better understood when placed in the context of classic Hollywood cinema—and in the context of his own oeuvre. Thematically, the tale concerns Mateo (Lluís Homar), a former filmmaker who's now blind. Mateo is trying to piece together a tragic episode of his past, his doomed affair with Lena (Penélope Cruz), a would-be actress and the mistress of Ernesto Martel Sr. (José Luis Gómez), the millionaire producer of Mateo's latest picture. Crammed with many characters and subplots and structured as a film-within-a-film, *Broken Embraces* is a work in which the director places in one

text almost everything he knows about cinema. There's another problem: the closure in the last reel, which brings everything together by deploying a Freudian perspective, may be too facile.

Like other Almodóvar pictures, *Broken Embraces* starts with a tricky beginning—here a steamy sex scene between a blind, middle-aged but still handsomely virile writer and a much younger girl (half his age) he invites to his place after she helps him cross the street. Mateo asks the girl to describe in detail her face, her skin, her dress, and, above all, her body measurements—specifically, breasts and thighs. Surprisingly for a stranger, who doesn't know a thing about her host, she responds to each question with a curious glee in her eyes. Mateo begins to caress her perfectly shaped breasts, and soon the couple is in the sack. Through a slow tracking shot of a purple sofa, we see just one foot of the girl hanging up in the air, with sounds of moaning and groaning in the background. When the quick sex is over, the girl goes to clean up in the bathroom, and in perfect timing, the bell door rings and his producer, Judit García, enters. Realizing what has happened, she helps Mateo retrieve his shirt from the floor while he zips up his pants.

Having a double identity, the protagonist answers to two names. At times, he is Harry Caine (perhaps a combination of the hero of *Citizen Kane* and Harry Lime, the character played by Orson Welles in *The Third Man*), a playful pseudonym with which he signs his stories. However, as a famous director he went by the name of Mateo Blanco, his real name.

Switching back and forth between Madrid in the 1990s (first 1992, then 1994) and the present time, the story establishes that fourteen years ago Harry-Mateo had a brutal car accident on the magnificent island of Lanzarote, in which he lost his sight and the love of his life, Lena. After the accident, the circumstances of which would be revealed at the end, Mateo goes back to his pseudonym, denying his past. Harry is being taken care of by Judit (Blanca Portillo, who played Agustina in *Volver*), his faithful production manager, with whom, we find out later, he had a brief affair. Also helping him is Judit's sensitive son, Diego (Tamar Novas of Alejandro Amenábar's Oscar winner, *The Sea Inside*), who's multitasking as Harry-Mateo's secretary-assistant, driving him around, typing his scenarios, serving

as his guide and social companion, and listening to his advice and his stories. In a state of denial, Harry, still dynamic and attractive, lives a lifestyle caused by a self-induced amnesia. Over the years, he has learned how to benefit from his other, ultradeveloped senses, a compensation for the loss of his sight. Though Harry is a good listener, he is a much better raconteur.

Harry's and Diego's mutual affection evolves into a deeply intense male bonding when Harry rescues the youth after a drug overdose accident in a disco club sends Diego to the hospital. The two men conspire not to tell Judit, who was out of town that night. During his convalescence, Diego asks Harry about the origins of his other name, Mateo. Initially resistant, Harry goes on to tell him the story of his life as a form of entertainment, the way fathers tell children fairy tales when they put them to bed. In the course of the narrative, Harry also embraces the role of Diego's father, first surrogate and then biological.

Like Manuela in *All About My Mother*, all of her life Judit has lied to Diego about his father's identity, leading the boy to believe that he is the product of an affair with a stranger. Manuela had no chance to reveal the truth to her son, but Judit has. In a lengthy confession, she discloses that she had a brief affair with a man (who unbeknownst to her or to him was a closeted gay), but that Diego is actually Mateo's biological son, a fact unknown to the father as well but disclosed at the end.

Not surprisingly, Harry's fable is dark, a classic *amour fou* in which the central triangle is formed by Lena, a beautiful aspiring actress, and two older men—Harry, her director in a film called *Girls and Suitcases* (*Chicas y maletas*), and Martel, the film's producer and Lena's older lover and provider. Early on, Lena works as Martel's secretary, and when she confides in him that her father is dying of cancer, Martel, who's been lusting after her, comes to the rescue, providing expensive private care for him.

We learn that Lena has occasionally worked as an escort-prostitute for an old madam. One night, when Lena's worried mother calls to report that her father's condition had worsened, Lena, out of desperation, calls the madam. In yet another tribute to Buñuel, Lena introduces herself as Séverine; the heroine in Buñuel's celebrated

surreal masterpiece, *Belle de jour*, is Séverine Serizy (played by Cathe-rine Deneuve). Violating professional ethics, the madam gives Lena's personal number to her client, who "happens" to be Martel. Martel calls Lena right away, prompting the frightened girl to hang up and to immediately protest the madam's violation.

Broken Embraces is, after all, a melodrama, so to complicate mat-ters, Almodóvar introduces Ernesto Martel Jr., the abused gay son of Martel Sr., who hates his father and seeks revenge. Wishing to be a filmmaker, Martel Jr. follows all of the characters with a video cam-era that produces incriminating footage of them. The extensive use of phallic items, such as canes, guns, and staircases, is symbolic, as are the motif of the double (prevalent in Almodóvar's films), the playful tone, and the self-reflexive references.

Girls and Suitcases, the film-within-a-film in *Broken Embraces*, starring Lena and produced by Martel Sr., is a funny, self-conscious tale bearing striking similarity to Almodóvar's own satire *Women on the Verge of a Nervous Breakdown*, right down to the barbiturate-laced gazpacho. In *Girls and Suitcases*, Cruz plays Carmen Maura's role in the original—her name is Pena in lieu of Pepa. Both films were shot in the same location, and the terrace is populated by the same creatures. Cruz's physical appearance in *Girls and Suitcases* is an imitation of the look of the young Audrey Hepburn. Other wigs worn by Lena in the tale are inspired by such sex icons as the plati-num blonde Marilyn Monroe and the dark-skinned and voluptuous Sophia Loren.

The color red is one of the unifying elements of Lena's guises, a color that defines her numerous costumes and the whole picture. Just as in Hitchcock's *Marnie* and Krzysztof Kieslowski's *Red*, each and every scene in *Broken Embraces* contains several objects in red, be they shirts, shoes, dresses, or paintings of big revolvers, which Almodóvar time and again pans, tracks, and scans as ominous signs of things to come. His careful scripting and methodical editing result in an intricate fusion of disparate elements. Jumbling genres and characters, he crams everything that he loves about cinema into *Bro-ken Embraces*. In the movie that Lena is making for Mateo, Almodóvar pokes fun at the casually shocking contents, bright colors, and hys-terical tone of his own work. His trademark hot primary colors leap

out of the shadowy backgrounds in the exquisite imagery of Rodrigo Prieto, the brilliant Mexican cinematographer.

Broken Embraces reflects the work of a director confident in his game, though it is hard to shake the feeling of déjà vu. The film is replete with self-conscious references to other films and other directors. Particularly touching is the homage to Italian neorealist cinema. In a brief scene, Mateo and Lena flee Madrid for the vacation that would end disastrously. In their hotel, they watch on a small TV screen a famous scene from Rossellini's 1953 masterpiece, *Voyage to Italy*, starring Ingrid Bergman and George Sanders as a couple whose marriage collapses while they are visiting archeological ruins. The scene, which shows in close-up Bergman's horrified reaction to the skeletons, proves to be too much for the already distraught Lena, and Mateo turns off the TV abruptly. There are also allusions to classic Hollywood staircase falls, such as the one taken by Gene Tierney in *Leave Her to Heaven*, though here it is not self-induced; Lena is pushed down by her insanely jealous husband.

Like most American film noir, *Broken Embraces* contains time shifts and unfolds in flashbacks and flashbacks within flashbacks. The flashbacks to Lena's story begin in 1992, when she's hoodwinked into marrying her wealthy stockbroker boss, Martel Sr. The latter is brilliantly played by Almodóvar newcomer José Luis Gómez, whose performance blends ruthlessness, benevolence, and vulnerability; Gómez is equally impressive in a small part in the director's next feature, *The Skin I Live In*.

Early on, Mateo declares that he wants to make a movie about a relatively unknown story: the son of the famous American playwright Arthur Miller and his wife, Inge (whom he wed after Marilyn Monroe), who has Down syndrome. There is a good inside joke here. When Judit claims that it would be tough to get rights for a biopic about Miller, not to mention Mateo's contempt for this popular but artistically debased genre, Mateo says that they will just fabricate and fictionalize the truth. There are the by now expected torn-up photos, suppressed secrets that scream to be revealed in public, blood ties that need to be restored before it's too late, and even scripts about cosmetic-inventing vampires. Sporadically, there are some comedic touches, such as the lip-reading girl (Lola Dueñas), hired by the

insanely jealous Martel Sr., who insists on hearing every word that the adulterous Lena had said, when the tape's sound fails to reproduce her speech.

Cruz, who has always looked more comfortable in Spanish than Hollywood films, is terrific as Lena, offering a more nuanced performance than the one that accorded her the Oscar in Allen's romantic comedy *Vicky Cristina Barcelona*, in which she plays the crazy former wife of Javier Bardem! (The two are now a real-life couple, raising their children.) *Broken Embraces* suffers considerably from the disappearance of Cruz three-quarters of the way into the film, and her riveting presence, as a femme fatale juggling lovers and guises, is very much missed.

Broken Embraces is so rigorous in its aesthetic strategy that it's easy to disregard its overwrought narrative and succumb to the flow of strikingly artful images. However, formal style aside, the film is cold and detached, in sharp contrast to the effortless warmth and emotional depth of Almodóvar's previous features, *Talk to Her* and *Volver*. One of the director's most inward-looking films, *Broken Embraces*, he has said, is rooted in the migraines that began afflicting him in recent years. While recovering from them in a darkened room, he conjured the character of a blind filmmaker, reflecting his nightmare (and that of many other directors) of losing his vision. In *Broken Embraces*, the middle-aged director takes stock, exploring his roots as well as imagining his future. But for all its dark tragedy, it is ultimately an optimistic film. In the end, the disabled Harry-Mateo continues to work, determined to (re)embrace life. In one of the film's most moving moments, he answers to his Caine identity for the first time after a long denial in a surreal Felliniesque scene, set on the beach surrounded by kites, surfers, lovers, children, and dogs.

No Almodóvar film is complete without personal confessions, revelations of secrets, and acts of redemption. Taking revenge on Mateo, who has run away with his wife, Martel Sr. cuts the footage of his film senselessly and mercilessly. Upon release, the film is predictably panned by the critics and proves to be a flop, a fact that Mateo and Lena learn from the newspaper clips they read during their vacation. But perhaps reflecting Almodóvar's wish fulfillment as a director, the last word belongs to the auteur. Knowing Mateo's love for

this particular movie and his devotion to his work, Judit had secretly kept an assemblage with all the takes, which she now gladly hands over to him. *Broken Embraces* is a film in which pleasure emerges out of darkness, in which light needs to struggle before conquering the shadows. At the end, the newly formed social and professional family, composed of Mateo, Judit, and Diego, sets out to work on a new version, which is faithful to the director's original vision, resulting in a satisfying movie. After two hours of a relentlessly bleak melodrama, Almodóvar lifts his viewers' spirits by making them realize that, no matter how bad things are in the present, there's always something to enjoy in the present and anticipate for the future.

* * *

The gloom and doom of *Broken Embraces* goes further in *The Skin I Live In*, Almodóvar's creepiest film to date. After its world premiere at the 2011 Cannes Film Festival, it played at the Toronto Film Festival and served as the centerpiece of the New York Film Festival before opening theatrically in October 2011 to a mostly positive response.

Asked about the artistic influences on his medical horror-thriller, Almodóvar mentioned Buñuel, Hitchcock, Fritz Lang, the Hammer horror films, the psychedelic and kitsch style of cult Italian director Dario Argento, and the lyricism of Georges Franju—specifically, Franju's best-known film, *Eyes Without a Face*. This multiplicity of inspirations might be one of the problems with *The Skin I Live In*, a feature that tries to do too much thematically and then is too eager to present a "neat" closure.

Despite my concerns with the narrative and its ideological foundations, *The Skin I Live In* boasts stylish elegance, rigorous mise-en-scène, and ultrapolished production values that are striking even by the director's usual high standards. Harsher and grimmer than *Bad Education*, *The Skin I Live In* is the director's first genuine tragedy, a horror drama devoid of humor or light notes. The film takes the Frankenstein-like fable to its most terrifying extremes, justifying for the first time the label of "cinema of cruelty." More specifically, it borrows the bondage and captivity from *Tie Me Up! Tie Me Down!* as well as the brutal rape (in fact, dual rape) from

several films, and the car accident in which a loved one (here a wife) is injured or killed recalls *Broken Embraces*.

Almodóvar has lamented the "loss" of Antonio Banderas to Hollywood and star-wife Melanie Griffith (now divorced), claiming, "I can no longer afford him." Reteaming with Banderas for the first time in two decades, *The Skin I Live In* is a welcome collaboration for both filmmaker and actor. Banderas's cool image and effortless sex appeal were evident in *Matador* and *Women on the Verge of a Nervous Breakdown* as well as in Robert Rodriguez's *Desperado*, in 1995. But that was two decades ago, after which he has experienced a dwindling career. One could hardly come up with three or four decent Hollywood movies—the *Zorro* films included—that Banderas has made in the United States. Ironically, Banderas was cast for his overt sex appeal as Tom Hanks's lover in the AIDS drama *Philadelphia*, but the director (Jonathan Demme) and writer (Ron Nyswaner) lacked the courage to show the couple in intimate scenes, not even kissing.

Well cast in *The Skin I Live In*, Banderas plays Dr. Robert Ledgard, a famous plastic surgeon and widower whose wife was burned in a car crash. The accident left his wife nearly dead, burned with deep wounds, and placed under her husband's loving care. It also left Ledgard the responsibility of raising by himself a young, oversensitive daughter. In flashbacks, it is later disclosed that the adulterous wife was running away with the wild son of Marilia, the loyal housekeeper, when they got into the accident.

Ever since that tragic event, Ledgard has been trying to create a new, special skin that he believes could have saved his wife. It has taken extraordinary time, energy, and money to develop in his laboratory a "miracle," multifunctional skin that's sensitive to caresses but that also serves as a shield against aggression, both external and internal. In his work, Ledgard has relied on thorough studies, risky experiments, and his ambitious personality; he lacks any scruples and morals—his obsessive goal justifies all means. To fulfill his aim, he has relied on one accomplice, Marilia (Marisa Paredes), the loyal housekeeper who has looked after him from the day he was born. The two reside in a huge, splendid estate named El Cigarral (The Orchard), seen as a prison, as an isolated, inaccessible place in the midst of Nature.

The early images are crucial in establishing the film's particular locale and mood, showing a mansion surrounded by trees, a seemingly idyllic place protected by stone walls and high barred gates. Through one of the barred windows, a female—later revealed as Vera—is in motion. Almodóvar's piercing camera tracks Vera, who is presumably naked as she is doing her yoga exercises. However, it turns out that she's wearing a flesh-colored stocking that clings to her like a second skin (pun intended). In the kitchen, Marilia prepares Vera's breakfast, which she sends up in a dumbwaiter that opens directly onto the Vera's room. Vera is the captive woman, and Marilia is her jailer, supervising each and every move via TV screens all over the house.

Vera now serves as a guinea pig for the doctor. In a previous life, Vera was a handsome boy who had seduced and then brutally raped Ledgard's only daughter during her first outing to a wedding party with her father. The girl is still troubled by the suicide of her mother, who had jumped out of the window upon seeing a reflection of her ravaged face. In one second, during which the otherwise ultraprotective father is not watching, she is approached by a charming young man. It is clear that this is the first time the shy girl has been courted. This is depicted in a magnificently shot nocturnal scene in a fable-like forest, lending the film the aura of a fairy tale, populated by male wolves and young innocent virgins. Tracing his daughter's whereabouts, Ledgard retrieves one of her purple shoes, whose heel is broken, and her purple scarf before finding the girl comatose by a tree.

Ledgard recalls seeing a man fleeing the scene on a motorcycle. Seeking revenge, Ledgard captures the rapist, starves and tortures him for days like a dog, and then forces upon him a sex-change operation, renaming him Vera. The scene in which the boy realizes that he is now a girl is horrifying to him and to us. Through flashback, we learn that the boy worked in a women's clothing store owned by his stern and domineering mother. A peculiar boy, he is both a mama's boy and a bigoted womanizer, unable to accept the fact that his attractive coworker is a lesbian who rejects his persistent advances.

In six years of enforced reclusion, Vera has lost her own skin—literally—but she hasn't lost her identity entirely. She's tougher than her appearance suggests: As a survivor, she has been forced to learn

how to live within her skin, even if it is imposed by others. Once she accepts her new skin, Vera instructs herself in endurance and patience—learning how to wait. But wait for what? The dramatic turning point occurs during a carnival, when a tattooed man, in a tight tiger costume that accentuates his crotch, forces Marilia to open the gates. He turns out to be Marilia's birth son and, unbeknownst to Ledgard, the doctor's stepbrother. Marilia has always preferred Ledgard, treating the other son as a mad man. Blaming his mother for what he has become, he ties her up in a chair and gags her in a scene that recalls *Kika*, where Rossy de Palma's maid is tied and gagged in the kitchen by her brother.

Retrieving the key to the sealed room where Vera is held captive, he brutally rapes her. Arriving just in the nick of time, Ledgard shoots and kills the tiger man (his stepbrother). Vera, bleeding and severely injured, begins yet another healing process. She proves resilient and indestructible: later, after a failed attempt to run away from Ledgard, she slits her own throat but survives.

Too hermetic and inward-looking, *The Skin I Live In* also suffers from a forced closure, though it is decidedly not a happy one. After a gory shootout, in which both Ledgard and Marilia are killed, Vera finally escapes. Showing up at his mother's store where he used to work as a man, Vera identifies herself/himself to her/his coworker and his mother. Ironically, Vera is wearing the same dress that early on he wanted his female coworker to try, and the latter suggested jokingly, "Why don't *you* try it on?" The joke has become a tragic reality. The last image depicts a newly formed family unit, now composed of three females, including Vera, whom Almodóvar places at the center, flanked by the two other women.

Ledgard could be seen as a modern-day Frankenstein, sending postmodern chills through our bones as he's seen walking in his huge, meticulously decorated estate as if it were composed of halls of mirrors. Visually, the film is gleaming with seductive images, but they are mostly on the surface. The film's more serious issues—the extent to which human beings feel comfortable in their own skin and how that feeling relates to their identity—are presented in provocative and shocking ways. A close female friend of mine pointed out that for her the movie is fascinating because it portrays in graphic detail

the pain involved in penetration. There are three scenes in which the doctor tries to penetrate into Vera's (reconstructed) vagina but has to stop because she cannot tolerate the pain. This makes Vera's rape by the tiger man all the more horrific, teaching her a lesson about what it means to rape a young girl (Ledgard's daughter).

Almodóvar shows masterful skill over the technical aspects of the production. Over the years, he has turned from a jokester into a stylist, from the maker of joyous satires into the director of shrill and polished melodramas. It is impossible not to admire the slow pans along the decorated walls and the carpeted floors, the gates/curtains used to introduce new chapters and characters, the subtle and seamless dissolves, the elegant tracking shots, and the smooth cuts. But his early trademarks of vivid spontaneity and joy are sacrificed for what is essentially a calculated, cold-blooded revenge tale.

Of Almodóvar's nineteen films to date, *Broken Embraces* and *The Skin I Live In* stand out in their distanced approach and lack of empathy for most of the characters, be they male or female. *Broken Embraces* is a manipulatively constructed puzzle that relies on a film-within-a-film to supply answers to its issues in order to make sense of the convoluted narrative. In *The Skin I Live In*, the grimmest of the director's films, five of the tale's six characters and up dead in one way or another, and the only survivor is a former young man forced to become a woman.

* * *

After a couple of stylized melodramas, devoid of any humor or fun—the film noir *Broken Embraces* and the horror-thriller *The Skin I Live In*—Almodóvar went back to his roots with *I'm So Excited*. The movie was complete in time for showing at the 2013 Cannes Film Festival, where all of his pictures since 1999 had premiered. However, for a variety of reasons, it did not make it as an official selection. Sony Classics, the director's loyal distributor, decided to open the movie in June, as counterprogramming to Hollywood's blockbusters.

A minor work, *I'm So Excited* is an ultra-slight sex farce that's retro in both the positive and the negative senses of the word. The picture is rude and crude in the manner of Almodóvar's first pictures, except

that it's airless and only sporadically involving. It divided the British critics and got similarly mixed to negative reactions from their American counterparts. For me, it's Almodóvar's weakest movie in what has otherwise been a glorious career spanning thirty-five years and consisting of nineteen features, most of which are good or really great.

Almodóvar's seemingly wild and transgressive feature is too simple, too broad, and too silly as a comedy or farce. The movie goes out of its way to joyously celebrate free-for-all sexuality, in its variations of gay, straight, and bisexual. *I'm So Excited* is meant to be light and fluffy, and for a while it is, but, ultimately, it's too strained, fractured, and lacking in genuine comic energy. The cast reunites many thespians from all the phases of the director's career, beginning with Cecilia Roth, who was in his first two pictures and in his 1999 masterpiece, *All About My Mother* (still my favorite Almodóvar picture).

The first scene is sort of a teaser, featuring Almodóvar's regular actors Penélope Cruz and Antonio Banderas in cameo parts as airport workers-lovers who suddenly realize they are soon going to become parents. The action then moves up into an airplane that's bound for Mexico. Due to technical problems, it begins circling in the air—just like the film itself, which never really takes off.

Almodóvar is obviously in a camp mood, manifest in his introduction of three male flight attendants, whose roles are scripted as caricatures (by intent, I assume). Javier Cámara (*Talk to Her*) plays Joserra, a high-strung, fast-talking gay attendant who has something to say about everybody and everything. Raúl Arévalo is the slender, pill-fueled Ulloa. Carlos Areces is the chubby, sexually repressed, religiously fanatic Fajas, who prays for the souls of his mates and passengers with a portable toy altar he carries with him.

Most of the action is confined to the passengers in business class, as those traveling in economy have been given sleeping pills. The passengers include Bruna (Lola Dueñas), a sexually hung-up psychic who has a particular ability for sensing death and claims to be a virgin. Bruna is the first to see the oncoming troubles, which she shares with the pilots. The middle-aged but still attractive Norma Boss (Cecilia Roth) is a former actress who is now a dominatrix serving members of Spain's political class. Norma claims to have video recordings of Spain's 600 most important people as they engage in

bondage. Also on board, and initially not mixing together well, are the soap star Galán (Guillermo Toledo), the corrupt businessman Más (José Luis Torrijo), and the notorious Mexican hit man Infante (José María Yazpik).

The pilots are forced to circle for hours, and so does Almodóvar, unable to find good or funny or crazy reasons for the queeny flight attendants, first-class passengers, and pilots to fight and fuck. The movie offers some superfluous fun, like the bitching, vamping, eye-rolling, and humping. But, overall, the visual pleasures are minor, such as the safety signs that look like erections or the piles of suds bobbing up and down, not to mention the name of the airline, Peninsula Airlines, which has phallic connotations. It's as if the director set out to exploit the most facile attributes of his earlier features, bitchy dialogue and high camp—here associated with the gay-dominated profession of flight attendants.

The attendants decide to keep the passengers' spirits up by lacing their drinks with mescaline. Later on, they suddenly erupt into a performance of the Pointer Sisters' disco classic "I'm So Excited," which gives the picture its English-language title. In Spanish, it's called *Los amantes pasajeros* and initially was known as *The Brief Lovers*. When the drugs kick in, all class and sexual barriers disappear, resulting in erotic scenes between the pilots (one bisexual, the other straight) and the attendants and among the passengers, forming some of the most unlikely and unappealing couples in Almodóvar's output.

A pre-credits note states that the film bears no relation to anything factual, but I suspect that it may have resonated better in Spain, due to the allusions made to that country's economics, politics, and morality. Artistically, *I'm So Excited* is a misfire, a satire that's just wildly erratic but neither funny nor erotic. Thirty years ago *I'm So Excited* might have been considered sexually audacious, but by Almodóvar's standards, the movie is retro camp. The stylistic control and formal restraint that had characterized his last two pictures are all gone, replaced here by the kind of anarchic mood that's simply not humorous enough.

Predictably panned by most critics, the movie also failed to attract viewers. The screening I attended at the Provincetown Film Festival,

where the audience was largely gay and familiar with Almodóvar's work, went poorly; there were even some walkouts. After the showing, I overheard a spectator tell his companion, "This is Almodóvar for the masses," echoing the perceptive review of critic Wesley Morris: "Almodóvar is basically exploiting what people presume an Almodóvar movie to be—bitchy campiness—in order to get some stupid telenovela fun out of his system. By the time you see a pile of suds bobbing up and down, the sight gags have basically driven over a cliff. Yeah, this is what people think Almodóvar is. But it's Almodóvar for people who assume they can't get Almodóvar otherwise. It's Almodóvar for Target."[104] As a result, the picture was not seen or liked by any demographic group, resulting in a flop for the distributor, Sony Classics, with a paltry gross of $1.5 million.

Having made nineteen films, Almodóvar may be going through a transition, perhaps even a turning point in his career. His next feature or two will be crucial to maintaining his reputation as a major director. Over the past thirty-five years, he has produced a body of work that's thematically challenging and visually compelling. At sixty-five, he's still an inventive director who has many more stories to tell. I have no doubt that *I'm So Excited* is just a footnote in an otherwise diverse and impressive oeuvre of a director who continues to boast the most significant voice in contemporary European cinema. As of this writing, Almodóvar is shooting his new film, *Silencio*, which he describes as a hard-hitting drama and a return "the the cinema of women." Starring Emma Suarez and Adriana Ugarge as the older and younger versions of the protagonist, the film is slated to release in 2016.

PEDRO ALMODÓVAR FILMOGRAPHY

1974 *Two Whores, or a Love Story That Ends in a Wedding* (Dos Putas, o, historia de amor que termina en boda) (short)
 The Fall of Sodom (La caída de Sódoma) (short)
1977 *Sex Comes and Goes* (Sexo va, sexo viene) (short)
1980 *Pepi, Lucy, Bom and Other Girls on the Heap* (Pepi, Loci, Bom y otras chicas del montón)
1982 *Labyrinth of Passion* (Laberinto de pasiones)

1983 *Dark Habits* (Entre tinieblas)
1984 *What Have I Done to Deserve This?* (¿Qué he hecho yo para merecer esto!)
1986 *Matador*
1987 *Law of Desire* (La ley de deseo)
1988 *Women on the Verge of a Nervous Breakdown* (Mujeres al borde de un ataque de nervios)
1990 *Tie Me Up! Tie Me Down!* (¡Átame!)
1991 *High Heels* (Tacones lejanos)
1993 *Kika*
1995 *The Flower of My Secret* (La flor de mi secreto)
1997 *Live Flesh* (Carne trémula)
1999 *All About My Mother* (Todo sobre mi madre)
2002 *Talk to Her* (Hable con ella)
2004 *Bad Education* (La mala educación)
2006 *Volver*
2009 *Broken Embraces* (Los abrazos rotos)
2011 *The Skin I Live In* (La piel que habito)
2013 *I'm So Excited* (Los amantes pasajeros) *2015 Silencio* (in production)

2

TERENCE DAVIES

Subjective Memoirist

A TRUE RENAISSANCE man, Terence Davies is a filmmaker, screenwriter, novelist, actor, and narrator. His critical status is based on the poetic autobiographical features he made in the first decade of his career. Though best known as a film director, he has also produced several radio plays, including one based on Virginia Woolf's *The Waves*. In 1983, he dramatized the life of his alter ego in the novel *Hallelujah Now*, a brutally candid account.

Despite a small output—half a dozen features in four decades—Davies is arguably Britain's greatest living filmmaker. Some critics may choose Ken Loach as the country's premier filmmaker, but having been born in 1934, he is older than Davies and belongs to a different artistic cohort. Stephen Frears, who is more or less Davies's age, is the most prolific and commercial of Britain's filmmakers, but he does not qualify as a genuine auteur. Davies shares some similarities with Mike Leigh, an accomplished director who is only two years older and, being Jewish, an outsider like Davies. But as I will show later, Davies is a more significant filmmaker, using more fully the language of film as a unique medium. For starters, Leigh's features could be done as stage plays because they are highly dependent on the characters and the actors who cocreated them, but Davies's features can exist only as films.

Thematically, like Pedro Almodóvar and Todd Haynes, Davies has explored the lives of women in his work. Unlike Almodóvar, however, whose female protagonists are diverse and ultimately are not victims, Davies has largely depicted middle-class or working-class women who are victims of their social circumstances. His female characters are products of the rigid patriarchal British society of the 1950s, a context in which he grew up, witnessing firsthand sexual segregation and physical abuse as they prevailed in his own family.

Aware of his consistent preoccupation with certain motifs and characters, Davies said: "My films are always about outsiders. I've always felt like an outsider myself. I've never felt part of life. I've always felt like a spectator. I think that's what interests me about all the people and the things that I've written about. Lily Bart in *The House of Mirth* is an outsider, and so is Hester Collyer in *The Deep Blue Sea*."[1] One can easily add to that list Aunt Mae, the protagonist of *The Neon Bible*.

As a filmmaker, Davies is noted for dealing with some recurring themes: explorations of life's temporal dimension and the complex relationships among past, present, and future; women's emotional and physical suffering but also endurance; the influence of subjective memory on everyday life; and the crippling effects of paternal abuse and rigid religiosity on individuals' welfare and happiness.

Davies's output is small but artistically distinguished. His oeuvre consists of critically acclaimed shorts and features that are highly personal, philosophical in their concerns, coherent in their scheme, and stylized in their visual and sound design. His films represent acts of exorcism of a tormented past, but they also function as acts of redemption and renewal. "I make films to come to terms with my family history," the director has said. "If there had been no suffering, there would have been no films."[2] But unlike other artists, he does not think that personal pain is a necessary condition for creating good films—or any art.

One of the distinctions of great artists is their ability to turn drab human existence, pain, and misery into joyous, lyrical, and sublime art. Davies exults in the power of cinema as a medium of personal transformation and redemption. He has displayed a profound understanding of how art can liberate people from their sorrow. Time in his

films may be transitory and ephemeral, but he knows that his ability to capture particular historical moments in a uniquely filmic mode represents the kind of self-fulfillment associated with spiritual or even religious experiences.

Unlike other directors in this book who have occasionally collaborated with other scribes (Haynes, Almodóvar) or who have relied on scripts by other writers (Gus Van Sant), Davies has always been the sole screenwriter of his films, which gives him a greater measure of authority and control. As a director, he has frequently explored gay themes via screen characters that are his alter egos. He is more concerned with reflecting on and recreating his own life than with making films about gay characters or gay issues per se. Indeed, three of his six features revolve around women, and the other three favor the female characters (on-screen mothers and sisters).

Davies has a special gift for constructing luminous visual images and resonant sounds whose power is both aesthetic and emotional. Stylistically, his works are defined by multi-nuanced texts, elaborate mise-en-scènes, symmetrical compositions, and "symphonic" narrative structures, to borrow a term from classical music, which he admires. He leaves nothing to random chance: to achieve maximal dramatic and emotional impact, his brick-a-brick strategy calls for each shot to be measured and placed in the "right" position. Similarly, each sound of his rich scores is carefully wedded to a particular image, resulting in emotional reverberation. Believing that film is the most emotional and expressive art form, he uses songs in his narratives to express his characters' innermost feelings—often repressed and frustrated sensations.

Of the five directors in this book, Davies is the most rigorous, methodical, and subjective. Asked what he wanted to achieve in his life, he said: "Even though I'm a very pessimistic person, I believe that it's worth striving to be a better person. Better, not better off. That's just vanity. I want to say that it is worth going on."[3] According to his philosophy, "You are worthy because you were born, and being of service is what makes you great as a human being."[4] Davies's films suggest that his working-class life was difficult, and even unbearable, but that it also had great beauty and genuine warmth. There is nothing intellectual about Davies's approach to narrative construction or

characterization. In sharp contrast to Haynes, there is no conscious deconstruction, no overall analytical perspective, no use of postmodernism. As Davies explained: "My point of view comes from instinct and heart. I try to be as truthful to memory as possible. I remember the intensity of those moments, which I still reverberate to even today. So I have no aesthetic distance from the material of my films."[5] His screen characters are not meant to be symbolic representations of stereotypes or prototypes. The mothers in several of his films are not the self-sacrificing type, and Hester Collyer in *The Deep Blue Sea* does not stand for the sexually starved, long-suffering wife as seen in Hollywood films.

It goes without saying that, commercially, Davies is the least accessible director in the book. His career is entirely dependent on critical response and festival showings. Most of his features have had their world premiere at the Cannes or Locarno Film Festival and then have been shown at the Toronto Film Festival, where he is particularly appreciated. None of his features has crossed over beyond the art houses in big metropolitan centers and the festival circuits, and he is still much better known in Europe than in the United States.

EARLY LIFE AND CAREER BEGINNING

Born on November 10, 1945, in Liverpool to working-class parents, Davies is the youngest child in a family of ten children, only seven of whom had survived. Though raised Catholic by his deeply devout mother, he later rejected religion—he now considers himself an atheist. He has stated that filmmaking has helped him work out his rejection of Catholicism and views his complete devotion to film as a sacred calling, an individualized, secular religion.

The movies that his sisters took him to see as a boy had a profound influence on Davies. He recalls fondly musicals, such as MGM's *Meet Me in St. Louis* and *Singin' in the Rain*, admiring their vivid color, energy and vitality, exuberant life, and boisterous songs performed by the likes of Judy Garland and Gene Kelly. He admits, "My teenage years and my twenties were some of the most wretched in my life. True despair. Despair is worse than any pain."[6] This period led to his

leaving both Liverpool, which offered little creative outlet, and the Catholic Church, which might have damaged him irreparably.

As an adolescent, Davies saw Alec Guinness on television reciting from memory T. S. Eliot's *The Four Quartets*, a group of poems about time and memory published in 1943, two years before Davies was born. "Time present and time past / Are both perhaps present in time future / And time future contained in time past," writes Eliot, which would become a leitmotif of the director's work in exploring how images and memories of the past, present, and future subtly interface. The poems had such a profound effect on him that "I now read them once a month." As a young man, he also discovered the classical music of Anton Bruckner, Jean Sibelius, and Dmitri Shostakovich, whose compositions "worked deeply into my unconscious, so when I look at images, I think of music."[7]

Davies has professed love for "the poetry of the ordinary" and the "beautiful in the mundane," apparent if one observes objects and events of reality closely. This may be why he frequently quotes the last stanza of *The Four Quartets*, in which Eliot states the relationship between time and mortality: "All manner of thing shall be well / When the tongues of flame are in-folded / Into the crowned knot of fire / And the fire and the rose are one."

After leaving school at sixteen, Davies, just like Almodóvar, took a day job, working for years as a shipping-office clerk and accountant. As he later recalled: "Liverpool was a world I had to escape. The environs I grew up in were tiny. It consisted of house, church, street, and the movies. I wanted a creative life, rather than becoming an accountant, which I did for twelve years, and I detested it. It was like a slow death."[8]

Due to funding difficulties and his refusal to compromise, Davies's output has been small and sporadic. Of his six feature films, the first two, *Distant Voices, Still Lives* and *The Long Day Closes*, are autobiographical films set in Liverpool. *The Neon Bible,* starring Gena Rowlands, is an adaptation of a novel by American author John Kennedy Toole. *The House of Mirth*, boasting a strong performance from Gillian Anderson (then famous for TV's *The X-Files*), is based on Edith Wharton's well-respected book of the same title. His new feature *Sunset Song*, an adaptation of the novel of the same name by

Lewis Grassic Gibbon (1932), was to star Kirsten Dunst in the lead, but it got delayed due to financial difficulties. The film, now starring Agyness Deyn, is in post-production as of this writing.

Davies has also produced several works for radio. *A Walk to the Paradise Garden*, an original radio play, was broadcast on BBC Radio 3 in 2001, and a two-part radio adaptation of Virginia Woolf's *The Waves* was broadcast on BBC Radio 4 in September 2007. *Intensive Care*, the autobiographical radio feature Davies wrote and narrated for BBC Radio 3, was broadcast on April 17, 2010.

Like most of the directors in this book (Van Sant is the only exception), Davies has coaxed great performances from his female stars. This group includes Gillian Anderson, who proved in *The House of Mirth* that she is more than a TV presence, and Rachel Weisz, who won the Best Actress Award from the New York Film Critics Circle for *The Deep Blue Sea,* Davies's 2011 feature. In the autobiographical features, there are vivid performances by the various actors, deliberately unknown, who impersonate himself and his real-life mother and siblings.

Davies told *Cineaste*: "I'm very black-and-white, I either feel great passion or nothing at all."[9] Though a very different director, he almost echoes John Waters, when he says, "People either love what I do or they absolutely detest it." He even agrees with the assessment of a critic who wrote about the grim tone of his features: "Davies' films make Ingmar Bergman look like Jerry Lewis."[10]

PERSONAL FEATURES

Leaving Liverpool, Davies attended the Coventry Drama School, where he studied acting and wrote the screenplay for his first autobiographical short, *Children* (1976), financed by the BFI Production Board. He then went to the National Film School, after which he directed *Madonna and Child* (1980), the second chapter in the story of Davies's alter ego, here named Robert Tucker. Several years later he completed the trilogy with *Death and Transfiguration* (1983), in which he dramatized, among other things, his own death. These works were screened together at film festivals (I saw them at the estimable

Toronto Film Festival) as *The Terence Davies Trilogy*, winning numerous awards and loyal aficionados. In this austere black-and-white trilogy, he depicts himself as the closeted Robert Tucker, chronicling his life from abject childhood to miserable adulthood to lonely death.

Despite the seven years separating the first short from the last, as the critic Henderson notes, they are coherent due to their stark outlook, aesthetic formalism, and reliance on subjective memories. Like Davies's future features, they are fragmentary and elliptical, offering in their dour tone a poignant portrait of a lifetime of suffering.

The first, *Children*, in which Phillip Mawdsley plays Robert Tucker as a boy, paints a picture of suffocating isolation, school bullying, and abusive parenthood. Davies displays remarkable detail in rendering Robert's fear of undressing during health examinations in school and his shyness in the public showers, experiences that made him first aware of his attraction to men. The ordeal of Robert's burying his head in his pillow while listening to his father beating his mother is even more painful to behold because after the assault his mother, overcoming pain and humiliation, goes up to Robert's room to comfort him. Despite Robert's close relationship with his mother, he doesn't glorify her—she is depicted as an ordinary woman who loved him unconditionally. The funeral of Robert's father provides the film's climax, emphasizing British funerals as macabre ceremonies and grotesque rituals, especially when seen from the POV of children.

Children showed Davies's technical inexperience as a director, which he himself later acknowledged. Nonetheless, despite the roughness and "my many mistakes," the short still maintains raw power. Shooting it was a grueling process because none of the crew members liked Davies's "peculiar method." He credits cinematographer William Diver for supporting his vision and helping him complete the work.

In *Madonna and Child*, the second short, Davies continues to explore the issues of Catholic guilt, homosexual fantasies, his intimate rapport with his mother, and oppressive isolation. It depicts Robert as a bright young man, stuck in a wearisome, life-sucking office job. Davies displays growth in the technical aspects of directing, manifest in the high contrast of black-and-white imagery, and poignant editing, which place this short in a darker realm than that of

Children. For instance, the scene in which Robert knocks on the door of a gay club is contrasted with his confession at church. Juxtaposing the sacred and the profane, we hear his voice-over requesting a tattoo on his "bollocks" while the camera sweeps the interiors of the church. Another scene juxtaposes Robert's confession of his sins with a fellatio he performs, detailing both the pleasure and the guilt involved. The holy-profane binary motif is manifest in his homosexual fantasies, which are contrasted with his mundane office job. In one sequence, the director cuts from a domestic scene of mother and son drinking tea to a public one in which Robert is engaged in an S&M scene.

The last scene, a nightmare of Robert's own death, echoes the morose scene of his father's death in *Children*. Davies follows a procession, which leads up to a casket where Robert himself lies while the priest delivers the eulogy. Robert's loud screaming as he wakes up offers a chilling effect. According to the director, these plaguing nightmares were caused by being forced to stay in his father's bed after the latter died. The remaining hope, as he says in his commentary, is that he was able to "get out" and escape into professional filmmaking.

Death and Transfiguration, the third short, brings the trilogy to a transcendent closure. Wilfred Brambell plays the elderly Robert Tucker, who is now confined to the hospital after a stroke. But even though his body is broken, his mind floats freely. The film contains seamless contrasts and polar opposites. It is rooted in the pain of the flesh, but it also offers spiritual grace, reveling in the kind of hope that's found in despair. The choirs of children singing Christian songs take on a haunting quality, and there is a subtle transition between the nurses putting up holiday decorations in the hospital and the young Robert celebrating Christmas with his mother.

Doris Day's rendition of "It All Depends on You" opens the short with a note of sentimentality that's quickly muted. In one long take, Davies pans from Brambell in his wheelchair to a rainy window and then back to the younger Robert (Terry O'Sullivan, reprising his role from *Madonna and Child*), standing by the window in his place. Shot in one take, it shows Davies's remarkable capacity to slip smoothly between varied historical times. In the trilogy's most harrowing moment, the director tracks through the darkened hospital

as Brambell's heavy breathing punctuates the soundtrack before cutting to him as he reaches toward a majestic light.

* * *

Distant Voices, Still Lives, made in 1988, is Davies's first masterpiece, as reflected in its critical reputation. *The Guardian* described it as "Britain's forgotten cinematic masterpiece," and in a 2011 *Time Out* poll, the film ranked 3rd among the 100 greatest British films of all time. This superlative start, not evident in the careers of the other four directors, indicates the challenges for a filmmaker who begins on a high note and then has to strive to match that achievement. In my view, Davies has done it twice, with *The Long Day Closes*, the 1992 follow-up, and *Of Time and the City*, the sublime 2008 documentary.

Davies has described *Distant Voices, Still Lives* as "homage to my mother and to my family, "focusing on a household ruled by a tyrannical father Part warm nostalgia, part cold nightmare, and part painful memoir—and satisfying on each of these levels—the film offers a bittersweet look at Davies's working-class upbringing in post–World War II Liverpool. The narrative structure explains the title of the film, which consists of two parts, shot separately. Essentially a dramatic musical, or a musical drama, which is a rare subgenre, the film goes against the grain of most Hollywood musicals, past and present, which are joyous, upbeat, and boisterous.

Davies's real-life father is seen an old and bleached photograph hanging on the wall, when the mother and her three children, Tony, Eileen, and Maisie, walk out of the frame, reinforcing the notions that the film is grounded in reality and that the patriarch's presence still is—and would always be—felt. As noted, the director was the youngest of ten children, born into a working-class, Catholic household. His father died when he was six, though memories of him as a powerful, domineering, violent man are vivid, as are his memories of the love and support of his mother. Davies has noted that the films based on his own early years represent "partial, very partial reality, particularly the bits that I am not in." Recalling a life lived in constant, imminent terror of his father, he has said, "If I had put in everything that happened, nobody would have believed it. My father was so psychotic I

had to leave a lot out. You cannot recreate the terror. The suffering was so prodigious you couldn't put it on screen. Nobody could bear it."[11]

Tommy Davies is given to erratic bursts of temper and contradictory display of emotions, ranging from deep love and compassion to brutal physical abuse. For example, a crucial Christmas scene begins with a tracking shot of a row of similar houses. Accompanied by choral music, the camera goes into one of the houses, where Tommy is decorating the Christmas tree. He says good night to his children and later makes sure they are sound asleep (they're all crammed in one bed). "God bless, kids," Tommy whispers before placing a stocking on their bedpost. In the next scene, the family is gathered for Christmas dinner, and as usual, Tommy claims his seat at the head of the table. Then, without any warning, his fingers begin to tremble and his body to shake. He angrily pulls off the tablecloth with all the dishes and food, yelling at his wife, "Clear this up!" This two-minute sequence captures the erratic conduct of an alcoholic patriarch, subject to contradictory impulses and going from extreme tenderness to uncontrollable brutality. Significantly, no explanation is offered for Tommy's schizoid personality.

A stylized portrait, *Distant Voices, Still Lives* is a plotless narrative, consisting of impressionistic set pieces, presented out of order in a nonlinear mode. Told in flashbacks, the film begins and ends with family weddings, held several years apart, during which the grown-up children reflect on their father and his impact on their lives. Though Davies's look is uncompromisingly harsh, the film is imbued with unmistakable humanism, an approach that refuses to see life as just a gloom-and-doom experience. The characters' daily lives, he suggests, may be rough, but they are certainly not dull or conventional. His subtle observations form a compellingly coherent, visually vivid, emotionally powerful memoir. Though subjective and fragmented, his portrait bears the kind of timeless resonance that succeeds in speaking to viewers who grew up in totally different circumstances than his own.

In his unflinching search for truth, Davies shows understanding for all of his characters. The distinguished actor Pete Postlethwaite (nominated for a Best Supporting Actor Oscar as Daniel Day-Lewis's father in Jim Sheridan's 1993 social injustice drama, *In the Name of the Father*) plays Tommy Davies, the violent taciturn father, and

Freda Dowie is his suffering yet stoic wife. Angela Walsh is Eileen, the daughter whose marriage offers some promising change, if not complete freedom from a life of misery.

Davies transcends the dreariness and misery of his mood piece by creating a work in which music serves as a direct and lyrical expression of emotions. The musical numbers are stylized statements of feelings. The opening number, "I Get the Blues When It Rains," plays in the background during a languid tracking shot through an empty, dark-green living room. The scene then dissolves into a medium shot of the main characters: the mother and her grown children, Eileen, Maisie (Lorraine Ashbourne), and Tony (Dean Williams). Clad in black and positioned in a spare tableau, they suggest figures in a faded family album.

The emotional power of Davies's fractured and elliptical family chronicle is undeniable. The first part, *Distant Voices*, revolves around the painful memories of childhood, defined by fear and wartime suffering. As a boy, he is the product of a repressive Catholic childhood. The second half, *Still Lives*, portrays the slightly happier life of a widow, her daughters and son, and their friends, including Micky (Debi Jones). They gather in pubs, sing collectively, and begin to live—and also suffer from—their own lives. The songs they sing together include popular tunes like "Buttons and Bows," "That Old Gang of Mine," and "Bye-Bye Blackbird." But the director makes sure to include some specifically ethnic songs, such as the Jewish "My Yiddisher Mama," the Irish-flavored "When Irish Eyes Are Smilin'," and the black-oriented "Brown-Skinned Girls."

Music is the film's main element, taking up over half of its screen time and fulfilling both narrative and emotional purposes, based on Davies's belief that of all art forms, film is closest to music. Davies told Paul Farley: "I got my family to sing the actors the songs—on tapes. It was difficult, actually, deciding what to leave out. All the songs I'd heard them sing, that were my favorites, I put in. It was as simple as that."[12]

The actors, being younger than the real-life characters they played, did not know the lyrics, and Davies engaged in a painstaking process of training and rehearsal. He has singled out Jones's rendition of "Buttons and Bows," Walsh's heartbreaking rendition of "I Wanna Be Around," and Peter Pears's "O Waly, Waly," which he sings as the

newlyweds and the family disappear into the dark. Through the songs, the director wanted the viewers to feel his images instinctively and viscerally, just as they respond to music.

The marriages of Eileen, Maisie, and Micky signify solidarity with one another—and also hope, based on their innocent belief that their unions would differ from those of their parents. Nonetheless, from the start, Eileen's marriage threatens to follow the same tragic pattern of her mother's. In the pub, right after her wedding, Eileen sobs into the arms of her husband, George (Vincent Maguire), fearfully crying, "I want me Dad!" Later on, already sensing the patriarchal tyranny in her own marriage, Eileen rebelliously sings Johnny Mercer's "I Wanna Be Around to Pick Up the Pieces," a personal response to her own domineering husband.

Davies's family life is evoked through subjective recollections. His poetic narrative drifts in and out of reality, suggesting the prevalence of ghosts and demons of the past. The film offers tension between the public solidarity, reflected in pub sing-alongs, weddings, and mournings, and the private horror of domestic abuse, depression, and unfulfilled dreams.

Davies's empathy, just like that of Almodóvar and Haynes, resides with the women. The men are either flawed or damaged goods. The husbands of Eileen and Maisie seem to be variations of Tommy, the rigid father. "They're all the same," Micky remarks about the males, "When they're not usin' the big stick, they're fartin'." Though they are the heroines of the piece, the women are creatures of compromise. "Why did you marry him, Mom?" asks one daughter. "He was nice, and he was a good dancer," her mother replies.

Memory is intensely linked to music from Davies's childhood. Each snippet heard is connected to a specific emotional experience. Ella Fitzgerald's "Taking a Chance on Love" is heard while the mother sits on a windowsill polishing the glass from the outside—a lyrical moment placed against the drab milieu. The director then cuts from the kids watching their mother by the window to her being brutally beaten by their father, but he lets the same music play as he shifts from a fondly recalled moment to a traumatic one.

The Futurist Cinema inspired one of the film's most artistic and most emotional sequences, in which sisters Eileen and Maisie

attend a showing of *Love is a Many Splendored Thing*, a 1955 Holly-wood romance starring William Holden and Jennifer Jones. Quite impressively, a crane shot rising from the umbrellas outside the theater dissolves into a pan over the crying faces of those attending the show. The water imagery, which moves smoothly from the heavy rains outside to the intense tears inside, shows the interface of the external physical with the internal emotional worlds. It is set to the powerful melody of the movie's theme, which became a hit song independently, going beyond the picture. (It is still a memorable song that's often used in various contexts to signify romanticism). Incidentally, the Futurist, Liverpool's first purpose-built and longest-surviving cinema, opened in 1912 and closed its doors in 1982, after seventy years of operation, an event lamented by Davies and many other cineastes.

Dramatically, it seems that the main purpose of Tony's going AWOL as a soldier is to create the opportunity for a willful confrontation between father and son. The scene begins with Tony smashing a front window with his fist and ends when he is arrested by the military police and thrown into prison. Yet, while locked in the brig, Tony pulls out his harmonica and plays the melodic theme from Charlie Chaplin's 1952 *Limelight*. In one of the film's striking moments, Tony and George are observed in an overhead shot as they are falling together in slow motion through the same skylight. Both men have suffered work-related accidents that send them to the hospital, yet only George's fall from the scaffold is shown on screen.

There are moments of comic, even surreal relief. When Maisie and her husband, Dave (Michael Starke), who live with her grandmother, are having dinner together, the door suddenly opens, and a man (a pale version of the father) appears with a candle. "I switched the light off," he says, "but I don't know whether I'm doing right or wrong." After leaving, Dave asks, "Who was that man?" Maisie simply says, "Uncle Ted." A moment later, Uncle Ted and his candle are shown as he is stopped at the stairs by the grandmother. "Teddy, stop acting soft!" she says firmly before blowing out the candle.

The text is restricted to a few locations—mostly interiors like the living room, the kitchen, the staircase, and the children's bedroom. The outdoor scenes take place in the stable (the father's work space),

the hospital ward, the church, and, most important of all, the neighborhood pub. Confining the characters to specific areas highlights the prevalent sexual segregation and also intensifies the film's emotional impact. Women in the pub often sit by themselves and sing together in joyous moments that are interrupted abruptly when the men are done discussing sports or wish to leave the party right away, disregarding the women's needs.

The area in front of the house, as critic Koresko has noted, is of particular significance because it's neither an indoor nor an outdoor space, though sometimes it functions as both, literally and figuratively. It is a place of relative relaxation, an escape from the internal and external oppression. Eileen, Maisie, and Micky go out there to smoke, and other family members use the space for much-needed fresh air during shared events. After his own wedding, Tony is seen crying in front of the house, which captures a rare moment of aloneness—the family is so large and there are so many gatherings that there are not many occasions to be quiet or alone.

Looking for locations, Davies recalled: "The house where I grew up was demolished in 1961. And it was unique. I was able to rebuild it for *The Long Day Closes*, but we didn't have a huge budget for *Distant Voices, Still Lives*, so we had to find something that looked like a working-class street, and we shot in Drayton Park, but there were no cellars, so it wasn't like our house. We had to go with what was there, because we didn't have the money."[13]

Though the interiors are cramped settings, such as bomb shelters, crowded houses, and pubs during holiday celebrations, the characters reach out and connect through music, while their feet remain firmly on the ground. Performing songs represents a fleeting, defiant ecstasy, a revolt against the crushing oppression around them.

Still Lives, the film's second half, doesn't make the same intense emotional demands on the viewers as *Distant Voices* does. Once the father dies, the film loses its dramatic momentum and narrative urgency, though it still offers plenty of events, both highs and lows, of family folklore. The tale concludes on a lovely note, showing Tony's wedding followed by the departure of the guests, which signals an elegiac tone.

Davies has said that he deliberately divided the film into two contrasting halves, each made with different crews over a two-year

period. *Distant Voices* has pale sepia tones, whereas *Still Lives* abounds in ethereal fades to white. Painterly stillness alternates with gliding camera movement. Bleak darkness prevails from the imagery of the dreary, cramped rooms and sunless hallways, to the black alleys, to the pubs and bomb shelters, which are lit only by pale rays. The little color that exists in these lives is reflected in the old photographs, which with time have faded into yellowish brown.

Distant Voices, Still Lives stands in sharp opposition to the Technicolor glory and upbeat mood of the MGM fantasy-musicals of the era, such as Vincente Minnelli's *Meet Me in St. Louis*, starring Judy Garland, or *American in Paris* and *Singin' in the Rain*, starring Gene Kelly, musicals that Davies loved as a boy and remembers fondly as an adult, but there are no glossy or glitzy set pieces in his art.

With his detached approach, Davies avoids the clichéd nostalgia and sentimental romanticism that often characterize such autobiographical movies. Take, for example, the personal features of British director John Boorman, who's older than Davies by a decade. In 1987, Boorman wrote, produced, and directed *Hope and Glory*, based on his own experiences of growing up in the Blitz in London during World War II, the same era covered in *Distance Voices, Still Lives*. The title of his charming, Oscar-nominated feature derives from the patriotic British song *Land of Hope and Glory*.

Like Davies's film, made one year later, at the center of Boorman's fable-like story is a middle-class white-collar family, the Rowans, headed by Grace and Clive, who are raising three children—Bill, Dawn, and Sue—in a suburb of London. When Clive joins the army, Grace alone watches over the children. For ten-year-old Bill (Sebastian Rice-Edwards), the "fireworks" caused by the Blitz represent an exciting rather than terrifying spectacle. In a funny scene, Bill says "Thank you, Adolf" (Hitler) for forcing his school to close down. Though the rest of the family is not as cheerful as Bill, their will to survive the nightly raids brings them closer together. The melodramatic events— sister Dawn falling for a Canadian soldier and getting pregnant, or the family's house burning down, ironically not in an air raid but in an ordinary fire—are secondary and depicted in a light way. The Blitz, the fire, and other disasters are causes for celebration because they allow Bill to stay home and spend more time with his favorite family

member, the curmudgeonly grandfather (Ian Bannen). Significantly, Boorman, just like Davies, revisited his character in a sequel titled *Queen and Country,* shown at the 2014 Cannes Film Festival, in which he depicted the bittersweet rite of passage of Bill (now played by Callum Turner), focusing on his national service in the British Army.

A comparison between *Distant Voices, Still Lives* and Dennis Potter's *The Singing Detective* highlights the distinctive attributes of Davies's film. Philip E. Marlow, the hero of Potter's series, is a mystery writer suffering from writer's block—and from psoriatic arthritis, a chronic skin and joint disease. As a result of constant pain and fever, and his refusal to take medication, Marlow falls into a fantasy world involving his Chandler-like novel *The Singing Detective*, an escapist adventure about a detective named "Philip Marlow" who sings at a dance hall and takes jobs that "the guys who don't sing" won't take. The tale's three worlds of the hospital, the noir thriller, and wartime England often merge in Marlow's mind, resulting in a fourth layer, in which the various fictional characters interact. Many of Marlow's friends and enemies (real and perceived) are represented by the novel's characters—particularly Raymond, Marlow's mother's lover, the villain in the "real" and noir worlds, who committed fornication with Marlow's mother and cuckolded Marlow's beloved dad.

There are many similarities between Davies's and Potter's works: Both are original, critically acclaimed personal works, inspired by and based on their authors' respective experiences. Potter suffered from the same disease as his hero, and he wrote with a pen tied to his fist just as Marlow does in the last episode. Both were made at more or less the same time: Davies's film was released in 1988, and Potter's was broadcast as a BBC serial drama in 1986; it was telecast in the United States in 1989. Both works rely heavily on music and singing to convey the tone of the era and the shifting moods of the characters. The two works use flashbacks to evoke their heroes' childhood during World War II, centering on the heroic mother figure. The real Marlow experiences flashbacks to his childhood in rural England and his mother's life in wartime London.

But the differences are just as striking. Potter's series unfolds as a noir mystery-melodrama that is never resolved, though there's a

vague plot about Nazi war criminals. This reflects Marlow's and Potter's view that fiction should be all clues and no solutions. Fiercely personal and idiosyncratic, *Distant Voices, Still Lives* does not borrow elements from film noir and does not conform to any genre—in fact, it creates its own genre. Then there is the absence of sex among the characters in Davies's film, as opposed to the prevalence of adultery in Potter's series. Finally, the tonality of the two works is decidedly different. *The Singing Detective* is sardonic, ironic, and bitter: Potter sees pop culture as the great divide, inevitably separating idealized fantasy from cruel reality. In contrast, Davies's film, despite the pain and suffering, is ultimately a celebration of life, an upbeat manifesto of his personal philosophy that even the most mundane and miserable existence contains some elements of beauty and joy that should be cherished. Davies is able to find humanity and salvation in the most sorrowful reality.

American distributors are unfortunately (mis)treating *Distant Voices, Still Lives* and other art films by marketing them as depressing artworks, which is a misconception. Through the songs' physicality and the women's mixture of laughs and tears, Davies suggests that, despite the sorrow and grief, they—and we—should be grateful just to be alive. As an artist, he invites audiences to share in the suffering of his characters, which is realistic and grounded, but he also encourages audiences to participate in their joy and happiness, fleeting and ephemeral as they may be.

* * *

Davies's follow-up, *The Long Day Closes*, is more profound and fully realized than *Distant Voices, Still Lives*—of the personal works, it's his acknowledged masterpiece, though I personally prefer the 1988 film. In this 1992 text, which is extremely dense, he recalls the burgeoning awareness of his own homosexuality and how his discovery of cinema provided him both cathartic escape and ecstatic relief. In *Distant Voices, Still Lives*, the abusive father dies, and *The Long Day Closes* picks up the family during its next four years, relating events that occur until the time Bud (Davies's screen surrogate) leaves primary school. The narrative is condensed into one crucial period,

1955–1956, when he was ten and eleven. With the father dead, the obvious dramatic tension is gone, but the saga contains a more subtle tension, one that resides in Bud's emotional development and self-consciousness.

The Long Day Closes is more radical in form. Whereas physical and emotional pains bled out of the 1988 portrait, here the events in the life of the filmmaker's surrogate, Bud (Leigh McCormack), evoke exaltation. Bud claims it was the most joyous time of his life—"I was sick with happiness." "Everything seemed fixed, and it was such a feeling of security that this is how it will be forever, and I really believed that,"[14] Davies said of this period.

In lieu of the father's threatening violence in the earlier film, there's tender love from his mother (Marjorie Yates) and protective affection from his three siblings (Ayse Owens, Nicholas Lamont, and Anthony Watson). Though bathed in love, he still feels isolated, as he is too young to be included in the activities of his older brothers and sister. Meanwhile, he experiences the first signs of homosexuality, a subject the director would return to in his nonfiction work, *Of Time and the City*.

Despite the warm family settings, Bud is a painfully solitary boy who experiences the first stirrings of homosexual desire along with the weight of Catholic guilt. We get a vivid image of Bud's burgeoning awareness of homosexuality. From his window, he spots in his neighbor's yard a hunky bricklayer, and there's erotic desire in his staring. Upon noticing his look, the shirtless man winks back at him, which scares the boy and makes him feel ashamed. Bud is just beginning to realize (but not yet understand) his sexual difference, which will induce guilty feelings. Davies fuses the two elements by casting the same actor to appear first as the muscular bricklayer and then as the crucified Jesus during one of Bud's daydreams. Later on, a Christmas family dinner is envisioned by the director as a version of The Last Supper, except that it's Bud's mother now who occupies Christ's seat.

The soundtrack underscores the emotional content of the images. Once again, popular culture, songs, and old movies hold a sacred place in Bud's life. In the opening sequence, the camera glides through a rain-drenched alley while sound snippets are heard, including the bombastic horns of 20th Century Fox's logo theme and

Alec Guinness's sinister introductory line from *The Ladykillers*. They are followed by Nat King Cole's smooth and velvety "Stardust," with the lyrics "the music of the years gone by."

As the family necessarily begins to dissolve, Davies brings to the gatherings a nostalgic (but unsentimental) sense of a community, one that struggles with the inescapable passage of time. The title implies the stagnation of oppressed lives, yet the movie is defined by motion and beauty. This becomes clear at the very beginning, with the credits sequence. We observe a seemingly static image, a still life of a bowl of roses slightly illuminated by sunlight, over which the credits roll. But then gradually the roses begin to wilt—their decline conveyed through extremely subtle, nearly imperceptible dissolves—until the petals scatter all over the table.

The idiosyncratic vision of Bud, a movie-crazed boy, is reflected in the densely layered sound design. Significantly, most of the songs are heard but not actually seen performed. The rich score consists of over thirty compositions, some of which are only partially sung or heard. Some songs are performed by a single figure and by the characters in groups while others are sung by characters in aural clips from classic films.[15]

There are tunes from Orson Welles's second film, the elegiac 1942 *The Magnificent Ambersons*, and Judy Garland's songs from Minnelli's masterful 1944 *Meet Me in St. Louis*. The narrative reaches one of its heights with the *Tammy* sequence, in which the connections among the church, the school, and the movies, all forces and sacred places in Bud's evolving consciousness, are made explicit. A series of overhead tracking shots linked by dissolves is scored with Debbie Reynolds's sugary singing from that picture. (The impact would have been totally different had Davies actually shown the perpetually perky Reynolds performing it.)

Images of doors (and windows) recur in Davies's oeuvre, suggesting the dual meaning of portals, capable of taking his characters into the exciting and the unknown, but also capable of closing behind terminated chapters with ominous signs for a darker future. In the opening, the camera drifts down a rain-soaked Kensington street where Davies grew up, now demolished and in disrepair. The camera then enters the open front door of an abandoned row house, showing

its battered and drenched staircase. A subtle dissolve indicates that we are in the past when this boarded-up place is brought back to life with Bud on the stairs. At the end of the film, Bud passes through a door, and the camera stays at a remove as he enters a portal in his basement, beyond which there is a pitch-black void. We hear sounds of Welles's melancholy narration from *The Magnificent Ambersons*, the voice of Martita Hunt's Miss Havisham in David Lean's *Great Expectations*, and then a voice-over of a school lecture about erosion. These snippets signify deterioration and decline, the effects of the inevitable passage of time.

Only a pure filmmaker who's totally free of commercial constrains would conclude his movie the way Davies does. The closing image of *The Long Day Closes* is a bold and original three-minute take of a full moon gradually vanishing behind the clouds.

ADAPTATION OF AMERICAN NOVELS

The moon is again a major image (and sort of a character) in *The Neon Bible*, Davies's first film to be set in the United States. A young boy comes of age in rural Georgia during the 1930s and 1940s in this visually satisfying but thematically flawed and dramatically inert 1995 drama—by far the director's weakest work.

Acclaimed for his evocative reflections of his own past as a boy of various ages in post–World War II England, Davies looks beyond his home country with his adaptation of the novel by John Kennedy Toole, who also wrote *A Confederacy of Dunces*. Once again, the story is told through the subjective eyes of an ultrasensitive teenager, here named David, who is played by Jacob Tierney at age fifteen (and by Drake Bell at age ten). As was the case for Davies himself and his alter egos in the British films, everyday life is one big continuous struggle for David.

The Neon Bible is narrated by David, who reflects on his youthful experiences with his father, a laid-off factory worker who turns to agriculture and fails. Abusive and short-tempered, he is like Davies's own father in his British movies. Once the father goes off to war, the small family (David is the only child) slides into breakdown and

deterioration. David is raised by his emotionally unstable mother, Sarah, who eventually loses her grip on reality. His chronic loneliness is interrupted by the arrival of his mother's sister, Aunt Mae, a fun-loving actress and swing-band vocalist with a sputtering career, who stays with the family for several years.

The literary source on which the movie is based has an interesting back story: it is Toole's first novel, written in 1954 when he was sixteen. Toole once described the novel as "a grim, adolescent, sociological attack upon the hatreds caused by the various religions in the South. The fundamentalist mentality is one of the roots of what was happening in Alabama." Toole did not think much of his creation—"the book was bad, but I sent it off a couple of times anyway."[16] The book was published only after the successful reception of his second novel, *A Confederacy of Dunces*. Toole, who committed suicide in 1969 and never saw the publication of either book, left his manuscripts under the control of his mother, Thelma.

In the novel, David learns of the religious, racial, social, and sexual bigotry in rural Mississippi, and he frames his ten strongest memories, one memory per chapter, while onboard a train, trying to escape the past. The tale comes to life when Aunt Mae moves in with David's working-class family in their small and provincial town. Not much happens to David in the course of the text; the only character that experiences life is Aunt Mae, who becomes David's mentor, surrogate mother, and confidante.

David does not get along with the other boys his own age. As director, Davies can obviously relate to the episodes in which the ultrasensitive, physically timid, emotionally introverted David is challenged by the more masculine boys, who slap him, beat him, and call him a "sissy." Unable to defend himself, the humiliated boy runs back home, seeking comfort and consolation from the women, his mother and aunt.

David's father, Frank, loses his factory job, and the family moves to an older house on a hill. The circumstances get worse and worse: when the family runs out of money, the frustrated and angry Frank buys seeds. When his wife argues that crops cannot grow in the clay of the hill soil, he hits her, knocking out one of her teeth. The family sighs with relief when Frank is shipped to Italy to fight in World War II.

A "revival" ministry that visits the town warns the residents that popular dancing is "immoral." But the local preacher opposes this incursion and begins a rival Bible study class. Placing editorials in the papers and spots on the radio, each side attacks the other.

At one point, Aunt Mae becomes involved with a much older man, but her affair ends when the latter is arrested on morals charges. Aunt Mae takes a job as a supervisor in the local propeller factory, and at a company function, after entertaining the crowd, she gets an invitation to join the hired band as a singer.

David's mother descends from mental instability into outright insanity upon learning that Frank has been killed in Italy. David and Aunt Mae take care of her as Aunt Mae tries to pursue a singing career. At age fifteen, David gets a job at the pharmacy, where he meets Jo Lynne, a girl visiting her ill grandfather. After seeing a movie together, David and Jo Lynne begin to date. Clyde, a member of Aunt Mae's band who is in love with her, promises a record deal in Nashville, and she leaves, promising to send for David and his mother right away, which never happens.

In the last reel, when David realizes that his mother is missing, he begins searching for her in the yard, where she used to spend most of her time. He finds his mother bleeding, able to utter one last word—Frank—before expiring. From that point on, the tale becomes relentlessly downbeat. The local preacher insists on placing Sarah in an asylum, but Davis tries to stop him, and as the stubborn preacher climbs the stairs, he is shot dead. After burying his mother, David uses the remaining money to board a train, hoping to start a new life.

David's loose recollections make up the plot, such as it is, which stresses intense images and poetic touches over narrative momentum. Working with cinematographer Michael Coulter, Davies again creates sharply conceived, painterly compositions—but to little emotional effect. Music has always been one of Davies's strong suits and a staple of his features. In this picture, he makes evocative use of the Tara theme from *Gone with the Wind* and Glenn Miller's version of *Perfidia*, among others. In the course of the tale, Aunt Mae gets to sing gently, in a small, husky voice, versions of "My Romance" and "How Long Has This Been Going On?" Aunt Mae is a feisty and sexual lounge singer, dreaming of a bigger, more successful career

elsewhere. A woman who has lived a rich life, she represents the outside world to David's limited existence. Once David meets her, his life is forever changed.

Only a few reviewers were impressed by Davies's poetic approach and the dreamlike, hallucinatory quality of the narrative. However, most critics were frustrated by the text's slow pacing, elliptical style, and recurrent imagery of a sad, lonely boy sitting in a railroad car with a huge moon looming over his head.

What the movie lacks in dramatic thrust is only partially made up for in momentary glimpses of insight and imagery. In *The Neon Bible*, Davies applies his customary pictorial vocabulary and poetic structure to a new territory. Occasionally, his storytelling is composed of images that bear some mystical resonance. For instance, the nocturnal revival meeting and a few other scenes suggest the paintings of Edward Hopper or Thomas Hart Benton. But historical authenticity is beside the point for Davies, and scenes of an evangelical tent show and a Ku Klux Klan meeting seem secondhand and peripheral.

Davies's vision of the American South lacks the touching lyrical moments of his British stories. *The Neon Bible* is sharply uneven: some domestic scenes are portrayed with acute detail, but others, like the murder of the preacher and the funeral scene, are reduced to a few impressionistic images.

Arguably more than most directors, Davies knows how to convey a sense of nostalgia without sentimentalism. The entire film is a flashback, and the studied pacing and unrelenting downward mood never really allow viewers to forget that fact. *The Neon Bible* seldom manages to shake out of the dull funk that daydreaming creates. The end of the story takes a violent turn, upsetting viewers with its unexpected bloodshed. The conclusion, out of step with the film's otherwise dreamy mood, is deliberately jarring.

Additionally, Davies was not careful in casting his leads. The two boys who play David are not expressive enough, and as played by Diana Scarwid, David's mother, Sarah, comes across as one-dimensional—a frail, hysterical woman. Fortunately, the movie boasts a strong performance by Gena Rowlands as a woman who adores the spotlight—her hot red and purple dresses raise eyebrows among the Bible-thumping local farmers.

The Neon Bible is not a significant work—compared to the British masterpieces that preceded it and the personal memoir that followed. The film was poorly received—with mostly negative or indifferent reviews—at its world premiere at the Cannes Film Festival. Released by Strand, it failed to register with critics or viewers; shown only in big cities, it grossed a dismal figure ($78,072) in its initial run. And it did not do much for Gena Rowlands after the death of her brilliant husband director, John Cassavetes, with whom she made some seminal movies (The 1974 *A Woman Under the Influence* is my favorite).

Critics complained about the slow, lingering shots, which are meant to provide insightful meditation but instead emphasized even more the film's inherent dramatic shortcomings. Others found fault with the elliptical style, which underscored the film's slender narrative and lack of continuity. Critic Stephen Holden suggested that the film "may have succumbed to its own dreamy esthetic" by focusing on the same image too often.[17] Another critic noted poignantly that the film "starts off dark and gets darker," unfolding as "one long crawl into an emotional abyss without catharsis."[18] Indeed, the plot is not only weak but also marred by an absurdly hopeful ending that throws the whole tale out of balance.

Artists are often wrong in assessing the merits of their work, but in this case, Davies was right on target when he told *Time Out*: "*The Neon Bible* doesn't work, and that's entirely my fault. The only thing I can say is that it's a transition work. And I couldn't have done *The House of Mirth* without it."[19]

<p style="text-align:center">＊ ＊ ＊</p>

Adapted for the screen from Edith Wharton's beloved 1905 novel, *The House of Mirth* is a much stronger film than *The Neon Bible*. It is also more satisfying than *The Age of Innocence*, Martin Scorsese's 1993 version of Wharton's other famous book. Davies treats this novel of mores and manners, the author's first important fiction, with respect but not slavish reverence.

Viewers expecting a middlebrow Merchant-Ivory production (*A Room with a View*, *Howards End*) or a film in the style of *Masterpiece Theatre* were disappointed with Davies's version. As one critic wrote:

"The masterpiece's tasteful reserve—the aesthetic that allows the comfy feeling that the plight of characters in corsets and cummerbunds has little to do with our own—remains in aptly short supply."[20] Davies also refrains from the excessive voice-over narration that marred Scorsese's *Age of Innocence*, an overstylized feature to begin with that was made even more detached by the mediated narrator (Joanne Woodward).

Wharton's working title for the book was *The Year of the Rose*. The final title derives from Ecclesiastes 7:4: "The heart of the wise is in the house of mourning, but the heart of fools is in the house of mirth." Set against the backdrop of New York in the 1890s, the text places its tragic heroine, Lily Bart, in a society described as a "hot-house of traditions and conventions." Upon publication, the *New York Times* review hailed the book as "a novel of remarkable power whose varied elements are harmoniously blended."[21]

Davies's 2000 version was not the first stage or screen presentation of the book. In 1906, *The House of Mirth* was adapted to the stage by Wharton herself and Clyde Fitch. In 1918, there was a silent film adaptation, *The House of Mirth* (*La maison du brouillard*), made by French director Albert Capellani and starring Katherine Harris Barrymore; it's considered to be lost.[22]

The House of Mirth is Davies's most accessible and commercial film to date (grossing about $2 million in the United States), largely due to its casting. The ensemble is headed by Gillian Anderson (of TV's *The X-Files* fame), Laura Linney, Dan Aykroyd, and Eric Stoltz, all estimable actors, but not necessarily associated with mainstream Hollywood. Though based on a prestigious literary source, Davies (who also wrote the screenplay) has made a personal work that bears testimony to his distinctive theme, visual style, poetic languor, and grace. He builds a mood of omniscient dread with a claustrophobic mise-en-scène. The period recreation is meticulous, but Davies's adaptation is so precise and his strategy so austere that the film's critique also becomes applicable to the present. The film, like the novel, indicts the morals and mores of New York's social elite through the grueling tale of a fragile woman who becomes a victim of social prejudice and self-inflicted shame.

Lily Bart (Anderson)—like Hester Collyer, Davies's heroine of *The Deep Blue Sea*—is a fallen woman who goes down the social ladder. However, *The House of Mirth* is darker in tone and closure. Initially, Lily is of good standing, even holding some power—she rejects an offer of advantageous marriage. However, torn between her desire for a luxurious existence and a life based on mutual respect and love, Lily ultimately sabotages her chances for marriage. In the end, she loses the esteem and support of her social circle, dying young, poor, and alone.

The story opens as Lily meets Lawrence Selden (Stoltz), a bachelor lawyer she is attracted to but cannot marry because he is not wealthy enough. Her social status begins to erode when Gus Trenor (Aykroyd), the husband of her friend Judy, gives her a large sum of money, and she innocently thinks it is a rewarding return on investments made for her. But transaction and mysterious visit to Gus have damaging effects on Lily's standing.

To escape vicious gossip, Lily joins Bertha Dorset (Linney) and her husband, George, on a European cruise aboard their yacht, the *Sabrina*. During the trip, Bertha accuses Lily of adultery with George in order to shift attention from her own infidelity with the poet Ned Silverton. The ensuing scandal ruins Lily, her friends abandon her, and her Aunt Peniston disinherits her. Descending the social ladder, she works as a personal secretary until Bertha sabotages her position by turning her employers against her. She then takes a job in millinery, but her poor performance leads to termination.

Simon Rosedale, a Jewish suitor who had proposed when Lily was younger and more reputable, comes back. But she perceives his offer as a form of blackmail—he plans to use letters revealing Bertha's affair, thus forcing Lily to burn them. Eventually, she receives her inheritance and pays her debt to Trenor. However, she has become addicted to drugs and dies from an overdose of sleeping pills. Ironically, Selden, the passive-aggressive lawyer who despite relative poverty is the only man she has loved, gains greater intimacy with Lily when she is dead than when she was alive.

What attracted Davies to the book was its structure and heroine: *The House of Mirth* is a tragic melodrama about how materialistic concerns can—and do—damage a frail woman physically and mentally.

Lily is an aging society bachelorette, an ambivalent gold digger whom Wharton describes as "a figure to arrest even the suburban traveler rushing to his last train."[23] Like others in her milieu, Lily becomes addicted to the trappings of the upper class, but in order to attain them, she is dependent on the kindness of her old aunt—at least until she gets married. Perceiving herself as a commodity, she tries to sell herself to the highest bidder, but most of the available men whom she encounters are either bullies or adulterers.

Wharton's narrative, which is replete with satiric details and psychological insights, chronicles the narrowing options of a woman who has never had many opportunities to begin with. The heroine's longings make her unavailable to "men of substance" who would provide her status and fortune. And at the same time, she is vulnerable to humiliation by her rivals. Landing in debt, Lily begins her downfall, a process that continues until her demise.

A martyred woman, Lily personifies the tension between materialistic obsessions and moral principles. She's a modern woman who "wants it all"—love and money—but on her own terms and with society's approval. As a character, she belongs to the same universe as the titular heroines in James Cain's *Mildred Pierce* and Henry James's *Daisy Kenyon*, famous novels made into classic women's pictures of the 1940s—both, incidentally, starring Joan Crawford at her prime.[24]

Some critics complained that Anderson was not beautiful or refined enough to play the heroine. However, in his film, Davies underemphasizes Lily's charisma in order to show her as an outsider, a woman whose allure isn't sufficient to disguise her lack of social status. She is driven by the impossible ambition to blend in, to become part of the social fabric. Davies said that he cast Anderson because he could imagine her as the subject of a John Singer Sargent painting. In his interpretation, Lily appears to be both magnetic and indistinguishable from her surroundings. Complicit in marketing herself as a commodity, Lily passes her expiration date and ends up, as she puts it, "on the rubbish heap," dying devastatingly heartbroken.

In conveying Lily's slow disintegration, Anderson relies more on body language and expressive gestures than on verbal dialogue. We observe her shifting from seductiveness to desperation and finally to resignation. She renders a commendable performance as

a vulnerable femme, highly aware that one false move, one wrong word, can damage her reputation and affect her already uncertain future. Perpetually insecure and never comfortable in any position or social interaction, she illustrates Selden's description of Lily as "a woman who has it in her to be whatever she believed to be."

Uncharacteristic of Davies's other works, *The House of Mirth* presents the story in a seamless linear way. He said he saw his goal as making a movie whose watching would be akin to reading Wharton's novel, cover to cover. In his adaptation, he approximates what an article in the *New York Times* predicted: "The discriminating reader who has completed the whole story in a protracted sitting or two must rise from it with the conviction that there are no parts of it which do not properly and essentially belong to the whole. Its descriptive passages have verity and charm, it has the saving grace of humor, its multitude of personages has the semblance of life."[25]

OF TIME AND THE CITY

It took Davies almost eight years to make another film, despite the critical praise for and success of *The House of Mirth*. In 2008, he completed his first documentary feature, *Of Time and the City*, which had its world premiere at the Cannes Film Festival to great critical acclaim. With its vintage newsreel footage, contemporary pop music, and wry narration by the director himself, the work is a bittersweet paean to Davies's hometown of Liverpool.

Davies described his richly textured work as a "Chant d'amour for all that has passed,"[26] borrowing, of course, from Jean Genet's notorious feature. Some critics felt that with this documentary, which reflects a uniquely poetic sensibility, the director had done for Liverpool what poet Dylan Thomas had done for Wales. An elegiac remembrance of life, it is a beautifully assembled collage of images linked by subjective narration. Part photo album, part confessional memoir, Davies's journey through his past reveals disappointment and anger, but it is not gloomy or bleak due to the witty and irreverent tone of his voice-over.

In *Of Time and the City*, Davies recreated the texture of his past by combining existing archival footage of Liverpool and the Merseyside

area with new footage he shot specifically for this nonfictional work. The blend of documentary footage, which is radiant and often shocking, and personal observations offers insights into the ever-changing city as well as the ever-changing artist himself. Suitably timed to coincide with Liverpool's year as European Capital of Culture, the film is a lyrical poem in which the director infuses his chanson d'amour with references to William Butler Yeats, James Joyce, Karl Marx and Friedrich Engels, Anton Chekhov, Carl Jung, A. E. Houseman, T. S. Eliot, and others.

Davies begins with a quote from Félicien de Myrbach: "If Liverpool did not exist, it would have to be invented." What follows is an intimate look at the process by which the city had transformed from the 1940s to the 1960s, during which time Davies came of age and began making movies; he left Liverpool in 1973. Though impressionistic, the portrait rings true. There's harrowing World War II footage as well as a report of the director's struggle with his homosexuality as a Catholic boy.

Davies's sharp tongue is revealed in his poignant commentary on the British upper class and the pompous monarchy, institutions that have existed—and continue to exist—at the expense of the working class, whose socioeconomic conditions have only worsened over the years. It's a concern shared by his contemporary compatriot Mike Leigh in several films—specifically, in *High Hopes*.

Davies is a few years younger than the Beatles, but they grew up in similar working-class milieus. Nonetheless, having suffered acute Catholic guilt over his homosexuality, he recalls a different history of British life than the Beatles' view of Liverpool and then swinging London expressed through their cheery songs. Showing disdain for the popular group, he greeted the ascension of the Fab Four with a sarcastic rendition of "yeah-yeah-yeah-yeah." Later on, he also lamented the decline of the "witty lyric and well-crafted love song," reiterating his admiration for classical music and poetry.

Satirizing Liverpool's aspirations, Davies dwells on his hometown's pretentious official architecture, including the imposing cathedrals. He shows the city's past through the grandeur of its imperial buildings, depicting how municipal and religious institutions have turned into chic restaurants and parking lots. Switching to contemporary

images of the presumably rejuvenated city, he asks, "Where are you, the Liverpool I loved?"

Davies's culturally informed narration includes quotes, poetry readings, personal memories, segments from radio plays, and carefully chosen songs, such as The Spinners' "Dirty Old Town." His commentary is in the same magisterial vein, though with savage and often camp and bitchy wit. In many passages, he adopts a mocking tone, but there are also touches of nostalgia, although without tears.

In one of the most revealing chapters, he shows the new slums. The camera pans across miserable housing and filthy cement halls, images that are accompanied by Peggy Lee's rendition of the saccharine "The Folks Who Live on the Hill." In another contrast, troops embarking for the Korean War, reflecting stark and harsh reality, are projected to the sound of the sentimental "He Ain't Heavy, He's My Brother." Davies concludes a tour of failed urban development by citing "the British genius for making 'the dismal,'" which he perceives as a national characteristic.

The imagery reveals a tough, working-class, heavily Irish (Protestant and Catholic) port city dominated by railways and factories. There are rows and rows of dingy terrace houses—and steps that are scrubbed daily by the women who live there. In Davies's neighborhood, old and young interacted, with children playing skipping songs and games on the streets, which were extensions of their small homes, populated by large families: "So much of our life as children was lived on the street. It's utterly different today—the street life is gone." While the women work in a communal laundry, wringing and mangling, the men are laboring to lay cables in tunnels. Davies doesn't let his audience forget the hard labor of his parents and grandparents. He describes the narrow cobblestone streets where lower-class families lived in row-house terraces and in decaying brick tenements and their children played in squalid, rubble-filled lots. The narration doesn't follow a linear course but goes back and forth in time, contrasting the old and the new Liverpool. Davies's only bitter and angry work, *Of Time and the City* reveals deep ambivalence and ambiguity: He is unable to decide whether he wants to remember or to forget elements of his past. On the soundtrack, he reads in wry, melancholy voice his own poetry as well as quotes from great

writers like Chekhov, Joyce, and Eliot. There are also recordings of fragmented ordinary voices, traces of old radio shows, and a wide selection of music ranging from Peggy Lee and the Hollies to George Frideric Handel and Gustav Mahler. Davies observes the ecstasy of attending big Hollywood musicals in dark movie houses and his adolescent fascination with and erotic desire for masculine professional wrestlers. The feature evokes his growing up as a working-class, Catholic, movie-obsessed, gay lad.

Davies has fashioned a melancholy love letter to the city that had shaped him—but that he had to leave. *Of Time and the City* takes an ugly reality and turns it into sublime poetry, resulting in a work that's much more poignant than just an aggregate of memories and stark facts of urban life in decline. He notes that in constructing the documentary, the images preceded the text: "I wrote the commentary as the images unfolded, while I was cutting the film. At times, silence was sufficient."[27] At first, the producers didn't want him to narrate, asking him to find a more famous commentator, but as he recalled, "I wanted to narrate my own poetry and T. S. Eliot, and I did the narration in one day."[28] Among the extracts used are tracking shots of street life from the documentary *Morning in the Streets*, a work he would have shot in the same manner.

Though Davies is not a political director, the film attacks sacred institutions: the monarchy, the government, and, above all, the church. He told *Cineaste*: "I am an intense Republican, and I see the monarchy as callously living off the people's money."[29] He may be one of the few British artists to show public scorn for the royal coronation, described by him as "the start of the Betty Windsor Show."

The government also comes under sharp criticism:

People were misled that the council estates were going to improve their lives and that a New Jerusalem was going to arise. But they were built shoddily. They were slums in the making, despite the government's commitment to improve lives. The government had the illusion that they could create a community instantly. The old neighborhoods of terrace houses took generations to evolve. With the destruction of the old neighborhoods, the country began to socially and culturally implode, accelerated by Thatcher's pernicious reign.[30]

Davies vents his frustration and antipathy toward the public-housing towers that promised a paradise to the working class but turned out to be new versions of slums. The homogenized buildings—beer cans in the elevator, graffiti in the halls, cracks in the pavement—emanate despair and desolation, the antiparadise.

As noted, a main target is the Catholic Church—the center of Davies's life as a boy. He recalls deviant priests and corrupt officials who were never punished, and yet gay men were persecuted and imprisoned. That left its mark on a boy who knew he was gay. He was so eager for grace that he could never confess his homosexuality to the priest. He now feels that it was all "one big lie," that he wasted years in prayer. He views organized religion as an unforgiving institution: "The church did me a great deal of damage. For somebody like me who discovered at puberty that I was gay—it was then a criminal offense in Britain—the church offered no succor. I felt then that if I prayed and was really good, God would make me like everybody else. Those years when I prayed until my knees bled were awful. I finally realized the priests were just men in frocks, and I dropped the church when I was twenty-two. It left a deep emotional hole in me, a sense of chaos."[31]

Even though the church gave Davies a taste for pageantry and the fleeting joy of observing spectacle, it also scarred him deeply with its strictures, particularly regarding his homosexuality. It was the discovery of cinema and music that enabled him to build an alternative world and to become a first-rate artist. All of his work celebrates the joys, the pains, and the miseries of working-class life in images that are at once tender and harsh, emotional and scathing, indignant and hopeful, and tremulous with yearning and desire.

The emerging portrait is subjective: "The Liverpool I knew has disappeared. I've recreated a city that is no longer there. The last cinema in my old neighborhood, the Odeon, has been pulled down. The city is now a mythical city for me because memory is myth." The film is about time and mortality: "I find some of the aged people in the film heartbreaking, like the old woman who lived a hard life but says God has been good to her."[32] Significantly, the only people who are heard speaking in the film are older women.

Davies remembers a Liverpool where soccer matches attracted huge crowds and Orange Parade marchers howled against Papists.

There were also simpler pleasures like funfairs and trips to the beach at New Brighton with its bathing-beauty contests, deck chairs, and dancing. And there were the movies that he attended regularly, especially the Hollywood musicals that he loved and "swallowed whole."

Davies said: "Returning to funerals and walking around the city made me feel how alien I had become. Liverpool is filled with memories, but much of what I remember has been pulled down."[33] He has no illusions about the past, but he is turned off by the modern Liverpool. His boyhood world was admittedly rough and constricted, but as bad as it was, there was joy to be had in family and community. In contrast, the new Liverpool has demolished its history and semblance of communal life. Now, it's a city whose old churches have been turned into discotheques, whose promenades are empty of people. Much of the new construction consists of sterile office buildings and parking garages.

Like all of his work, *Of Time and the City* is a film about memory and the passage of time. Davies's awareness of his own aging and mortality is manifest in the large number of shots of old people. In the ambivalent conclusion, fireworks accompany Davies's "Good night, good night, good night."

BACK TO THE WOMEN'S DOMAIN

Davies's *The Deep Blue Sea* is based on one of Terrence Rattigan's signature plays, about a sexually repressed woman fatally attracted to a younger World War II veteran. Despite strong reviews and a dominant performance from Rachel Weisz, the film received only limited theatrical release in the United States in the spring of 2012, after showing at the 2011 Toronto Film Festival.

This was the first play Davies adapted to the screen, and the result is his most obviously "British" film, though in terms of narrative and visual strategies, he has shaped it to his own specifications. The more he read Rattigan's play, the more engaged he became in its theme:

It's the story of a woman who leaves her husband William and her luxurious life for Freddie, the younger man with whom she has

fallen madly in love. It's the first time she's felt erotic love. Her marriage was about companionship with a kind man. After rereading the play, I realized that it was about love, which is the strangest of all human emotions. It's about how each character—Hester, her husband and Freddie—wants a different form of love from the person they're in love with, and how it can't be given. These are all heart-breaking themes.[34]

Davies makes a valiant attempt to modernize a play that is old-fashioned and middlebrow, even by the standards of London's West End and New York's Broadway. The film is meticulously directed with his characteristic style, beautifully acted by the performers who form the central triangle, and often touching. A major work in his canon, *The Deep Blue Sea* continues to explore the plight of love-starved, sexually repressed women, as manifest in the protagonists of *The Neon Bible* and *The House of Mirth*.

Most of Davies's films are set in post–World War II England, including his autobiographical works, *Distant Voices, Still Lives* and *The Long Day Closes*, not to mention his documentary, *Of Time and the City*. Both historically and dramatically, *The Deep Blue Sea* belongs to Davies's distinctive universe. The play takes place circa 1949–1950, when Davies was only four. However, that era, with its socioeconomic hardships and suffocating cultural mores, assumes a special importance for him, as he spent his youth growing up in working-class Liverpool a few years later.

With *The Deep Blue Sea*, Davies adapted a play by one of Britain's most famous (and most produced) playwrights. Born in 1911, Rattigan was a diplomat's son, educated in modern history at Oxford before embarking on a career as a playwright and screenwriter. Many of Rattigan's works have been made into films, such as *The Winslow Boy*, *The Browning Version* with Michael Redgrave, and the Oscar-nominated *Separate Tables*, for which Wendy Hiller won the Best Supporting Actress Oscar. Like other gay playwrights, Rattigan drew on his own life (he was in love with a younger man who killed himself) and wrote especially strong roles for women. In 1952, Frith Banbury directed *The Deep Blue Sea* on the London stage with Dame Peggy Ashcroft. Since then, the part of Hester Collyer has been played by

Vivien Leigh, Penelope Keith, and Blythe Danner, among others. And now the Oscar-winning Weisz essays the role of a judge's wife who becomes the abandoned lover of a drunken World War II pilot. Davies's film is the second screen version of his play, the first one being released in 1955.

In his play, Rattigan dissects the values of bourgeois morality— men's fear of commitment, women's sexual repression—and also the digressions and deviations from its restrictive codes, all of which are also recurring themes in Davies's own work. The story is told from Hester's POV, both in the present and in the past, the latter through carefully inserted flashbacks, one of which is set in 1940. As the opening credits roll down, the last words of Hester's suicide note to her lover, Freddie, are heard. The scars of World War II are everywhere to be seen. The setting is a badly blitzed neighborhood in London one Sunday evening. Derelict buildings stand next to seedy boarding houses, and a bomb site exists at the end of the street.

The boarding house landlady, Mrs. Elton, puts out her milk bottles for the night. Unbeknown to her, one of her tenants—Hester—is about to take her own life. Hester leaves a suicide note on the mantelpiece. Lying down in front of the fireplace, she turns on the gas and drifts into a state of unconsciousness. She recalls the warm, comfortable home she had shared with her husband, Sir William Collyer, a celebrated lawyer. She then remembers meeting Freddie Page, a handsome RAF pilot, on a visit to the Golf Club at Sunningdale. The moment Freddie touches her, she realizes she has fallen in love. Despite her conventional morality, they begin an adulterous affair, during which she becomes sexually fulfilled for the first time in her life.

Hester's reverie then stops abruptly. It is early on Monday morning, and some of the tenants in the boarding house have smelled gas coming from her flat. Mrs. Elton lets herself in with another tenant, Phillip Welch. Because the gas meter has run out, they attempt to revive Hester and send down for Mr. Miller, a tenant on the floor below. A mysterious figure who possesses medical knowledge, Mr. Miller will not admit that he's a doctor. He forces Hester to vomit up the aspirin she has taken. She recovers but asks that they not tell Freddie about her "accident." She then takes the suicide note and puts it into her gown.

With a cigarette in her mouth, she continues to remember the past. She recalls her father, a stern Anglican vicar, reproaching her and advising that she go back to her husband. She then remembers a weekend at her mother-in-law's house. The monstrous Mrs. Collyer has little time for Hester and is wary of her daughter-in-law's passionate nature. When Mrs. Collyer overhears Hester talking on the phone with Freddie, Hester is forced to confess her infidelity. William tells Hester he never wants to see her again, and she moves into Freddie's grim apartment. To the landlady, and the rest of the outside world, the couple seems to be married.

Freddie hopes that Hester will make the flat "feel like home in no time." On Monday afternoon, Freddie breezes in from playing golf at Sunningdale. As charming and upbeat as ever, he tells Hester about a possible job in South America. He doesn't notice Hester's silence, but suddenly a penny drops, and he realizes that he had forgotten her birthday and the special meal she had prepared for the occasion. He apologizes, but clearly it's not something that is important to him.

When Hester relents, they kiss passionately, and Freddie's casual cruelty is forgotten. While he is looking for some cigarettes in her gown, he finds the suicide note. Appalled, he leaves the flat in a fury. As she hurries to follow him, she runs into her estranged husband on the landing. Mrs. Elton, worried about her, had contacted William without telling Hester. It is the first time William has seen Hester since she had left him, and she invites him into the flat. Though he is angry with her, he is deeply concerned, wondering what could have driven her to suicide. She explains that it's not money or that Freddie has been unfaithful to her. Rather, she feels ashamed of her position as a woman driven by desire for a man who doesn't love her—or even care for her.

At night, Hester finds Freddie in a local pub where he has been drinking with his old RAF friend, Jackie Jackson. Outside the pub, the lovers quarrel—he is tired of her manipulative ways and needy sensuality. She pleads with him to come home, but he tells her that the relationship is over. He then tosses her a coin for the gas meter, just in case he's late for dinner again. Hester muses on her past with Freddie. A row at an art gallery indicates how little he is interested in the cultured world that she had previously enjoyed. But she remembers

the pleasure of being with him in the pub singing with his friends and the intense feelings when they danced together. In those romantic and sensual moments, she feels that her new life is more rewarding, perhaps even justifying the sacrifice of her old and secure lifestyle.

Hester calls Freddie from a public phone, asking him to come home and collect his things. She just wants to see him one more time, but he hangs up the phone on her. Deeply wounded, Hester goes down into the tube station and stands in agony on the edge of the platform. Is she about to follow the fate of other doomed adulteresses, such as Anna Karenina, played with great panache by Greta Garbo in 1935 and Vivien Leigh in 1948?

As the train approaches, causing her hair to flow sensually, Hester continues to remember the past. She recalls being in a crowded tube station during the war, where people took cover from the Blitz. Faced with the memory of many people wishing to preserve their lives, she wonders whether she really wants to extinguish her own. The train passes by and she decides to go home. Outside the boarding house, William is waiting, again concerned about her. He offers a new chapter with him, but she refuses—she can never go back to him or to her old life.

As Hester enters the house, she watches Mrs. Elton tenderly soothing her dying husband. In the dark room, Mrs. Elton tells her what true love is: "Wiping someone's arse, and changing the sheets after they've wet themselves, but never letting them lose their dignity, so that you can both go on." When Freddie tells Hester that he is taking the job in South America, she begs him to stay for one more night; she can't bear being alone. The next morning she helps him get his things ready. Neither can bear to let the other go but won't ask the other to stay. Freddie walks out, and Hester finally summons the courage to let him go. She goes to the gas fire and ignites it. But this time, having decided to live, she opens the curtains and faces a new life, alone. Like Aunt Mae and Lily Bart, Hester is liberated and then destroyed by sexual desire, but unlike them, she is liberated again, this time around from her own chains, her dependency on men for self-identity.

Titles of films are crucial to Davies' work. The expression "between the devil and the deep blue sea" connotes ambiguity, a dilemma caused by the need to choose between two undesirable situations.

It was originally a nautical reference citing the deep blue sea and a "devil"—a seam where two hull planks meet that is difficult to reach on a ship. For the director, the story of a woman who risks everything for the man she desires is a painfully uncompromising chronicle of the fear of loneliness and the frustratingly unreliable nature of love.

Rattigan is an expert in exposing British insecurities and hypocrisies about sex and class, and *The Deep Blue Sea* is one of his finest achievements. However, in Davies's hands, Rattigan's story, in which the playwright explored how the idea of love is inexplicable in terms of logic, becomes more than a love triangle: It is a personal dilemma that also reflects the collective state of the nation in the early 1950s. Britain is "Great" no longer, bankrupt as an economy, exhausted as a culture, and spent as a world power. It is a time of rationing and privation where luxury and indulgence, like Hester's former life, amount to a prewar memory. Hester's struggle for fulfillment is a rallying cry for personal freedom, particularly for women, reflecting the social and cultural transitions that were ushered in by World War II and that would result in real changes of sexual politics in the 1960s.

The movie depicts the desperate struggle of ordinary British folks trying to rebuild their lives and their society after the war. In the process, they have to come to terms with the decline of the British Empire, a thematic motif in the work of John Osborne, Arnold Wesker, Tony Richardson, Lindsay Anderson, John Schlesinger, and others involved in the new British theater and cinema of the late 1950s and early 1960s.

Davies does justice to a text that shares a common thread that runs throughout his work, exploring women's positions in Britain's oppressive society after World War II. *Distant Voices, Still Lives* is also a painful and devastating film about women's positions in the 1950s. But in *The Deep Blue Sea*, the director has filtered the story through Hester's POV, stripping away a lot of exposition to get to the heart of the story. As a result, the movie feels bigger and deeper than just another love triangle, with something to say about a nation climbing out of the rubble of war. All the characters are shaped or damaged by the war. By removing the extraneous characters, the film is like a symbolist story about individual freedom and sexual fulfillment.

Like Haynes, Davies holds that the great melodramas of the 1940s and 1950s, once dismissed as "merely women's pictures," should

be regarded as serious works of art, as collective articulations of women's desires. However, unlike Haynes, who's inspired by Douglas Sirk and pays tribute to him, Davies is an original director who does not imitate or pay homage to any artist. Instead, he imbues texts of "women's films" with his own idiosyncratic style, as he once elaborated: "If you didn't grow up in the 1950s, you have no idea how shocking it was for a woman like Hester to do what she did. She does something very courageous and bohemian. Hester gives up someone who loves her because she's found erotic love. For me, the idea of doing something because you're in the thrall of an emotion you can't control, that's timeless."[35]

That said, Davies is uncomfortable with graphic depictions of sex. This movie is the first and only work in which he shot explicit sexual encounters between Hester and Freddie, though he presents them as a montage of still images, failing to convey the sexual passion that drives the couple. This weakness has led critic David Denby to poignantly observe: "Sex is the subject of everything that happens, yet this may be one of the least erotic movies ever made."[36]

Davies does not impose any moral judgments on his screen persona. "I wanted to show sympathy for all the characters, even though they do things that could be judged wrong or hurtful. We see several different characters—it's kind of a microcosm of what Britain was like then—and I wanted to make them all human because as soon as you give them humanity, you can accept their good and bad points."[37] Mrs. Elton cares for her husband, and Mr. Miller is brusque, but he's also tender and offers help. They are all needy people but they've all got their different kinds of courage. The film is about "the nature of love, the nature of guilt, the nature of behaving honorably even if it hurts someone else."[38]

As shown, the nature of time is one of Davies's recurrent obsessions: "I love moving in and out of linear time, because there's something thrilling about doing that."[39] Opening up the story to the wider canvas of film presented challenges, but it also gave the director an opportunity to explore a different way of telling the story. "Cinema and theatre are different. Cinema can reveal things," he said. "And if you can reveal things, then there's no need to talk about it. But you can also show the ambiguities that arise between the cuts. You

can dissolve and the audience knows it's time past or time forward. You can play around with the linear story and the remembered story, which influences the narrative. I love that idea of people being in reverie, thinking of the past and how it affects their present."[40]

The film's stylistic touches recall a seminal film from the 1940s, David Lean's *Brief Encounter*. In *The Deep Blue Sea*, Davies pays homage both to Lean's classic and to other admired "women's films," such as *Letter from an Unknown Woman*, *Now Voyager*, *The Heiress*, and *All That Heaven Allows*. *Brief Encounter*, produced in the year Davies was born, has haunted him for decades. Both Lean's film and *The Deep Blue Sea* are about conventional women torn between the fulfillment of desire and the oppression of convention. Like *Brief Encounter*, *The Deep Blue Sea* is a subjective narrative, filtered through Hester's consciousness. Like Celia Johnson's Laura in *Brief Encounter*, Hester articulates her feelings to the audience in voice-over, which draws a real sense of intimacy[41]

Shot by cinematographer Florian Hoffmeister, *The Deep Blue Sea* displays meticulously crafted lighting. There are impressive tracking shots, such as the one of an underground station during the Blitz. The film's remarkable pans indicate precisely the shifting space and the changing proximity between Hester and her lover. The rigorous art design, the careful contrast of lights and shadows, and the evocative music are all devices that heighten the portrait of Hester as she transforms, leaving behind her initial vulnerability, pain, anguish, and humiliation and ultimately gaining greater self-consciousness and coming into her own as a woman. This is conveyed in Davies's signature style of long, masterfully constructed takes, which place viewers inside the minds and souls of his characters.

Davies's work resonates with moody music that comments on the characters and their actions. For this film, he chose a heartbreaking soundtrack, Samuel Barber's *The Violin Concerto* to articulate the depth of Hester's dilemma, much in the same way that Rachmaninoff's *Piano Concerto No. 2* articulates Laura's emotional crisis in *Brief Encounter*. Moreover, the director chose to stage Hester's second suicide attempt at the underground station because the scene recalls Laura's suicidal thoughts at Milford Junction. As dramatic characters, both women are in crisis, provoked to consider extreme acts.

As he does in *The Long Day Closes*, Davies employs popular music and pub sing-alongs to depict the era's specific mood. The songs place the story in a particular historical moment and also add commentary on the characters. Jo Stafford's "You Belong to Me," a popular love song, expresses Hester's needy, suffocating love of Freddie. The traditional folk song "Molly Malone," about the life and death of a passionate woman, which is sung during an air raid also comments on Hester's state of mind.

* * *

I began this chapter by stating that Davies is Britain's greatest living filmmaker, and I would like to conclude by offering my reasoning. Mike Leigh, his contemporary and competitor for the title (in the positive sense of the term) has been more prolific and more accessible.[42] Like Davies, he has premiered most of his features at the Cannes Film Festival, where *Secrets & Lies*, one of his two or three masterpieces, won the 1996 Palme d'Or, before scoring five Oscar nominations, though no awards. He was later nominated for the Best Director Oscar for *Vera Drake*, his chronicle of the cheery and innocent abortionist, splendidly played by Imelda Staunton.

Nonetheless, Leigh hails from television, and he is known for the long, collaborative process in which he writes his screenplays with his actors. The resulting features are very much character-driven and thus highly dependent on the particular actors involved. He has worked with such established talents as David Thewlis in *Naked*, Brenda Blethyn in *Secrets & Lies*, Jim Broadbent in several features, Sally Hawkings in *Happy Go Lucky*, and so on. In contrast, Davies does not work in such a collaborative way, and his best British features don't boast recognizable stars, his American adaptations notwithstanding. Perhaps most significant is the fact that you can see (and enjoy) Leigh's work as stage productions or teleplays, but you can't see Davies's work performed on stage due to his full use of the unique properties of film qua film.

Davies's signature, including his distinctive visual style, is manifest in all of his features, regardless of their source material, cast, and director of cinematography. In fact, unlike Leigh, who has collaborated consistently with Dick Pope, Davies has teamed with four

different cinematographers, and yet his features have a remarkably similar look. *Distant Voices, Still Lives* was shot by William Diver (first part) and Patrick Duval (second part), whereas *The Long Day Closes* was photographed by Michael Coutler.

Of the directors in this book, Davies is the most subjective, a single-theme filmmaker devoting his features and documentaries to one subject: his own life. Though he has not acknowledged the influence of Marcel Proust, in terms of subjectivity and remembrance of things past, Proust's philosophy is evident in his work. The passage of time plays a profound role in all of Davies's films: "We are at the mercy of time. In my films, I try to create a sense of the randomness of time remembered by moving from emotional moment to emotional moment, instead of depicting in a linear fashion what literally happened."[43]

Thematically, the scope of Davies's films may be limited, but their texture is richly detailed and their visual and aural strategies precise, elevating his oeuvre to the realm of pure art. Rigorously crafted, his films channel every element—images and sounds—through his subjective memory, one that's inevitably shaped by the collective memory. You could say that he is using Liverpool not only as a historical setting but also as a sound stage (literally and figuratively) for his art. In each work, Davies has shown unfailing faith in the power of film as a personal and redemptive art as well as a broader form of entertainment.

TERENCE DAVIES FILMOGRAPHY

1976	*Children* (short)
1980	*Madonna and Child* (short)
1983	*Death and Transfiguration* (short)
1984	*The Terence Davies Trilogy* (collection of the three shorts)
1988	*Distant Voices, Still Lives*
1992	*The Long Day Closes*
1995	*The Neon Bible*
2000	*The House of Mirth*
2008	*Of Time and the City*
2011	*The Deep Blue Sea 2015 Sunset Song*

3

TODD HAYNES

Deconstructive Queer Cinema

TODD HAYNES, a quintessentially independent and experimental filmmaker, is best known for his provocative short *Superstar: The Karen Carpenter Story* and several postmodern, deconstructive features, such as the 1991 Sundance Grand Jury Prize winner, *Poison*, and the 2002 Oscar-nominated *Far from Heaven*. In 2011, he made the HBO miniseries *Mildred Pierce*, based on James M. Cain's novel, which inspired the classic 1945 film noir, and his latest film, Card, will bow soon.

Over the past three decades, Haynes has made provocative films about various forms of deviance, explorations in theoretically informed gay and queer cinema. His transgressive works subvert the narrative structure and viewers' expectations that define classic Hollywood cinema. Half of his output deconstructs the role of the middle-class housewife, played in two of his best films, *Safe* and *Far from Heaven*, by the estimable Julianne Moore. The critically acclaimed *Safe*, from 1995, is a portrait of a San Fernando Valley housewife who develops unbearable allergies to her physical and emotional state, conditioned by stifling suburban existence and rigid patriarchy.

Haynes's work is influenced by postmodernist structuralism, along with elements of feminist and queer theories. Like other postmodern filmmakers, he has deliberately problematized viewers' expectations, exploring the relationship between formal experimentation

and spectators' perceptions. He hopes that his audiences, both while watching his films and beyond the immediate viewing experience, question their own orientation toward issues of storytelling and characterization.

Haynes perceives human sexuality as socially and culturally constructed and identity formation as a fluid and dynamic process. The protagonists of his films are social outcasts whose "subversive" identity and "abnormal" sexuality place them at odds with society's dominant norms. In his universe, sexuality is a major, dangerous force that can potentially disrupt social order and cultural values. As a result, it is repressed by the hegemonic ideology of the ruling class. Artists and writers, especially gay ones, are for the director the ultimate subversive groups because they often stand "outside" of conventional norms. Their rebellious creativity represents great opportunities for both personal liberation and broader cultural changes. Thus, several of his films have revolved around artists and musicians, such as the singer Karen Carpenter in *Superstar*, the David Bowie–inspired character in *Velvet Goldmine*, and the multifaceted Bob Dylan in *I'm Not There*.

Haynes's films display formally complex narratives that challenge normative notions of identity, sexuality, and lifestyle. He aims to show the artifice of the filmmaking process—but without denying the strong emotional power of the medium itself. Stylistically, Haynes favors formalism over naturalism, innovation over convention. For example, he used Barbie dolls instead of real actors in *Superstar*, and he cast multiple actors to portray different facets of his sole protagonist, Bob Dylan, in *I'm Not There*.

Each of Haynes's films represents a new challenge that calls for different narrative and visual strategy. He employed the documentary or semidocumentary format in *Poison* and *I'm Not There*. But when the material allows, as in *Far from Heaven*, he has borrowed (and reinvented) the glossy style of Douglas Sirk's 1950s melodramas—specifically, *All That Heaven Allows* and *Imitation of Life*.

EARLY LIFE AND CAREER BEGINNING

Born on January 2, 1961, in Los Angeles, Haynes grew up in the suburb of Encino. His father, Allen E. Haynes, was a cosmetics importer,

and his mother, Sherry (Semler) Lynne, studied acting; she makes a cameo appearance in *I'm Not There*. Like Gus Van Sant, Haynes is openly gay, and also like Van Sant, he has been living in Portland, Oregon, after spending over a decade in New York City.

Showing interest in film at an early age, Haynes produced a short, *The Suicide*, in 1978, while still in high school. He credits a particular teacher for introducing him to American avant-garde movies and for influencing his notion of filmmaking as artifice: "In high school I had a teacher named Chris Adam, who had studied with Beverle Houston at USC, and that was really important to her way of thinking about film. Chris showed a lot of experimental films in her classes. We saw James Benning, Stan Brakhage, Ken Jacobs, Dem Watermelons, even the trash classics."[1]

Haynes studied at Brown University, where in 1985 he directed his first professional short, *Assassins: A Film Concerning Rimbaud*, inspired by the nineteenth-century gay French poet Arthur Rimbaud. He would again reference Rimbaud in *Poison* and in his feature *I'm Not There*. After graduating from Brown with a BA degree in Arts and Semiotics, he moved to New York City and became involved in the independent film scene. With Barry Ellsworth and Christine Vachon, his classmate at Brown, he launched Apparatus Productions, a nonprofit organization aimed at helping to fund filmmakers of shorts who would not be competitive enough to obtain grants through the usual channels. As he recalled: "We wanted to preserve the form of short filmmaking, and make it something really exciting that wasn't just a stepping stone for feature filmmaking."[2] Serving as role model, he considers his shorts as valuable and independent works in their own right. He made his best-known short, *Superstar: The Karen Carpenter Story*, in 1987 while he was an MFA student at Bard College. The short depicts the American pop singer's struggle with anorexia and bulimia, dwelling in close-ups on Ipecac, the drug that she used to make herself vomit. Carpenter's chronic weight loss is portrayed by using a "Karen" Barbie doll with the face and body whittled away with a knife. The film also contains a controversial dream sequence in which Karen, in a state of deteriorating health, imagines being spanked by her father.

The audacity of this forty-three-minute piece stems from its innovative concept and inspired casting. The late anorexic singer; her

brother, Richard; and their overbearing parents are all portrayed as Barbie-type dolls. In this short (and several features), Haynes's target is what is pejoratively known as "The Disease-of-the-Week Teleplay." He replaces the devices associated with this lowbrow format with more inventive ones, such as intertitles, voice-over narration, and insertions of documentary footage. *Superstar* makes extensive use of Carpenter songs, showcasing Haynes's love of popular music, which would be a recurring element of two later films, *Velvet Goldmine* and *I'm Not There*.

The subversive strategy of *Superstar*—telling the story of a pop group with plastic dolls—contains elements of camp, some of which are intentional while others are not. The tale unfolds in a rather straightforward manner, but Haynes challenges audiences' customary need to sympathize or at least empathize with Karen's battle with anorexia. At first, *Superstar* may elicit laughter at, or even contempt for, Karen, making us feel superior to her, but gradually we begin to feel for her. A shrewd filmmaker, Haynes knows that if the telling is sincere and effective, viewers will identify even with plastic dolls.[3]

However, Haynes failed to obtain licensing for the music, prompting a lawsuit for copyright infringement from Richard Carpenter, who was offended by Haynes's unflattering portrait of him as a narcissistic bully, along with suggestions that he might be a closeted gay. Richard won the lawsuit, and subsequently *Superstar* was removed from public distribution. Nonetheless, bootlegged versions of the film continued to be circulated, and the short also sporadically turned up on YouTube. *Superstar* became an outlaw film, making Haynes an underground figure even before his controversial debut feature, *Poison*.

For a while, Haynes was involved with ACT-UP (AIDS Coalition to Unleash Power) and the ACT-UP art collective, Gran Fury. Although he doesn't label himself as a gay filmmaker who makes explicitly gay films, his name has become synonymous with the New Queer Cinema.[4] He is a founding member of this early 1990s movement, whose goal was to explore the politics of gay representation and redefine new and distinctive gay subcultures. It's impossible to understand his work unless one places it in the context of the New Queer Cinema,

whose members also include producer Christine Vachon and directors Gus Van Sant, Gregg Araki, Tom Kalin, and Rose Troche.

In an attempt to be inclusive, mainstream Hollywood has held onto the naïve and self-serving belief that American society is a "melting pot." The strategy of dominant Hollywood during the Golden Age, as the scholars Doty and Smelik have observed, was to disregard gender, racial, and sexual distinctions in search of a common, unifying cultural denominator that would be acceptable to all—and offensive to none. Up to the 1980s, moviegoers seeking gay fare had limited options, watching mostly films made by the avant-garde, underground, and experimental filmmakers. But the climate has changed, as gay indie director Gregg Araki (*The Living End*) said: "There's a sense that the issues have become so charged that you have to take a stand one way or another. There's this new generation of queers, who feel that being gay is a very big part of their identity, and they are much more vocal and much more expressive about it."[5] Meanwhile, gay audiences began to express more aggressively their discontent, demanding wider and fairer treatment, but Hollywood did not care or dare.

That attitude began to change in the early 1990s, when the New Queer Cinema began to coalesce. The watershed years of the queer wave were 1991–1992, which saw the release in 1991 of Haynes's *Poison*, Van Sant's *My Own Private Idaho*, and Jennie Livingston's documentary *Paris Is Burning* and in 1992 of Kalin's *Swoon*, Christopher Munch's *The Hours and Times*, and Araki's *The Living End*. As a result, 1992 became known in the industry as the "gay year" of the nascent Sundance Film Festival. Gay visibility hit Hollywood more overtly in the mid-1990s, when new voices began challenging old stigmas, fighting for a more realistic representation. The more mainstream cinema responded in 1993 with comedies like *Three of Hearts* and *Threesome* and Jonathan Demme's AIDS drama, *Philadelphia*, starring Tom Hanks in an Oscar-winning performance. The queer film cycle reached its maturity at the 1994 Sundance Film Festival when director Rose Troche and her cast stormed Park City with *Go Fish*, their edgy lesbian romantic comedy. I had the pleasure of giving the film its first (favorable) review as a critic for *Variety*. Industry suits suddenly began

to envision the potential economic power of gay viewers, a realization that encouraged the making of more gay-themed movies.

POISON AS AIDS METAPHOR

AIDS, the lethal transformer of gay life, has influenced every aspect of American culture. It has generated as much anger as sadness, with veiled (and not so veiled) references to politically correct values that sparked new offensives against homosexuality. However, gay filmmakers have been energized by the ongoing debate: They have stretched the boundaries of traditional cinema, rolling the stylistic dice and challenging viewers' expectations with more innovative narratives and bolder styles. Through their works, British director Derek Jarman (*Edward II*, *Caravaggio*, and many others), who died of AIDS in 1994, and American filmmakers Van Sant (*Male Noche*, *My Own Private Idaho*) and Haynes have continued to serve as role models for young gay directors.

The new films have differed in sensibility and style. To relegate *Swoon* and *The Living End* to the same category requires a certain bias, but it's tempting to generalize about their similar motivations and effects. Several films have centered on social outcasts or fugitives from the law, propelled toward a tragic fate by a hostile world and obsessive desire. The real-life case of the Chicago murderers Leopold and Loeb, which had inspired Alfred Hitchcock's *Rope* in 1948 and Richard Fleischer's *Compulsion* in 1959, also motivates Kalin's *Swoon*, which offers a new, more sexually explicit perspective of the two killers. Araki's *The Living End* can be perceived as a gay version of *Gun Crazy* in 1949 and *Bonnie and Clyde* in 1967. The two male protagonists wrestle with hypocrisy, mortality, and redemption, issues that mainstream cinema has not probed at all, or not probed with enough honesty. "Gay content in film is usually in the independent sector," said Livingston, whose *Paris Is Burning* is about black and Latino drag queens. "Before and after the Hays Code, gay subject matter was not permissible except as an index of freakishness, which you still see in films today."[6]

In 1991, the same year that Haynes made *Poison*, four high-profile films made by major directors—Oliver Stone's *JFK*, Paul Verhoeven's *Basic Instinct*, Barbra Streisand's *The Prince of Tides*, and Jonathan Demme's *The Silence of the Lambs*—came under heat for their one-sided, distorted portrayals of gay and lesbian characters. Hollywood's well-intentioned but tame efforts to be sensitive about gay issues, from the lesbian sports melodrama *Personal Best* and the squeaky-clean gay romance *Making Love*, both in 1982, to the aforementioned *Philadelphia* in 1993, have only reinforced the idea that gay filmmakers must create their own distinctive cinema. The fact that *Philadelphia* was written by an openly gay writer, Ron Nysmayer, obviously didn't matter much, judging by its middlebrow approach, which among other shortcomings did not show any erotic encounter (not even a kiss) between its male lovers, played by straight actors Tom Hanks and Antonio Banderas. (See chapter 1 for a description of how Pedro Almodóvar constructed Banderas's erotic appeal in his pre-Hollywood pictures.)

For lesbian director Troche, *Philadelphia* is not a really gay film "but a tidy representation of gays, a safe film that straights could embrace because everyone knows Tom Hanks is straight. There's no way that film would've done what it did if they'd cast a gay man in the lead."[7] Nonetheless, despite criticism, the commercial success of *Philadelphia* in middle America made it easier for more adventurous gay films to thrive in the marketplace. "The studios have realized these films can make money," said Troche, "but their attempts to cash in on the market have been pathetic." The comedy *Three of Hearts* is fairly typical—it's always a threesome, where heterosexual desire has the final word. With their "implied disclaimer on homosexuality," they leave artists like Troche "feeling used."[8]

"I don't think *The Living End* or *Swoon* or *The Hours and Times* are 'spokesperson' films," said Kalin, "but the whole issue raises questions about being a spokesperson, about a community, about the debate over presenting 'positive images,' what's the inside and outside of queer?"[9] Some gay movies have crossed over, appealing to wider audiences, but despite their relative commercial success, both their budgets and their profits are minuscule compared to those of Hollywood movies. The cycle of gay independents came out of the

Hollywood tradition, even if their strategy was to fracture the very foundations of that tradition. The new films were counterreactions, playing off Hollywood genres. Perhaps the most profound change effected by queer cinema was noted by Haynes: "At least Hollywood is discovering that money isn't homophobic."[10]

* * *

Poison marked Haynes's first feature collaboration with Vachon, who has since their days at Brown University produced all of his films and many other significant indies, both with and without gay themes. She was instrumental in getting the $1 million budget for *Safe*, a low figure by indie standards but four times as much as the budget for *Poison*. Funding sources included American Playhouse, Britain's Channel 4 TV, and some of the original investors in *Poison*, including John Hart and Jeff Sharp. Asked if it was easier to get backing for gay films after the impact of *Longtime Companion*, *Poison*, *Swoon*, and *Paris Is Burning*, Haynes observed: "No. It's easier for Jonathan Demme to get money to do a film about AIDS, *Philadelphia*. The so-called easier acceptance of queer images comes down to letting people like Demme make their queer movies. I have nothing against Demme making gay films. It's just that I wish it were easier for me to get money to make my films."[11]

For Vachon, it all boils down to economics—there isn't any money for gay films. She explains: "I get asked a lot if Hollywood is homophobic. But the issue really is, is money homophobic? If a gay film does really great box-office, then another gay film will be released. That's just the way it works."[12] Lesbian films are in a worse position than gay films because, according to Vachon, "it's a known fact that lesbians will go and see *The Living End* or *Poison* or *Swoon*, but I don't think gay men will go to see lesbian films. So an even smaller section of the gay community has to be targeted."[13]

Film critic B. Ruby Rich has cited Haynes's feature debut, *Poison*, as a defining film of the New Queer Cinema because of its focus on the potential of sexuality as an antiestablishment force that could disrupt the status quo of the social order. The movie positioned Haynes as a major voice of a generation of boldly innovative filmmakers.

Nonetheless, early on, Haynes decided not to be typecast as a gay director by the industry or to label his characters as just gay for fear of limiting the artistic possibilities of his exploratory narratives as well as his career as a filmmaker.

It's not a coincidence that French enfant terrible Jean Genet inspired Haynes, another enfant terrible, in making the most provocative movie about the AIDS crisis to date, *Poison*. *Homo*, one of the three stories in *Poison*, makes explicit links to Genet's reminiscences (both factual and fictional) of his days in reformatory school and prison. An adaptation of part of Genet's *The Miracle of the Rose*,[14] it tells the story of one prisoner who is physically attracted to another, whom he had met and seen humiliated as a youth in a juvenile facility.

Significantly, Genet's *Un chant d'amour* (*A Song of Love*), the only film the French writer made, is a cult work cited by many gay and other independent directors. As we shall see, the black-and-white style and homoerotic imagery of Van Sant's 1985 *Mala Noche* also recalls the feel of the 1950 movie, credited by the director as a major source of influence. Because of its explicit homosexual content, Genet's 26-minute film was initially banned; later on, it was disowned by Genet, who was not pleased with it.[15]

Genet's tale is set in prison, where a nasty guard takes voyeuristic pleasure in observing the prisoners perform masturbatory sexual acts. In two adjacent cells, there is an older Algerian-looking man and a handsome convict in his twenties. The older man, attracted to the younger one, rubs himself against the wall and then shares his cigarette smoke with his neighbor through a straw. The jail guard, jealous of the prisoners' relationship, beats the older convict, and humiliatingly forces him to go down on his gun in a suggestive fellatio. The brutal scenes are contrasted with some lyrical ones, in which the inmates drift off into fantasies that allow them to escape to the countryside and make love. The message is clear: The guard's legal power cannot suppress the imaginary attraction and erotic fantasies of the prisoners. In defiance of dialogue or words, Genet relies on close-ups of semi-naked bodies, faces, armpits, butts, and penises. Well ahead of its time, the film's eroticized and fetishistic look has influenced many gay artists, including Andy Warhol and Paul Morrissey.

Over the years, *Un chant d'amour* has become a cause célèbre. In 1966, distributor Sol Landau attempted to exhibit the film in Berkeley, California. But he was informed by the police that if he held screenings, the film would be confiscated and he would be arrested.[16] Landau then initiated what became the case of *Landau v. Fording* (1966), seeking to show Genet's work without police harassment. The Alameda County Superior Court watched the film twice and declared that it "explicitly and vividly revealed acts of masturbation, oral copulation, the infamous crime against nature, voyeurism, nudity, sadism, masochism and sex. . . ." The court rejected Landau's suit, condemning the film as "cheap pornography calculated to promote homosexuality, perversion, and morbid sex practices." He was also rebuffed in the California District Court of Appeal, which accepted that Genet was a major writer but cited the film as a lesser work and declared that in the end it was "nothing more than hard-core pornography and should be banned." When the case reached the U.S. Supreme Court, the decision was confirmed once more, in a 5–4 per curiam decision. The justices simply stated that *Un chant d'amour* was obscene and offered no further explanation.[17]

Winning the 1991 Grand Jury Prize for a dramatic film at the Sundance Film Festival, Haynes' *Poison* garnered not only considerable acclaim but also controversy. The film was denounced by one of the country's most outspoken conservatives, Reverend Donald E. Wildman, for containing "explicit porno scenes of homosexuals involved in anal sex." Though he had not seen the film, Wildman was infuriated by the government support it received in the form of a $25,000 postproduction grant. However, John E. Frohnmayer, chair of the embattled National Endowment for the Arts (NEA), defended the film as a responsible work of art, claiming that "the central theme is that violence breeds violence, lust breeds destruction. It is clearly not a pornographic film."[18]

One chapter of *Poison* deals with homosexual obsession, though its overall tone is neither exploitative nor pornographic. *Poison* is, in fact, a socially conscious art movie, the kind that government agencies should subsidize (and in Europe, they do). But for many, the very fact that *Poison* portrays homosexuals sympathetically was enough to condemn the NEA support. Almost every major newspaper and TV

program, from *CBS Evening News* to *Entertainment Tonight*, covered the scandal more extensively than the film itself.

When *Poison* finally opened theatrically, to well-deserved critical praise, it had already become an infamous artwork. In fact, the NEA attack helped push an avant-garde artist into the spotlight. Genet's release from a lifelong prison sentence—achieved with help from the French intellectual elite (Jean-Paul Sartre and Simone de Beauvoir, among others)—had been a major media event. In a similar manner, the NEA controversy catapulted Haynes from a tyro outlaw director to a celebrated filmmaker.

Soaked in paranoia, *Poison* begins with a provocative statement: "The entire world is dying of panicky fright." This is followed by subjective shots of the police breaking into a besieged apartment. The film's major theme is deviance, in its various manifestations, and the inevitable pain and isolation that it generates. The title refers to society's penalizing attitude toward deviants, expressed through various forms of stigmas. Pushing the boundaries of narrative cinema, *Poison* both parodies and challenges the conventions of some classic Hollywood genres.

Composed of three interwoven stories, *Poison* gains cumulative power by juxtaposing themes and contrasting relationships. As critic Jim Hoberman pointed out, the bodily fluids (blood, pus, saliva) that leak from the various characters and the relentless equation of love and death serve to bind the three texts in a tight web of cross-references.[19] Everything in the text amplifies everything else. The stories in a way form a single biography, with its three aspects represented by three males—a little boy, a young man, and a mature scientist.

The most inventive segment in *Poison* is the black-and-white *Horror*, which mocks the genre's conventions of cheap look and stilted, self-conscious dialogue. In this spoof, the mad scientist, Dr. Thomas Graves (Larry Maxwell), distills the "mysteries of the sex drive" in a bubbling teacup, accidentally drinks his own concoction, and turns into a contagious leper whose kiss can kill. "Leper Sex Killer on the Loose," a tabloid headline screams, while Dr. Nancy Olsen (Susan Norman), the sweet scientist who loves Thomas, contemplates his "change of heart." Although Haynes never mentions it, the allusions to AIDS are obvious, and the message is clear. The naïve dreams of

Nancy (allusions to First Lady Nancy Reagan?) give way to knowledge that love equals death.

The theme of *Horror* is echoed in the other segments. In *Homo*, the most controversial segment, the prisoner John Broom (Scott Renderer) becomes obsessed with handsome fellow inmate Jack Bolton (James Lyons). Haynes constructs a prison whose blue-shadowed filth and claustrophobia contrast sharply with flashbacks of a reform school set in a lush countryside, where Broom first glimpses his object of desire. An incredibly painful but powerful scene in *Homo* shows school boys relentlessly spitting into Bolton's mouth. *Homo* is more about mental than sexual brutality: a homosexual rape is discreetly shot, emphasizing the emotional rather than the physical abuse.

The film's third section, *Hero*, is a fake documentary in which reporters investigate the disappearance of a little boy named Richie Beacon. His mother, Felicia (Edith Meeks), claims that, to save her from savage beatings, Ritchie shot her husband, Fred (Edward Allen), and then flew out an open window.

Poison intercuts a triptych of queer-themed episodes that are visually divergent, each adopting a different genre and each set in a world defined by panic, fear, and death. Stylistically, the film displays bravura technical skills, and thematically, it makes a unified statement about life and death. A parody of black-and-white 1950s sci-fi movies, *Horror* was shot in the slightly exaggerated noir vein, with skewed angles and dark shadows. *Hero* is a pop documentary, employing a deliberately chosen banal style with TV-like camera setups and talking heads. *Homo* is a gay prisoner love story, shot in a soft, romantic style that suggests Sirk's 1950s Hollywood melodramas. (Haynes will return to that style in *Far from Heaven*). Awash in blue light and populated by blue-clad convicts who remove their shirts and caress their scars tenderly and erotically, the prison scenes are deliberately shot like a soft-porn gay fantasy. The reformatory scenes of sexual initiation and degradation take place in a courtyard decorated with exotic flowers and splashed with sunlight.

Poison ends with a wonderful quote from Genet, the "transgressive" (and outlaw) gay writer: "A man must dream a long time in order to act with grandeur, and dreaming is nurtured in darkness." It's a

fitting coda because Haynes, just like Genet, asks all those individuals who have been alienated, oppressed, and isolated from society not to give up but to become engaged in action.

The film explores traditional perceptions of homosexuality as an "unnatural" social force. It presents Genet's vision of sadomasochistic gay love as a subversion of heterosexual norms, culminating in a detailed depiction of a marriage ceremony between two male convicts. This scene was well ahead of its time, filmed years before the issue of same-sex marriage became the subject of intense national debate; it also became prophetic when, twenty years later, President Barack Obama officially endorsed same-sex marriage as part of his reelection campaign platform.

Some critics felt that *Poison* was too academic in its deconstructive nature, basing their argument on the film's self-consciousness and overly symbolic subtexts. The first segment's boy, sort an angel of light, is named Richie Beacon. Flying away after killing his dad, he is like an extreme version of Peter Pan. The dedicated scientist who turns into a monster is called Graves, and he embodies Dr. Jekyll and Mr. Hyde. There are also symbolic doors and windows and quotations from Genet. All three characters are linked by the theme of death, an issue that is also shared by Almodóvar and Van Sant, albeit in different ways. In *Poison*, the scientist plunges to his death from one window, the little boy soars away through another, and the convict remains locked away, which is also a form of death.[20]

Put in perspective, the iconoclastic *Poison* is akin to two of Haynes's shorts, *Dottie Gets Spanked*, in which a young boy is obsessed with a TV star, and *Assassins: A Film Concerning Rimbaud*, inspired by the gay French poet, who contributed to art, literature, and music and died prematurely (of cancer) in 1891, at age thirty-seven. These gay-themed movies are "deliberately messy," according to Haynes. He felt that since they deal with characters that are deviant and acts that are transgressive, they should not be presented in a neatly structured mode. In contrast, his second feature, *Safe*, which for some critics still represents his best work, is more aligned with *Superstar*. Both films are conceptual projects about individuals in whom he initially didn't have, to use his words, "emotional investment,"

approached by him in a more detached and dispassionate way from the outside.

* * *

It took Haynes four years to get funding for his next feature, *Safe*. Meanwhile, he made a short, *Dottie Gets Spanked*, for the ITV series *Television Families*. A logical follow-up to *Poison*, the short revolves around an outsider, Steven, a boy who's only six. Alienated from his surroundings, he is obsessed with TV sitcom star Dottie Frank, but his more distinctive (and perverse) trait is his interest in spanking as a form of authority and discipline. Alienated from his father due to his "inappropriate" interests, Steven experiences true moments of happiness when he escapes into solitude, when he draws portraits of Dottie, and in public, when he visits the star's TV settings.

The short is a bittersweet, deeply felt tribute nod to Haynes's own childhood fascination with the TV show *I Love Lucy* and its iconic star, Lucille Ball. While Steven's mother encourages his obsession and has no problem with it, his father grows increasingly frustrated by his son's habits and tastes, which by standards of mainstream culture are too "feminine." This personal and provocative short is a logical prelude to *Safe*, and also anticipates Haynes' 2002 *Far From Heaven*, which also deals with rigid sexual politics, emotional repression, and the suffocating effects of shallow facades.

With its world premiere at the 1995 Sundance Film Festival, *Safe* signaled the arrival of a significant and original American voice. An emotionally devastating portrait of insulated domesticity, *Safe* centers on Carol White (Julianne Moore), a San Fernando Valley housewife who develops a peculiar health problem—an "environmental illness," in the form of an all-encompassing allergy to chemicals. The problem, which baffles the medical establishment, has gained the moniker "the twentieth-century disease." Defeated and helpless, due to her weak immune system, Carol turns to a self-help organization, which then leads to an even more compromised lifestyle and greater isolation from the outside world.

A view of Carol's bourgeois milieu opens the film, when the camera tracks through the Whites' car as it drives up a hill populated by houses that get increasingly larger and more simulated in their design. This sequence is influenced by Haynes's childhood in Encino, a suburb of Los Angeles, where the architecture was "frightening, fake Tudor, fake country manor, everything fake."[21] For further inspiration, the director looked at films depicting Los Angeles as a futuristic city, where every trace of nature has been superseded by humans. In this film, Los Angeles is perceived as an airport because, as he said: "You never breathe real air. You're never in any real place. You're in a transitional, carpeted hum zone."[22]

Conventional cues that usually tell viewers how to respond to various situations and characters are either minimized or altogether avoided. *Safe* breaks the Hollywood mold for emotional identification by not using close-ups and other audience-controlling devices. As is well known, Hollywood uses close-ups to increase the connection between the viewers and the characters and, more importantly, between the viewers and the particular actor-stars who play them. Thus, most of the narrative is shot through medium and long shots. Some are extremely long and static, as, for example, when Carol goes to the drugstore in an impersonal mall or when she visits the dry cleaning shop, where she experiences a major attack. The film also reduces psychological manipulation, letting viewers make up their own minds through their subjective perceptions. Like Van Sant, Haynes refuses to judge his characters or subject them to ridicule, two conventional strategies of mainstream films.

The first scene depicts the selfish lovemaking of Carol's husband, Greg, to which she dutifully submits. Disregarding her erotic needs, he climaxes all too quickly, satisfying his immediate urge but ignoring his wife's desire. Thus, from the start, Haynes chronicles Carol's increasing loss of control in her desperate efforts to conform. This is also evident in the *The Bride of Frankenstein*–like perm she receives and the fruit diet she adopts on a friend's recommendation, all steps indicating her urge to accommodate, her strong need to conform and to blend in.

At the tale's center is a rigorous dissection of Carol's identity, including her incessant need to be reaffirmed by others, usually

dominant male figures. Watching the film, we are engaged in a two-phase process: first, a deconstruction of Carol's "old" and troubled identity and then a reconstruction of her "new" but equally troubled identity. Haynes expects viewers to participate in the process alongside him and Carol herself.

I disagree with critics who claim that as a character Carol is a blank or an enigma. *Safe* avoids the psychological devices and cultural codes used in Hollywood's character-driven dramas, but Haynes finds all kinds of unusual ways to relate basic information about her. For starters, she is primarily defined by social class. She is utterly dependent on her Hispanic housekeepers, down to getting a glass of milk. Her role as homemaker means decorating the house and tending the garden. Even more important are her ritualistic farewell to her husband in the morning and her ritualistic greeting after waiting all day for his return from work in the evening.

What does Carol do all day? She certainly does not lead a double life like the single mother-prostitute (Delphine Seyrig) in Chantal Akerman's seminal 1975 chronicle, *Jeanne Dielman: 23 Quai du Commerce 1080 Bruxelles* (boasting a running time of 201 minutes), a film whose influence both Haynes and Almodóvar have acknowledged with great admiration. Carol takes aerobic classes, after which she inadvertently shocks her friends in the locker room because she is not sweating; it's the first sign that she is different, that "something is wrong" with her. She has regular lunches with her female friends and attends baby showers. In the evening, she accompanies her husband when they meet friends at a chic restaurant, but it seems that "she is not there" (to borrow from Haynes's future title). She pretends to listen, but she really dozes as a male friend tells a semifunny vulgar joke about a woman who calls for help to remove the vibrator stuck in her vagina.

Moreover, she is never seen interacting with her stepson on her own. There is only one scene in which the entire family has dinner together, in which Rory relates his gory school essays to his father who seems proud of his son's audacity and to his stepmother who is only slightly indignant; she basically doesn't care one way or another.

Carol's sense of aesthetics is conventional but precise; she seems to know exactly what she likes. In the course of the tale, she gets

alarmed and annoyed on several occasions, but she really gets upset just once, when furniture in the wrong color (black) is delivered by mistake to her house. It's the only proactive thing in which she engages, first complaining on the phone to the company and then paying a personal visit to the manager, where she demands (politely) that the right couch be sent. She is attractive, but her looks are bland, and they get blander and blander as the tale unfolds. Showing attention to minute detail, Haynes changes the color and style of her originally red hair from scene to scene, mirroring acutely the progression/regression of her persona.

Compared to more traditional films, *Safe* deliberately withholds background information about Carol until much later in the proceedings. There are no flashbacks to her past, and there are only two voice-over narrations, though both highly significant. In the first voice-over, she reads aloud a letter she is writing to the Wrenwood Center, in which she introduces herself and relates her social background. By her own admission, all her life she has been a Texan-born and -bred girl who wanted to fit in and live a normal life. We don't know how she met her husband and whether the marriage was based on love or pressure, self-imposed or exerted by peers, to be attached. She is young enough to start a new family with children of her own, but she never expresses maternal instincts, and there are only a few scenes with her stepson. The second voice-over comes at the end, also in the form of an enigmatic letter, this one to her husband and stepson in which she relates her relative progress and welfare at the Wrenwood Center, about which we spectators have serious doubts, based on what we have observed.

Haynes said that his main goal was to overcome the gap between himself as a director and Carol as a character because otherwise she could have easily become a target for criticism with her bourgeois social class, her conventional tastes, and her lack of knowledge and self-consciousness. The same even-handed approach is taken toward the New Age characters: "I wanted to put the film about as far from my reality and my experience as possible—in a seemingly safe, undisturbed world. I wanted to challenge my own innate criticism of their world. I had no interest in condemning them, or placing myself above them."[23] At the same time, Haynes didn't want Carol to become

too attractive or larger than life, the kind of character she would have been in a typical Hollywood movie or teleplay.

Haynes wanted Carol to evoke the vulnerable, fractured nature of modern identity, an issue that American films have rarely addressed. Indeed, identity formation—and how it is manipulated by larger social forces—is explored here with subtle complexity. Like other women of her kind, Carol is not capable of breaking out of her prison-domestic milieu. "L.A. and Wrenwood both have isolation built into them, but both are telling you that you're not alone, and that if you do these things, you'll be affirmed as part of the group." *Safe* shows the costs entailed in "joining help groups or giving up things in ourselves that can never be harnessed."[24]

Though refusing to indulge in a sappy style, on one level *Safe* belongs to the tradition of the "woman's film," drawing on the melo-dramas of Sirk and Rainer Werner Fassbinder. Haynes uses the melo-dramatic format to place limits on his narrative: Carol is enclosed in certain systems, whether it's Los Angeles or another system. The measured rhythms of *Safe*, which are rigorous and austere, are con-veyed by the anesthetic suburban spaces through which she moves: grand living rooms, cavernous car parks, clotted freeways, spot-less spas. The film's prevalent silence is disrupted by technological sounds, vacuum cleaners, television sets, a radio station's call-in program—all indicators of how Carol's identity, fragile in the first place, goes through an increasingly scary process before, alarmingly, she shuts down. It's a process that inevitably leads her into a passive life of quiet desperation.

Carol fits the outline of Haynes's protagonists in his other films, mostly victims rather than just products of their social contexts. Shaped by her environment, which is ruled by various kinds of patri-archs, she belongs to his gallery of female characters that are like plastic dolls. *Safe* raises provocative issues: Is Carol the problem? Is she yet another humorless figure out of a tale like *The Stepford Wives*, honed by aerobic drill instruction, looking like an emaciated repli-cant, a luminous pod who never breaks a sweat?

Filmed by Alex Nepomniaschy in wide-angle shots that reduce all human activity to miniaturized, doll-like movements, *Safe* is steeped in entrapment, paranoia, and malaise. To that extent, Haynes

observes Carol coolly through a series of static deep-focus shots, making her an invisible woman who appears anesthetized in her materially comfortable but emotionally sterile life. Toward the end, covered from head to toe and using a mask that barely allows her to see or to breathe, Carol floats around the space slowly and quietly— as if she were an alien in a Stanley Kubrick sci-fi film.

Safe plays on the "comfort and resolve" (Haynes's words) format of the "television movie of the week." It subverts the rhetoric of recovery guru Peter Dunning, a "chemically sensitive person with AIDS," to whom Carol turns for help. In one subtle scene, looking more haggard than ever, though supposedly "adjusting" to the Wrenwood Center, Carol is approached by Peter, who's concerned over her reluctance to join in the group-think. Eager to fit in, she admits that she's "still just learning the words." He sighs, "Words are just the way we get to what's true," turning what she's said into yet another essentialist statement. For Haynes, "words just show you how truth is unobtainable, because you can never articulate it."[25]

By insisting on pride, which equals self-blame, Peter allows his patients to fail and fall, while his "therapeutic success" allows him to succeed and ascend. This is shown by the image of his majestic villa high on a hillside. Haynes wanted to examine the New Age philosophies of Louise Hay, the self-help author of *You Can Heal Your Life*, which led to the upsurge of similar treatments among many individuals, especially gay men with AIDS. *Safe* raises several questions: What is it about these philosophies that makes the sufferer of incurable illnesses feel more at peace? Why do we choose culpability over chaos? However, it's a tribute to the film's nuanced narrative and subtle tone that it doesn't provide answers to these absorbing questions.

Though not specifically identified, Carol's illness has been interpreted by some as an analogy for the AIDS crisis, as a similarly uncomfortable and largely unspoken "threat" in 1980s Reaganomics America. This may explain why Haynes inserts a title card before the film begins that states the story is set in 1987.

Peter, one of the few explicitly homosexual characters in Haynes's work who's already gay when we meet him, is a complicated man— intentionally problematized by the director. Though a self-proclaimed help guru, Peter defies easy categorization. At first, he appears to be

FIGURE 1 The director who loves women: Almodóvar (*on the right, seated*) and the female-dominated cast of *Women on the Verge of a Nervous Breakdown*, his first acknowledged masterpiece. Antonio Banderas, a regular presence, is on the left (*standing*).

FIGURE 2 A crucial dinner scene in *Dark Habits*, Almodóvar's third film, a satire of deviant nuns enamored of drugs and kinky literature, hosting only one resident, Yolanda (Cristina S. Pascual), at the center, wearing a red dress. (COURTESY OF AMPAS)

FIGURE 3 *Matador*, Almodóvar's most stylized film, features one of the boldest sex scenes in his work (and cinema's history), emphasizing his recurrent motif of passion and death. Maria (Assumpta Serna) and Diego (Nacho Martinez) enact the ultimate fantasy of doomed lovers. (COURTESY OF AMPAS)

FIGURE 4 *Law of Desire*: Antonio (Antonio Banderas), as the troubled, insanely jealous guy, burning the shirt of Juan, the lover of his object of desire, Pablo, after killing him.

[COURTESY OF AMPAS]

FIGURE 5 In the gay noir melodrama, *Law of Desire*, the filmmaker Pablo (Eusebio Poncela, *right*) is concerned about his sister Tina (formerly his brother, played by Carmen Maura) held by the hot-blooded and vengeful Antonio (Antonio Banderas).

[COURTESY OF AMPAS]

FIGURE 6 The joyous 1988 comedy, *Women on the Verge of a Nervous Breakdown*, centers on Pepa (Carmen Maura) initially hysterical and dependent but ultimately strong and resourceful femme, holding the film's main communication mode, the telephone (red, of course). [COURTESY OF AMPAS]

FIGURE 7 *Live Flesh,* considered to be one of Almodóvar's most mature films. *Top:* David (played by the young Javier Bardem), the young cop involved in an affair with a married woman. *Bottom:* David, now a paraplegic after an accidental shooting, and the irrepressible Victor (Liberto Rabal), both in love with the same woman, Elena. ⟨COURTESY OF AMPAS⟩

FIGURE 8 An early scene in *All About My Mother*, my favorite Almodóvar film. *Top*: the protagonist, single mother Manuela (Cecilia Roth) stands against a poster of Huma (Marisa Paredes), an actress visiting town with a production of *A Streetcar Named Desire*. *Bottom*: Manuela (Roth) and her son Esteban (Eloy Azorin), about to attend a performance of Williams' play that would fatally change all of their lives. [COURTESY OF AMPAS]

FIGURE 9 *Talk to Her,* Almodóvar's 2002 Oscar-winner, reverses gender roles, focusing on a female matador, Lydia (Rosario Flores). *Top:* with a bullfighter (Javier Conde). *Bottom:* with bullfighter and former lover Nino de Valencia (Adolfo Fernandez).

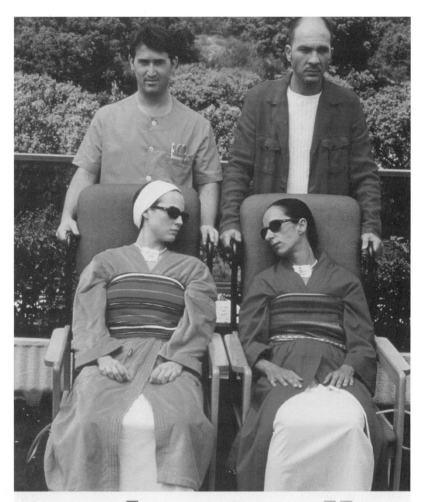

parle avec elle
un film de Almodóvar

FIGURE 10 *Talk to Her*, one of the few Almodóvar films about friendship between men, one straight and normal, the other troubled and perverse, both taking care of women in comas. *Left:* the nurse Benigno (Javier Camara) and Alicia (Leonor Watling). *Right:* Marco (Dario Grandinetti) and Lydia (Rosario Flores). [COURTESY OF AMPAS]

FIGURE 11 There are hardly any men in Almodóvar's *Volver*, his coming home and home-coming film that celebrates the traditions of his past through an intimate community of women, headed by Penelope Cruz (channeling Sophia Loren) in an Oscar-nominated performance. (COURTESY OF AMPAS)

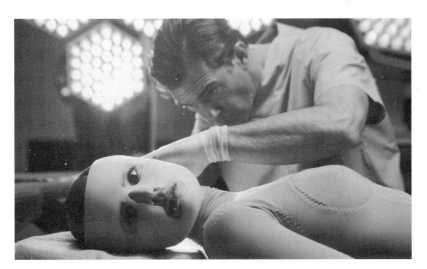

FIGURE 12 The horror thriller, *The Skin I Live In*, is the only tragedy in Almodóvar's oeuvre, a tale of revenge in which a Frankenstein-like doctor (Antonio Banderas) forces a sex-change operation on the young man now named Vera (Elena Anaya) who had raped his daughter. (COURTESY OF AMPAS)

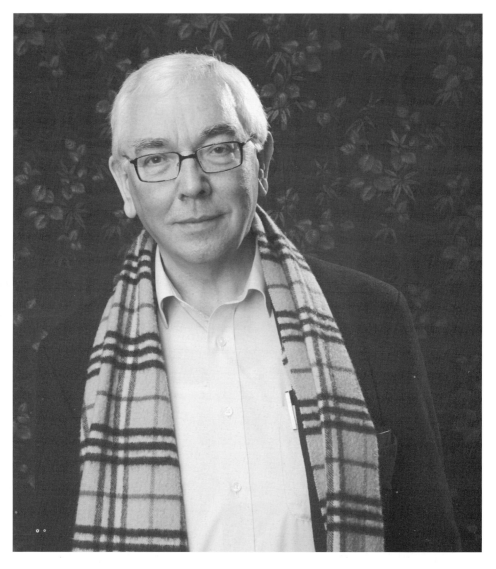

FIGURE 13 Portrait of the artist: Terence Davies, a product of a poor working-class family, is arguably the most brilliant British filmmaker living today.

FIGURE 14 A typical dinner scene in Terence Davies's semi-autobiographical *Distant Voices, Still Lives*, presided by the brutal and temperamental patriarch (Peter Postlethwaite), a figure of dread in all of the director's movies. (COURTESY OF AMPAS)

FIGURE 15 The family in Eileen's wedding in *Distant Voices, Still Lives*, Mother (Freda Dowie) and her three children, Tony (Dean Williams), Eileen (Angela Walsh), and Maisie (Larraine Ashbourne). (COURTESY OF AMPAS)

FIGURE 16 In *The Long Day Closes,* Davies's striking follow-up to *Distant Voices, Still Lives*, the movie theater features prominently in Bud's life, as a pleasurable escape from dreary reality and inspiration for a future filmmaking career. [COURTESY OF AMPAS]

FIGURE 17 The *House of Mirth*, Davies's sublime adaptation of Edith Wharton's famous novel. *Top:* Lily Bart (Gillian Anderson), the romantic heroine seeking love, fame, and wealth. *Bottom:* Lily and Gus Trenor (Dan Aykroyd), husband of her friend Judy.

FIGURE 18 *House of Mirth:* Lily Bart (Gillian Anderson) and Lawrence Selden (Eric Stoltz), a lawyer she is attracted to but can't marry because he is not wealthy enough.

[COURTESY OF AMPAS]

FIGURE 19 Todd Haynes, one of the founding leaders of the New Queer Cinema, planning a shot on the set of *Safe*. [COURTESY OF AMPAS]

FIGURE 20 "Homo," one of the three tales that forms the 1991 *Poison*, a powerful AIDS drama, depicting gay marriage long before the issue became socially acceptable.

(COURTESY OF AMPAS)

FIGURE 21 Todd Haynes on the set of *Safe*, directing Julianne Moore, the talented, quintessentially indie actress, who plays Carol, an oppressed housewife and victim of patriarchy.

FIGURE 22 *Safe*, a cold, detached, almost clinical portrait of a housewife (Julianne Moore) suffocated in sexless marriage to an insensitive husband, sitting on the edge of the bed, with his back to his wife.

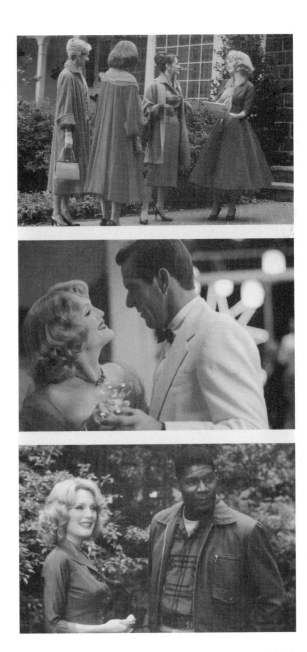

FIGURE 23 A montage from *Far from Heaven,* Haynes's most accessible film, again starring Moore as "the perfectly ideal" housewife. *Top:* Cathy with her gossipy friends. *Center:* Cathy and her husband (Dennis Quaid) in a party in which he gets drunk and loses his temper. *Bottom:* Cathy forming a new friendship with her black gardener (Dennis Haysbert) whom she had barely noticed before. [COURTESY OF AMPAS]

FIGURE 24 Van Sant on the set of *Drugstore Cowboy*, his award-winning indie hit of 1989, directing leading man Matt Dillon. (COURTESY OF AMPAS)

FIGURE 25 The sex scenes in *Mala Noche*, the low-budget, black-and-white indie film that put Van Sant on the map, are brief and suggestive rather than graphic and explicit.

(COURTESY OF AMPAS)

FIGURE 26 As Bob, Matt Dillon in *Drugstore Cowboy* is one of the most charming and eccentric men in Van Sant's output, a guy defined by various contradictions and hilarious superstitions. (COURTESY OF AMPAS)

FIGURE 27 At the center of Van Sant's anti-establishment *Drugstore Cowboy* is a straight couple—and for a change a married one—played by Matt Dillon and Kelly Lynch.

(COURTESY OF AMPAS)

FIGURE 28 The star presence of River Phoenix and Keanu Reeves as the two hustler-friends in *My Own Private Idaho* elevated the status of the film considerably.

(COURTESY OF AMPAS)

FIGURE 29 Van Sant's *Elephant*, which won the top award (Palme d'Or) at the 2002 Cannes Film Festival, is short in plot and rich in mood and style, defined by long and elegant tracking shots of the school's corridors where senseless mayhem erupts.

(COURTESY OF AMPAS)

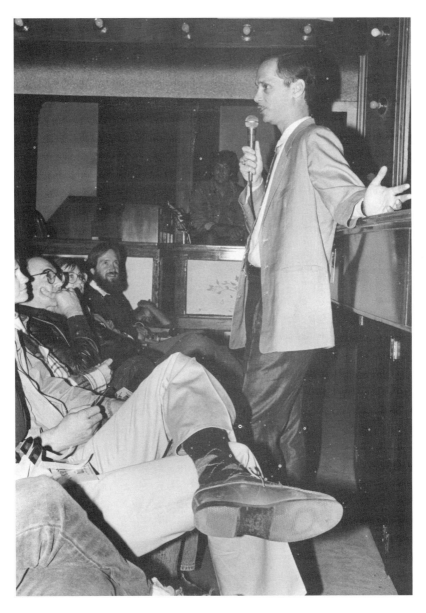

FIGURE 30 John Waters on stage, entertaining live audiences, demonstrating his great skills as a comic and raconteur. [COURTESY OF AMPAS]

FIGURE 31 Waters made a star of Divine, the 300-pound transvestite in the 1972 cult midnight movie, *Pink Flamingos*, here with David Lochary, another member of the Dreamlanders, the director's reliable troupe. [COURTESY OF AMPAS]

FIGURE 32 The setting of Waters' most scandalous film, *Pink Flamingos:* Divine in her living trailer in a desolate landscape decorated by pink flamingos.

[COURTESY OF AMPAS]

FIGURE 33 *Female Trouble,* arguably Waters's best panel in the "Trashy Trilogy," features Divine and David Lochary, as the owner of the Lipstick Beauty Salon.

(COURTESY OF AMPAS)

FIGURE 34 *Female Trouble* offered Divine, Waters's muse and "leading lady" until his death, his most substantial role, here with her ungrateful daughter, Taffy (Hilary Taylor).

(COURTESY OF AMPAS)

FIGURE 35 In Waters' *Desperate Living*, most of the characters are deviant or eccentric femmes, including Grizelda Brown (Jean Hill), the overweight black maid and crime partner of the protagonist, suburban housewife Peggy. [COURTESY OF AMPAS]

Carol's savior who can make her feel better by curing her chemical oversensitivity. But then Haynes deliberately undercuts him by suggesting that he might just be a self-absorbed and manipulative charlatan, perhaps even a fraud. The more patients the Wrenwood Center has, the better off Peter is materially. Like other figures in Haynes's oeuvre, he is ultimately more defined by class, status, and power than by sexual orientation. We never see Peter's private life or nocturnal activities; he may be asexual, preaching for love but abstaining from any erotic conduct, leading a sexless life.

The text's subtlety, however, was mistaken by some viewers as formal endorsement of the new dubious fads, as if *Safe* was promoting New Age philosophies and places like the Wrenwood Center. In actuality, *Safe* is critical of New Age therapies, perceiving them as a trap no better than the mindless materialism that had previously defined Carol's life. Ultimately, the film is more of an indictment of New Age medicine than of California's stifling bourgeois lifestyle. The chilling conclusion shows how Carol's self-imposed exile is carried to an extreme. She retreats to her antiseptic, prison-like "safe room," and standing in front of the mirror with a blank expression on her face, she murmurs repeatedly, "I love you," to her own reflection. It is the biggest of the few close-ups that Haynes accords his (anti) heroine. This ambiguous ending has evoked considerable debate among critics as to whether she has really emancipated herself or simply traded one form of oppression, as a housewife, for an equally constricting identity, as a reclusive invalid and patient. Scholar Julie Grossman has argued that Haynes made a film that challenges the traditional Hollywood narratives, which usually end with the heroine taking charge of her life.[26] Instead, he sets Carol up as a victim both of a repressive, male-dominated society and of an equally debilitating self-help movement, which is yet another male-dominated culture that encourages patients to take personal blame for their illness.

Acclaimed by many critics, *Safe* was released by Sony Classics in June 1995 as counterprogramming to Hollywood's commercial fare. Unfortunately, the film was a box-office disappointment, grossing about $500,000, which was even less than its low budget. Nonetheless, *Safe* afforded the gifted Julianne Moore her first, much-admired leading role in a feature, and it gave Haynes a considerable measure

of critical recognition. In a *Village Voice* poll, *Safe* was chosen as one of the best American films of the 1990s![27]

DECONSTRUCTIVE MUSICAL

Stylistically, *Safe* is marked by deliberate pacing, confined settings, and minimalist design, all devices that are polar opposites to those that define Haynes's next feature, *Velvet Goldmine*, which is excessive, energetic, and highly stylized. Haynes, like Almodóvar, but unlike Van Sant and John Waters, has deployed a completely different style for each of his films. Made in 1998, *Velvet Goldmine* is Haynes's most visually flamboyant and textually dense film but also his most problematic.

Again showing interest in rewriting cultural history and highlighting the ideological importance of pop icons, Haynes made a radical shift in direction. The deconstructive musical stars the then young and promising British thespians Christian Bale, Ewan McGregor, and Jonathan Rhys Meyers. Set in London, where it was also shot, the film is an intentionally unstructured tribute to the glam rock era of the 1970s, drawing heavily on the histories and mythologies of such glam rockers as David Bowie, Iggy Pop, and Lou Reed.

Velvet Goldmine, like *Poison*, was inspired by a major gay artist, Oscar Wilde. The opening scene shows how baby Oscar is delivered to his parents' doorstep by a spaceship. Starting with a quote from Wilde, seen by Haynes as sort of the spiritual godfather of glam rock, *Velvet Goldmine* revels in the era's gender politics, experimentation with identity, and fashionable bisexuality. The movie chronicles the power of glam rock as a form of self-expression for both heterosexual and homosexual youths. As an avenue of escape, glam rock served functions similar to those of other transient fads and fashions.

Shaped as sort of a mystery drama, *Velvet Goldmine* follows Arthur Stuart (Bale), a British journalist enraptured by glam rock as a teenager, who returns a decade later to hunt down his former heroes. They are Brian Slade (Rhys Meyers), a feather-boa-wearing androgyne who bears the alter ego of Maxwell Demon and resembles David Bowie in his Ziggy Stardust incarnation, and Curt Wild (McGregor), an Iggy Pop–style rocker with an incoherent accent.

Brian stages his own death onstage while performing: when a shot is heard, he falls to the ground covered with blood. However, when the act is exposed as a hoax, it marks the end of his stardom. A decade later, in 1984, Arthur, who had witnessed the hoax murder, requests and gets an assignment from his editor to do an investigative story. In what becomes an obsessive interrogation, he visits the wheelchair-bound Cecil (Michael Feast), who discovered Brian. He then tracks Brian through his early life and his initial encounter with Curt, an outrageous, maniacal American singer. We also meet Brian's manager, Jerry Divine (British comedian Eddie Izzard), as he moves in to take over the performer's career.

In a scene lifted out of *Citizen Kane*, Brian's former wife, Mandy Slade (Toni Collette), is interviewed by Arthur in a dark nightclub, and she recalls in a voice-over flashback their initial meeting in 1969 at the Sombrero Club. It comes as no surprise that their marriage parallels his Bowie-like ascent to fame as a bisexual star pushing the limits. Idolized by teens, Brian teams up with the drug-addicted Curt. The marriage comes to an end, and Mandy claims she has not seen him in years. The reporter recreates the star's rise and fall, climaxed by his fake onstage murder at a London concert. In a more conventional film, the focus would have been on the glamorous exploits and exotic adventures of Brian and Curt. But rather than presenting Brian's rise to stardom directly, Haynes shows it from Arthur's perspective—in a way that dispenses vital information about the couple in bits and pieces.

The narrative deals playfully with the facts and myths of glam rock, without intending to be an authentic portrait of the short-lived but forceful cultural phenomenon. Brian, for example, flirts with bisexuality and lives a careless lifestyle of "decadence" before staging his own death during a live performance. Haynes refers to Bowie's disavowal of glam rock in the late 1970s and his subsequent self-reinvention as an avowedly heterosexual pop star.

As noted, the text imitates *Citizen Kane* by presenting multiple contradictory perspectives on Brian's life. However, for savvy critics and viewers, the film's structural parallels to Welles's 1941 masterpiece were too obvious (and too pretentious), whereas for those not steeped in film history, they were just perplexing. Even more so than Carol's

character in *Safe*, Brian remains an enigma up to the end, when presumably he is assigned a "new" identity, because many crucial pieces of the puzzle are missing.

The film's less successful subplot describes the affair between Brian and Curt, alluding to rumors about Bowie and Reed's sexual relationship. Haynes adds a flashback to Curt's enforced shock treatment as a teenager in an effort to "cure" him of homosexuality, echoing Reed's teenage records as a victim of the homophobic culture and the rigid medical profession. The director's critique of society's silly beliefs and efforts to "cure" homosexuals, both forced on the victims or chosen by them, also appeared in *Poison*, and it would feature prominently in *Far from Heaven*.

This time around, having learned the bitter lessons from *Superstar*, before making the film, Haynes approached Bowie for permission to use his music. Quite expectedly, he declined, leaving the director no choice but to use a combination of original songs from other artists and glam-rock-inspired music, written specifically for the film by contemporary rock bands, including Suede.

Velvet Goldmine had its world premiere in the main competition of the 1998 Cannes Film Festival (Haynes's first feature to play there), winning a Special Jury Award for Artistic Contribution. (Martin Scorsese was the jury president that year.) Gifted British designer Sandy Powell received an Academy Award nomination for her costume design, and she did win the Oscar in that category the same year—but for her work on another film, *Shakespeare in Love*, which swept all the major Oscars, including Best Picture.

Despite fearless performances from the leads (especially Rhys Meyers), who sang their musical numbers, *Velvet Goldmine* received mixed to negative reviews from critics, resulting in a flop. There were disputes between producer Vachon and Miramax's Harvey Weinstein regarding the shape and running time of the final cut, which might have accounted for the film's commercial failure. The film grossed about $1 million at the domestic box office, only a small fraction of its considerable $10 million budget.

A tweener, *Velvet Goldmine* never found an appreciative audience. Audacious viewers seeking offbeat fare and expecting self-reflexive camp were disappointed, and rock fans did not like the movie either.

Some critics claimed that Haynes had miscalculated with the music, using "too much" of it and in a mode that was not well integrated into the narrative. Moreover, some of the songs are grating, and their excessive rendition through montage is unappealing.

In hindsight, *Velvet Goldmine* is Haynes's most disjointed film. The narrative's layers over layers make it difficult to get involved with any of the characters. Arthur is forced to examine his own adolescent fascination with glam, his confused or unclear sexuality, and his brief affair with Brian's muse, Curt. The journalist's coming out subplot is superfluous and, for a bold director such as Haynes, sort of déjà vu. Unfortunately, Haynes seems more interested in Arthur, whose life was shaped by glam rock, than in the other men, although Arthur is too staid to qualify as an interesting dramatic persona.

For me, *Velvet Goldmine* is Haynes's least satisfying work, a film of some brilliant moments that do not add up to a coherent whole. His biggest coup was in casting his three leads, all extremely talented and attractive actors, just before they became stars: Bale (before the *Batman* franchise), McGregor (before *Moulin Rouge*), and Rhys Meyers (before the TV series *The Tudors*). All three had developed loyal followings among younger viewers, including gay men. This was particularly the case with McGregor after appearing in Danny Boyle's cool, drug-themed *Trainspotting* and showing off in full frontal nudity in Peter Greenaway's intellectual-erotic puzzle *The Pillow Book* (both in 1996). The director exploits McGregor's lack of shyness and in *Velvet Goldmine* again shows the actor full frontal—albeit briefly and in context.

Despite major shortcomings, *Velvet Goldmine* indicated that Haynes was an original director who makes personal and iconic pictures that are not easily classifiable or marketable. This might explain the director's motivation behind his next feature, *Far from Heaven*, which became his most accessible feature to date.

WOMAN'S MELODRAMA: *FAR FROM HEAVEN*

Like other directors, Haynes has dealt with gay identities and lifestyles, though in deconstructive ways. *Velvet Goldmine* and *Far from Heaven* depict the perennial topic of gay-themed films: coming out.

Yet even then, the coming out is just one issue in films whose scope was much broader.

In 2002, Haynes achieved the greatest critical acclaim and commercial success of his career with *Far from Heaven*, a family drama inspired by Sirk's stylish 1950s melodramas. The German-born, Hollywood-based Sirk continues to influence filmmakers (both American and foreign) over half a century after his last American work, *Imitation of Life* in 1959, and decades after his death. *Far from Heaven* had its world premiere at the Venice Film Festival, where Julianne Moore won the Best Actress Award. The film was released in the United States by Focus Features and its box-office receipts totaled about $15 million, outgrossing all of Haynes's features put together, especially after winning a number of major awards, including Best Film from the New York Film Critics Circle.

Like *Safe*, the narrative concerns a suburban housewife, here named Cathy Whitaker (Moore), who is thrown into a major identity crisis by unanticipated circumstances. Set in 1957, the nominal plot, the surface text, is rather simple: the effects of Cathy's discovery that her husband, Frank (Dennis Quaid), is a latent homosexual. After a painful divorce, she falls in love with Raymond Deagan (Dennis Haysbert), her longtime African-American gardener, whom she had barely noticed before. However, as always with Haynes, it's the rich and dense subtext, the attention to detail, and the meticulous reconstruction of the era and its fashions that make the film more interesting than just another period melodrama or homage to Sirk in narrative structure, visual look, and even music (by Elmer Bernstein).

From the start, we sense Cathy's feelings that "something" isn't quite right in her presumably ideal marriage. Frank begins working later and later, canceling dinners at the very last moment, and spending less time with Cathy. He seems easily irritable and more distant, both physically and emotionally. Their two children also feel neglected by their dad. One day, after yet another call that he needs to work late, Cathy goes to Frank's office to bring him dinner, fulfilling her duties as a housewife. Quietly opening the door, Cathy discovers something she had never expected, her husband in a compromised position with another man—the office's lights are dim, and the shirts

of the two men are open. The mysterious homosexual leaves the office, and Cathy runs out in panic, dropping the dinner on the floor.

Prior to this traumatic experience, Cathy and Frank represented a perfect married couple living a perfectly harmonious suburban life in a nicely decorated house, overseen by a respectful black housekeeper, Sybil (Viola Davis). When the film begins, the couple is interviewed by a gossipy journalist for a popular magazine article as a "model family." They live in a beautiful home and raise two healthy and obedient children. Frank pursues a successful career in sales, and Cathy is a full-time housewife.

Cathy has plenty of time on her hands, as all the domestic chores are supervised by Sybil. Cathy's lifestyle allows her to always be meticulously made-up and elegantly dressed up, even when she just stays in the house or runs errands around town. In a scene that might be anachronistic for the times in which the tale is set, Cathy and her female friends, led by Eleanor Fine (Patricia Clarkson), discuss their sexual habits, like the frequency with which they have sex with their husbands, whether the sex comes before or after drinks, and so on. Significantly, Cathy remains silent, feeling too uncomfortable to share her frustrations; after all, honorable suburban femmes were not supposed to enjoy sex, let alone initiate it. Nonetheless, the conversation touches a nerve: it becomes the first step in her growing consciousness as a woman defined by unfulfilled desires.

As was the norm at the time, upon the shocking discovery of Frank's homosexuality, at Cathy's urging they go through marriage counseling and psychotherapy with an "expert." Throughout the process, Cathy tries to keep up a brave face. But the emotional trauma takes a great toll on her, and she sadly realizes that there are few people she can talk to. Most disappointing is her presumably intimate friendship with her neighbor Eleanor. The two femmes chitchat and borrow dishes from each other for dinner parties, but at this point, Cathy doesn't share with Eleanor any details of her personal troubles.

Cathy strikes up a friendship with Raymond Deagan, the African-American gardener who has worked for the Whitakers for some time but had not been noticed before. Taking over the job after his father passed away, Raymond is a widower raising a young daughter, Sarah. Gradually, Cathy discovers how intelligent, compassionate, and

sensitive Raymond is. Their encounters begin randomly when she sees a black figure in the garden and suspects that the stranger might be an intruder. In their second interaction, full of symbolic meanings, Raymond retrieves the purple scarf that Cathy has lost in the wind. But the turning point occurs when Cathy meets him at an art gallery; Raymond and his daughter are conspicuously the only black visitors at the opening night. When Cathy goes to greet him, she raises eyebrows among her bigoted friends.

Small and random talks lead to a drive to a local black-dominated club at the outskirts of town. Cathy and Raymond, in a relaxed mode and away from the restriction of "white civilization," listen to jazz and dance. However, suburban Hartford is a provincial, suffocating small town, and when Mona (Celia Weston) sees Cathy and Raymond, she sets off a wave of vicious gossip that threatens to make public the Whitakers' private secrets.

As noted, *Far from Heaven* pays tribute to the settings, mise-en-scènes, colors, costumes, cinematography, and lighting of Sirk's elegant 1950s melodramas. The relationship between Cathy and her gardener, Raymond, resembles that between an older widow, played by Jane Wyman, and her younger and handsome gardener, Ron, ironically, played by the then latent gay actor Rock Hudson, in Sirk's 1955 *All That Heaven Allows*. The age gap, which plays a prominent role in *All That Heaven Allows*, is not a factor in *Far from Heaven*. The bond, however, is more complex in Haynes's film because Cathy and Raymond need to overcome differences not only of social class but also of race.

In *Far from Heaven*, Haynes adds an important interracial subplot, which recalls a similar one in another Sirk melodrama, *Imitation of Life*. In Haynes's picture, Sarah, a disciplined, well-behaved black girl, is bullied by bigoted white boys when she offers an unwanted opinion. The incident leads to cursing and stoning, sending the wounded girl to the hospital. Moreover, Cathy's relationship with Sybil, her African-American housekeeper, recalls the friendship of Lana Turner and Juanita Moore in *Imitation of Life*, although it is disappointingly superficial. In the 1959 film, Moore's Annie has a significant role in the plot, functioning as a shrewd housekeeper (she negotiates a deal with the milkman when they are poor); responsible biological mother to

her daughter, Sarah Jane (Susan Kohner); attentive surrogate mother to Lora's white daughter, Suzie (Sandra Dee); and reliable companion and trustworthy personal confidante of Lora. But in Haynes's film, Sybil is inexplicably a secondary, underdeveloped (almost mute) character with no life of her own. Presumably single, she has no family and no friends. She is mostly seen in the background, cooking, serving, cleaning, and scrubbing the floors.

While staying within the period's language, Haynes updates the sexual and racial politics, showing new narrative possibilities. Cathy and Raymond's interracial love affair and Frank's homosexuality and then divorce, followed by a newly formed gay relationship, would not have been permitted by American censors of the 1950s or accepted by the public in the conservative Eisenhower era, during which Sirk had worked and flourished. Significantly, the gardener's character is more fully developed and individualized in Haynes's film. Unlike Hudson's Ron, who is single, Raymond is a widower raising his daughter. Raymond is also more educated than Ron: Haynes makes a point of showing the father and daughter at an art gallery. When the girl is stoned because of her race, it serves as a crisis point in the narrative and a turning point in the relationship between Cathy and Raymond.

Haynes also defies Sirk's happy ending (though it's an ironic one) in *All That Heaven Allows* and concludes his tale on a more melancholy and ambivalent note, closer in tone to the "woman's films" (pejoratively known as "weepies") of the 1940s and 1950s. Cathy remains friends with her former husband, who is now better adjusted with a younger male he meets at a public pool (while Cathy is around). But she is not attached (yet) to Raymond, and it remains unclear whether their bond will continue or become more committing.

The last scene is too sentimental for a postmodernist director like Haynes, but it hits the right emotional buttons. It depicts a teary parting at the train station when Cathy rushes to bid farewell to Raymond and Sarah, who are leaving for Washington, D.C., after he loses his business in Hartford. Milking the scene for all its potential, Haynes shows Cathy arriving almost too late, seconds before the train leaves. Frantically searching for Raymond, she spots him, and the two exchange a meaningful look, waving good-bye as the train begins to

depart. Left alone at the train station, Cathy, more resilient, determined, and confident than ever before, gets in her convertible and drives way, lending the film a logical closure. The final image brings the tale, which begins with Cathy driving her car back home with her children, full circle.

Far from Heaven is effective as homage to a popular Hollywood genre and director but it is also satisfying as a stand-alone melodrama, containing elements relevant to the present. The critical acclaim for *Far from Heaven* was evident in the four Oscar nominations it received, including one for Best Actress for Julianne Moore; that same year she was also nominated for the Best Supporting Actress Oscar for *The Hours* but lost in both categories. The other nominations were for Haynes's original screenplay, the score by Elmer Bernstein, and cinematography by Ed Lachman. Though losing in all four categories, the film won several Spirit Awards and was deemed a breakthrough for the independent film movement in achieving more mainstream recognition. *Far from Heaven* elevated Haynes's stature as a filmmaker, bringing him the attention of a wider audience and helping him secure backing for his next feature.

DECONSTRUCTING IDENTITY

I'm Not There, Haynes's fifth feature, was his most ambitious film to date. Densely textured, like the previous ones, it offers a provocative meditation on the lives and times of legendary singer-icon Bob Dylan. It also comments on the impossibility of capturing any individual life in a filmic or literary format, be it fictional or nonfictional.

Haynes succeeded in obtaining Dylan's approval to use his music in the soundtrack. Surprisingly, all it took was a one-page summary of the film's concept to Jeff Rosen, Dylan's manager. Innovative in narrative structure and visual style, *I'm Not There* is not a biopic in any sense of the term. A title card informs viewers: "Inspired by the music and many lives of Bob Dylan." Nor is the film a linear narrative that's meant to be accurate or to do justice to the complex, mysterious, and evasive songwriter who became a spokesperson of his generation—despite himself.

An uncompromising film that divided critics and viewers, *I'm Not There* was far less accessible than *Far from Heaven*, which still is Haynes's only commercial hit. The 2007 film played in all of the fall festivals (Telluride, Venice, Toronto, New York), where it received mixed critical response, ranging from raves to dismissals. It was released theatrically in November by the Weinstein Company (TWC), scoring moderately with a total gross of $2.5 million.

The life of Bob Dylan is dramatized in the film through a series of shifting personae—poet, prophet, outlaw, folk singer, rock and roll star, martyr, and born-again Christian. The film boasts a wonderful cast of actors (including the brilliant Cate Blanchett) who impersonate different facets of Dylan in various decades of his life. Thematically, the notion of different actors playing the same role goes back to the surrealist Luis Buñuel, who deployed this strategy in 1976 in *That Obscure Object of Desire*, in which two actresses played the same femme.[28] Stylistically, *I'm Not There* is inspired by the work of various European auteurs, such as Federico Fellini's *La Dolce Vita* and particularly his *8½*. Haynes also watched Jean-Luc Godard's deconstructive film essays of the 1960s, *Masculine Feminine* and *Two or Three Things I Know About Her*. Like Fellini's *8½* and some of Godard's works, *I'm Not There* is personal and self-reflexive.

American influences on Haynes's work can also be detected. Early on, Dylan is observed as Woody Guthrie in scenes that vaguely recall Hal Ashby's 1976 Oscar-nominated biopic, *Bound for Glory*. And at the end, the Richard Gere sequences bring to mind various Westerns, including Sam Peckinpah's 1973 *Pat Garrett and Billy the Kid*. Nonetheless, *I'm Not There* is not a pastiche or structurally messy, as charged by critics who did not like the picture. To the contrary, each and every frame is rigorously measured, a result of careful planning and editing.

Those familiar with Haynes's work could detect recurrent motifs, prime among which are the notions of a fluid, socially constructed identity shaped by personal and political forces and the impossibility of capturing one's life by any conventional format. This becomes clear in the 1960s sequences, arguably the film's best, in which Blanchett plays one of Dylan's facets, Jude Quinn. In a posh London hotel, reading what he perceives to be embellished and distorted reports of his

(mis)conduct, Jude says, "I'm glad I'm not me." But there is really no "me"—to phrase it differently, there are so many "me(s)" that it's up to the audience to select elements out of the open-ended structure.

Todd Solondz used the same strategy of casting different actors to embody the same character in the 2004 American indie *Palindromes.* Eight actors (young and adult, male and female) play the character of Aviva in his failed effort. Haynes's approach is more effective and less gimmicky than Solondz's. The casting is not just a stunt, as it was in *Palindromes*, which didn't benefit much from its multiactor characterization because none was compelling enough and they did not add up.

At first, the six thespians (and seven roles) follow more or less a chronological order, but later on, Haynes inserts them in a less predictable manner. Then, toward the end, there's a brilliant moment in which all of the actors are flashed on the screen at the same time. Arthur, a renegade symbolist poet played by the handsome British actor Ben Whishaw (*Perfume*), serves as the film's narrator in a single black-and-white set. Whishaw's Arthur, who undergoes interrogation about the responsibility of the artist to society, is named after French poet Arthur Rimbaud, whose work Dylan admired and whose precocious career he emulated. Rimbaud, like the later figures of Wilde and Genet, serves as a heroic figure for Haynes.

Like the long interview scene in *Velvet Goldmine* (which echoed a sequence in *Citizen Kane*), in this movie Arthur is questioned by a nameless commission (the House Un-American Activities Committee, remembered for its Communist witch hunt?) about his allegedly subversive undercurrents and the suspicious political readings of his work. His witty and ironic responses provide counterpoint to the more prosaic chapters of the life that follow.

Chronologically, the saga begins in the late 1950s, centering on the young and ambitious Dylan. At first, he is played by a black boy, Marcus Carl Franklin, as a blues-guitar prodigy. These sequences are in color and set aboard a train. The precocious train-hopper calls himself Woody Guthrie, despite his age (only eleven) and race (black). He has adopted in earnest the posture and stories of the Dust Bowl troubadour. To the supporters encountered on the road, who are mostly white, Woody's tall tales of circus escapes and musical glory reflect

regional authenticity. Interestingly, the fans continue to embrace him even after his calculated impersonation is disclosed.

The character who first achieves success in "singing about his own time" is Jack Rollins (Christian Bale), a womanizer who moves to New York City's Greenwich Village and spearheads the protest-music scene of the early 1960s with his live performances and LPs. The adoring public likes the political consciousness in Jack's lyrics, but Jack severs ties with his "message" music in a strange retreat from his lover, folk singer Alice Fabian (a cameo by Haynes regular Julianne Moore, standing in for Joan Baez), and his worshiping audience. Snippets of an interview with Alice, which are not particularly illuminating, are inserted throughout the film. She represents one of the film's few characters that call attention to the saga's academic concept.

Robbie (Heath Ledger), another persona, is a New York actor and motorcyclist racing to counterculture fame with his performance in *Grain of Sand*, a 1965 biopic about the now-gone Jack. Robbie's troubled ten-year relationship with Claire (Charlotte Gainsbourg) is chronicled from their initial meeting in a Greenwich Village coffee shop through their eventual separation. It is placed in the context of the turmoil of the Vietnam War—TV sets show violent images of the war. Claire's character is based on Dylan's ex-girlfriend Suze Rotolo in the early 1960s, whose parents were members of the American Communist Party. Robbie's sequences consider accusations made against Dylan of misogyny, in his life and in his work. These are the film's most personal and emotional sequences—and also the most French cinema–inspired, with references to Godard, François Truffaut, and even Claude Lelouche's stylishly elegant 1966 Oscar-winning *A Man and a Woman*, starring Jean-Louis Trintignant and Anouk Aimée.

In the film's most poignant act, which lasts about one reel, Blanchett embodies Dylan in his most popular and political phase as Jude, a folk and rock performer forced to confront issues of celebrity, including endless demands by his fans. While Robbie struggles to balance his private life with public fame, Jude surrenders to the era's sex-drugs-music spirit. Closely following Dylan's mid-1960s adventures, Jude shocks his audience by embracing amplified rock and flaunting an increasingly nihilistic, drugs-fueled persona. His new

music attracts attention from gay Jewish poet Allen Ginsberg (David Cross) and underground ingénue-socialite Coco Rivington (Michelle Williams, Heath Ledger's real-life companion at the time). But he also infuriates the protest-music guard and inquisitive journalists like Mr. Jones (Bruce Greenwood), who follows him obsessively, demanding to know "everything" about him.

Bale and Greenwood are the only actors to play two roles. Bale plays Jack Rollins and Pastor John, the Dylan who converts to Christianity. Evading emotional attachments and self-preservation, Jude's dangerous lifestyle propels him into nervous breakdown, and eventually, he goes through a resurrection process. Pastor John is Jack 20 years later, a born-again Christian preacher who has jettisoned his folk music legacy for gospel in Stockton, California.

The film's weakest sections, which are set in the 1970s, involve Richard Gere, who impersonates the oldest character, Billy (Billy the Kid?), a glasses-wearing cowboy. Withdrawing from the outside world, he is now loyal only to his dog. Having survived a famous showdown, he finds refuge in the metaphoric town of Riddle, Missouri. However, the town's impending demise leads him to confront his old nemesis, Pat Garrett (Greenwood, in his second role), abandon his self-imposed exile, and move on. Overly long and static, with Gere looking at the skies or at the distant hills, this act is the least dramatic (though it's not the actor's fault), almost bringing the narrative to a stop. We sigh with relief when Gere bids farewell to his dog and hops the train.

The film concludes on a more poignantly emotional note by presenting the real Bob Dylan in a concert performing the seminal *Mr. Tambourine Man* on his harmonica. This brief glimpse highlights the notion that, ultimately, what matters is not the artist or his personal life but his creation. Dylan's music, Haynes seems to suggest, would outlast both the singer and his historical times.

In its resonant moments, *I'm Not There* shows just how impossible it is for fans, scholars, and viewers to fully grasp any artist's persona. Furthermore, it implies that even Bob Dylan may not know who he is or what he is doing. Self-awareness, in all Haynes's films, is a variable, a matter of extent. The seven identities braided together are like seven interrelated organs pumping life through one dense tapestry.

The movie begins with a series of graphic titles on the screen: "I'm he," "I'm her," "I'm here," "I'm not here," "I'm there," "I'm not there," encouraging audiences to think of the incessant flow and constant changes of their own lives.

Dylan's music, including songs from bootleg recordings as well as his original ones, is featured extensively in *I'm Not There*. There are also songs by Calexico (which appears in the film), Gainsbourg, and other musicians. In the beginning of the film, there is voice-over narration from country singer and actor Kris Kristofferson, a popular screen presence in such iconic 1970s films as Peckinpah's 1973 *Pat Garrett and Billy the Kid*, as Billy, and Scorsese's 1974 *Alice Doesn't Live Here Anymore*, as Ellen Burstyn's sensitive yet masculine lover.

Of the large ensemble, it's Blanchett who received particular mention for her compelling impersonation of Dylan, winning the Volpi Cup at the Venice Film Festival and an Oscar nomination for Best Supporting Actress, just two years after winning the Oscar for impersonating Katharine Hepburn in Scorsese's biopic *The Aviator*.

With *I'm Not There*, Haynes invites the spectators to enter into a unique universe and experience it viscerally—but never to forget the artifice of the spectacle, the filmic creation. In order to present and represent what he perceives as Dylan's chameleonic persona and his resistance to easy interpretation and categorization, the director reverses the conventions of the biopic genre. The narrative, dialogue, characters, and visuals are selectively drawn from Dylan's music, lyrics, and personal history. Defying generic codes, the daring and visionary *I'm Not There* is part Hollywood biopic, part deconstructive essay, part folk-rock opera, and part meditative reverie—and ambitious to a fault—which might explain its mixed critical acclaim and below-expectations commercial appeal.

HOUSEWIVES: MILDRED IN THE COMPANY OF CAROL AND CATHY

Unlike the other directors in this book, Haynes has not depicted the lifestyles of contemporary gays. Largely drawing on the past, he has set his tales in various historical decades. Chronologically speaking,

Mildred Pierce is set in the 1930s; *Far from Heaven* takes place in the late 1950s; *I'm Not There* spans two decades, from the 1950s to the 1970s; *Velvet Goldmine* is set in the late 1970s and early 1980s; *Safe* takes place in the late 1980s; and *Poison* pays tribute to various bygone periods.

Made as an HBO miniseries, *Mildred Pierce* stars Kate Winslet (who won an Oscar for *The Reader*) in the title role, bringing to life the memorable character introduced in James M. Cain's 1941 novel. Having seen Michael Curtiz's much-lauded 1945 screen version starring Joan Crawford in an Oscar-winning performance, Haynes approached the book from a different perspective. "For some reason, I pictured Kate Winslet when I first started to read the book," Haynes told me.[29] "I had never met Kate, and I hadn't worked with her before. I could not get her out of my mind. It just felt so innately right and so constitutionally correct that this was the only actress I could see playing this part. Kate became the propelling force while we were writing it and starting to visualize the piece for long-form."[30]

Haynes first read Cain's novel in 2008 at the recommendation of a friend, writer Jon Raymond. As the director immersed himself in the tale of a divorced mother, he began paying attention to her outside world, which seemed to mirror Mildred's plight—the financial markets tumbled, impacting political and cultural sectors. This broader aspect convinced him that Mildred's story felt relevant to the present, dealing with a newly divorced independent woman forced to figure out how to support herself and her family against great odds, and might resonate with today's viewers. The novel is set during the Depression, "but not the Depression of dustbowls and breadlines," said Haynes. "The crises it explores are those of middle-class privilege, issues of pride and status, the struggle to regain one's standing and then to maintian it through hard work and ingenuity. This feels very much like the particular struggles of our current economic crisis, coming out of a period of unbridled consumption."[31]

In its time, the novel was considered a departure for Cain, an acclaimed novelist whose previous 1930s works, such as *Double Indemnity* and *The Postman Always Rings Twice*, were hard-boiled, first-person crime dramas. These books served as fodder for excellent film noirs of the 1940s, the former starring Barbara Stanwyck and Fred MacMurray under the direction of Billy Wilder and the

latter with John Garfield and Lana Turner, helmed by Tay Garnett. Most domestic dramas concern characters confronting social constraints, suburban repression and vulnerability, but *Mildred Pierce* is the exception. Containing no murder or other crime elements, *Mildred Pierce* is unique in its depiction of an ambitiously successful woman operating in a male-dominated world. It's bold in its sexual honesty, as reflected in Mildred's bond with her new lover, Monty, and with her older daughter, Veda, which borders on the obsessive—and the incestuous. The incest element was not included in the 1945 film, but Haynes brings it out suggestively. He appreciated the stylistic devices of the Curtiz film, but he was more intrigued by the special relationship between the mother and one daughter, spelled out vividly in the novel, and by the complexity of both characters. He thus dwells on the unique place Veda occupies in Mildred's life, which he perceives as a tragic story of unrequited love. In lieu of the men and love objects that should define Mildred's life, it's Veda who prevails throughout.

Mildred's relationships with men are also atypical of the times. Brían F. O'Byrne plays Mildred's philandering husband, Bert Pierce, who in the book and in Haynes's version, remains Mildred's loyal friend, lending a sympathetic ear whenever needed. The teleplay ends with a toast of friendship between Mildred and Bert. (This is also the way that several Almodóvar films end.) James LeGros, a quintessential indie actor who plays Julianne Moore's friend in *Safe*, is cast as Wally Burgan, Bert's former partner who's also personally intrigued by Mildred.

Haynes and cowriter Raymond embody Cain's vision, without the murder plot that sensationalized the original film. Mirroring the novel's emphasis on women, they highlight the strength and ambition of Mildred and her daughter, showing them as more powerful forces than the men. For Haynes, "emotional dynamics are the central conflict, but they get externalized and played out through work and productivity. Issues of money, class, and status come into play in almost every relationship in our story."[32]

Haynes's reputation and creative unpredictability drew Winslet to the project. She told me: "Todd is something of an enigma. He has the capacity to change it up all the time and do something different and keep surprising audiences by taking risks. I felt that his work

ethic and his choices would go hand-in-hand with my way of thinking and the way that I like to work, which is about taking chances and thinking outside the box." Given that Winslet's Mildred appears in every scene in the film and that her character is absent from only two pages of dialogue in a 280-page script, Winslet said she was amused by the term *miniseries,* because "There's nothing mini about my character, or the story."[33] "The story is set in realms," Haynes noted. "We wanted to make sure that, as Mildred travels from realm to realm, they are both historically accurate and also distinct from one another. For Mildred, the decision to be a diner waitress is the first foray outside of her home. We wanted to show that what goes on outside the diner's windows on the streets of Hollywood is just as interesting as what goes on inside."[34]

In this conception, Monty Beragon combines dashing allure and slight seediness, qualities conveyed by the sexy Australian actor Guy Pearce (*Memento*), who shows strong chemistry with Winslet. Pearce got to the core of that blue-blood inherited way of speaking and carrying himself. His conduct stands as counter-energy to Mildred, who embodies lower-middle-class upbringing, tastes, and values. The pivotal role of Veda is played by Evan Rachel Wood, who makes her character credibly frightening in her selfish greed and ruthless demands from her mother, never concerned with paying back in attention or love.

The real sense of the desert that prevails in Los Angeles just doesn't exist in New York, where the teleplay was shot. Although Haynes utilized the streets in Peekskill, Northern Westchester County, Long Island, his crew brought in truckloads of succulents and palm, orange, and avocado trees from Florida to decorate the neighborhoods with the right look for that time period. Production designer Mark Friedberg, with whom Haynes had worked on *Far from Heaven*, effectively creates the dusty reality of 1930s Los Angeles.

Haynes's visual conception is artfully executed by Ed Lachman, his reliable cinematographer on *Far from Heaven* and *I'm Not There*. The director saw *Mildred Pierce* as akin to the great revisionist films of the 1970s, which brought "smart, relatable naturalism and frankness to updated genre films, such as *Chinatown*, *The Godfather* or *The Exorcist*. These 1970s period films were the first to dress the costume

drama with the same subtle performance, natural light, and unvarnished production that so often imbued classic genres with fresh relevance."[35]

The work of midcentury American photographer Saul Leiter inspired the particular way that Haynes and Lachman convey the period details. Leiter's use of windows, reflections, and dusty surfaces to refract his images influenced the specific mode in which the sets were built, the kinds of glass put into the houses, and the way space was structured. The challenge of evoking the era and the characters' social and professional evolution through authentic costumes was met by designer Ann Roth, who had previously worked with Winslet on Stephen Daldry's *The Reader*. Known for her attention to detail, Roth was meticulous about costume choices for each scene, considering how they informed the character's shifting mood and social status. Assisted by Roth, Haynes is able to show the specific mode in which the period's undergarments affect the way in which Mildred moves and how she feels about her body.

* * *

As of this writing, Haynes's new romantic melodrama, Carol, is set to premiere at the 2015 Cannes Film Festival, the director's second appearance (after *Velvet Goldmine)* there. Adapted for the screen by Phyllis Nagy, it is based on the novel The Price of Salt by Patricia Highsmith and features two great actresses, Cate Blanchett, fresh off her Oscar-winning turn in Woody Allen's *Blue Jasmine*, and Rooney Mara of *Girl with the Dragon Tattoo*. Though he did not write the script, set in New York City, Haynes continues to explore middle-class women living in the past, as he did in *Far From Heaven*, which starred Julianne Moore in suburban Connecticut. Blanchett's heroine is Carol, which was the name of Moore's protagonist in *Safe*. Expectations are high due to the starry cast and the cachet of the source material (Highsmith's novels have been made into successful Hollywood movies before, including Hitchcock's 1951 *Strangers on a Train* and Anthony Minghella's 1999 *The Talented Mr. Ripley*. Penned under the pseudonym Claire Morgan, *Price of Salt* was a controversial novel due to its explicit lesbian affair and unusual ending. Mara plays Therese

Belivet, a young, lonely woman working at a temp job in a depart-
ment store where she encounters the older and elegant Carol Aird
(Blanchett), a femme going through a difficult divorce from Harge.
A product of a neglectful mother who put her in a boarding school,
Carol dreams of becoming a theater designer. Though dating, she is
not in love with Richard and is reluctant to have sex with him, espe-
cially after falling under Carol's spell. Things change dramatically
when the two men, Richard and Harge, become jealous and insecure
about the deep bond that develops between Carol and Therese.

Haynes is a cult director but in different ways than Waters was in
the 1970s and Almodóvar was in the 1980s. Haynes's following con-
sists of scholars and highbrow critics who marvel at his visionary and
groundbreaking output. He also appeals to a small audience of open-
minded viewers seeking experimental independent cinema. If Waters
assumes that his public is familiar with pop culture, Haynes assumes
that his viewers possess a more highbrow knowledge of history, lit-
erature, music, and film—otherwise, they will not comprehend the
quotes from Rimbaud, Wilde, and Genet and the allusions to Welles,
Sirk, Bowie, and Dylan.

Velvet Goldmine, Haynes's evocation of the glam rock era, was
meant to be an accessible work, but it didn't cross over. Nor did it
become a cult movie, despite its hip cast, opulent visuals, glamor-
ous costumes, and original soundtrack. In twenty-five years, he has
directed only one crossover work, *Far from Heaven*, and it remains to
be seen whether *Mildred Pierce*, his foray into TV, is a single incident
or the beginning of a new path. The most remarkable attribute of
his career is his refusal to compromise his vision, even when given
a chance to make a crossover picture. He has maintained artistic
control by guiding each work through all the stages of development,
production, and execution. Early on, he relied on collaborations with
cinematographer Maryse Alberti and with actor-editor James Lyons
(also his personal companion for a while), who died of HIV complica-
tions in 2007.

Haynes's deconstructive strategy—his playing against audiences'
expectations for emotional identification—might suggest that his
films are ironic and detached. But as Justin Wyatt has shown, he is
a compassionate filmmaker who cares about his characters, even if

he refuses to sentimentalize them or turn them into role models. He is more interested in the historical construction of "gayness" than in telling stories about gay lives. None of his films has addressed the lifestyles of contemporary gays or lesbians. Most are set in the distant or recent past, from the late 1950s of *Far from Heaven* to the early 1970s of *Velvet Goldmine* and the late 1980s of *Poison* and *Safe*. Additionally, *Velvet Goldmine* and *Far from Heaven* contain issues of coming out, the standard issue of most gay-themed films, but they are not the single focus of their respective films. They form subplots in narratives that are richer, broader, and more resonant in their concerns.

TODD HAYNES FILMOGRAPHY

1985 *Assassins: A Film Concerning Rimbaud* (short)
1986 *Superstar: The Karen Carpenter Story* (short)
1991 *Poison*
1993 *Dottie Got Spanked* (short)
1995 *Safe*
1998 *Velvet Goldmine*
2002 *Far from Heaven*
2007 *I'm Not There*
2011 *Mildred Pierce* (TV miniseries, HBO)
2015 *Carol*

4

GUS VAN SANT

Poet of Lost and Alienated Youth

L IKE THE other directors in this book, Gus Van Sant is a multi-talented artist, working as a filmmaker, producer, photographer, musician, actor, and even author. He wrote some of the screenplays for his earlier movies; collaborated with other scripters on other films; published one novel, *Pink*, and a book of photography, *108 Portraits*; and filmed over a dozen shorts and music videos.

Van Sant has been one of the undisputed leaders of the new American independent cinema. An iconoclastic filmmaker, he has provided a fresh and distinctive voice over the past three decades. Unlike Quentin Tarantino, Robert Rodriguez, Steven Soderbergh, and other American directors of his generation, Van Sant employs a style that's too devious, a vision that's too personal to be easily imitated. His expressive imagery is defined by odd rhythms and jagged camera angles. Coming to filmmaking by way of painting, he is more concerned than other directors with the ability of visual images and evocative silences to tell stories poignantly, without reliance on language or dialogue. He favors images that are shot from odd angles: the grille of a car with clouds looming overhead, the edge of a pack of gum, the printing on the top of a lightbulb, the full ashtray and cigarette smoke. These idiosyncratic shots yield powerful moments that

deliberately disrupt the flow of his narratives, preventing them from being too smooth or too easy to digest.

Since the 1980s, Van Sant has reaffirmed his status as American cinema's most dedicated chronicler of youth—working-class youth, disaffected middle-class youth, regional youth, dispossessed black youth. His stories are often set in Portland, where he has lived and worked for most of his life. His explorations of society's skid row have yielded such potent films as *Mala Noche*, *Drugstore Cowboy*, and *My Own Private Idaho*. Disconnected teenagers and alienated youngsters have occupied the center of his mainstream films, such as *Good Will Hunting* and *Finding Forrester*, as well as his independent ones, like *Gerry*, *Elephant*, *Last Days*, *Paranoid Park*, and *Restless*.

Van Sant was nominated for the Best Director Oscar twice—in 1997 for *Good Will Hunting* and in 2008 for the biopicture *Milk*. The leading actors of both movies, Matt Damon and Sean Penn, respectively, were also nominated for Best Actor Oscars, and Penn won for *Milk*. Beginning with *To Die For* in 1995, most of Van Sant's features have premiered at the prestigious Cannes Film Festival, where he has won the Palme d'Or in 2002 for *Elephant* and a special award in 2007 at the festival's sixtieth anniversary.

In his films, Van Sant has dealt with marginalized subcultures, including homosexuals; however, his concern lies more with working-class youths, disregarding their particular sexual orientation or at least not dwelling on it as the crucial defining attribute of their identities and lifestyles. A running motif in his work is the painful formation of identities of lower-class adolescents. Nonetheless, unlike the sexually charged tales of Pedro Almodóvar, there is no graphic depiction of sex (homosexual or heterosexual) in his films and few overtly erotic scenes—for reasons that I will later try to explain.

EARLY LIFE AND CAREER BEGINNING

Van Sant was born July 24, 1952, in Louisville, Kentucky, to Betty (née Seay) and Gus Green Van Sant Sr., a clothing manufacturer and traveling salesman who worked his way up the corporate ladder to become

a top executive of several companies. His father's job caused the family to move frequently during his childhood. In 1962, the family settled in Darien, Connecticut, about forty miles northeast of New York City. The director later referred to his family as "corporate gypsies" because they were continually relocating during his boyhood. With his father frequently away from home, he was forced to mature and become self-reliant at an earlier age than his cohorts. More significantly, the lack of roots in one place may explain his attraction to outsiders—particularly migrant and uneducated youngsters from Mexico, seeking a better life in America.

"I had a family that moved around a lot, and I was always amassing a new group of friends. Each city had its own group of friends,"[1] Van Sant later recalled. The necessity of making new friends might have resulted in the specific themes in his work—the dispossessed family, the search for home, the embrace of new surrogate families. "For whatever reason, if it's just by chance, I'm always drawn to these stories." The constant moving did not suggest diversity, however, because all of the towns were "very suburban and very similar places." This made it easy for him to adapt to different locales but "not necessarily to blend."[2] Like John Waters and Almodóvar, early on, Van Sant realized that he was "the strange, quirky, and infamous member of the family."[3]

Like Todd Haynes, Van Sant has acknowledged the effect of particular teachers on his artistic sensibility at a crucial period in his life—when he was an adolescent. As he recalled: "I had some influential teachers in school, one was a great art teacher. There was a whole group of students who religiously took his art class. We all had to take the class, but a bunch of us worked after school because we were entertained by him and he encouraged us. He was my inspiration in the early days."[4] That the teacher was sophisticated and well versed in the new aesthetics of Andy Warhol and company was expected, but the fact that he was openly gay was unusual in the context of 1963 Connecticut. Then there was a bright writing instructor who exposed Van Sant and his cohorts to new books and showed his class Orson Welles's *Citizen Kane*, a movie whose powerful imagery and innovative techniques had an immense impact on the impressionable teenager. In this respect, his formative years and the strong influence of

particular teachers recall Todd Haynes's adolescence and stand in sharp contrast to that of Almodóvar, who is an autodidact as far as film history and technical skills are concerned.

Inspired by his teachers, Van Sant took regular trips to New York City, visiting the Museum of Modern Art and other art forums, through which he familiarized himself with the work of Warhol and other iconoclastic artists. At sixteen, he got a summer job in the mailroom of McGregor-Doniger in Manhattan, which enabled him to buy books, such as Sheldon Renan's *An Introduction to the American Underground Film*, and, more importantly, to buy a Super 8 movie camera, with which he would make several shorts in school. It was around this time that he was exposed to the experimental films of Warhol, Kenneth Anger, Bruce Conner, the Kuchar brothers, Jonas Mekas, Ron Rice, and Stan van der Beek, the same figures (more or less) that inspired Waters.

In 1970, Van Sant was accepted by the prestigious Rhode Island School of Design (RISD). At first, he was interested in painting, but after a few classes, he changed his mind, revealing his pragmatic side. Years later he told actor River Phoenix: "I changed from painting after my first year, because I thought that maybe a career in the film business was a more moneyed career. It was a safety bail-out. But, also, films were more complicated, and I'd pretty much mastered—at least in my estimation—painting. Filmmaking was a big mystery, and I thought to get anywhere in the business, I'd have to work really hard and forget about painting for a while."[5]

Van Sant's classmates at RISD included David Byrne and other members of the post-punk band Talking Heads. While at the school, he was introduced to some avant-garde directors, such as Stan Brakhage, Mekas, and Warhol. (The last had also inspired Almodóvar, albeit in different ways than Waters and Van Sant.) These encounters with the edgier, more offbeat figures of American cinema further encouraged Van Sant to change his major from painting to cinema. The aforementioned directors had long-lasting effects on him at an impressionable age.

After spending some time in Europe, Van Sant moved to Los Angeles in 1976, where he worked as a production assistant to writer-director Ken Shapiro. As noted, Van Sant has lived and worked in Portland for most of his life. Just as Waters has a deep connection

to Baltimore, he feels a personal and professional affinity with the Pacific Northwest; as he explained: "I like shooting here, because it's where I live and it's accessible."[6] Tame and friendly, Portland, the City of Roses, is almost the opposite of Los Angeles: "People here tend to be more eccentric than people elsewhere. This place is full of folks who disdain the things that you might go to L.A. for, like a big house, a lot of money, ego."[7]

In 1977, Van Sant made a short, *The Discipline of D.E.*, based on an essay by his hero William S. Burroughs Jr., in which the filmmaker tried to explain the art of DE, or "Doing Easy." The short was shown at the 1978 New York Film Festival to great acclaim, indicating to the young director how important festival showings are. An unsettling sensibility has prevailed in his work since *The Discipline of D.E.* and another twenty-minute short, *The Happy Organ*. Produced in collaboration with a high school classmate, the latter concerns two siblings who go on a weekend trip that ends tragically. (A similar story is told in his 2001 film, *Gerry*.)

While on the East Coast, Van Sant got a job at the Cadwell Davis ad agency in Manhattan as an assistant production manager, making the estimable salary of over $40,000 a year. Like all the other directors in this book, he experimented with 16mm shorts before daring to make a full-length feature. One of those was a personal short documentary, sort of a "coming out" on screen, titled *My New Friend* and lasting all of three minutes, which he narrated in a deadpan style: "I'm falling in love with a guy. So that's frightening, isn't it? It's frightening to me?" Other shorts included a three-minute tribute to his paternal grandmother, Dorothy Green Van Sant, titled *Where'd She Go?* and a longer short (seven minutes) about an anonymous caller, which he named *Nightmare Typhoon* (aka *Hello, It's Me*).

Van Sant first attempted a feature in 1980 with *Alice in Hollywood*, a troubled film that suffered from protracted production and editing processes. The film went through various versions, though none satisfying to the director or to the few viewers and critics who saw it. Based on firsthand observations of life around Hollywood Boulevard when he lived there in the late 1970s, his dark, ironic version of *Alice in Wonderland* centers on a naïve actress who goes to Hollywood to become a star, but in the end, she is forced to abandon her dreams

and winds up as a street urchin. Though never released theatrically, *Alice in Hollywood* proved to be an extremely useful learning experience for the fledgling director. During that period, he began observing the down-and-out parts of Hollywood Boulevard (way before it was renovated and Disneyfied). Through these "trips," Van Sant, a white, upper-middle-class man, became aware of the beauty and distinction of marginal subcultures, which stood in sharp contrast to the more prosperous worlds that surrounded them, the Hollywood Hills and Beverly Hills.

Though he had never concealed his sexual orientation, Van Sant described himself as "openly gay" only in the early 1990s. He was exposed to gay life in Manhattan (the West Village) in his late teens and early twenties, but by his own account, he was a late bloomer, coming out at age thirty: "I wasn't really out in the 1970s, I was locked in my film world, I was writing scripts."[8] Even so, he was aware that "my films were about gay characters. They were what brought me out of the closet. That's what my interest was, the gay characters and gay stories. And I was gay, when my private life became my public life."[9] For him, gay is "a political term that's printable, and so it's printed." But he claimed: "It's not exactly how I orient my life. It's not how I view myself."[10] As a result of his philosophy, the director has declined to problematize gay identity and sexuality in his films, based on his background and his belief that there is nothing problematic about gay men or gay subcultures. For him, gay subcultures are among the many distinct subcultures that coexist alongside other distinct subcultures in society, be they defined by age, social class, or ethnic background.

Van Sant's most articulate statement on the issue is found in a *Rolling Stone* interview: "I haven't really personally felt any discrimination, but I'm not really that spotable as a gay male. Your sexuality is a private thing—and as far as culture goes, I don't think of a gay culture as separate from mass culture. I just look at it as human culture. It's obvious there's all kinds of stuff oriented toward heterosexual culture, because that's the majority, but it's also oriented toward white culture, because that's also the majority. It's not surprising, and it doesn't bother me."[11] For him, it's a matter of perspective, of one's membership and reference groups, to use a more sociological jargon.

As he explained: "Inside certain artistic cultures, a lot of friends of mine that are straight feel left out, because the major composers and artists of this century are all gay. They feel inferior to the point where they wish they were gay. So it just depends on what group you want to join."[12] He has not used same-sex relationships in his films as social messages or political statements, even when such relationships occupy the center of his films, as in *Mala Noche* or, most notably, in *Milk*.

Van Sant has not been a political activist; as he explained: "I don't think you have to align your whole life in any particular quest, unless you want to. The work itself is the political part. But me as a spokesperson, no. I'm just a person behind the camera."[13] Nonetheless, he liked the idea that many of his films had premiered as benefits for gay causes—specifically, AIDS. For example, *To Die For*, which is not a gay film, premiered in New York City on September 25, 1995, as a fund-raiser for the National Gay and Lesbian Task Force.

PERSONAL MOVIES

Like other intellectually curious youths who came of age in the 1960s, Van Sant opened himself up to the subcultures of the Hippie and Beat Generations. He read and cherished such writers as Beatnik Jack Kerouac (his seminal *On the Road*), gay Jewish poet Allen Ginsberg (*Howl*), and especially Burroughs (whose surreal, drug-infused literature includes *Naked Lunch*). He has never concealed his experimentation with drugs; as he confided in 1989: "Drugs played a big role in my life in the 1960s and 1970s, and I was pretty familiar with pot and LSD during that period."[14]

Like Almodóvar, who is older by three years, Van Sant has made eighteen features to date, though unlike Almodóvar and Haynes, at least half of his features are based on previously published sources or scripts not written by him. As writer and director, he has adapted to the screen Tom Robbins's novel *Even Cowgirls Get the Blues*, which features a diverse cast (Keanu Reeves, Roseanne Barr, Uma Thurman, and k. d. lang). *My Own Private Idaho*, his most original and celebrated film, which featured two up-and-coming stars, Keanu Reeves

and River Phoenix, also derives from existing sources on which he has unmistakably put his idiosyncratic signature.

Based on relatively low budgets, Van Sant's movies have examined the lives of individuals who inhabit society's underground. However, despite their bleak circumstances, his films display a nihilistic, often subtle humor—but are decidedly not camp. He has made wildly subjective pictures that celebrate outsiders: illegal immigrants, male hustlers, dropouts, and drugstore cowboys. In depicting drug addicts and male prostitutes, he has revealed their humanity without exploiting their tawdriness. His eccentric POV provides an intimate look at down-and-out characters—individuals on the fringes of society—which he neither glorifies nor condemns. He doesn't expect his audience to take such a stance either. It's as if his camera was looking through a peephole, dropping in on secret lives and exposing their elements. Though drawn to realistic issues and grounded characters, he treats them playfully. *Village Voice* critic Jim Hoberman has justifiably singled out "the unabashed beatnik quality to Van Sant's worldview."[15] The director's attraction to street youths and their sordid milieu is based on his belief that they are more interesting to observe and that there's more drama in their lives than is the case with bourgeois characters.

In his first three films, which are thematically linked, Van Sant showed a natural lyrical touch and an instinctive feel for recording lowlifes that is free of any judgment—there was neither condescension nor romanticizing.

Van Sant's first feature, *Mala Noche* (*Bad Night*), put him on the map of the then nascent independent cinema. It follows the doomed infatuation of Walt (Tim Streeter), a clerk in a skid-row convenience store, with the hunky Mexican immigrant and street hustler Johnny (played by Doug Cooeyate, a Pueblo Indian), who barely understands English. The film's source material is a novella by Walt Curtis, a Portland street poet. The director kept the manuscript, which was "sexually explicit like a dirty book," under his bed for years, reading and rereading it, eagerly waiting for the time he could translate it into a personal film.

Mala Noche begins with images of outsiders, down-and-out characters in the marginalized section of Portland's inner city. After the

credits, there is a slogan: "If you fuck with the bull, you get the horn." Walt, a thirty-something white homosexual, likes the company of migrant workers. Van Sant cast his leads with local Portland figures that do not look like Hollywood actors playing male hustlers, as was the case with handsome Richard Gere in Paul Schrader's glorified portrait *American Gigolo*. Thus, Walt is played by Streeter, a plain, chubby, ordinary-looking Seattle stage actor.

The main thread of the plot is Walt's sexual attraction to Johnny, an illegal newcomer who wanders into his shop. Van Sant shows the Northwest landscape from Johnny's POV, first seen from a railroad boxcar. The narrative, which is slight in ideas but rich in imagery, unfolds as a variation of *amour fou*, in which a mature Caucasian man is first infatuated and then obsessed with a Mexican youngster who doesn't care about him. By the standards of most characters in American cinema, Walt is a loser—he is unkempt and unshaven, wears an old and dirty raincoat, and spends hours in seedy bars drinking. He proudly declares to a female friend: "I'm in love with this boy. I don't care even if it jeopardizes working at the store. I have to show him I'm gay for him."

Johnny, like other runaways and street hustlers, enjoys playing with his buddies in a video arcade. Insisting he is straight, he says he doesn't like *putos*, a pejorative term for homosexuals. In Almodóvar's films, the straight men use the equally pejorative term *maricones*. Nonetheless, Johnny makes exceptions if the gringos have money—cash money—and cars. Socializing with white gay men is tolerated so long as they provide materialistic favors, functioning as "friends with benefits." Essentially, Johnny exploits Walt, eating at his expense and driving around in his car. Never mind that the vehicle is ramshackle; it still enables Johnny to show off to his Mexican mates, who are poorer than he is.

Johnny's closest buddy is Roberto, nicknamed Pepper, played by local amateur boxer Ray Mongue. Based on mutual exploitation, the relationship between Walt, as the older mentor-tutor, and Johnny and Pepper, as the uneducated but desirable simpletons, is peculiar, to say the least. It is defined by occasional sexual encounters and laced with touches of sadomasochism. When Walt allows Pepper to drive his car, the boy proves to be a lousy driver, landing the car in a

ditch, despite Walt's careful instruction. "You drive like you fuck," the exasperated Walt says.

When Johnny mysteriously disappears, Walt switches his attention to Pepper, taking care of him when he is ill and trying to have sex with him (in any position Pepper consents to). Melodrama kicks in when the police arrives at Walt's place and Pepper, afraid of being deported, attempts to flee with a stolen gun in his hand, forcing the police to shoot him. All that Walt can do is hold the dead boy in his arms.

In the next sequence, Walt spots Johnny, who had been sent back to Mexico as an illegal alien but managed to come back to Portland. Their friendship resumes until Johnny finds out about Pepper's death, for which he unfairly blames Walt. Rushing out in anger, he writes *puto* on Walt's door and leaves. Unfazed, the passive-aggressive Walt continues to pursue Johnny, and the tale ends ambiguously with Walt driving down the street.

It's hard to describe Walt's encounters with Pepper as real lovemaking, reflecting Van Sant's shy personality, his conservative upbringing, and the refusal of his "actors" to be shown naked or engaged in any explicit sexual positions. There's extreme cautiousness in showing briefly frontal nudity, when Walt strips off his clothes. Van Sant just shows Pepper spread on a sleeping bag on the floor. Through meticulous editing and darkly shadowed intercuts, the director creates the illusion of intercourse, focusing on the participants' faces rather than their bodies. As a director, he didn't like the way sex was depicted in Hollywood movies because "a lot of times sex scenes become a bumping and grinding activity, which is not particularly sexy."[16] This ultracareful approach to sex would continue to characterize his films, even when they concern straight lovemaking, such as the oral sex between Nicole Kidman and Joaquin Phoenix in *To Die For*.

Van Sant's motivation behind *Mala Noche* was to make an honest, nonjudgmental movie about a subject that mainstream Hollywood would never touch. He financed the black-and-white film himself and shot it on cut-rate stock. The meager $25,000 budget came from Van Sant's savings after years of working at an advertising agency in New York. Low as its price was, however, it took almost a decade for the film to recoup its expense.

Van Sant said that *Mala Noche* was inspired, among other things, by the commercial appeal of the 1981 gay movie *Taxi Zum Klo* (*Taxi to the Toilet*), which screened at the New York Film Festival and then played commercially in New York's Cinema Studio (my neighborhood) for months. In that personal movie, German director Frank Ripploe chronicles in graphic detail and with dark yet realistic humor the sexual adventures of a gay schoolteacher in West Berlin. The film culminates boldly with the teacher coming out (in drag) in front of his pupils in class. Van Sant was encouraged that *Taxi Zum Klo* "was making a lot of money and though it was so out there, very straight audiences went to see it. I remember that being a signal that I could make a film about a gay character and get my money back."[17]

Other artistic influences on Van Sant included David Lynch, who shot his first two movies—the underground *Eraserhead* in 1977 and the studio-financed, star-driven *The Elephant Man* in 1980—in heightened black-and-white contrasts. The former, produced with assistance from the American Film Institute while Lynch was studying there, was particularly influential in its lighting style and expressionist visuals. *Mala Noche* contains expressive close-ups of Mexican youths; dark shots of ashtrays, cigarettes, and smoke; and other images that fit into the tale's nocturnal nature.

The locations in *Mala Noche* are the grim sites of Portland's Burnside region: shabby buildings, rundown motels, cheap grocery stores, and filthy streets. Mixing distinctive exterior vistas of the Pacific Northwest with nihilistic, darkly humorous sensibility marked the arrival of an exciting talent. *New Yorker* critic Pauline Kael singled out the film's "authentic grungy beauty" and its "wonderfully fluid grainy look," which she found expressionist yet made with an improvised feel that recalls Jean Genet's short film, *Un chant d'amour*.[18] (Genet proved to be an inspirational figure to all the filmmakers in this book.) *Mala Noche* received scant attention before winning the Los Angeles Film Critics Association Award for Best Independent Film, in appreciation of its authentically personal nature. This recognition emphasized the importance of critics for the promotion of esoteric fare, turning *Mala Noche* into a staple of the festival and art-house circuits.

It took years for *Mala Noche* to get a legitimate theatrical distribu-
tion beyond the festival circuit—until December 1989 to be exact—
and to recoup its expense. Contrary to Van Sant's expectations, *Mala
Noche* was perceived and received as a more ghettoized film than *Taxi
Zum Klo*. By that time, he was already in his late thirties and about
to release his next feature, *Drugstore Cowboy*. Following Kael, other
critics responded favorably, as evident in the review of Peter Rainer, a
Kael protégé: "The ardor in this film isn't only in its love story; it's also
in Van Sant's experimental, poetic use of the medium." Rainer stated
that "Van Sant can't pretend true nihilism, because he is too enrap-
tured in the possibilities of his new-found art."[19] Other critics also
singled out the director's penchant for depicting the romanticism of
losers, without succumbing to soft-headedness or sentimentalism.
In the *Washington Post*, Hal Hinson observed: "Van Sant is fascinated
by the poetic allure of poor beautiful boys riding the rails into the
Promised Land and ending up dead, crumpled on the pavement in
the middle of a street, thousands of miles away from home."[20]

Mala Noche has remained a model of film grunge for young inde-
pendent directors. It displays ideas and themes that would recur in
Van Sant's future works: unfulfilled love, unrequited romantic yearn-
ing, and a vivid sense of life's ironies and absurdities. Most relevant
to this book's concerns is his refusal, from the beginning of his
career, to treat homosexuality (and sexual orientation) as a "prob-
lem" or a phenomenon that needs to be discussed or judged in any
explicit way. The sexual orientation (lesbians and straights included),
sexual practices, and sexual identities of his characters are taken as
given, alongside other social attributes. In *Mala Noche*, Johnny's and
Pepper's Mexican backgrounds, minority status, social class, and
outsider position are far more important than whether or not they
sleep with Walt or how they perceive themselves sexually. The direc-
tor doesn't define Johnny and Pepper as male prostitutes; they are
just street hustlers who would sleep with anyone for a few bucks.

Earning acclaim beyond the festival circuit, *Mala Noche* soon
attracted Hollywood attention, and Van Sant was courted by the
major studios, such as Universal. He pitched some ideas (that would
materialize in future movies, *Drugstore Cowboy* and *My Own Private*

Idaho), but the established companies showed no interest in such "esoteric" and "risque" projects.

* * *

Van Sant's next film, *Drugstore Cowboy* in 1989, was a logical follow-up to *Mala Noche*, focusing on a gang of junkies who rob pharmacies to support their drug-induced lifestyle. Efforts to secure Hollywood backing for the project were thwarted by his nonjudgmental approach. It was, after all, the era of Nancy Reagan's "Just Say No," a hollow, sloganeering prescription for a drug-free America. The scenario was rich with procedural details of how to obtain and use drugs, and studio executives feared that the movie would promote drug abuse. Recalled Van Sant: "A lot of people in Hollywood said this is 'an immoral film' that promotes drug use."[21] Anticipating some backlash, he could see how the sympathetic characters could motivate amateur junkies to further their drug habits to an extreme. "The movie may make a junkie want to go out and take drugs," Van Sant commented semiseriously, "but the movie isn't a political statement about drugs."[22]

A newly formed independent company, Avenue, which favored more personal, offbeat, and unorthodox films (such as Alan Rudolph's *Choose Me*, in 1984), put up the necessary $6 million. The project was produced by Laurie Parker, who had a track record with such indie titles as Spike Lee's striking debut, *She's Gotta Have It*, and Jim Jarmusch's widely praised sophomore, *Down by Law*, both of which came out in 1986. Going from the self-financed $25,000 budget of *Mala Noche* to the ultimately increased budget of $7 million was not just impressive; it also brought about significant changes in the filmmaking process: preproduction, casting, shooting, and editing. The bigger budget enabled Van Sant to work with a professional ensemble, headed by Matt Dillon and Kelly Lynch; to cast one of his heroes, novelist William S. Burroughs Jr., as a junkie priest; and to pay all of his actors decent fees.

The film's script, cowritten by Van Sant and Daniel Yost, a journalist for the *Oregonian*, was based on an unpublished autobiographical novel by James Fogle, an inmate at the Washington State Penitentiary.

Fogle claimed that the lead, Bob Hughes, was a composite character made up of several drugs thieves, but others felt that the novel incorporated many of Fogle's own experiences. The director was attracted to the gritty quality of the writing and to the subjective perspective of the central con man, who is also the narrator. To ensure authenticity, he ran his ideas by Jim Carroll, the former drug abuser and author of *The Basketball Diaries*, a critically acclaimed memoir about the drug culture, published in 1978 and made into a 1995 movie, starring the young Leonardo DiCaprio and Mark Wahlberg. Other texts that inspired *Drugstore Cowboy* included *Junkie*, the pioneering 1953 chronicle by Burroughs, and Larry Clark's books of illuminating photographs, *Tulsa* and *Teenage Lust*, which portray drug addicts in graphic mode. Van Sant would produce Larry Clark's feature-directing debut, *Kids*, in 1995 (see the discussion later in this chapter).

Remarkably, Van Sant was able to avoid turning the film into a platform for an antidrug message. As he explained: "Not being a drug addict myself, I was making it for myself, and for the lay public, as a way of experiencing the life of a drug addict." In fact, for him, *Drugstore Cowboy* was an antidrug story: "It was like an anti-war film that has a lot of killing in it. My position on drugs comes through if somebody is really looking for it, and though my position is admittedly lightly ambiguous, it was never my intention to make a pro-drug film."[23]

Nonetheless, Van Sant felt strong enough pressures, forcing him to make several concessions or compromises. The tale's setting was moved back to 1971, a more naïve era, in which dope and other drugs still projected an aura of cool hipness. The new historical setting eliminated the specter of AIDS and the effects of crack, the lethal drug of the 1980s. The subject matter was not entirely new: several bold movies about drugs had already been released, including Roger Corman's LSD chronicle, *The Trip*, scripted by Jack Nicholson; *Panic in Needle Park*; and, of course, the Dennis Hopper-Peter Fonda iconic *Easy Riders*, in 1969. *Drugstore Cowboy* makes no references to politics or to the outside reality of the Vietnam War, the Columbia University Student Revolution, the Kent State Massacre, or President Nixon.[24] The director also turned Bob into a more sympathetic character by adding self-redemption to the tale. In the last chapter, Bob decides

to go straight, checking into a rehab facility. And in the ambiguous finale, having been shot and wounded, Bob is taken in an ambulance to the hospital.

Casting the good-looking and charismatic Matt Dillon as Bob made the antihero even more likable. In his appealing screen persona, he combined street toughness and emotional vulnerability, traits that are crucial for humanizing Bob's character. Dillon, then twenty-five, was a heartthrob who made an impression in his 1979 debut, *Over the Edge*, and then in Francis Ford Coppola's *The Outsiders* in 1983, but in the late 1980s, his career was already in decline. As much as his director, he needed a good movie to put him back on the map.

A chronicle of the (mis)adventures of petty criminals, *Drugstore Cowboy* provides an inside view of the drug world and its inhabitants, youths proud of their aimless existence. Though lyrically shot and boasting an offbeat nonchalant tone, by Van Sant's standards the film is a tad too conventional in its linear narrative. The film-journal follows a quartet of bumbling outlaws that forms sort of a nuclear family. The clan is made up of Bob; his wife, Dianne (Kelly Lynch); the younger member, Rick (James LeGros); and Rick's girlfriend, Nadine (Heather Graham). The two couples differ in age and experience. Bob and Dianne are married and in their late twenties; Rick and Nadine are naïve and younger, in their early twenties. In many ways, the younger ones function as surrogate children—similar to the way that Sal Mineo's latently gay Plato related to his classmates' parents, James Dean and Natalie Wood, in Nicholas Ray's 1955 cult classic, *Rebel Without a Cause*.

In the opening scene, Bob struts down the street, complimenting a female pedestrian on her hat, stopping by a water fountain, and then heading into the pharmacy he plans to rob. He is followed by the gang's members, who enter one by one in order to distract the owner's attention. Suddenly, Nadine fakes a seizure that creates a chaotic panic, giving Bob an opportunity to sneak into the offices and clean out the shelves. By the time the alarmed pharmacist calls for an ambulance, Nadine simply gets up and leaves—to the amazement of the customers there. After the heist, Bob shoots up in the backseat of the getaway car driven by Dianne, who reproaches him for being impatient.

As Bob trips, we see his subjective reverie in which various objects float—spoons, toys, airplanes, cows, and chickens—reflecting Bob's childlike and childish nature. It's Van Sant's homage to *The Wizard of Oz*, the MGM fantasy film that has influenced every director in this book (and many others, like David Lynch). The druggies practice their craft, robbing drugstores and hospital pharmacies for only one purpose, to satisfy their personal needs. They aim low: all they hope for is to elude the law and find a new haven—at least for a while—and this temporary haven is treated by Van Sant as a fairy-tale land.

Early on, they are visited by David (Max Perlman), a young junkie who lives nearby. Feeling superior, Bob treats David with contempt; there will be grave repercussions for his mistreatment. Occasionally, the gang's motel rooms or temporary apartments are ransacked by law enforcers, led by Gentry (James Remar), a narcotics officer who is engaged in a cat-and-mouse chase with Bob and is determined to throw him behind bars. Bob concocts an intricate plan that causes one of Gentry's officers to be shot by an angry neighbor. Bob manipulates the neighbor, claiming that the neighborhood is unsafe at night and that there are all kinds of strangers climbing up ladders and peering into the residents' bedrooms. Later, when Gentry beats up Bob in retaliation, Bob knows that their luck in this particular location had ended, and they leave in a hurry. "The Israelites," the popular tune by Desmond Dekker and the Aces, injects joy, vitality, and continuity as the band moves from one location to another.

On a rare excursion outside of their immediate locale, Bob and Dianne visit his mother (Grace Zabriskie), not because he misses her but for practical reasons—to get his remaining clothes or steal cash from her. In one of their drugstore raids, they get the strong drug Dilaudid, which Van Sant shows in close-ups to accentuate the "wow" effect. Later on, Bob narrowly misses the police at a motel when, ironically, the law officers meet for a convention and his room is needed.

Unfortunately, when they are on one of their missions, Nadine overdoses and dies. While Nadine's corpse is hidden in the ceiling crawlspace, Bob has a nightmare in which he sees himself caught and handcuffed. Believing that Nadine's death is an omen, he decides to abandon drugs, but he leaves alone, as Dianne cannot exist without drugs and doesn't wish to reform.

At a rundown hotel, Bob encounters Tom (Burroughs), a former priest and longtime addict who had initiated Bob into substance abuse. Displaying an acting style that differs from the naturalistic performances of the other members, Burroughs raves in long, angry, feverish monologues. Dianne later visits Bob, insensitively leaving him drugs, which he hands to the more appreciative Tom. Their farewell is decidedly unsentimental: Dianne tells Bob that she is now working for Rick, who is also her lover. Shortly after, David breaks into Bob's room, and when Bob claims that he has no drugs, David shoots him. Earlier Bob had interrupted a street fight, stopping David from harassing a crying teenager. But, again, living by his inner code, Bob refuses to rat on David and doesn't inform Gentry as to who had shot him.

Subjectively, the members of the quartet see themselves as romantic figures, sort of contemporary Bonnies and Clydes. However, Van Sant takes a more satirical approach, emphasizing their foolish petty crimes and the fact that their robberies involve low stakes. They steal drugs for self-consumption, not for profit, and some of their adventures end in a shambles. Their lives are devoted to pleasure, and their activities are subsumed under the goal of, as Bob says, "getting happy and staying happy."

A comedy of the absurd, defined by expressionist visuals and a surreal tone, *Drugstore Cowboy* is more humorous than grim or somber, which it could have been in the hands of another director. Van Sant makes the story less bleak, without sacrificing the spirit of the original source material. The text's offbeat absurdity derives from his insights into the peculiarities of the junkie subculture and from his idiosyncratic direction. Observed from the POV of the junkies, the film depicts their states of high, when they are on drugs, and their states of low, on the rare occasions when they are sober.

The film's spirit is deliberately removed from reality: Van Sant does not try to show their experiences from a "more objective" perspective. The tale unfolds as a fairy tale where everything (almost) works out in the end. When the characters are high, they are goofy and funny, but there is also the downside, when the junk wears out. *Drugstore Cowboy* is a black comedy about addicts who are immoral but not amoral. In fact, far from being unprincipled, they live by a strict code of ethics

that dictates how to behave in varying conditions. Bob has his own set of rules as to what is right and what is wrong, and he is extremely superstitious about what brings him good or bad luck. The gang's "Ten Commandments" are expressed by Bob when he is sober: "You should never look at the back side of the mirror, because you'll be looking at your inner self. The owner of a hat may have the evil eye, so if anyone puts a hat on a bed, it signals trouble." All cats, not just black, are bad, and talking about dogs is really bad, as is shown in a flashback about the tragic death of Bob's own dog.

Van Sant avoids preaching a hypocritical antidrug message, maintaining a nonjudgmental attitude toward his characters. He said that he didn't want the characters to do anything that was inconsistent in order to just satisfy generic conventions of Hollywood movies or to please the expectations of audiences conditioned by mainstream cinema. The humor is low-key but not punched up, and even the witty one-liners are not overemphasized. In a scene between the always-horny Dianne and the laid-back and not particularly sexual Bob, Dianne complains, "You don't fuck me anymore, and I have to drive." While in the methadone program, the shamelessly unrepentant Bob explains to the drug counselor (played by Bea Richards, Sidney Poitier's mother in *Guess Who's Coming to Dinner?*) that people who use drugs are trying to "relieve the pressures of everyday life, like having to tie their shoes."

The frenetic life of petty crime and drugs defines a subculture that's both specific and restrictive. The members' sole focus—their raison d'être—is satisfying their drug needs in the fastest way possible. Their world is guided, as Bob says in one of his voice-overs, by "the dark forces that lie hidden beneath the surface, the ones that some people call superstitions, howling banshees, black cats, hats on beds, dogs, the evil eye."

Refreshingly, the characters do not represent familiar types. Bob is street-smart but superstitious, living by his wits, showing intuitive feelings as to when to move ahead with the raid and when to lay low. He claims that inner voices tell him: "Get out there and get it. It's there for the taking. It's free this week." Dianne, Bob's drug-dependent wife, is feisty, tough, and randy. Rick, Bob's second in command, is a minor-league criminal, full of contradictions: he could be clear

but also vapid, tough but also gentle, goofy and serious. Nadine, the amateur grifter, is a confused, insecure girl who needs to be loved. Though a novice, she tries to assimilate into the group (too) quickly. She insists on getting her fair share after her first heist and demands to shoot up, just like the rest of the clique.

With all my admiration, the film is not flawless. The secondary roles—including David, the neighborhood druggie and small-time dealer, and especially Gentry, the pursuing police officer—are underdeveloped and used mostly to fulfill plot points. Burroughs appears as Tom, the former priest, in the last, nearly surreal sequence, set in Seattle's shabby St. Francis Hotel. Initially, Tom had been written as a pathetic loser, but with his pride, gravitas, and acting, Burroughs elevates him to another level. His strong interpretation, however, makes the role bigger and stronger, and in some ways, he throws the film off balance because the other actors engage in more naturalistic performances.

If Almodóvar and Haynes tend to defamiliarize the familiar aspects of life, Van sant likes to do the opposite, to show ordinary objects in extraordinary ways, reflecting the protagonists' skewed vision, particularly when they are high. In Bob's reveries, objects float on and off the screen or spin against swirling clouds whose colors change. After burying Nadine, for example, Bob experiences another vision, in which hats are flying in front of his eyes. The usual stylistic device of showing objects in close-ups, first impressing in *Mala Noche*, recurs here with coffee cups, lightbulbs, lit cigarettes, and cluttered ashtrays. Often punctuating the end of a scene, the objects are used as abstractions of visuals that reflect Bob's fertile mind and distorted memory but that also express the director's idiosyncratic vision.

The careful choice of décor contributes in establishing the film's offbeat tone. In *Drugstore Cowboy*, green is the dominant color: there are green cars, green clothes for Dianne, green furniture, and green walls, not to mention the natural green of the Pacific Northwest.[25] The movie was shot in the late fall, and the dry season with its overcast skies allowed cinematographer Robert Yeoman to shoot most of the outdoor scenes in natural light. The costume design is distinctive, too, replacing the customary Hollywood gear of tight blue jeans and torn white T-shirts, worn by James Dean and Marlon Brando in

their rebel movies (*Rebel Without a Cause* and *The Wild One*, respectively). Instead, Bob wears V-neck and mohair sweaters, velour shirts, and plaid slacks, and the director makes sure that we observe the brown shoes that he wears, in lieu of the customary sneakers or boots in mainstream Hollywood movies.

Critic Paul Andrews singled out the quality of *Drugstore Cowboy* for its blend of "absurdist humor with near-documentarian realism." In this movie, he wrote, "drugs have a certain fascination. They open up your consciousness. They're fun. They carry the danger of any addiction, but do not turn everyone's brain to fried eggs. They're like fast food, except that fast food takes longer to kill you and is legal."[26] For Kael of *The New Yorker*, Van Sant's films are "an antidote to wholesomeness" because they manage to achieve a controlled style out of the random and the careless.[27] Indeed, *Drugstore Cowboy* was an antidote to John Hughes's naïve youth movies, such as *Pretty in Pink*, *St. Elmo's Fire*, and others, starring the Brat Pack, which were produced at the same time. It was also a counterpoint to yuppie films made in the late 1980s, such as *Less than Zero*, about rich upper-class youths.

The National Society of Film Critics (NSFC) named *Drugstore Cowboy* the Best Picture of 1989, Van Sant the Best Director, and his original scenario the Best Screenplay. The scenario was also honored by the New York Film Critics Circle and the Los Angeles Film Critics Association. Van Sant was the surprise winner of the NSFC over such promising talents as Spike Lee and Steven Soderbergh, both of whom made breakthrough films that year—*Do the Right Thing* and *sex, lies, and videotape*, respectively. Both films played at the 1989 Cannes Film Festival, and *sex, lies, and videotape* won the festival's top Jury award, the Palme d'Or. A major contender for the Spirit Awards (the Oscars for indies), *Drugstore Cowboy* swept many kudos: screenplay, male lead (Dillon), supporting male (LeGros), and cinematography (Robert Yeoman).

Commercially, the movie grossed $4.7 million in its initial theatrical release, an impressive figure for an American indie but not vis-à-vis its considerable budget of $7 million. Soderbergh's *sex, lies, and videotape* was made for $1.2 million and grossed $25 million, and Lee's debut cost much less but earned over $7 million. Nonetheless, the picture performed better in ancillary markets, on video and DVD.

More important than box-office gross was the critical acclaim: *Drug-store Cowboy* furthered Van Sant's reputation as a gifted director who could make personal yet accessible indies. It also helped revitalize the career of Matt Dillon, who would appear in Van Sant's *To Die For* in 1995.

Films with similar themes or issues often appear in cycles, as was the case with the new black cinema of the late 1980s and early 1990s. The work of Lee (*Do the Right Thing* in 1989), John Singleton (*Boyz n the Hood* in 1991), and others was energized by the broader sociopoliti-cal context of American society at that time. Similarly, specific fac-tors have affected gay cinema of the 1990s, prime among which was the AIDS epidemic. For years, there was fearful avoidance of dealing with the AIDS phenomenon, and then controversy erupted over the kind of "morally responsible yet realistic" entertainment that art-ists should be making about AIDS. As I showed earlier, this dilemma became clear in the reception of Haynes's *Poison*, which came out in 1991, the same year that Van Sant made *My Own Private Idaho*.

The exploration in *Drugstore Cowboy* of young hustlers living on society's outer fringes, as well as the film's Portland settings, is also manifest in the critically acclaimed *My Own Private Idaho*, arguably Van Sant's strongest, most ambitious feature. Once again, he chose a subjective perspective, presenting the narrative from the POV of the protagonist, Mike Waters, an apocalyptic street hustler. In earlier versions, the director entertained other titles for his film, such as *In a Blue Funk* and *Minions of the Moon*. The film's ultimate moniker derives from a song lyric by the rock group B-52 and also from Van Sant's trips to Idaho. He has always regarded Idaho as more than just a geographic place—for him, it is a state of mind, a refuge taken for comfort.

* * *

After the critical and commercial success of *Drugstore Cowboy*, the studios courted Van Sant with lucrative offers, but he resisted the mainstream. His interest in *My Own Private Idaho* was deemed "too risky" by the studios. After all, one of the very first scenes depicts the hero, Mike, having oral sex for pay with an older man in a seedy motel.

However, with the support of bright young executive Cam Galano of New Line Cinema, the director got the green light for a $2.6 million movie, to be released by Fine Line Features, the art division of New Line, soon to be headed by the entrepreneurial Ira Deutschmann.

A personal film, *My Own Private Idaho* reflects some of Van Sant's own experiences. Michael Parker, a homeless street hustler who smokes pot, served as inspiration for the character of Mike. Scott Favor, the tale's other lead, is a rich boy who goes slumming in the underbelly of Portland and Seattle. As the product of an upper-class family, the director could relate more easily to Scott: "Scott is, or could be, me, coming from the blue-blood and royalty of Portland."[28] The project became even more personal when he cast himself in the film as the ponytailed bellboy in the Idaho hotel.

While the film was in the planning phases, Michael Parker was supposed to play Mike, and Rodney Harvey was going to be Scott. Both were close to Van Sant: Parker played the harassed youth in *Drugstore Cowboy*, and Harvey, an Andy Warhol alumnus, was pulled out of that picture due to drug problems. But the critical acclaim of *Drugstore Cowboy* enabled the director to send the script to bigger casting agencies. After struggling with some talent managers due to the script's risqué contents, he was able to get a high-profile ensemble, headed by River Phoenix and Keanu Reeves in the lead roles of Mike and Scott, the appealing street hustlers. In a bizarre turn of events that seldom happens, the real-life hustlers on which the fictional Mike and Scott are based appear in the movie in smaller roles.

The film is cast with eccentric actors, many of whom are veterans of Van Sant's previous efforts. The chicken hawk Bob Pigeon, an unappealing part, is played by filmmaker William Richert (*Winter Kill*, among others). Robert Lee "Bob" Pitchlynn (a veteran of bits in previous Van Sant films and the inspiration for the Bob Pigeon character) was cast as Walt, the first john who performs fellatio on Mike. Grace Zabriskie, who had played Matt Dillon's mother in *Drugstore Cowboy*, appears as a wealthy matron who pays for the company of younger men. The European gentleman Hans, a traveling car parts salesman who likes male hustlers, was played by German actor and cult figure Udo Kier, who had earlier scored in Warhol's productions of *Blood for Dracula* and *Flesh for Frankenstein*.

My Own Private Idaho won the Independent Spirit Award for Best Screenplay, and it also gained River Phoenix the Best Actor honor at the Venice Film Festival. Quite established for his age, Phoenix had already impressed in *Stand by Me* (1986) and received a Best Supporting Actor Oscar nomination for *Running on Empty* (1988), Sidney Lumet's political melodrama. Van Sant's feature also helped Keanu Reeves, then best known for his *Bill and Ted* movies, to get better screen roles.

Thematically, the film explores the notions of being an outsider (even if one belongs to the upper class or power elite), family abandonment, unrequited love, self-estrangement, social alienation, and the meaning of friendship and family bonds. All these are concepts that Van Sant had explored and would continue to examine in future films.

As usual with Van Sant, the screenplay was a reflection of all the literary sources that he had absorbed up to that point. He publicly acknowledged, in addition to Shakespeare, the influence of playwright Sam Shepard—specifically, in the intense scenes in which Mike and Scott visit Mike's brother, Richard (played by James Russo). In those scenes, significant revelations are made about their troubled family past: how their unstable mother fell for a gambler-cowboy who did not love her; how Richard spent time in a mental institution; and how their mom shot her beau in a movie house while they were watching *Rio Bravo*, Howard Hawks's 1959 cult Western, starring John Wayne. Says Richard: "The popcorn spread all over the floor soaked with blood," an image seen in a powerful flashback.

Van Sant has always admired John Rechy's 1963 chronicle *City of Night*, which he read and reread in the 1970s while observing hustlers. The book helped him to understand the denizens of Hollywood Boulevard as they walk the streets aimlessly, go on the prowl, sit in coffee shops and video arcades, pass time between tricks and drug boosts, and crash at friends' apartments. There were also negative points of reference, to use sociological jargon. Although Van Sant was impressed with the visual texture of Martin Bell's acclaimed documentary *Streetwise*, which deals with homeless teenagers in Seattle, it was hard for him not to notice the conspicuous omission of male prostitutes from the narrative. The stark *Streetwise* was

nominated for the 1984 Oscar, but, ironically, the winner that year was *The Times of Harvey Milk* about the gay politician, a figure that had intrigued Van Sant and that would be the subject of his 2008 film, *Milk*.

As a retelling of Shakespeare's *Henry V*, now set among street hustlers, *My Own Private Idaho* is by turns nonchalant and touching, structurally loose but coherent, and graced with unexpected lyrical images and narrative hairpins. Shakespeare is used in the film to convey the transcendence of time, suggesting that Mike and Scott are figures that can—and do—exist anywhere and anytime. (That this is the case becomes clear in the film's Rome sequences when Mike and Scott meet Italian youngsters who are both their counterparts and their clones.)

In this postmodern skid-row tale, Van Sant reworks ideas from Shakespeare in a light and playful mode. He must have also been inspired by Orson Welles's 1966 film, *Chimes at Midnight*, which is based on Shakespeare's *Henry IV*, with the then portly and grandly operatic Welles as Falstaff. Having teenage hustlers lapse into Shakespearean verse, in a deliberately modern and stilted way, didn't always work for some critics, but it suited the story and added an original touch. Spectators used to more conventional fare found the film's veering off the narrative track disturbing and problematic. For them, the tale was like a pileup of open parentheses, within parentheses, that never got fully closed (by design, as far as Van Sant is concerned).[29] This kind of critique points to the expectations of those critics who favor clear closures over ambiguity and uncertainty.

Upon closer look, however, *My Own Private Idaho* reads more like an expanded version of Van Sant's earlier films, elevating their issues to a more lyrical and symbolic level. A narcoleptic hustler, Mike is haunted by his mother's abandonment when he was a boy. One of the narrative's strands depicts Mike's desperate and obsessive search for his mother, reversing the conventions of most Hollywood movies, in which it is the parents who search for their missing children or relatives—from John Ford's seminal *The Searchers* all the way to Martin Scorsese's *Taxi Driver*, Paul Schrader's *Hardcore*, and John Boorman's *The Emerald Forest*. Throughout, the director inserts images of Mike's mother caressing him as an adolescent (though emotionally

he's still a child) while reassuring him, "Don't worry. Everything will be all right." Later on, brief vignettes of the mother and Mike as a baby are also shown, evoking the image of *Madonna and La Pieta* (which, as I showed, also appears in Almodóvar's oeuvre).

The ailment of narcolepsy is a metaphor for the effects that Mike's emotional life has on his physical life, and vice versa, the impact of his illness on his helplessness as a hustler. But narcolepsy also fulfills a narrative function as a time-traveling device and as a way to segue from one locale to another. Structurally, the film is divided into chapters, each set in a different place, which is indicated by a title card. The narrative begins in Seattle and then moves to Portland, Idaho, and Rome before ending back in Portland. Mike is observed falling asleep in one site and then being carried away while sleeping or reawakening by himself in another place.

Mike falls in love with Scott, a fellow hustler who stands to inherit a fortune from his father, Portland's paraplegic mayor; in Shakespeare's plays, he was the king's son. Until then, Scott looks on Bob Pigeon, the raucous, cocaine-dealing braggart and the film's equivalent of Falstaff, as his "true father." Like Shakespeare's Prince Hal figure, Scott intends to renounce his street life and repudiate his friends when his father dies, which he does in a heartbreaking scene set at the cemetery.

My Own Private Idaho begins and closes with a similar image. In the opening scene, Mike falls asleep on an empty road in Idaho; at the end, Mike again experiences a narcoleptic episode when he physically collapses. While sleeping, a truck stops by, and two men steal his belongings, including his shoes. Shortly thereafter, another car stops by, and its unseen driver puts Mike's body in his vehicle before speeding away. In these images, the circular narrative celebrates the romance of the road and drifting as a uniquely American lifestyle.

Once again, Van Sant courted controversy in treating the homoerotic exploits of hustlers. All along, Van Sant insisted that it was not a gay story, a label that was attached to the film in the prerelease publicity due to its subject matter. "It doesn't bother me if people call it gay. The film was made by a gay person—me. But I don't think it's addressing a gay audience or issues in the gay world directly. It's not done from a particular point of view about sexual orientation. It's

written with a general audience in mind." Explaining his perspective, he claimed that the film's hustlers think of themselves as straight—they are like "pirates, street people." He elaborated: "It's a film about an area of society—prostitution—that's not defined in terms of gay or straight. The hustlers and their johns don't think of themselves as gay. In real life, the clients, the paying johns, tend to be middle-class businessmen or construction workers with families."[30]

Characteristically, Van Sant ignored warnings that male prostitution and homosexuality were taboos in the social climate of the early 1990s. The hysteria prevalent in American culture was a combined result of the public's ignorance and the media's deliberate neglect of the AIDS epidemic. That said, he was cautious in the specific way he depicted sex on screen, a function of his shy personality as well as his fear of alienating a major segment of the film's potential audience, which was supposed to go beyond gay viewers.

In both *Drugstore Cowboy* and *My Own Private Idaho*, Van Sant made sure *not* to depict the men's lifestyle in a cheap, sleazy, or lurid manner. As he later commented: "The sex in *My Own Private Idaho* is not so important. It's sort of something that they do as routine. As long as the audience got the idea that they are routine sexual objects, it isn't really about sex." To that extent, he shows the sexual encounters from the POV of the partners involved: "If you make the camera not a voyeur but a participant, you can get away with a little more. But it's still a problem, because of our own perception of sex. I'm embarrassed by certain things. Being 'bad' is part of it, although it doesn't have to be that way, and I know other cultures know that, but our culture is pretty uptight."[31]

One of the most eccentric scenes, set in a porn shop with the covers of gay magazines talking to the audience, was shot at Portland's Film Follies Bookstore. Initially, Van Sant wanted Mike's magazine to say "G-String Jesus," but it was changed to "G-String" in order to avoid offending the religious factor. The line is delivered while Mike is tied to a post, wearing a loincloth padded with foam rubber in order to make his crotch look bigger.

There was a lot of anxiety at New Line about other sexual aspects of the movie, as yet unseen by the top executives. Rolfe Mittweg, a senior vice president, was quoted in *Premiere*: "If Van Sant's going

to show erect dicks, I don't know what we're going to do." Van Sant coolly responded: "Of course, it's only a problem, because men get embarrassed when they see dicks on the screen."[32] The distributor sighed with relief upon seeing the final cut, in which there are no shots of penises, erect or otherwise.

None of the directors in this book has shown erect penises on screen. Waters showed flaccid penises early on in his career, and Almodóvar has presented several such images. It is still one of the biggest taboos in world cinema. If memory serves, only a handful of directors have broken this taboo. They include Denmark's controversial filmmaker and enfant terrible Lars von Trier, in *The Idiots* and *Antichrist*; France's enfant terrible Leos Carax, in *Lovers on the Bridge*, *Pola X*, and, most recently, *Holy Motors*; and, of course, Paul Morrissey, in his Dallesandro features.

In dealing with eros, Van Sant was guided by his philosophy that representing sex, rather than actually showing it, is more interesting. He wanted to give the viewers an idea of sex by showing still images of naked bodies in tableaux of specific positions but not relying on actual sexual movements. Taking a different approach would have turned the scenes into pornography and also would have changed their dramatic purpose. It was important to the director that the visual style of the explicitly gay scenes be varied and not stereotypical and that the sexual acts serve the narrative dramatically. For example, the scene in the coffee shop, when real-life hustlers Michael Parker and Scott Patrick Green and their cohorts spontaneously relate their first sex-for-pay adventures, was done in a realistic cinema verité mode. But the three-way orgy among Mike, Scott, and Hans was shot in a more stylized way. Finally, the seduction scene between Zabriskie, who's dressed in white, and Mike in her salmon-colored bedroom ends on a funny, surreal note when Mike literally falls asleep in her arms as they begin making out. At that moment, the older Zabriskie is like Mike's missing mother, holding her lover-boy and boy-lover in her arms in yet another suggestion of *Madonna and La Pieta*.

No doubt the film's strongest emotions are evoked in the intimate interactions between Mike and Scott. When the two hit the road to Idaho on motorcycles to look for Mike's mother, they take a break. Sitting at a campfire, Mike proposes to have sex in order to relieve

their boredom. It was River Phoenix who expanded the three-page scene in the script into a long eight-page act, which he wrote by himself, inspired by the mood of the text and encouraged by his mate, Keanu Reeves. To express his genuine feelings for Scott, Mike says, "I love you, and you don't have to pay me," indicating the clear distinction between love and sex in his "other" life.

Mike's sexual ambiguity is seen as integral to his state of emotional arrest and awkwardness. The scene in which Mike declares his love for Scott made Mike "more normal, more positive," even though in Van Sant's initial conception the character was unable to say something like that. The director explained: "I wanted them to fool around, to suck each other off, because they were in the desert and there was nothing to do."[33] That was the impulse of the scene and the reason why he makes Scott say, "No, man, I don't do that." In the released version, Mike tells Scott that he wants to kiss him, and the two embrace. It's so dark, however, that it's hard to see what exactly it is that they do, not to mention the fact that the scene ends abruptly.

The couple's visit to Rome searching for Mike's missing mother is propelled by the timeless quality of the Eternal City as well as by the place's prevalent homoeroticism in Renaissance art. Male prostitution has been a tradition in Italian culture, inspiring many of its gay directors, such as Luchino Visconti and Pier Paolo Pasolini. What makes the foreign scenes distinctly American and Van Santian is that, as soon as the two arrive in Rome, they have a moment of recognition—they see male hustlers that are just like them. As James Parish noted, in a symbolic way, Mike and Scott meet their counterparts, who are essentially extensions of themselves.

With his exotic look, Keanu Reeves was extremely photogenic and beginning to rise in films like *Bill and Ted's Excellent Adventure* as well as *Point Break*, which he shot just before *My Own Private Idaho*. Van Sant was intrigued by Reeves's photogeneity as well by his arch speech, which gave the Shakespearean scenes a more formal and artificial eloquence. When Mike and Scott communicate, it's as if they speak their own secret language that makes sense only to them and that only they can fully understand. The two actors' differing styles complement each other. There is a playful, childlike spontaneity to Phoenix, a Method actor known for thoroughly researching each

and every one of his roles. In contrast, Reeves is a more cerebral and detached actor whose physical stiffness and emotional clumsiness serve well the character as written by Van Sant.

Dominated by yellows and reds, the color palette that production designer David Brisbin chose for the picture was different from the green-dominated scheme of *Drugstore Cowboy*. More specifically, the salmon color is used extensively, as in the bedroom walls of Zabriskie's home, the interiors of the house where Bob presides over the hustlers, and Mike's zippered jacket and various shirts and T-shirts. The strong yellow color stands out in the various cars and taxis, the jackets of the cops who raid the house, the interiors, and the sunflower that Mike holds so touchingly toward the end.

Van Sant was hoping that his movie would have a broader exposure than *Drugstore Cowboy*, and it did, though not substantially. *My Own Private Idaho* grossed about $6.4 million at the domestic box office. However, far more important than the commercial success (especially by indie standards) was the near-universal critical acclaim. Many scholars and critics (myself included) consider the film to be the director's masterwork.

* * *

In 1993, avoiding typecasting as a director with a narrow (male-oriented) range, Van Sant made a radical shift from the all-male terrain of *My Own Private Idaho* to the nearly all-female turf of Tom Robbins's feminist manifesto, *Even Cowgirls Get the Blues.* His first flop, both commercially and artistically, *Even Cowgirls* was the equivalent of the "sophomore jinx" that Soderbergh had experienced with his second feature, *Kafka*, in 1991, after the strong impact of *sex, lies, and videotape.* However, in Van Sant's case, it was his fourth feature, excluding *Alice in Hollywood*. The movie boasted his biggest budget to date ($8.5 million) and a large, eclectic cast, including Uma Thurman, John Hurt, Keanu Reeves, and a newcomer, River Phoenix's younger sister Rain (at River's own suggestion). Testing poorly, the film was worked and reworked, but the end result remained disappointing. In my view, *Even Cowgirls* is one of weakest films the director has made.

The film promised a different kind of challenge, and Van Sant was glad to announce that in "*Even Cowgirls*, you don't really get this sex-object angle, although at the same time you get the feeling that the writer is living in a fantasy in sex-object land. It's sort of this other world, a city of women. The whole project is a great women's film." In this particular case, like Almodóvar, Van Sant evoked the spirit of the great gay "woman's director" George Cukor: "It's a chance to make the ultimate remake of *The Women*, which is a beautiful Cukor film from the 1930s."[34]

The reality of the film, however, proved to be much different. The most original element of this misconceived picture is its title, deriving, of course, from the novel—it's hard to beat that. Barely a year before she would be catapulted to stardom in Quentin Tarantino's *Pulp Fiction*, Thurman stars as Sissy, a woman destined to be the world's greatest hitchhiker. Due to her large thumbs, Sissy grows up to become a beautiful woman and a champion hitchhiker. In due time, she becomes a spokesperson for the Yoni Yum line of women's products made by the Countess (Hurt), a transsexual from Mississippi who has made a fortune in the hygiene industry. While in Manhattan, the Countess introduces Sissy, who is still a virgin, to her future husband, Julian Gitche (Keanu Reeves), a Native American artist who's asthmatic. In typical Van Santian fashion, the mating between the two fails. Sissy incurs the wrath of the government when she joins a group of radical cowgirls who live at the Rubber Rose Ranch, the Countess's commune in the Dakota Badlands. Fellow cowgirl Delores Del Ruby (Lorraine Bracco) sees the migration of the whooping crane as crucial to their political battle with the FBI.

During the long days and nights at the Rubber Rose, Sissy befriends the beautiful Bonanza Jellybean (Rain Phoenix), who finds a new use for Sissy's thumbs. A mysterious foreigner, known only as the Chink (Pat Morita), enters Sissy's world. Describing himself as the guardian of the universe's secrets, he offers to pass his wisdom on to her. The long, verbose nocturnal scenes between Sissy and Chink are boring, almost bringing the film to a halt.

Most of the tale is set within the ranch, where the cowgirls are led by Bonanza, who becomes Sissy's lover. Violence erupts when one of Sissy's thumbs is amputated, but she continues to travel, while

keeping in contact with Bonanza. From that point on, the narrative, thin in the first place, loses the little energy that it has. The women hold hostage the country's last surviving flock of cranes. Sissy arrives just in time to witness the cowgirls and the ranchers holding off the authorities, who demand custody of the cranes. The cowgirls decide to surrender, but in the process, Bonanza gets killed by the ruthless government agents. In the unsatisfying resolution, the Chink, who had been living with Sissy and Delores, decides to leave for Florida.

Even Cowgirls lacks the narrative momentum, distinctive rhythm, and lyrical touches of Van Sant's previous efforts. Thematically, though, *Even Cowgirls* belongs to his distinctive universe. All of his films are structured as odysseys of outsiders, journeys that celebrate the openness and endless possibilities of American life on the road. Sissy's oversized thumbs make her an outcast who very much belongs to the director's gallery of outsiders, and her odyssey is just as random and unpredictable as theirs. In his good films—*Mala Noche*, *Drugstore Cowboy*, and *My Own Private Idaho*—the stories are told from the subjective perspective of their characters. *Even Cowgirls* might have failed due to its lack of clear perspective and consistent POV. The protagonist, Sissy, remains an enigma, as Van Sant himself later acknowledged, "an object that you're watching, as opposed to someone you're watching the world through."[35]

Though it was nice to see Van Sant working with a diverse group of talented actresses, such as Thurman and Bracco, he didn't get particularly strong performances from them. Made right after *My Own Private Idaho* and served as the opening night of the prestigious Toronto Film Festival, the film was all the more visible and vulnerable to criticism. Fine Line, which distributed the film, incurred a major financial loss.

* * *

Unfazed by the failure, Van Sant pushed forward with two personal projects that came to fruition in 1995. Making his debut as executive producer, he was instrumental in the production of *Kids*, the screen debut of photographer Larry Clark. It was a most fitting collaboration, given the film's theme and the fact that Clark's photographs

had served as references for Van Sant's *Drugstore Cowboy* and for his more general artistic sensibility. Miramax, the hottest indie studio of the 1990s, slipped *Kids* into the Sundance Film Festival as an unannounced midnight screening, and it immediately became the talk of the festival—the only controversial film that year. The screening's clandestine nature, combined with Clark's penchant for lurid subject matter, created a huge buzz and packed houses of attentive viewers.

In its bold approach, candid portrayal of sex and drugs, and frank language, *Kids* dwarfs Hollywood's youth movies. Among other things, *Kids* was shocking because the roles were played by real teenagers of the right age, not Hollywood actors in their twenties, as was the norm; James Dean was twenty-five when he played a high schooler in Nicholas Ray's *Rebel Without a Cause* in 1955, and Sidney Poitier was thirty when he made *Blackboard Jungle* in the same year. In contrast, *Kids* feels more authentic in look and its impact more horrific due to the casting.

Set on a hot summer day, *Kids* presents a twenty-four-hour chronicle of young Manhattanites who hang out on the streets pursuing kicks, smoking pot, and guzzling booze. Parents may not like to acknowledge it, but the kids in this movie are perpetually and dangerously libidinous, and violent acts are part of their lives; incidents of gay baiting and black bashing are routine occurrences. In the opening scene, Telly (Leon Fitzpatrick), a horny, irresponsible fourteen-year-old, talks a naïve blonde (Sarah Hendersen) into the sack. As soon as the sex is over, the cocky kid hits the streets to boast to his buddies about his conquest. Telly's monologue about his obsession with virginal girls and his plan to score another conquest that night is unsettling precisely because it's so believable.

In the afternoon, the kids head to the local pool for some skinny-dipping and more sexual pranks. They finally crash at a friend's apartment, where they get high and drunk again. Later that night, another virgin is victimized by the same swaggering and careless seducer. But it's not just the boys who talk down and dirty. There's also ultrafrank talk among the girls about their favorite sexual positions. Jennie (Chloe Sevigny) admits to her friends that she had lost her virginity to Telly, the only guy she has ever slept with.

Kids depicts never-before-seen acts of adolescent seduction, girls' fears of losing their virginity, and boys' aggressive anxiety to score and then brag about it. AIDS is a constant threat looming large in the foreground. Indeed, it's all the more shocking when Jennie, one of the least promiscuous girls, is diagnosed as HIV-positive based on a single experience. Graphic depiction of youngsters indulging in unprotected sex and uninhibited booze results in an upsetting film. One of the most disturbing aspects of *Kids* is its ability to sustain genuine horror and voyeuristic fascination with "dubious" subject matter. It's one thing to read about teenage sex in *Time* magazine; it's another to see it on screen.

Clark, a middle-aged artist, captured the values, speech patterns, mannerisms, and sexual urges of his teenage ensemble because he won their trust. No doubt the filmmakers were helped by the screenplay written by Harmony Korine, then nineteen and a street kid himself, who shows a gutsy, beyond-the-boundaries sensibility. Clark, Van Sant, and Korine demonstrate their intuitive understanding of youth angst and burning libido. (Korine went on to become a director with a series of controversial films, beginning with the terrible feature *Gummo* in 1997; most recently, he completed the intriguing *Spring Breakers*.)

Cinematographer Eric Edwards, who had worked with Van Sant before, deploys a restless, mobile camera to give the film a striking visual quality and a deceptively improvisatory feeling. *Kids* achieves the remarkable feat of being technically polished and yet feeling like a compelling documentary. Like Van Sant's work, *Kids* takes a nonjudgmental view toward urban youngsters, allowing viewers to make up their own minds about debatable contents. With hyper pacing and naturalistic (nonactorish) performances, *Kids* earns its claimed authenticity. At the same time, it walks a fine line between its moral intent as a cautionary tale, warning against the disregard for safe sex, and its undeniable voyeuristic, borderline exploitative elements.

Kids offered further proof of the vibrancy of the independent cinema in tackling difficult issues. Made in the tradition of cinema verité, it is a powerful exposé defined by its uncompromising take on kids' behavior. Miramax, then owned by Disney, had problems securing a decent rating from the MPAA, which threatened an NC-17.

Refusing to sacrifice the film's artistic integrity, Miramax decided to create a new division, Shining Excalibur Pictures, specifically in order to release the film as is.

Over the next two decades, Van Sant produced or executive produced other films with gay themes and/or focused on troubled youth, such as *Speedway Junky* (1999); *Tarnation* (2003); *Wild Tigers I Have Known* (2006); *Lightfield's Home Videos* (2006); *Howl*, about another of Van Sant's literary heroes, Allen Ginsberg (2010); *Act Up!* (2012); and the three-hour *Laurence Anyways* (2012), from Xavier Dolan, Canada's flamboyant gay director (whose films had their world premieres at the Cannes Film Festival to critical acclaim).[36]

COURTING MAINSTREAM

The black comedy *To Die For*, which played at the 1995 Cannes Film Festival (out of competition) was Van Sant's first effort for a major studio, Columbia. Its relative success paved the way for other, more commercial yet personal projects in the future. This loose adaptation of Joyce Maynard's novel features Nicole Kidman as a murderously ambitious weather girl, offering the actress (then better known as Tom Cruise's wife) her most fully realized part to date. Kidman had to fight to persuade the director that she was right for the part of Suzanne Stone, which was originally offered to Meg Ryan. Jodie Foster, Michelle Pfeiffer, Uma Thurman, and Bridget Fonda were also considered before Kidman landed the part, albeit for the reduced fee of $2 million.

Blending the thematic and stylistic conventions of a darkly humorous satire with those of a mockumentary, *To Die For* relies heavily on direct-to-the-camera monologues by Suzanne and personal commentaries on her behavior by the other participants. The novel that inspired the movie was loosely based on the factual trial of Pamela Smart, a school media services coordinator who was imprisoned for seducing a sixteen-year-old student and talking him into killing her husband. The trial was the first fully televised case in the United States. However, the film is considerably more satirical than Maynard's straight treatment of the case.[37]

The film also features one of Van Sant's favorite actors, Matt Dillon, as Suzanne's hapless husband, and a third Phoenix sibling, Joaquin Phoenix, as her equally hapless young lover. River Phoenix had died from a drug overdose outside a nightclub in West Hollywood in 1993 in a much-publicized incident. The tragedy devastated the director, who was close friends with River and hoped to collaborate with him again, based on the fruitful teaming on *My Own Private Idaho*.

A mean-spirited comedy told in mock-tabloid fashion, *To Die For* traces the rise and fall of Suzanne, an ambitious girl obsessed with becoming a TV celebrity. Though living in the provincial town of Little Hope, New Hampshire, Suzanne dreams of being a world-famous anchor. To that end, she marries Larry Maretto (Dillon), whose successful family business offers a comfortable lifestyle. Whether primping for the camera as a weather anchor or pondering reality ("Everything is part of a big master plan"), Suzanne is sly, immoral, and amoral. Her TV-Age narcissistic philosophy is simple: "What's the point of doing anything worthwhile if no one is watching." As critic John Powers noted, Suzanne is "a peculiarly American monster who can transform anything, even murder, into what she calls a learning experience."[38]

Larry starts nudging her to take time off from her career to start a family, and Suzanne, upset by the idea, decides to kill him. During a dancing project at her house while Larry is away, she seduces Jimmy Emmett (Phoenix), a lonely youngster, strong-arming him and his friends, delinquent Russell Heines (Casey Affleck) and the low self-esteemed Lydia Mertz (Alison Folland), into killing Larry. Jimmy, who's initially hesitant, eventually complies when Suzanne offers sexual favors; she later threatens to leave him if he doesn't kill her "abusive" husband. Jimmy commits the murder, after which he is ridden with guilt due to Larry's calm demeanor during their struggle.

In their investigation, the police retrieve a "Teens Speak Out" video in which Jimmy hints at a relationship with Suzanne. Jimmy and Russell are arrested, but Lydia makes a deal with the police to talk to Suzanne with a secret tape recorder. Not as smart as she thinks she is, Suzanne unwittingly reveals her part in the murder. But despite evidence of her guilt, Suzanne is acquitted on the grounds that the police had used entrapment. She walks free, but Jimmy and

Russell are sent to prison and Lydia gets out free for her coopera-
tion. Justice prevails when Suzanne gets her comeuppance—she fab-
ricates a story about Larry's drug addiction and how he got killed
by drug suppliers, who wanted to keep him silent. Larry's father Joe
(Dan Hedaya) then realizes that Suzanne is behind the murder, and
he uses his mafia connections to have her murdered. In a stroke of
luck and irony, Lydia becomes a celebrity by telling the true story in
a TV interview. In the next-to-last sequence, Suzanne is lured away
from her home by an old executive from Hollywood pretending to
be interested in her career. He turns out to be a hit man, hired by
the Marettos to get rid of the monstrous woman. The fact that he
is played by director David Cronenberg, best known for his horror
films (*Scanners*, *The Fly*, *Dead Ringers*), brings an extra edge to the
act. Cronenberg had recently released his controversial adaptation
of the presumably unfilmable *Naked Lunch*, based on the book by
Van Sant's literary and cultural hero William S. Burroughs Jr. (which
Van Sant had also wanted to film).

The film's very last scene may be too literal for a movie that aims
to be subtle and cool, but is a tad too starch and obvious. It shows
Larry's sister, Janice (Ileana Douglas), skating on the frozen lake
where Suzanne's corpse was buried by the hit man. There is, how-
ever, a visually satisfying coda, in which the image of Lydia, who had
achieved the kind of fame Suzanne had yearned for, is split into two
images, then into four, and then into numerous ones. (This device
had been used in earlier films, such as Sidney Lumet's 1976 Oscar-
winning satire, *Network*.)

As a send-up of Americans' media madness and their obsession
with becoming a celebrity, *To Die For* disappointed Van Sant's devo-
tees, who expected something wilder than yet another spoof of tab-
loid culture. As Powers observed, "For all its hilarious moments, the
picture feels slightly desperate, as if the filmmakers were trying to
fatten up a satire that's not outrageous enough to compete with pic-
tures like *Natural Born Killers*, let alone the reality of Kato Kaelin, John
Wayne Bobbitt, and all those lunatic statues of Michael Jackson."[39]

Reflecting his worldview, Van Sant shows sympathy for the alien-
ated working-class teenagers. As usual, he finds something lyrical,
authentic, and touching in the forlorn isolation of the pudgy Lydia

and the uneducated, impressionable Jimmy. Jimmy explains his reckless love for Suzanne with pop culture references to the zombies in *Night of the Living Dead*—it is the only real/reel knowledge he possesses. The director suggests that, despite having indifferent parents and teachers and despite being engulfed by a trashy, superficial, and disposable culture, working-class youths still believe in such "old-fashioned" values as love, loyalty, decency, and camaraderie. They possess the capacity for genuine emotions, even if they cannot verbally articulate their feelings.

In her *New York Times* review, Janet Maslin described *To Die For* as "an irresistible black comedy and a wicked delight," adding that "it takes aim at tabloid ethics and hits a solid bull's-eye, with Ms. Kidman's teasingly beautiful Suzanne as the most alluring of media-mad monsters. The target is broad, but Gus Van Sant's film is too expertly sharp and funny for that to matter; instead, it shows off this director's slyness better than any of his work since *Drugstore Cowboy*. Both Mr. Van Sant and Ms. Kidman have reinvented themselves miraculously for this occasion, which brings out the best in all concerned."[40]

Ultimately, *To Die For* is not that smart as a black satire of America's fatal obsession with TV and the dangerously growing culture of fame. The movie lagged behind the zeitgeist: Waters satirized this issue in his 1970s comedies (see chapter 5), and Scorsese's *King of Comedy* in 1983 and Oliver Stone's *Natural Born Killers* in 1994 tackled in darker and wittier ways the obsession with fame and the cost of its relentless pursuit. Despite critical acclaim, the movie was not particularly commercial, considering its sizable budget and the hype before its release, grossing only $20 million at the box office.

* * *

In 1997, for the first time in his career, Van Sant gained mainstream acceptance with *Good Will Hunting*, a tale of a troubled, blue-collar mathematical genius. It was cowritten by and starring two bright but unknown actors, Matt Damon and Ben Affleck, who had known each other since childhood and were soon to become major Hollywood players and national celebrities. A huge critical and commercial success, grossing $220 million worldwide, the film received seven

Academy Award nominations, including a Best Director nomination for Van Sant. The movie won the Best Screenplay Oscar for Damon and Affleck and the Best Supporting Actor Oscar for Robin Williams. (Later on, Van Sant, Damon, and Affleck parodied themselves and the film in Kevin Smith's rude comedy *Jay and Silent Bob Strike Back*.)

Centering on a working-class youth who's forced to come to terms with his creative genius and tormented inner feelings, this film is emotionally involving and sporadically quite touching. Fans of Van Sant's earlier offbeat films were disappointed by the more conventional attributes of *Good Will Hunting*, a "problem" drama dealing with the complex relationship between a rough, extraordinarily gifted kid and his troubled, equally bruised therapist. However, Damon's towering performance in the lead and a superlative ensemble headed by Robin Williams elevate this engaging psychodrama above its middlebrow, therapeutic sensibility.

Thematically, the film recalls Robert Redford's 1980 *Ordinary People* and especially Jodie Foster's 1991 *Little Man Tate*, which also revolves around a child-genius of the working class. Younger viewers embraced Van Sant's film in the same way that a previous generation had related to Mike Nichols's *The Graduate* in 1967. Though they were both zeigeist pictures touching a chord with younger demographics, there is a major difference between them: *Good Will Hunting* was written from the inside by twentysomething guys, unlike *The Graduate*, which was made by older filmmakers: writer Buck Henry, director Nichols, and star Dustin Hoffman, who looked younger but was thirty when he played college graduate Benjamin Braddock. It's a testament to Van Sant's idiosyncratic talent that he endows the narrative with the nihilistic humor and deceptively casual and nonchalant style that have marked *Drugstore Cowboy*, which was also straightforward, and *My Own Private Idaho*, which was not.[41]

The film centers on Will Hunting, a twenty-year-old working as a janitor at MIT and spending most of his free time with his coarse friends at the neighborhood bar. Blessed with the grace of genius, Will, who does not attend college, can summon obscure historical references based on his exceptional photographic memory. He can solve difficult mathematical problems with ease, which makes MIT's richer, more educated students envious of him.

When Professor Lambeau (Stellan Skarsgård of *Breaking the Waves*) presents a math challenge to his graduate students, with a fine reward to match, Will anonymously solves the problem on the blackboard in the school's corridors. Lambeau begins searching for the mysterious student, and upon finding Will, he takes him under his wing. It's the only way for Will to get parole after several run-ins with the law and the courts. However, Lambeau sets two conditions. First, Will must meet with him once a week for a math session, and, second, Will must begin therapy.

A succession of psychologists try to reach Will, using various techniques (including hypnosis) but to no avail—he won't cooperate. Finally, Lambeau summons his old classmate Sean McGuire (Williams), now a community college instructor and therapist, and the real drama begins. In essence, the script is structured as a battle of wills. Four individuals are vying for Will's soul: a mathematician; a therapist; an affluent British student named Skylar (Minnie Driver), who has a crush on him; and his neighborhood buddy Chuckie (Affleck). Each of the four represents a distinct point of view, but all are presumably trying to help Will find his true self.

Most of the narrative consists of intense one-on-one sessions between Will and Sean, two equally stubborn, equally damaged men. True to form, psychological revelations and emotional disclosures are made about their respective pasts. An orphan who was abused by his surrogate father, Will has carried a chip on his shoulder ever since boyhood. For his part, the widower Sean is still in love with his wife, who had painfully died of cancer. A tough Irishman on the surface, Sean, also a product of an abusive parent, is quite vulnerable. These parallels are, in fact, a major weakness of the script, which increasingly gets too schematic: At the end, every personal problem and turbulent interaction is neatly resolved. Van Sant must have realized that the story is too predictable, as he imbues the film with his customary devious style that's grainy and arty at the same time. And, ultimately, the tale offers strong emotional, if conventional, payoffs.

Again, Van Sant showed that he is one of the few American directors who really understands—and doesn't condescend to—working-class and blue-collar America. Here he gets deep into his characters, resulting in a beautifully textured movie about outcasts (Van Sant's

favorite topic), which is seldom seen in mainstream Hollywood. Rich in tone, *Good Will Hunting* is by turn funny, nonchalant, moving, and angry, effortlessly alternating moods between scenes and often within the same scene.

Endowed with the good looks of Brad Pitt and Leonardo DiCaprio (whom he physically resembled at the time) and blessed with impressive discipline and technical skills to match, Damon gives a charismatic performance in a demanding role that catapulted him to international stardom. Perfectly cast, he makes the aching, step-by-step transformation of Will's psyche and soul both realistic and credible. As for Williams, comparisons were inevitably made between his Oscar-nominated role in *Awakenings* (in which he played a shy doctor) and his work in *Good Will Hunting*, which in my view is stronger, subtler, and more satisfying.

After a couple of disappointing assignments (Allison Anders's *Grace of My Heart* and Harmony Korine's *Gummo*), the cult French cinematographer Yves Escoffier shows his brilliant lyrical style, opting for natural light whenever possible and fully integrating South Boston as one of the story's characters. Longtime Van Sant collaborators Missy Stewart and Beatrix Aruna Pasztor also make significant contributions with their detailed production design, which illustrates the uneasy coexistence of disparate social classes in America.

* * *

Good Will Hunting afforded Van Sant the opportunity to remake Alfred Hitchcock's best-known film, the 1960 classic *Psycho*. The director opted to recreate the film (almost) shot for shot, but in color, with a cast of young Hollywood talents. Unfortunately, they are all miscast: Anne Heche in the famous Janet Leigh role of Marion Crane; Vince Vaughn as Norman Bates, played by Anthony Perkins in the original; and Julianne Moore as Marion's sister Lila. Moreover, the few deviations from Hitchcock are pointless: Van Sant made the first scene, in the Phoenix hotel, more sexually explicit, and Sam (played by Viggo Mortensen) is walking around the room naked (shot from behind). To adjust for inflation, the amount of money that Marion steals is $400,000, instead of the $40,000 in the original. Worse yet,

the famous murder montage in the Bates Motel is interrupted for no apparent reason with a brief exterior shot of the clouded sky (a visual motif in Van Sant's work).

Van Sant might have misunderstood the nature of Hitchcock's classic, for one of the few new elements is the very last shot, which took the viewers out of the motel onto the highway, in a sharp deviation from Hitchcock's intent to submerge viewers deep down in the slimy mud where Marion is buried in her car. Significantly, the last image of Hitchcock's *Psycho* was a shot of a chain that pulls the car (and the money inside it) out of the swamp.

From the start, Van Sant's decision to remake *Psycho* was met with skepticism, and when the film was released, in the summer of 1998, it met with derision from both critics and industry insiders. As expected, *Psycho* was perceived as a pointless and risible remake whose artistic and commercial failure surprised no one, winning Van Sant the Razzie Award for the year's Worst Director. Perhaps the only "good" thing that came out of this inane effort was Van Sant's awareness of his strengths and weaknesses: "I learned a lot about myself as a filmmaker. The images and the things in my films tend to be sentimental, and Hitchcock is not about that. He's about suspense and austerity and separating everybody, and I'm about including everybody."[42]

However, the *Psycho* debacle didn't derail the director, who was soon busy with new projects. In addition to directing, he devoted considerable energy to releasing two albums. He also published a well-received novel, *Pink*, which was a thinly veiled chronicle of his deep grief over River Phoenix's death on October 31, 1993.

<p align="center">* * *</p>

Van Sant fared slightly better with his next studio feature, *Finding Forrester*, a drama about a high school student from the Bronx (Rob Brown) who befriends a crusty, reclusive author (Sean Connery). Critical response was mixed to positive, singling out the director's skill at melding the performance styles of first-time actor Brown and Hollywood legend Connery (still best known as the most iconic and popular James Bond). The script was seen by some critics as a

schematic combination of *Scent of a Woman* (1992), costarring Al Pacino as an older, blind military veteran and Chris O'Donnell as his young assistant-protégé, and Van Sant's own *Good Will Hunting*, which also concerns the relationship between a mature professional and a young, irresponsible boy.

Even so, for a Hollywood movie, the acts of reading and writing are portrayed in such gratifying ways that they made viewers want to read a real book rather than an "airport" best seller. Moreover, the interracial mentor-pupil relationship is presented as mutually rewarding, and the interracial teenage romance is depicted without punitive condescension or parental dissent. The film's title is admittedly too literal and didactic, but *Finding Forrester* is deftly crafted, providing, above all, a platform for Connery to deliver a riveting performance as the solitary and charismatic literary legend.

Finding Forrester highlights the auteur's most recurrent motifs, the moral odyssey of outcasts and the casual randomness of urban life. From the beginning of his oeuvre he has shown fondness for outsiders, such as the characters of *Drugstore Cowboy* and *My Own Private Idaho*. The director was known for depicting outcasts in a humanistic way by throwing them into a crisis mode, which forces them to confront the mores of their subculture as well as those of the society at large.

Telling a story that's similar to *Good Will Hunting*, *Finding Forrester* has Connery playing the Robin Williams part and black teenager Brown the Matt Damon role, a gifted kid with a chip on his shoulder. However, if *Good Will Hunting* idealizes a mathematical genius who's superior to Harvard and MIT students, *Finding Forrester* is critical of conservative education and tyrant instructors, but it doesn't put down the system as a whole.

With a touch of *Rear Window* voyeurism, the narrative introduces Forrester, a silver-haired eccentric spending a lot of time by his window, seemingly observing black kids playing ball on a court across the street; it turns out that he's an avid bird-watcher. Veiled in mystery, Forrester was last heard from forty years ago, when he was a brilliant Pulitzer Prize–winning novelist whose book became a classic. That book appears to be the only literary output for which he can claim credit. As the youngsters are aware of Forrester's invisible presence,

their curiosity naturally builds up. Sneaking into Forrester's apartment to get information about the mythical man, Jamal (Brown), a brash sixteen-year-old from South Bronx, accidentally leaves behind a backpack full of writings. The next day the bag appears at the window, forcing Jamal to collect it. To the boy's surprise, his papers have been thoroughly read and graded by Forrester, with a red pen.

A peculiar, unlikely relationship evolves, marked by all the ups and downs of such bonds. When Jamal is recruited by an elite Manhattan prep school for his brilliance on and off the basketball court, he needs help. Though at first hesitant and cynical, Forrester consents and hence becomes a reluctant hero. Gradually, Jamal becomes committed not only to realizing his own literary aspirations but also to cracking down the veneer of Forrester's sheltered existence. The film chronicles the flowering of a union that goes beyond the routine teacher-pupil interaction. Although authority lines are clearly maintained, Mike Rich's script shows how dependent the mentor becomes on the kid, who evolves from an intrigued fan to a loyal student to a social companion, determined to expose Forrester to the world and reignite his passion for literature and, by extension, life.

Unlike most Hollywood school sagas about outcast students, including Sidney Poitier's 1967 vehicle, *To Sir with Love*, in this film both parties get something substantial in return that they otherwise would not have gotten. Though earnest and predictable, the tale avoids the traps of the similarly themed *Educating Rita*, in which a married working-class hairdresser (Julie Walters) forces a boozy professor (Michael Caine) to become her instructor. Unlike *Educating Rita*, *Finding Forrester* doesn't unfold as a series of calculated setups painted with a broad brush, and there are no cute scenes, such as the one in which Rita gives her mentor a shampoo and haircut. Scribe Rich inserts narrative subtleties and moral shadings into a friendship that ultimately becomes a surrogate family relationship. Throughout, Van Sant goes out of his way not to suggest any sexual innuendos or erotic tension between the protagonists, who are more like surrogate father and son. This is evident in the mise-en-scène, especially when the two are in the same frame but never stand too close to each other or look closely at each other when they communicate.[43]

But the text is too old-fashioned for Van Sant's postmodernist sensibility and idiosyncratic vision. A crucial scene at school, in which Jamal is reprimanded for his conduct, functions as the equivalent of a courtroom scene, where bad and inflexible teachers are contrasted with good and charismatic ones. F. Murray Abraham almost reprises his Oscar-winning role as Salieri, a composer jealous of and inferior to Mozart in *Amadeus*. Here he plays an insecure writer-artist, Professor Robert Crawford, Forrester's jealous nemesis, who serves as an obvious catalyst to the predictable conflicts and ultimate face-to-face confrontation with Forrester, which is staged like an anticipated shootout in a classic Western.

The film's weakest parts deal with Jamal's friendships with cohorts of his age—specifically with Claire Spence, a rich, white classmate at the private school he attends (played by Anna Paquin, in one of her first adult roles after winning the Best Supporting Actress Oscar for *The Piano*). Neither Rich nor Van Sant seems interested in her character or in the bond between her and Jamal, resulting in brief, shallow interactional scenes based on the exchange of looks, smiles, and derivative dialogue. A superfluous figure, Claire seems to exist as a plot function—showing that Jamal is a normal adolescent who likes girls—and perhaps as a marketing hook to attract female viewers to what is essentially a male-driven feature.

It's the acting, no doubt, that binds viewers to the characters' shifting emotions and escalating tensions, both within and outside themselves. *Finding Forrester* is a chamber piece for two. More than half of the scenes are set indoors in Forrester's cluttered, seedy, oversized apartment. Inventively textured by Jane Musky to capture the feel of a capacious pre–World War II residence, the apartment becomes sort of a mythical never-never land. What gives the picture its needed outdoor dimensions are the basketball scenes, set at the Bronx's Copps Coliseum and dynamically shot by Harris Savides. The modulated editing is by Valdis Oskarsdottir, who had worked on such excellent Dogme 95 films as *The Celebration* (named the Best Foreign Language Picture of 1998 by the Los Angeles Film Critics Association).

Connery expertly fills the bill of an older man who's both ingratiating and infuriating, a recluse who needs to be rescued from his own misanthropy. The role allows him to display his signature humor,

flourish, and arrogance, but also his vulnerable humanity. As an actor, Connery has stopped masking his Scottishness; he now integrates it into his work, hauling his unique accent with grandeur. But the film is by no means a one-man show: though lacking previous experience, Brown stands up to Connery and in some scenes matches him with inner strength and remarkable stillness.

BACK TO INDIE AND ART-HOUSE CINEMA

After reaching the nadir of his career with the pointless remake of *Psycho*, followed by mainstream Hollywood fare, *Finding Forrester*, an old-fashioned star vehicle for Sean Connery, which made no demands on viewers, Van Sant took a radical turn. Going back to his independent roots, he began a new career phase that would last about eight years. The first result was *Gerry*, a visually compelling but thematically flawed road movie that vaguely recalls his distinctive work.

In its rigorous artistry, *Gerry* is an austere and minimalist film, displaying some awesome visuals and transcendent sounds. The film represents a reunion for Van Sant with Matt Damon after their fruitful collaboration on *Good Will Hunting*, and it offers a good role for the then young and inexperienced Casey Affleck (Ben's younger brother). Marked by sparse and sporadic dialogue, the narrative is slight even by the standards of experimental indies. *Gerry* received its world premiere at the 2001 Sundance Film Festival and traveled the global festival circuit before getting limited theatrical release a whole year later. Semiacademic, the film was embraced by scholars and fringe audiences seeking nontraditional fare.

Pushing fifty and at a midpoint of his career, the ever-unpredictable Van Sant made a film that at once signals and benefits from what might have been an artistic crisis, indicating a need to revitalize his creative juices. Having gone the commercial route, he decided to make a radical departure with a film that's as innovative as his first works, albeit in different ways. The central premise, which is replete with symbolic meanings, is rather simple. Two youngsters, both named Gerry (Damon and Affleck), go on a hike in a far remote desert (the film was mostly shot in Death Valley, California). The journey

puts to the test their camaraderie and ultimately their very existence. The trip forces them to come to terms with Nature's brutality and their survival instincts due to the lack of food, shelter, and water.

It takes time before any verbal communication occurs, a minimalism that continues throughout the picture, forcing viewers to speculate about the protagonists as their trip goes awry, before reaching its tragic but logical denouement. In the first long tracking shot, the camera follows a car from behind as it rides on an isolated road. It then switches angles and presents the couple's faces. Violating rules of classic narrative cinema, Van Sant deliberately avoids providing clues as to who the characters are or what their backgrounds and motivations are. Though there was a blueprint of a screenplay, credited to Van Sant and his actors, *Gerry* feels improvised. For the most part, it rings true in the sense of what the Gerrys talk about on the rare occasions that they choose to interact. They express concerns with dehydration, which escalates rapidly, and fear of getting lost in the wilderness, as there are no traces of the highway or memories of the spot where they had left their car.

Despite the strong presence of Damon and Affleck, *Gerry* is an auteurist film that deploys rich syntax. The film relies on an ever-changing point of view and a mixture of long and static takes and medium-range shots. Van Sant effectively manipulates cinema's most distinctive dimensions, physical space and temporal time. Discerning viewers should be able to notice the specific angles from which the Gerrys and the vistas are presented. Most impressive is the director's stubborn refusal to grant his actors close-ups, which is a common Hollywood device to elicit emotional identification and display the stars' screen presence. One can count on one hand the number of close-ups in *Gerry*, most of which appear toward the end of the journey, though there is not a single mega close-up.

The variable elements in *Gerry* are the landscape and the positioning of the characters, singly and jointly, against it. Although the changing landscape, presented at different times of the day and night, enriches the film visually, it also presents problems; about one third of the movie was shot in Argentina, but due to worsening climate conditions, Van Sant was forced to move to California's Death Valley for the rest of the shoot.

The other noticeable variable is the shifting tone, which gets progressively darker and more somber. The film's second reel is the most entertaining due to its eccentric humor. In a revelatory shot, Affleck is atop an isolated cliff, whereas Damon is placed below him on the ground waiting for him to jump off. In these segments, *Gerry* recalls the works of the silent clowns, such as Charlie Chaplin and Buster Keaton, and the comedies by French auteur Jacques Tati (*Mon Oncle*). In its resonant moments, *Gerry* is a stark existential fable in the tradition of Samuel Beckett's plays—specifically, *Waiting for Godot*. Like Beckett's (anti)heroes, the Gerrys are sort of ordinary clowns seeking meaning for their routine existence while utterly lost—literally and figuratively—in the wilderness.

Early on in his career, Van Sant's work was compared to that of Jean Genet, the French enfant terrible. Both thematically and philosophically, *Gerry* fits into the oeuvre of Van Sant, who has devoted his career to the odysseys of misfits and outcasts, exploring the bizarre and random nature of their lives. *Gerry* is not as lyrical or fanciful as *My Own Private Idaho*, the director's masterpiece, but like that 1991 indie, it centers on the changing relationship between two "deviant" personalities.

Visually, *Gerry* pays homage to such seminal figures as Hungarian filmmaker Bela Tarr, Belgian experimental director Chantal Akerman, and celebrated Iranian auteur Abbas Kiarostami (whose *Taste of Cherry* cowon the 1997 Cannes Film Festival Palme d'Or). The film was also influenced by Greek filmmaker Theo Angelopoulos (*Landscape in the Mist*, *Eternity and a Day*), whose films are odysseys into the countryside of bleak Greek existence, shaped and burdened by the past.[44] *Gerry* recalls Angelopoulos's work—it is necessarily languid and defined by its elaborate mise-en-scènes, shot duration, image composition, and so on. The shifts in perspective, the journey's progress or lack of it (depending on how you look at it), and the movement result in a movie that serves as a metaphor for understanding one's self as well as others.

Though favoring alterable camera movement and long takes, *Gerry* differs from Angelopoulos's work in its acting style. The performances add a distinctly American flavor to a feature that aspires to be a European art film. Van Sant's actors are not as studied as those

of the Greek director, and their line readings are not as Bressonian in their lack of inflection (referring to French director Robert Bresson). In its controlled artistry and Brechtian distancing, *Gerry* avoids facile emotionalism. The film is handled with tactful obliqueness that reflects Van Sant's inherent humanity. As shown in *Drugstore Cowboy* and other films, he never remains too far outside of the spectacle to cut to the heart of the drama.

Gerry displays some beautifully realized images by the brilliant cinematographer Harris Savides, who would shoot several of Van Sant's pictures. In one mesmerizing sequence, the camera tracks the Gerrys as they walk toward the horizon. The sequence is set at that crucial moment when darkness turns into dawn and the rising sun assumes its place in the universe with its gradually blinding light. In this and other moments, *Gerry* is personal and poetic in ways that few American indies are.

Van Sant's wish to explore minimalism in narrative strategy, visual style, and the whole filmmaking process itself (working with small crews and casts) led to three other quintessentially independent films, which expressed his unique vision, albeit at the price of failing to reach appreciative audiences.

* * *

It took *Gerry* over a year to make it to theaters, during which time Van Sant began production on his next film, the controversial *Elephant*. He was approached by HBO and actress Diane Keaton (serving as producer) to make a fictional film based on the 1999 Columbine High School massacre. Challenged by the idea, he chose to shoot the feature in his hometown, casting untrained teen actors for a chronicle about an "ordinary" high school day that is suddenly hit by unexpected mayhem and tragedy.

The film's title derives from a 1989 BBC short feature of the same name, directed by Alan Clarke. The expression "There's an elephant in the room" refers to a collective denial of a grave problem, which fits the theme of many Van Sant's films. Dealing with fanatical political violence in Northern Ireland, Clarke's *Elephant* relies on a minimalist visual style, which has also inspired Van Sant.

Set in the fictional Watt High School in a Portland suburb, the tale chronicles the events surrounding a senseless shooting. Going into the film, Van Sant anticipated controversy; as he told the *Los Angeles Times*: "An event like the Columbine school shooting is so grotesque that the taste level of doing a dramatic piece is brought into question, because of the way we think of drama itself. We think of it as entertainment, but I've never really thought of it as strictly entertainment."[45] The factual tragic incident was still fresh, what with the extensive coverage by the media, which reported the attack in grisly graphic detail. The shooters' faces then appeared on the cover of *Time* magazine. And, of course, Michael Moore's 2002 Oscar-winning documentary, *Bowling for Columbine*, includes surveillance footage of the shooting from within the high school.

Elephant provoked strong reactions from critics, who either embraced or rejected Van Sant's decision not to offer any rationale for the characters' homicidal tendencies. The consensus from the Jury of the Cannes Film Festival was unanimous, however, and in a surprise decision, it awarded *Elephant* the top prize, the Palme d'Or, and Van Sant the Best Director kudo. The U.S. premiere of *Elephant* was a fund-raiser for Outside In, an organization aimed at helping youth living on the streets of Portland.

Van Sant returned to the low-key style of his early independent efforts with this semi-improvised exploration of how violence infiltrates a typical American high school. Eric (Eric Deulen) and Alex (Alex Frost), close friends and students in a middle-class suburb of Portland, look ordinary, but they are truly misfits. They are placed at the periphery of the clique-oriented. Little about their behavior draws attention to itself, at least not during this "typical" day. In their leisure, the boys show fascination with Nazi iconography, enjoy violent video games, and explore homoerotic desires like quick masturbatory sex in the shower, which is implied but not shown.

A long tracking shot reveals Mr. McFarland (Timothy Bottoms) driving erratically to drop off his son, John (John Robinson), at school. John realizes that his father is drunk and instructs him to move to the passenger's seat. We immediately get the idea that the adult world, represented by Mr. McFarland, is not to be trusted.

The camera then follows the students as they walk back and forth down the hallways, talk to their friends, and go indifferently to their classes, which don't hold any special interest for them.

The film melds long and elegant takes, like those that marked *Gerry*, with Harris Savides reprising his famously fluid camera work. The pupils are shown in captivating tracking shots that position and dwarf them against the broader setting. Alex and Eric are routinely being bullied by the school's jocks. During a science class, one pupil diverts a teacher and then throws a spitball at Alex. Later Alex and Eric order weapons from a website and receive their rifles by mail. They plan an armed ambush of their school by drawing up diagrams, formulating a precise attack strategy with graphic charts of the school's sites, including the library and lunchroom. At home, while Alex is taking a shower, Eric gets in with him. Eric claims that he has never kissed anyone before, and the two kiss, which is seen vaguely through the glass door.

The next day Alex and Eric make their way to school as if it was just another day. Upon arrival, they encounter their classmate John and tell him to leave because "heavy shit is about to go down." Bright and alert, John realizes instinctively what is about to happen, and he tries to warn others not to enter the school—but to little effect. No one believes him—after all, it's yet another uneventful day at school, where nothing much ever happens. The two gunmen then invade the premises. When their initial plan to blow up the school with propane bombs fails, they begin shooting randomly and indiscriminately. A student named Elias (Elias McConnell) photographs them entering the library, where they open fire, shooting several innocent students. Realizing that the gunfire is for real, the students begin to panic while their teachers attempt an evacuation. The two boys then separate as they continue their killing spree.

Mr. Luce, cornered in the hallway, begs Eric to talk to him, but Eric yells, "I ain't putting *shit* down!" and fires at him. Eric warns the school principal to stop bullying his pupils, and seconds later he guns him down coldly. Alex then enters the cafeteria and strikes up a brief conversation with Eric, which ends abruptly when Alex shoots his chum, showing no emotion. When he discovers Carrie and

Nathan in a freezer, he recites, "Eeny, meeny, miny, moe," in order to decide which to kill first.

Elephant concludes as it begins, with a shot of cloudy blue skies, signaling ambiguous meanings—the start of either a bright new day or a day that might turn dark and ominous. Clouds in their various colors, formations, and movements are a staple in Van Sant's work, dating all the way back to *Drugstore Cowboy* and *My Own Private Idaho*.

Made with a small budget of $3 million, *Elephant* was a commercial failure domestically, grossing only $1.3 million at the box office. However, it was more popular in foreign countries, which accounted to for most of its global take of $10 million, thus recouping the expense and even turning some profit for HBO. (In general, Van Sant's work is more appreciated in Europe—specifically, France and the United Kingdom—than in the United States.)

* * *

Elephant could be described as the first component of a trilogy—what Van Sant refers to as his Death Trilogy—which also includes *Last Days* and *Paranoid Park*. All three are personal chronicles of lost contemporary American lives that end tragically, and all were shown in the main competition of the Cannes Film Festival.

Last Days, Van Sant's fictional meditation on the turmoil that engulfs a brilliant but troubled musician, was inspired by the late Kurt Cobain, to whom the film is dedicated. Like the director's former films, *Last Days* is an ultramodest effort, made on a limited budget with a cast and crew that were small even by indie standards. "He keeps his crews small and flexible," cinematographer Savides told me. "He doesn't want too much . . . to get in the way of the film."[46] Not as visually arresting or formally elegant as the previous pictures, however, *Last Days* also lacks the political urgency of *Elephant*, which, after all, dealt with violence in American high schools, a more significant social problem.

One doesn't have to be an auteurist critic to detect thematic continuities in Van Sant's films. For starters, dealing with death, all of

these features are bleak reflections on troubled youths that do not fulfill their potential due to untimely deaths. The causes of their deaths, however, differ: in *Elephant*, it's random and arbitrary, whereas in *Gerry* it's calculated and planned.

The extremely photogenic Michael Pitt (who previously had appeared in Bernardo Bertolucci's *The Dreamers* in 2003 and in the original musical *Hedwig and the Angry Inch* in 2001) plays Blake, the introspective artist-musician who is on the verge of collapse under the burdens of fame, professional obligations, and growing isolation. *Last Days* is Van Sant's speculation on Blake's last hours, spent in and around his wooded cabin. Blake, probably named after poet William Blake, seems to be a prisoner in his own home, a fugitive from his own life. The narrative, which spans two days, is meant to represent random moments in the life of Blake, whose fractured consciousness is expressed by a tormented and inarticulate mind.

Most of the story takes place outdoors, in the woods or by the lake, where Blake is seen wandering at the beginning and the end of the film. The film is based on what may be one of Van Sant's thinner screenplays (basically a treatment). For long stretches of time, there is no dialogue or sound. Blake's incoherent rambling and wandering in and out of the house are fused with or interrupted by spontaneous bursts of rock and roll, the kind of music that Blake/Cobain had composed and performed. Leslie Shatz's sound design for this film is truly remarkable, surrounding Blake with a wash of foreign noise, as if he is "never quite present in the real world around him."[47]

Last Days exhibits stylistic devices that are prevalent in many Van Sant films. Steering clear of mainstream cinema, the director continues to experiment with very short scenes and elliptic storytelling. Viewers are asked to be patient—it takes a long time for the layered images and nuanced sounds to form a coherent landscape. As writer and director, Van Sant opts for the kind of ambiguity that had characterized *Gerry* and *Elephant*. Further, all three films are inspired by current newspapers stories. *Gerry* grew out of a news item about two young men who got lost in the desert. *Elephant* offered a look at the wave of school shootings like Columbine in the 1990s. *Last Days*

was made after the controversial death of Cobain, an event that received extensive media attention and prompted the making of a documentary.

Unlike *Elephant*, though, in this picture, Van Sant doesn't use multiple angles and POVs to describe crucial events of the story. In a Cannes Film Festival interview, the director allowed that he didn't have much information about his subject. Nor did he conduct any research about Cobain's actual life. "I felt more comfortable just making it all up," he said. "I wasn't really covering much time; the story was always limited to two days."[48] Van Sant believes that, no matter what the subject matter, "you can never really get the truth, so you might as well have an analogy rather than a biographical depiction."[49]

Cobain (born in 1967) left Aberdeen, Washington, for Olympia in 1986, where he formed the band Nirvana. Nirvana became very popular, and in 1991, the band signed a contract with Geffen Records; the group's album *Nevermind* made it one of the most successful bands in the world. In 1992, Cobain married Courtney Love, who was already pregnant with his child. In 1993, Nirvana released its next album, *In Utero*, which topped the charts. On March 4, 1994, Cobain was taken to the hospital in a coma. It was officially reported as an accident, but many believed it was a suicide attempt. Family and friends convinced him to seek rehab, but he fled rehab after several days. On April 8, his body was found in his Seattle home, holding a shotgun that had been fired into his head. A note, written in red ink, was addressed to his wife and to his daughter, Frances Bean Cobain. Two days after his body was discovered, people gathered in Seattle, setting fires, chanting profanities, and fighting with the police.

Despite its factual source, *Last Days* doesn't aspire to pass as a docudrama or investigative report into Cobain's death. Instead, the film uses his death as a point of departure to tell a story with a personal angle.[50] Van Sant benefits from the fact that not much is known about Cobain's demise, allowing the director to rely on his subjective imagination and loosely linked associations. As in *Elephant*, he does not offer psychological explanation of the why and how Cobain died. Nor does he try to illuminate Cobain's troubled mind. His inspiration

derives not from the event but from Cobain's death as a huge mass-media event.

Made for the festival circuit, *Last Days* was an art film of limited scope, even less commercial than *Elephant*. It's an exercise in pure cinema—a sensory experience—based on Van Sant's multilayered structure of images and sounds. But there's no question *Last Days* is a personal film for the director: Cobain died in April 1994, only six months after the death of River Phoenix (in October 1993), Van Sant's friend and favored actor at the time, with whom he planned to make more movies.

* * *

Paranoid Park, the most technically accomplished film in the youth series that began with *Elephant* in 2003 and continued with *Last Days* in 2005 showed Van Sant in top artistic shape. Style and form coalesce in such a smooth and fluent way that the film stands as a summation of Van Sant's directorial powers, a climactic return to his indie roots. The film's budget was relatively low ($3 million, just like that of the former indies), based on Van Sant's having perfected a quick and efficient production mode. Considering its level of technical polish, it's worth noting that the shoot lasted only eighteen days. Nevertheless, the audience for this kind of art film was clearly very limited.

If *Paranoid Park* is the most successful effort in the series, it's perhaps a result of the source material, a novel by Portland writer Blake Nelson that Van Sant adapted freely into a workable screenplay. The title describes a homemade facility, a site frequented by committed practitioners of skateboarding. For some critics, the problem with *Elephant* was its close association with the actual Columbine catastrophe, and the same can be said about *Last Days*, his pseudobiopic of music phenomenon Kurt Cobain. Free of those external political associations, *Paranoid Park* operates on its own terms as a one-of-a-kind experience.

Nominally, *Paranoid Park* recalls such American classics as Nicholas Ray's *Rebel Without a Cause*, starring James Dean, and Tim Hunter's *River's Edge*. Like Ray's film, *Paranoid Park* centers on a confused high schooler, again named Alex (Gabe Nevins). An amoral (rather

than immoral) teenager in desperate need of guidance, he doesn't get any useful support from his parents or teachers. And like Hunter's indie, *Paranoid Park* involves a fatal accident (and a dead body), focusing on the moral dilemma of how to deal with the corpse—specifically, whether or not to inform the police.

To lend the enterprise greater authenticity, Van Sant recruited his cast members on the Internet, using MySpace.com. Like his previous two films, *Paranoid Park* is not about subtle acting or compelling performances. It doesn't much matter that most of its actors are nonexpressive because they are largely used as tools in the director's broader and more elaborate scheme. Nonlinear and lacking real drama or melodrama, *Paranoid Park* unfolds out of order, beginning in the middle of the story, then going forward, and finally going backward. Midway, when Van Sant discloses details about Alex's role in the accidental death of a security guard, we realize that the film is not about the dead man but about a teenager who lives in a moral limbo, a state of confusion and anomie with no role models or even people to talk to.

Since Van Sant is not an amateur psychologist or charlatan sociologist, he is not interested in explaining Alex's conduct. But he is a good filmmaker who understands how color, movement, and rhythm can convey a subjective and distorted state of mind more precisely, vividly, and beautifully than scenes of long monologues or dialogues. As writer and director, he doesn't pretend to understand his protagonists, and he refuses to judge them; his main concern is to capture visually the texture of their lifestyle. To that end, he conveys visually and emotionally the existence of teenagers who find catharsis only when they skateboard in a park, even though they are not members of any organized community.

There's a wonderful scene in which detective Richard Lu (Dan Liu) visits the local high school and talks to its students. Lu claims that he wants to understand them as group members, but the very notions of group and collective behavior are foreign to them. This school scene recalls *To Die For*, in which Suzanne Stone goes to school with her camera, trying to involve the indifferent students, albeit in a self-serving project that, ironically, would prove to be her own undoing.

Unlike Catherine Hardwicke's *Lords of Dogtown* (and other similarly themed features), *Paranoid Park* is not really about the subculture of skateboarding. Van Sant is using this sport as a backdrop and a metaphor. Skateboarding is a solitary activity, but it's always more fun to practice when one is surrounded by others, even if there is no verbal communication or real physical interaction.

A quintessential Van Santian (anti)hero, Alex is a handsome, long-haired adolescent, a product of a broken family; his parents are separated but not divorced yet. Alex is both the protagonist and the narrator. The tale is punctuated by minimal voice-over narration, and it's illustrated by shots of Alex writing a journal, which always begins with the words "Paranoid Park," and often takes place outdoors.

Though the tale starts with a murder mystery when the body of a security guard is found (he was run over in the rail yards, and the police think there was foul play), Van Sant is not treating it as a mystery or a puzzle. Midway, he recreates the tragic night in which Alex inadvertently caused the guard's death while riding on the train with his buddy Jared (Jake Miller). The director is more interested in how Alex interacts—or doesn't interact—with his mates and parents and in how he deals—or doesn't deal—with the aftermath of the murder and his feelings of guilt and responsibility. Alex's interaction with the other boys is minimal, and he is more of a skateboarding voyeur than an enthusiastic participant, highly aware of his technical deficiencies.

There are only two women in Alex's life: Jennifer (Taylor Momsen), his current girlfriend, and Macy (Lauren McKinney), a girl who follows him around. Both women are more aggressive than Alex, which is no big deal, considering how passive and apathetic he is.

Van Sant shows only one sex scene, again indicating that as a director he is uncomfortable—too shy and self-conscious—with sexuality. As usual, he relegates the sex lives of his characters to a secondary, peripheral level. In this film, the sexual act, just like in *To Die For*, is initiated by a woman, though here she's a virgin. The sex itself is extremely brief, as if to suggest that the act itself is irrelevant, just one more thing to do, with no joy or impact. Right after sex, the girl, just like the boys in *Kids*, calls her mates to tell them how fabulous it was, though there's no evidence of her pleasure. The director spends more

time depicting Alex in the shower, but in a nonvoyeuristic manner, than showing the boy engaged in other activities. The shower scene, with its décor and sounds, inevitably contains references to Hitchcock's *Psycho* and *The Birds*, not to mention Van Sant's own shower scene in *Elephant*.

Enamored of his screen youths, Van Sant takes their POV, encouraging viewers to empathize with them. This is clear in the few interactions Alex has with his parents. In one scene, his mother is first heard—reproaching, of course—but not seen. And when she is seen, it's from a distance as a faceless figure. She's an ineffective parent with no influence on him. Alex's father is just as vague and ineffective as his mom. He appears in just one scene, in which he mumbles about not wanting to hurt Alex before explaining in a rather vague way that the divorce is difficult because "it's not easy to deal with your mother."

Working for the first time with ace cinematographer Chris Doyle, best known for his celebrated collaboration with cult director Wong Kar-Wai, Van Sant shot his film in both Super 8 and 35mm. The Super 8 footage, done by Rain Kathy Li, is particularly effective in conveying the fast-flying, nearly surreal images of skateboarding. As in previous films, other sequences are presented in slow-motion. To portray the routinized activities, the director favors repetition of images, here evident in showing Alex pacing the school's long hallways (scenes that are prevalent in *Elephant*) or walking in green fields toward the water.

Considering its running time (85 minutes), *Paranoid Park* boasts one of the densest and richest soundtracks of a Van Sant picture, courtesy of sound designer Leslie Shatz, who created forceful soundscapes orchestrated by Ethan Rose. The director deploys those buoyant scores as counterpoint to a rather somber text. But the music is so powerful that it's overwhelming, often drowning the slender scenario, calling too much attention to itself. One element of the score that's baffling and disturbing is the extensive and arbitrary use of music composed by Nino Rota, Fellini's brilliant composer who contributed immeasurably to the overall impact of *La Dolce Vita* and *8½*.

At this juncture of his career, it was clear to Van Sant that he could not just go on making movies with no solid audience or commercial

appeal. It is a known fact in Hollywood that youth-oriented pictures become cult films only when they contain sympathetic characters and are fully embraced by young viewers. But American youngsters were not interested in seeing *Paranoid Park*, *Elephant*, or *Last Days*. In the first decade of the new millennium, the director was dangerously making esoteric art films for a coterie of fans interested in indie and experimental cinema. Aware of the limitations of his strategies, he admitted that "this is the end of a certain way I was making films."[51] And, indeed, the timing was therefore right for a more commercial film in the vein of *Good Will Hunting*.

MAINSTREAMING GAY LIVES

Milk, made in 2008, represented Van Sant's most accessible film in a decade. After making four personal indies—*Gerry*, *Elephant*, *Last Days*, and *Paranoid Park*—which didn't go much beyond the festival circuit, he again showed that he could direct films with broader appeal about politically relevant themes. Playing Harvey Milk, the first openly gay politico elected to office, Sean Penn rendered such a sympathetic performance that he elevated Van Sant's biopic way above its conventional structure.

As written by Dustin Lance Black, *Milk* tries to present a well-rounded, multifaceted portrait of Milk as a gay rights activist, expansive politician, devoted friend, flamboyant lover, and loyal San Francisco resident. The end result is an enjoyable but middle-of-the-road picture that falls short of fulfilling its goals. In other words, *Milk* is a good film but decidedly not great. Penn received a second Best Actor Oscar for what was his strongest work since his 2003 Oscar-winning turn in Clint Eastwood's *Mystic River*.

Black's narrative assumes the shape of a survey of 1970s gay life in San Francisco, just before another major tragedy, the AIDS epidemic. The saga is punctuated by major events, which are indicated on screen with title cards. Although parts of the film are emotionally effective, they don't add up to a truly satisfying, fully fleshed out portrait of the man who became a symbol of the gay movement. Nor does the film convey the tumultuously vibrant sociopolitical times

in which he lived. Taking too balanced an approach to its subject, *Milk* doesn't dig deep enough into the psychosexual dynamics of its protagonist.

The structural device of Milk tape-recording his thoughts and pre-monition of death interrupts the flow of a narrative that's already too episodic. His commentary is too brief (two sentences or so), adding just another, unnecessary layer to the narrative. As a result, the film is not a particularly poignant profile of a seminal persona that went way beyond the rigid norms of his society in forging a new era defined by a more humanistic and liberal agenda. *Milk* turned out to be too mainstream for militant gay and indie audiences seeking offbeat fare and too outré for middlebrow viewers who like well-made biopics about "noble" heroes. As a result, the movie scored only moderately at the box office, grossing $31 million in the United States.

Van Sant's main achievement in *Milk* resides in his refusal to struc-ture it as a formulaic tale of the rise and fall of an outsider who was an underdog par excellence—a proud, openly gay man. Milk's platform of hope and heroic legacy continue to resonate in today's politics. The picture bowed in late November 2008, after the presidential elec-tions. Like Oliver Stone's biopic *W* (about President George W. Bush), *Milk* might have registered stronger impact had it been released prior to the party conventions and presidential debates.

Van Sant's *Milk* was not the first feature about the person or his era. In 1984, Robert Epstein and Bob Friedman made the Oscar-winning documentary *The Times of Harvey Milk*, which prepared the way for other features about AIDS, such as *Parting Glances* (1986), *Longtime Companion* (1990), and *Poison* (1991), to mention just a few significant gay-themed titles. (See chapter 3.)[52]

The Times of Harvey Milk chronicled the rise to political power and tragic murder of Milk. His story paralleled the story of the modern gay rights movement—specifically, the heady times of the 1970s in San Francisco's Castro district, the world's most famous and most organized gay community. That community couldn't ask for a more potent representative and mobilizing symbol than Milk. Displaying elements of both tragedy and nostalgia for a unique period in gay his-tory, the nonfictional work depicted how Milk, unsuccessful in his first attempts to win a city supervisor seat, eventually was elected

after the city restructured its districts. His campaigns were described by former campaign aides, who told of his generosity and insistence on recruiting a diverse staff. The footage showed Milk and his supporters react to his election with both disbelief and unmitigated joy. The tragedy that followed was foreshadowed by Dan White, the fellow San Francisco supervisor who murdered Milk and Mayor George Moscone in 1978. Despite White's confession and evidence of intent, he was given a minor sentence of only seven years in prison. As a result, San Francisco's gay community was catapulted into a state of rage that led to riots at City Hall. The scene of the candlelight march held for Milk after his murder was especially poignant. *The Times of Harvey Milk* was at once a piece of history and a tribute to a towering figure in the gay movement.

Because the documentary was made decades ago, Van Sant felt there was room for a new, more illuminating feature about this seminal figure. Shrewdly, Van Sant, as well as Epstein and Friedman, decided to focus on the last eight years of Milk's life, from 1970 to 1978, without dwelling on his childhood and adolescence. Thus, *Milk* covers the same turf as the 1984 documentary but adds some new characters and relationships. Van Sant and Black show how Milk recruited a diverse aggregate of people, from militant gays to senior citizens to union workers. In the process, he changed the political system and the meaning of a militant battle for human rights. In 1977, when he was elected to the San Francisco Board of Supervisors, he became the country's first openly gay man to be voted into major public office. His triumph was perceived as a victory for specifically gay as well as more general human rights, as he succeeded in forging new coalitions across the political spectrum. Milk became a national hero well before his untimely death.

In a flashback near the beginning of the film, the restless Milk is forty and living in New York City. Looking for a different purpose, he and his lover, Scott Smith (James Franco), relocate to San Francisco, where they establish a small business, Castro Camera, in the heart of a working-class neighborhood. Soon the place becomes a social (and cruising) center for gay people from all over the country.

Milk seems empowered by San Francisco (this was, after all, the sexual liberation in the pre-AIDS era) and by the Castro

neighborhood, sort of a mecca for gay Americans and foreigners—
and also for straight tourists wishing to get a glimpse of the distinctly
gay region. Surprising even himself, he decides to "go into politics,"
designating himself as an outspoken agent for radical change and
seeking equal rights and opportunities for all. His love for the city
and passion for its people bring him the support of unlikely demo-
graphic groups, young and old, straight and gay, at a time when preju-
dice and violence against gays were rampant—in spite (or because) of
the new sexual freedom begun in the late 1960s and increased in the
1970s—including Anita Bryant's vicious homophobic campaigns.

With vitalizing support from friends and volunteers, Milk
immerses himself in "dirty" city politics. Not neglecting the younger
generation, he also mentors street activists like Cleve Jones (Emile
Hirsch, who starred in Penn's *Into the Wild*). Bolstering his likable
public persona with humor, Milk begins to act in ways that spoke
louder than his gift-of-gab words. Soon he becomes a figure known
inside as well as outside his immediate milieu—a local celebrity. (In
1976, while visiting San Francisco for the first time, I, like many other
people, stopped at the camera shop, now a tourist landmark, and was
introduced to Milk by a friend.)

However, there is a price to be paid for his political commitment.
Milk's persistent determination to integrate himself and his agenda
into the city government has damaging effects on his personal life,
driving him apart from Scott. In what's truly an American success
story, Milk fails not once but three times to get elected, twice for the
San Francisco Board of Supervisors and once for the California State
Assembly. While making his fourth run for public office, Milk takes a
younger Mexican lover, Jack Lira (Diego Luna).

The latest campaign proves a triumph, and Milk is elected supervi-
sor for the newly zoned District 5. He serves San Francisco, lobbying
for a citywide ordinance protecting people from discrimination based
on their sexual orientation, but also rallies support against a proposed
statewide referendum that would have fired gay schoolteachers. Milk
realizes that his fight against Proposition 6 represents a pivotal point
for the gay rights movement. Thus, his political platform and that of
another newly elected supervisor, Dan White (Josh Brolin), increas-
ingly diverge, and their personal destinies tragically converge.

To Van Sant's credit, White is not vilified as a cartoon-type villain, and Brolin, who continues to impress as an actor (he played the lead in Stone's biopic *W* as well as the main character in Joel and Ethan Cohen's 2007 Oscar winner, *No Country for Old Men*), plays him as an eccentric politico, driven by his own set of ideas and deeply troubled by a whole set of demons. Some of the most illuminating scenes take place between Milk and White, and it's surprising to realize how complex their bond is. Milk, for example, was the only politician invited to the christening of White's son. The film suggests that White's Catholicism, not to mention his excessive drinking, might have played a critical role in his ferocious animosity toward Milk.

Structurally, the narrative of *Milk* borrows elements from Scorsese's *Taxi Driver* and other memoir-based sagas. In the first chapters, set in November 1978, Milk tape-records personal observations, such as "Everything I did in my life was with a clear eye on the gay movement." That he becomes an assassination target later in the month accords his observation a prophetic, even tragic quality. The film also raises questions of consciousness: Was Milk aware of the potentially dangerous effects of his radical politics?

Of the various lovers that Milk had, the most interesting is the first, Scott Smith, played by Franco as a charming, easy-going fellow. It's only in his scenes with Scott that we get a glimpse of the "gay" persona of Milk, making love, wearing drag, eating cake in bed, arguing and fighting, using gay witticisms. The weakest sections are those with Luna, as the effeminate Mexican lover, perhaps because his part is underwritten and stereotypical; it's hard to see what bound the couple together other than sex (which is not shown). Like most of Van Sant's films, this tale is largely male-driven. The only significant female figure is Anne Kronenberg (Alison Pill), a hard-core lesbian who helps orchestrate Milk's fourth, successful campaign.

TWEENERS: CONVENTIONAL INDIES?

Van Sant's *Restless* served as the opening night of the 2011 Cannes Film Festival's secondary series, Certain Regard, which means it was not good enough for the Main Competition, where his previous

pictures had premiered. An artistic disappointment and simplistic to a fault, this romantic melodrama of doomed youngsters lacks the nuance, dramatic tension, and bravura visual style expected by now of the director. Anything but what its title implies, the film is a static, inert tale about youth facing untimely mortality. The film fails to have much impact because its vision and scope are limited. There are only two characters, and there is no subtext or subtlety. It might be the most conventional picture that he has made thus far. (*Even Cowgirls Get the Blues* was an artistic and commercial flop, but it was not banal or routine.)

Mia Wasikowska, one of the most gifted and busiest actress around (she had appeared back-to-back in *Alice in Wonderland*, *The Kids Are All Right*, and *Jane Eyre*), plays Annabel Cotton, a terminal cancer patient with a deeply felt love of life and special penchant for the natural world—specifically, water birds. She is contrasted with Enoch Brae (Henry Hopper, son of Dennis), a youngster who has dropped out of school (and life) after an accident claimed his parents' lives. Elegantly dressed in white shirt, black tie, and black jacket, Enoch is a funeral junkie obsessed with death; he spends his time attending one memorial service after another.

When these outsiders meet by chance at a funeral, they find an unexpected common ground in their experience of the world. For Enoch, this (fantasy) world includes his best friend, Hiroshi (Ryô Kase), who happens to be the ghost of a Kamikaze fighter pilot. For Annabel, it involves an admiration of Charles Darwin and a strong interest in how other creatures live. As the last thing on Enoch's mind is to befriend or court a girl, he rejects with cynicism (actually self-protection) Annabel's efforts to get closer to him. However, upon learning of Annabel's imminent death, Enoch offers his company through her last days. (The film could have easily been titled *Last Days*.) What begins as a "rescue" mission on Enoch's part turns into an irreverent abandon that tempts fate and death itself.

It soon becomes clear that Enoch and Annabel are experiencing true love for the first time; in her case, it's also her last love. The film's stronger scenes evoke memorable, eccentric screen romances, such as *Harold and Maude*, in which the protagonists, an older woman and a suicidal youngster, also meet at a cemetery and also are obsessed

with death. As conceived by writer Jason Lew, other scenes contain cute lines that belong to a schmaltzy picture like the 1970 blockbuster *Love Story*.

As their love for each other grows, the realities of the surrounding world are closing in on Enoch and Annabel. Daring, childlike, and incurably romantic, the two bravely face what life has in store for them. With some playfulness and originality, the misfits go through the motions of pain, anger, and loss, trying to make (and then live by) their own rules. Inevitably, their journey begins to collide with the unstoppable march of time as Annabel's condition deteriorates.

It's hard to see what attracted Van Sant to the material, as he doesn't bring any particularly illuminating insights to the tale or to its central characters. In theory, the movie is meant to be a hymn to life, a celebration of the redemptive power of love, but in practice, most of what unfolds on screen is overly familiar from other, better tales. The film's problems reside in its conception and writing by first-timer Lew, who was a New York University classmate of Bryce Dallas Howard, director Ron Howard's daughter; both father and daughter are among the film's producers. The episodic screenplay betrays its origins as a collection of short stories, which were then developed into a stage play. Unfortunately, Van Sant and Lew isolate their protagonists from their surroundings. Enoch has two scenes with his aunt, played by gifted character actress Jane Adams (*Happiness*), who's totally wasted. For her part, Annabel has a family, but her interactions with her sister and mother are limited, too.

Lacking subtlety and depth, *Restless* gives the impression of an unfinished screenplay and a movie that might have been executed too quickly, without fully developing its dramatic potential. That said, Van Sant should be credited for refusing to make either a schmaltzy Hollywood picture like the crass and cute *Love Story* or a sentimental TV Movie of the Week to play on the Oxygen Channel.

The critical response to the Sony Pictures Classics release was decidedly negative. The bright *Variety* critic Justin Chang represented many others when he described the film's contradictory nature as "at once delicate and clumsy, tender and twee," struggling to balance the "low-key sweetness" with the "self-consciously cutesy" aspects of the tale.[53] After a limited distribution in major urban centers, *Restless* was

put to rest as an immediately forgettable work from an otherwise distinguished director.

* * *

Released in 2012, *Promised Land*, in which he served as gun-for-hire, is an equally disappointing enterprise. The soft-centered tale is set in a small town where a natural gas company seeks to extract gas from shale rock formations through a process known as hydraulic fracturing, or "fracking." Beginning with its title, the feature is a heavy-handed ecological message picture; the screenplay, written by actors John Krasinski and Matt Damon, is based on a story from prolific novelist and journalist Dave Eggers.

In his third teaming with Van Sant as a lead actor, Damon[54] stars as Steve Butler, a corporate salesman whose journey from farm boy to big-time player takes an unexpected detour when he lands in the small town of McKinley. Steve has been dispatched there with his sales partner, Sue Thomason (Frances McDormand). Because the town has been hit hard by the economic decline, the two sales executives think that its residents would accept their company's offer to lease the drilling rights.

The plot follows the two as they try to persuade community members to lease the drilling rights of their farmland to Global Crosspower Solutions one of the largest energy corporations in the country. As expected, the townspeople have divergent opinions about whether this is a good idea. Some feel that the lease is the only viable measure to keep their family farms from foreclosure. However, what initially seems like an easy sell and a short stay gradually becomes complicated by calls for communitywide consideration of the offer. Unfortunately, the characters represent an aggregate of types, including Frank (veteran actor Hal Holbrook), a schoolteacher; Alice (Rosemarie DeWitt), also a school teacher; and Dustin (Krasinski), a slick environmental activist whose arrival pushes personal and professional crises to a boiling point.

Van Sant saw the film as an opportunity to explore "America as a big place, in which we are all part, and so it's hard to really get a grasp on our identity. What I loved about the screenplay is that it tackled

big issues, but with a lot of humor and humility. It's a story about real people with all their foibles and greatness."[55] The director said he was intrigued by the protagonist, Steve Butler, who's a contemporary Everyman (Damon's specialty as a screen star). Steve had left the farming community where he grew up because it was dying. He migrated to the big city in search of opportunities, and, indeed, he lands a good job and makes good money. A corporate guy, he thinks that what he's doing is right; he doesn't feel bad about trying to get ahead. On the road for too long as a salesman, this is his chance to reach the executive level.

When Steve shows up in McKinley with his partner, Sue, their agenda is twofold, to help save the town from financial decay while simultaneously boosting their company. Steve figures it will be a smooth operation, based on his heartland background and his ability to speak its language. However, these traits prove to be both his strength and his weakness, ultimately forcing him to take stock of his existence and his own set of values. Said Van Sant: "The whole idea of democracy is dependent upon people working together, and without compromise, there can be no democracy. How would our parents or grandparents have handled what we face in our day and age? How are our grandchildren going to fare? Those are big and tough questions for anyone to deal with. Until we question everything, we're not going to have any possibility of a future that's within our control."[56]

Unlike most of Van Sant's films, *Promised Land* is a sentimental, Capraesque tale whose main reward is watching Matt Damon cast against type as the smooth-talking salesman out to cheat country folk of the same stock as himself. It aims to raise poignant questions of how quintessentially American values have devolved, but the execution is frustratingly conventional, and the narrative unfolds in broad, predictable strokes of black and white, good and bad. As a result, the film was dismissed by most critics as a simplistic agitprop, a messagy picture inferior to such issue-oriented features as *Norma Rae*, *The China Syndrome*, *Erin Brockovich*, and *North Country*, all of which deal with labor, ecological, and environmental problems by celebrating heroic individuals. Focus Features, which distributed the movie in the Christmas season, hoping for Oscar considerations, took a major

loss when *Promised Land* grossed a meager $7.5 million at the domestic box office.

<div align="center">＊ ＊ ＊</div>

Like John Waters, Van Sant experienced the best and most crucial phase of his career in his first decade as a filmmaker, from *Mala Noche* in 1985 to *To Die For* in 1995. During that time, he served as American cinema's major chronicler of youth disengagement and alienation, shown in a series of transgressive depictions of anomie and transient life. It's hard to think of another American director who has been so consistent in developing an idiosyncratic (truly inimitable) style, defined by nonlinear narratives, arresting imagery of unusual objects, languorous rhythms, and disorienting music. Early on, critic D. K. Holmes observed: "Beneath the humor and whimsy of Van Sant's work lurks a bleak, frightening vision,"[57] which may explain his preoccupation with disenfranchised individuals who die prematurely.

Like Soderbergh, the poster child of New American Independent Cinema ever since his stunning 1989 debut, *sex, lies, and videotape*, Van Sant has navigated (at time smoothly, at other times roughly) between small-scale, low-budget indies and more mainstream commercial fare. Clearly, the audience for his personal art films is very limited. It is not a coincidence that all four of his youth films in the new millennium have underperformed, grossing around $1 to $3 million in the domestic marketplace.

Even so, whether independent or more mainstream, Van Sant has remarkably maintained his distinctive voice as an auteur with a consistent vision. "He's very intuitive and spontaneous but also very precise and decisive," Savides said. "There's only one guideline for everything and anything that he does, which is what his gut instincts tell him."[58] Van Sant himself has said, "I'm not a film historian type, like Scorsese, who's seen everything. I'm influenced by what I happen to stumble upon,"[59] which explains the spontaneous yet iconoclastic nature of his films.

As this book goes to press, I can only report briefly (sight unseen) on Van Sant's latest feature, *The Sea of Trees*, a dramatic suicide

mystery written by Chris Sparling, with a high-profile cast headed by Oscar-winner Matthew McConaughey (*The Dallas Buyers Club*) and Oscar nominees Ken Watanabe and Naomi Watts. Announced as a world premiere at the Cannes Film Festival (where most of the director's features have debuted), the drama, budgeted at $25 million, belongs to Van Sant's mid-range projects (like *Milk*). A male-driven drama about a married American named Arthur Brennan, who intends to kill himself in the "suicide forest," where he meets a Japanese mad named Takumi Nakamura (Watanabe) who is there for the same reason, *Sea of Trees* very much belongs to the director's thematic universe. The site, Aokigahara forest, at the base of Mount Funi, is known for its numerous suicides. Upon meeting, the two men embark on a journey of self-reflection and discovery, which is also a motif of the director's work, though this time around it centers on adults rather than youths.

GUS VAN SANT FILMOGRAPHY

1981	*Alice in Hollywood* (never released)
1985	*Mala Noche*
1989	*Drugstore Cowboy*
1991	*My Own Private Idaho*
1993	*Even Cowgirls Get the Blues*
1995	*Kids* (as producer)
1995	*To Die For*
1997	*Good Will Hunting*
1998	*Psycho*
2000	*Finding Forrester*
2001	*Gerry*
2002	*Elephant*
2005	*Last Days*
2007	*Paranoid Park*
2008	*Milk*
2011	*Restless*
2012	*Promised Land* 2015 *The Sea of Trees*

5

JOHN WATERS

Queer as Trash and Camp

JOHN WATERS became a cult figure in the early 1970s, when he began making films of "dubious taste" or, to use his own words, "exploitation films for the art-house." Waters's contribution to American cinema and, by extension, to popular culture is his revisionist conception of taste. In terms of screen representation, he has effectively redefined what's "good" taste and what's "bad," what's beautiful and what's not, what's permissible and what's forbidden. In a revealing confession, he stated: "To me, bad taste is what entertainment is all about. If someone vomits watching one of my films, it's like getting a standing ovation."[1] This led to his self-description as the "Prince of Puke" and "King of Sleaze."

"I don't make films about things I hate," Waters has said. "What always make me laugh are people who have very extreme taste but think they're very normal. That to me is the funniest. I don't look down on it. I'm in awe of people who have on the most hideous outfit and think they really look good. Who am I to say that they don't really?"[2]

A filmmaker of outrage and gleeful vulgarity, especially in the first decade of his career, Waters has directed shockingly tasteless satires that contain garish characters and grotesque imagery. William S. Burroughs Jr., the late godfather of the Beat Generation, once labeled Waters "the Pope of Trash," and novelist Bret Easton Ellis (*American*

Psycho, among others) described Waters's work as "demented but endearing."

The taboo breaking in his films has made Waters more than just a priest of trash culture. He has cast his films with individuals whose appearance is bizarre, to say the least, and whose demeanor is deviant. "My films are about people who take what society thinks is a disadvantage, exaggerating their supposed defects, and then turning them into a winning style."[3] A consistent worldview has prevailed in all of his films. Along with gross-out moments, his films are imbued with irony, which for him is "the best kind of humor." Subverting conventional plots, his movies are designed to shock and stun viewers, based on his belief that "the fantastic is beyond the realm of observable reality."[4] To achieve that, he has deployed conventions that mainstream movies have prepared audiences not to expect.

A renegade filmmaker, Waters has survived for over three decades, despite changes in the country's political and cultural climate, though his last theatrical picture, *A Dirty Shame*, was released in 2004. "Even if you hate my films," he has said, "you have to at least say that I've created my own genre."[5] It may be hard to define precisely what that genre is, but it's distinctive enough to be identified as one. Waters's work is better appreciated by, and more enjoyable for, viewers who know movies and pop culture well enough to experience a fresh perspective on them. Making allusive and intertextual references to other films, TV shows, personalities, and pop culture is the name of the game in his oeuvre.

Waters's films have pushed the envelope, testing the boundaries of what's acceptable, but they have done so in funny and ironic ways, not hateful or angry ones. "Anger is only funny for a short time and then it turns, it curdles,"[6] he said. "I think my humor is completely politically correct, if you really think about it. My philosophy is, 'Don't judge other people until you know the whole story' and 'Mind your own business.' That's politically correct. That's a very democratic way of thinking."[7]

EARLY LIFE AND CAREER BEGINNING

Waters was born on April 22, 1946, in Baltimore, Maryland, into a middle-class Catholic family. He's the son of Patricia Ann (née Whitaker)

and John Samuel Waters, a manufacturer of fire-protection equipment. He grew up in Lutherville, a beautiful suburb of Baltimore, which was erroneously described by some as a "cultural wasteland," a conception that the mature Waters always rejected.

Early on, Waters realized that he wasn't like other kids; as he recalled: "I used to come home from kindergarten and tell my mother about this really weird kid in my class; he only drew with black crayons and wouldn't talk to other people. I talked about him a lot. My mother mentioned it to the teacher, and she said, 'Well, that's your son.' I was creating characters, really."[8] His mother would say, "Oh, he's just an odd duck. 'Each to their own said the old lady as she kissed a cow.'" He believes that his mother regrets saying that "because I took it much more seriously than she ever imagined."[9] Though his parents never understood him, he gives them credit for always making him feel safe, which for him was "the main thing parents should try to make their kids feel."[10]

The strange, the lurid, and the forbidden have always fascinated Waters. But, ironically, he fed his mind through mainstream avenues. "*Life* magazine was the biggest corruptor of youth," he said. "They didn't realize it. It was the magazine that every family got, where I learned about homosexuality, I learned about drug addiction, abstract art, beatniks and hippies—everything. I couldn't wait to get it every week. I also learned from the Encyclopedia Britannica that every family had. All those subjects other children might have been looking up—dinosaur—I wasn't."[11] Instead, he devoured all those "horrible" subjects that "I was obsessed about, because I knew that I was not supposed to know about them, like disease or censorship."[12]

In early childhood, Waters was intrigued by stories about devious subjects—criminals, murders, car accidents. A sharp observer of the "strange" aspects of everyday reality, he was more interested in the denizens of the working class than in members of his own milieu. He recalled his fascination with garbage collectors: "In our neighborhood, you always left the garbage man liquor at Christmas. I always wished that garbage men were my secret friends. I love when they pull up in Baltimore and go 'Hoo!' That's when you have to run out and give them liquor or money or whatever."[13]

The first movie that Waters remembers seeing, at age five, was Disney's *Cinderella*, after which he developed an instant crush—but not on the lovely princess. "I worshiped her evil stepmother," Waters recalled. "I remember getting the record from the movie and playing the stepmother's entrance over and over, this was the first sign my parents had that something was definitely amiss."[14]

Lili, the popular 1953 MGM movie, directed by Charles Walters and starring Leslie Caron (who sang the popular song "Hi Lili.") had a major impact on the young Waters. At the age of seven, he was enchanted with that film's puppets and staged shows for children's birthday parties that were sort of gross and violent versions of "Punch and Judy." His mother believes that the puppets in *Lili* had the strongest influence on his future sensibility. The legendary fantasy fable *The Wizard of Oz*, made in 1939 and starring Judy Garland, also proved influential to the creative mind of the young Waters—as it did to David Lynch, Gus Van Sant, and many others. "I was always drawn to forbidden subject matter," Waters recalled, "'*The Wizard of Oz* was one of the first movies I ever saw. It opened me up to villainy, to screenwriting, to costumes, to great dialogue. I think the witch has great dialogue."[15]

A fan of Little Richard's music while growing up, Waters claims that ever since he had shoplifted a copy of the song "Lucille" in 1957, "I've wished I could somehow climb into Little Richard's body, hook up his heart and vocal cords to my own, and switch identities."[16] In 1987, *Playboy* magazine assigned him to interview his idol, but the interview did not go well. He later remarked that "it turned into kind of a disaster."[17]

Waters discovered the world he was looking for in downtown Baltimore in a bar called Martick's, where Malcolm Maelcum (who would become a friend and appear in two of his shorts) worked as a bartender. The place's clientele was mixed: bohemians, beatniks, drag queens. They read and later discussed hip writers, such as Burroughs, John Rechy, and Tennessee Williams. It was also there that he was initiated into drugs, and the first time he took LSD was in high school.

Tacky "B" flicks at the local drive-in, which the Waters family watched from a distance with binoculars, also had long-lasting

effects. By age thirteen, Waters had become an avid reader of the trade magazine *Variety*, the "bible of showbiz." For his sixteenth birthday, while a student at Calvert Hall College High School in nearby Towson, he received a precious gift, an 8mm camera, from his maternal grandmother, Stella Whitaker. During high school, he was in a "beatnik" phase, a tough act to pull off in a place like suburban Baltimore. "My parents didn't know what to do," he recalled. "They'd dropped me off at this beatnik bar and hoped I'd meet some nice people." Then one day his mother took a quick look at the place and said, "Is this camp, or just the slums?"[18]

Waters made his first short, the seventeen-minute, black-and-white *Hag in a Black Leather Jacket*, when he was in high school. Shot on the roof of his parents' house, the tale concerns the interracial affair between a white woman named Mona, played by his childhood friend Mary Vivian Pearce, and a black man. The man, who woos the lady by carrying her around in a trash can, chooses a Ku Klux Klansman to perform their wedding ceremony. The Klansman, standing on the chimney like an angelic figure, represents Waters's first exploration of a sacred symbol of Catholicism. A girl with wild hair and a male in drag are also on the roof. Mona is dressed in a long bridal gown, and the train of her dress is carried by a child. The black man emerges from his can, and people eat wedding cake as the Klansman descends. At the end, Mona performs a sexy dance, the "Bodie Green," while Waters's real-life mother plays "God Bless America" on the piano.

Hag in a Black Leather Jacket was not released theatrically, but it was shown several times in a "beatnik" coffeehouse. In later years, it would be included in Waters's traveling photography exhibit. More importantly, the short introduced a character that would become a recurrent figure in his work, usually played by Divine: a woman who's trapped in a bad situation that's beyond her control and is brutally tormented, usually by men.

Waters enrolled at New York University (NYU), but as he later recalled: "I was there for about five minutes. I don't know what I was thinking. I went to one class and they kept talking about *Potemkin* (Eisenstein's silent masterpiece, aka *Battleship Potemkin*), and that isn't what I wanted to talk about. I had just gone to see *Olga's House*

of Shame. That was what I was more into."[19] Made in 1964, *Olga's House of Shame* is the third in a sexploitation series starring Audrey Campbell. It was helmed by hack director Joseph P. Mawra and produced by George Weiss, who also was behind Ed Woods's notorious feature *Glen or Glenda*. A surprise hit, the trilogy paved the way for some hard-edged sex films of the 1960s and the psycho-stalker films of the 1970s.

The only reason Waters went to NYU was to be able to live in Manhattan; as he recalled: "I only went to one class, but I lived in the dorm and went to movies every day and all day."[20] During that time, he saw four or five pictures a day; he started in the morning and then just kept going. He attended legitimate movie theaters but also went to places like St. Mark's Church. It was there and then that he saw Andy Warhol's "strange" films, the work of the Kuchar brothers, Kenneth Anger's *Scorpio Rising*, and Jean Genet's *Un chant d'amour*, a film that influenced in one way or another all five directors profiled in this book. The New York days were heaven on earth: he did lots of drugs and socialized with the Warhol crowd, though mostly its fringe people, who he recalled would take amphetamine and listen to Maria Callas records all night.

As a youngster, Waters used to sneak to a hill near a drive-in and use binoculars to watch films like *The Mole People* and *I Spit on Your Grave*. He has credited as significant influences on his sensibility Luis Buñuel, the gay German director Rainer Werner Fassbinder, and the American filmmakers the Kuchar brothers, Herschell Gordon Lewis (*Two Thousand Maniacs*, *The Gore Gore Girls*, and *Color Me Blood Red*), and Russ Meyer (*Lorna*, *Mudhoney*, and *Faster, Pussycat! Kill! Kill!*). He derived joy and pleasure from highbrow "art" films as well as sleazy exploitation films: "I love both Bergman and Fellini and *I Dismember Mama* and *Blood Feast*."[21]

In 1966, Waters and some friends were caught smoking marijuana on the campus grounds, which led to his expulsion from NYU. He returned to Baltimore, where he completed two shorts. The first, *Roman Candles*, was composed of three 8mm films, shot in color and shown simultaneously. It also introduced several Waters regulars (known as Dreamlanders, from Dreamland Productions, his production company), including David Lochary, Mink Stole, Pat Moran, and

Divine. In that film, Maelcum Soul exerted strong influence on Divine in terms of style and make-up—the hairdo, the big eyebrows, the red wig. Multiple images, which at first seem random, depict all kinds of bizarre lifestyles, playing off each other while juxtaposed with split-second shots from old horror flicks. Acts involving religious mockery (Maelcum dressed as a nun), drug taking, and weird sex emphasize the absurd and the provocative. The focus again is on victimized and tortured women. For instance, Mary Vivian Pearce is attacked with an electric fan, and a man in black leather beats another woman. The short concludes with a montage showing one actor photographing Mona Montgomery and another one in drag riding a motorcycle. In a shocking reference to John F. Kennedy's assassination, David Lochary fires a shotgun, just like Lee Harvey Oswald, and there is even an image of Oswald's mother. To accomplish greater impact, the wildly bizarre images are accompanied by Shangri-Las tunes.

In 1967, Waters made *Eat Your Makeup*, a forty-five-minute, black-and-white short shot in 16mm. It was inspired by candy bought in a candy store in Provincetown, Massachusetts. The film follows a couple of perverse gangsters (played by David Lochary and Mael-cum Soul) as they kidnap women and chain them. The three captives (Marina Melin, Mary Vivian Pearce, and Mona Montgomery) grovel for food, but the only thing they are given to eat is cheap make-up. Chained to a freestanding wall, the women are then forced to model before jeering crowds until they drop dead—literally.

It is the first and last Waters film in which the evil group, which exploits innocent others, wins at the end. In later Waters films, the villains always lose, and the misfits, who are comfortable with their deviance, always win, albeit after much suffering and long struggle.

Most of the feature's crude and tasteless images concern organized religion. A wicked couple and a vicious dog stalk Marina (wearing a peekaboo dress) as she emerges from church and then fingers her rosary. When the bishop intones the sacraments, Divine fantasizes herself as a Jackie Kennedy and Howard Gruber as a JFK. They ride joyously in an open car waving to cheering crowds. When a shot is fired, Howard slumps over, and Divine (in pink dress) climbs over the back of the car. The sequence ends with Divine's figure fading back to reality. After Marina dies on the runway and the vicious

people depart, a man in a cavalry uniform puts flowers on her body, and she comes back to life as a fairy princess.

In Waters's shorts, as in his features, several prominent themes emerge, some of which ahead of their times: America as an image-conscious and media-saturated society, the use of fables and fairy tales in deformed and distorted ways to comment on contemporary culture, and, of course, the championing of what can be called the aesthetics of trash through crass and shocking vulgarity.[22]

* * *

Though Waters deserves credit for his outrageous and gross-out features, he did not operate in a social or an artistic void. In the middle to late 1960s, the underground cinema in downtown New York was booming with the new voices and radical visions of the likes of Jack Smith, Andy Warhol (and the Factory), Paul Morrissey, and others. These revolutionary artists paved the way for a whole cohort of young and audacious filmmakers such as Waters.

Born in 1932 in Columbus, Ohio, Smith was a pioneer of underground cinema based on his contribution to a new kind of performance art. One of the first proponents of the aesthetics of camp, he made low-budget, eccentric features heavily influenced by Hollywood kitsch. Smith was involved with John Vaccaro, founder of The Playhouse of the Ridiculous, whose disregard for conventional theater influenced his radical ideas and costumes. Smith's style also influenced the work of Warhol. Interestingly, Vaccaro and Smith denied at the time that their sexual orientation had anything to do with their distinctive artistic sensibility.

Smith's most notorious production, *Flaming Features* in 1962, was a satire of Hollywood "B" movies and a tribute to the actress Maria Montez, who starred in such pictures. Because the authorities considered some scenes to be pornographic, the movie was confiscated at its premiere. It was subsequently banned, but it didn't disappear. Though not shown publicly, the movie gained notoriety when footage was screened during congressional hearings and right-wing politician Strom Thurmond mentioned it in his antipornography speeches.

Nearly a decade older than Waters, Morrissey (born in 1938) is best known for his association with Warhol and the Factory. *Flesh*, Morrissey's first production for Warhol in 1968, is the first film in what became known as a trilogy. It centers on a bisexual played by Joe Dallesandro. Emotionally affectless but exuding natural charm, Dallesandro had previously starred in such Warhol films as *The Loves of Ondine* and *Lonesome Cowboys*, but it's *Flesh* that made him a cult figure, in and out of the gay world. *Flesh* also featured the debut of two performers who would become Warhol superstars, Jackie Curtis and Candy Darling.

As the tale starts, Geri (Geraldine Smith) kicks her boyfriend Joe (Dallesandro) out of bed, insisting that he go out on the streets to make some money, which her girlfriend Patti (Patti D'Arbanville) needs for an abortion. During a long day of activities, Joe encounters various clients, including an artist (Maurice Bradell) who wishes to draw him and a gymnast named Louis Waldon. Shot on location in Manhattan (33rd Street, to be exact), *Flesh* shows Joe socializing with other hustlers (one played by his real-life brother), instructing a new hustler (Barry Brown) in the tricks of the trade, and spending time with his baby son. The film concludes with Joe in bed with Geri and Patti. After stripping Joe to his notorious genitalia, the women get more excited by each other, and the bored Joe simply falls asleep. Dallesandro, Darling, and Curtis were later immortalized in Lou Reed's song *Walk on the Wild Side*. Unusually explicit in its graphic sexuality, *Flesh* became notorious (a cause célèbre) when it was confiscated by the police during early showings.

The two other films in the trilogy, *Trash* and *Heat*, also gained immediate cult status due to their sexual audacity and taboo breaking. Though filmmakers Morrissey and Warhol are linked, their aesthetics differ. Warhol's films are known for their nonnarrative nature, lengthy and endless takes, drug-fueled improvisations, and casually amateurish production values in lighting and sound. In contrast, Morrissey deployed more traditional strategies and more polished technical values. The acting in his films is also better, which may explain their relatively greater commercial appeal.

Made in 1970 for the low budget of $25,000, *Trash* (aka *Andy Warhol's Trash*) was directed and written by Morrissey and depicts intravenous

drug use, frontal nudity (both male and female), and graphic sex. Transsexual Holly Woodlawn made her debut in the film, as did Jane Forth, a seventeen-year-old model who shortly thereafter appeared on the cover of *Look* magazine. It also features Warhol superstars Andrea Feldman and Miller. The episodic plot, set over one day, follows heroin-addicted Joe (Dallesandro) on his "holy quest" to score more drugs. He is observed overdosing and attempting to fool a gay welfare agent into approving methadone treatment by asking his girlfriend Holly to fake pregnancy. Holly and the other women are sexually frustrated by Joe's recurrent impotence, despite his being well endowed, which is the main reason Dallesandro became an attraction in the first place.

The trilogy's third and most accessible film, *Heat*, released in 1972, stars Dallesandro, Sylvia Miles, and Feldman. An unemployed former child star supporting himself as a hustler in Los Angeles, Joey Davis (Dallesandro) uses sex to get his landlady to reduce his rent. Sally Todd (Miles, then best known for playing a prostitute in the initially X-rated, Oscar-winning *Midnight Cowboy*) is a former Hollywood starlet who tries to help Joey revive his career, but her status (which is dubious) proves useless. Adding color to the tale is Sally's psychotic daughter, Jessica (Feldman), who complicates the relationship between her mom and the emotionally numb Joey. Morrissey conceived the film as a parody of Billy Wilder's 1950 classic noir, *Sunset Boulevard*, starring Gloria Swanson.

Waters got his real film education not in school but in New York City, seeing lots of trash movies and reading the *Village Voice*. He recalled: "The *Village Voice* had Jonas Mekas' column every week, and I loved him, because he wrote about movies and directors I wanted to know about."[23] It's noteworthy that each of the underground directors influenced Waters in a different way. Though he didn't imitate Warhol's sensibility and style (static camera, overlong running time), the latter impacted him in another way: "Warhol gave me the confidence that I could make films with my friends, for no money."[24] The films of the Kuchar brothers (George and Mike) were more influential "because they were lurid melodramas." Waters admired "punk filmmakers" Kenneth Anger, Nick Zedd, and Richard Kern, "who showed their films when punk came out at the Kitchen, a revered Downtown

institution. They were all "quite defiant and quite junk-ridden," which could be inferred from their titles: *Sins of the Fleshapoids*, *Hold Me While I'm Naked*, and *Pussy on a Hot Tin Roof*. And Waters doesn't neglect to acknowledge the impact of the trashy and gory pictures by Russ Meyer and Herschell Gordon Lewis, whose combined sensibility was described by Waters as "The New York Underground School meets the Drive-In."[25]

* * *

Waters's career can be divided into three significant phases. The first phase, by far the most important one both culturally and historically, consists of the gross-out shorts and trash trilogy, culminating in *Female Trouble* (1974), his best film in my view, and *Desperate Living* (1977). The second, "lighter" phase begins with the transitional *Polyester* (1981), an unsuccessful hybrid, and includes his most popular satires and accessible farces, *Hairspray* (1988) and *Serial Mom* (1994), which served as the closing night of the Cannes Film Festival, the most important film event in the world. The third and weakest phase, signaling artistic decline and commercially disappointing features, begins with *Pecker* (1998), continues with *Cecil B. Demented* (2000), Waters's worst picture, and ends with *A Dirty Shame* (2004), which unfortunately is his latest (and last?) movie.

In 1970, Waters left Provincetown, Massachusetts, an early gay-friendly resort, for San Francisco, then the gay mecca in the United States. That move proved crucial for him because it was the first place where "our movies caught on outside Baltimore." For a while, not knowing a single person there, Waters lived in his car. But he was a quick student of the "insanity" of San Francisco, especially its gay clubs and gay-friendly theaters. He credits the Palace Theatre as a special cultural site because prominent figures like Gore Vidal and Truman Capote would go there to see the Cockettes, a theater troupe. The audience, according to Waters, "was half of the show since everyone was on LSD, but straight people went too."[26]

Of all places, however, Baltimore has remained the most significant—his real home. Waters has shot all of his films in Baltimore for practical reasons: "I have a whole crew there, and we know the city better

than anywhere else." There was another reason for favoring Baltimore; as he explained: "It is the only place where I have friends who aren't involved in showbiz, who aren't always talking about movies, and who aren't trendy." Although Waters has not achieved the mainstream success of Baltimore's other native son, Barry Levinson (*Diner* in 1982 and the Oscar-winning *Rain Man* in 1988), the mayor of Baltimore proclaimed February 7, 1985, as "John Waters Day."

With few additions, Waters has worked steadily with the same staff and crew. Pat Moran supervises the casting and production, Vincent Perenio the sets, and Van Smith the costumes. These continuous collaborations have given Waters a sense of security as well as a sense of belonging. He has formed an acting ensemble, believing that audiences like to see the same actors go from film to film. Waters's regular troupe of actors, the Dreamlanders, included Divine, Mink Stole, David Lochary, Mary Vivian Pearce, Edith Massey, Susan Walsh, and Cookie Mueller. But, above all, Waters's films served as vehicles for the acting skills of Divine (né Glenn Milstead), his boyhood friend from Lutherville.

GROSS-OUTS

In 1969 and 1970, Waters wrote and directed *Mondo Trasho* and *Multiple Maniacs*, crude black-and-white features shot in 16mm. Alongside the shorts, they introduced Waters's formative vision, defined by offensive satire, bad taste, intentionally camp humor, and crude production values.

Mondo Trasho, a rough, amateurish comedy, cost only $2,000, which Waters borrowed from his parents. This ninety-five-minute feature was shot without dialogue, and for long stretches of time, not much happens. The "plot," such as it is, is propelled by old rock songs. The central figure is yet another tormented woman (Mary Vivian Pearce) who goes through one terrible day full of catastrophic adventures. Strolling through the park, she is accosted by a crazed foot fetishist who toe-licks ("shrimps") her. After the seduction, she wanders alone on a road until she is run over by Divine, driving a Cadillac convertible with the radio blasting. To conceal the crime,

Divine kidnaps the girl and changes her look on a laundromat table with clothes she had earlier shoplifted. The Virgin Mary then appears in the laundromat, prompting one of the film's funniest lines, when Divine begs, "Oh Mary! Oh Holy Trinity! Oh God! Teach me to be Divine." The saint grants Divine's prayer with a wheelchair to wheel the girl off. However, the two femmes are abducted and taken to an asylum (an image that might have been influenced by the 1948 Hollywood movie *The Snake Pit*), inhabited by bizarre-looking characters. The Virgin Mary again intervenes, providing a fur coat for the girl and a knife for Divine to enable their escape.

What begins as a "light" disaster turns into major torture and humiliation for both women. Committed to caring for the girl, Divine is put through various trials of her own, and she redeems herself through some traumatic encounters. In the climax, Divine brings the girl to a mad doctor (David Lochary) who possesses magic powers. Strangely, he amputates her feet and replaces them with misshapen monster feet, but the repugnant act somehow brings the girl back to life. In the end, pursued by evildoers, Divine dies in a muddy pigsty to the dramatic sounds of Wagner's "The Ride of the Valkyries." The girl, however, awakens to the shocking discovery that her feet have been transmogrified and that the mad doctor has imbued her with magical powers of her own. Clicking her heels together, she is now able to transport herself, just like Dorothy in *The Wizard of Oz.* In the finale, set in a Baltimore shopping district, she is subjected to disdain by older women using contemptuous epithets like "Whore," "B-girl," "Rimmer," and "Slut." However, clicking her feet again, the girl magically disappears.

Waters and Divine collaborated again, to better effect, in *Multiple Maniacs*, written in and inspired by the eccentricities of Provincetown in the late 1960s. Divine plays the manager of the Cavalcade of Perversion, a sideshow that exhibits perverse rituals and obscenities like puke eating. Admission to the show is free, though the performers must persuade reluctant passers-by to attend. At the show's finale, Lady Divine robs the patrons at a gunpoint, an act approved by her lover, Mr. David (David Lochary). However, bored with the routine, she ups the ante and begins to murder the patrons instead of just robbing them.

Escaping the murder scene, Lady Divine returns home to her daughter Cookie (Cookie Mueller), a prostitute, and Cookie's boyfriend, Steve (Paul Swift), a member of the Weather Underground. Things get worse when Edith (Edith Massey), the local bar owner, informs Divine that Mr. David is cheating on her. On her way to the bar for revenge, she is raped by two glue sniffers. Temporary relief seems to occur when the vision of the Infant of Prague appears and leads her to a church. But this is a Waters film, and the church is quickly and radically transformed into a cruising ground where Lady Divine is seduced by a stranger (Mink Stole).

Their sexual encounter, very much a typical Waters touch, culminates when Mink inserts a rosary into Divine's rectum while reciting the Stations of the Cross. In later years, Waters himself has singled out this scene as the most blasphemous in his entire work. Watching it today, it still is shockingly rude and rudely shocking because Divine is seen wiping it off with her sleeve while another person is shooting up on the altar. Waters recalled: "It was the most gratuitous shot in any of my movies—really ad-lib—for no reason, just another horrible thing to show."[27]

Because the guy shooting up did it for real, upon seeing the film, the priest asked Waters never to tell where the scene was shot; the director obliged and for a change kept his mouth shut. Waters attributes the religious mockery in this and other movies to his strict background: "I am certainly a Catholic filmmaker, but that does not mean that I am a good Catholic. They told us that we couldn't do this or that, so it has formed me, the same way as being gay has." As for the image of the Infant of Prague, he noted: "How could I not be a Catholic and do that!?"[28]

Divine and Mink, by now lesbian lovers, go to Edith's bar to kill Mr. David, and in a violent argument that ensues, Mr. David's mistress, Bonnie, accidentally kills Cookie. In retaliation, Divine kills Bonnie and devours Mr. David's internal organs with a knife. Angry for being betrayed, Divine then stabs Mink, but a giant lobster (Lobstora) rapes her. That specific notion was inspired by a postcard sold in Provincetown for decades, featuring a big lobster in the sky over the beach. Turning into a self-proclaimed "maniac," Divine goes on a killing spree clad in Waters's favorite garb, a mink coat. In the conclusion,

the National Guard shoots her, while in the background the iconic Kate Smith sings the patriotic tune "God Bless America."

Waters produced *The Diane Linkletter Story*, a fifteen-minute, black-and-white short, around the time of *Mondo Trasho*. It tells the story of Divine as the young Dawn Davenport, the girl who would become the protagonist of Waters's 1974 feature, *Female Trouble*. During the opening credits, Divine inhales drugs, and the tale begins with a voice-over of a letter from Diane to her folks (played by Mary Vivian Pearce and David Lochary). The parents are worried about Diane's drug abuse and aimless hanging out with her boyfriend. However, Diane responds to her parents by proudly declaring: "I am what I am, doing my own thing in my own time." This was a slogan of the 1960s, an era that Waters deliberately ridiculed, although he participated himself in its wild activities. The father, upset, calls a doctor, and when Diane protests, he screams up at her, "You're disgusting, slut." Diane walks deliriously to the window and jumps off. Seeing Diane's bleeding body, the hysterical parents beg: "Please come back to us. We love you. Call collect."

TRASH TRILOGY

Waters rose to national fame with a series of shaggy, amateurish, Baltimore-set and -shot features, some of which later became cult works. Offering a unique (some say perverse) vision of and a distinctive perspective on American life, his early work attacks suburban life—it's his pleasure dome. He literally exploded onto the cultural scene in 1972 with *Pink Flamingos*, his third feature, a darkly comic, unwholesome parade of murder, bestiality, rape, dismemberment, coprophagia, and other dizzying sexual perversions.

Pink Flamingos, *Female Trouble*, and *Desperate Living*, which Waters has labeled the Trash Trilogy, contest the boundaries of conventional morality while challenging both American censorship and viewers' expectations. In these camp movies, he places "filthily lovable" characters in intentionally outrageous, deliberately contrived situations and furnishes them with hyperbolic dialogue. A notorious scene from *Pink Flamingos* added a non sequitur to its ending: It shows in one

continuous take—without the benefit of artifice or special effects—
Divine stooping to eat a dog's excrement. In the same movie, viewers
are exposed to the spectacle of an "egg lady" begging for eggs from
her crib and to the rape and murder of a chicken.

A transgressive black comedy, *Pink Flamingos* is an auteurist
effort—written, produced, directed, edited, and "composed" by
Waters. For the score, he donated several of his single B-sides and
incorporated hits of the 1950s and 1960s. Made with a shoestring
budget of $12,000, it was shot on weekends in Phoenix, a suburb of
Baltimore. The shoot was a gratifying experience, both personally
and collectively. The set was like a hippie community, as the cast
and crew operated out of a farmhouse without hot water and other
facilities.

The movie has little to do with the tropical fowl that stands senti-
nel during the opening credits. "The reason I called it 'Pink Flamin-
gos' was because the movie was so outrageous, that we wanted to
have a very normal title that wasn't exploitative," Waters said. "To this
day, I'm convinced that people think it's a movie about Florida."[29] The
film certainly did not reflect Waters's personal background, whose
home was done in good taste. His mother, the president of a gar-
den club, cultivated flowerbeds and precise hedges. In their suburb,
lawn ornaments, especially plastic pink flamingos, were anathema.
"I don't remember ever seeing a pink flamingo where I grew up," he
mused. "I saw them in East Baltimore."[30]

Among several achievements, *Pink Flamingos* made an under-
ground star of Divine, the flamboyant, 300-pound transvestite. In the
next decade, the duo developed what could be described as a version
of the famous Josef Von Sternberg-Marlene Dietrich relationship—
without that couple's notorious sex, gossipy intrigue, and sado-
masochistic relationship (acknowledged by both director and star).
Divine began his career as a joke, mocking the desire of drag queens
to look pretty, but there was always rage in him and sometimes out-
right hostility. "Divine was hassled and bullied a lot as a boy," Waters
recalled. "I'm proud that I gave him an outlet for his anger and
revenge. The people that used to beat him up later stood in line and
asked for his autograph."[31] This was the sweet smell of revenge—not
to mention irony—for both director and leading lady.

When *Pink Flamingos* was initially shown, it caused controversy due to its perverse acts, all performed realistically in explicit detail. After screenings at universities and in basements across the country, the film was distributed theatrically by Saliva Films and later by New Line Cinema. Over the years, it has become a "notorious" classic— and one of Waters's most profitable pictures, grossing worldwide north of $10 million.

In this film, Waters depicts a dysfunctional family before the term was even invented: it became popular in the late 1980s. Divine plays Babs Johnson, a criminal on the lam from the FBI, who lives with her obese, dim-witted, egg-loving mother, Edie (Edith Massey); her degenerate son, Crackers (Danny Mills); and her duplicitous traveling companion, Cotton (Mary Vivian Pierce). They share a trailer in the middle of nowhere, a barren site framed only by two plastic pink flamingos.

In the past, the wading birds were a "straight" (in both senses of the word) attempt at making working-class neighborhoods more attractive. "The people who owned them had them for real, without irony," Waters said. "My movie wrecked that." Over the years, flamingos have become a fixture of high-end sensibility, shorthand for tongue-in-cheek tackiness and camp. The lawn sculptures have become "loaded objects" of rich people mocking bad taste. The real plastic flamingos are now extinct because, as Waters explains, "You can't have anything that innocent anymore."[32]

The film's central theme is the desperate need to achieve celebrity status by using all and any means. After learning that Babs has been named "the filthiest person alive" by a tabloid paper, her jealous rivals, Connie and Raymond Marble (Mink Stole and David Lochary), set out to take the title away from her and thus destroy her career. For Babs's birthday party, the Marbles send her a box of human feces with a card addressing her as "Fatso" and signed by "The Filthiest People Alive." Their act enrages Babs, who now seeks revenge. Well ahead of its time in subject matter, the plot depicts the Marbles as managers of an "adoption clinic," a black market baby ring. Their strategy is to kidnap young women, impregnate them by the gay servant Channing (Channing Wilroy), and sell their babies to lesbian couples that are

unfit for legal adoption. The proceeds are then turned into pornography and narcotics, including a network of drug dealers.

Along with the numerous verbal assaults, Waters breaks visual taboos. Raymond makes money by exposing himself in public parks with an extra-large kielbasa tied to his penis. Outraged by the sight, the ladies flee, allowing Raymond to steal their purses. One of the film's most infamous scenes involves sexual intercourse between Crackers and Cookie (a spy disguised as a date), crushing a live chicken between their bodies while being watched voyeuristically by Cotton through the window.

The plot switches back and forth between the Marbles and their schemes and Babs's entourage and their reactions. For example, when Channing dresses up as Connie and imitates her speech, he is locked in the closet by the nasty madam.

The birthday party's guests are entertained by a topless dancer with a snake and a contortionist who flexes his anal sphincter in rhythm to the song "Surfin' Bird" (Waters makes sure to show in close-up the actor's complete control over his muscles). The disgusted Marbles call the police, but Babs and friends kill the cops with an axe, which was given to them as a present, alongside lice shampoo (A-200) and a pig's head. The guests then proceed to eat the corpses, going way beyond Luis Buñuel's 1962 outré attack on bourgeois manners in *The Exterminating Angel*, a macabre comedy in which guests at an elegant dinner party cannot bring themselves to leave and the longer they stay, the more repulsive and animalistic they become in their conduct.

Babs and Crackers spread "filthiness" in the Marbles' house by rubbing items, an activity so erotic it leads to an exciting oral sex scene, with Babs performing fellatio on her own son. In this scene, Waters comes as close as any director to showing a semierect penis as mom goes down on her boy, a scene that was deleted from some early versions. Acts of brutality and revenge, centered on the characters' genitals, continue. Set free, the captive women, previously chained and impregnated by force, emasculate Channing (off screen), and the horrified Marbles find out that Channing has died from his bleeding penis.

There is no conventional acting in Waters's early pictures, just loud screaming and declarative speeches, laced with funny one-liners as exclamation marks. Consider Babs's proclamation of her "filth politics" manifesto: "Blood does more than turn me on. It makes me come. And more than the sight of it, I love the taste of it. The taste of hot freshly killed blood. Kill everyone now! Condone first-degree murder! Advocate cannibalism! Eat shit! Filth is my politics! Filth is my life!"

In a "kangaroo court," the Marbles are sentenced to death, accused of "first-degree stupidity" and "assholism." Though offered a chance to defend themselves, the Marbles opt for execution. Coated in tar and feathers and tied to a tree, they are shot by Babs, proudly handing the hungry media a juicy scoop of "live" homicide. By this point, Babs has flaunted her obesity in a dozen colorful outfits (which change from scene to scene), dominated by red, white, and blue, all clinging tight to her skin. Nonetheless, she opts for a more modest appearance when they relocate to Idaho. (Why Idaho?) The notorious ending depicts Babs, Crackers, and Cotton walking down the street in their new home in Boise, Idaho. Babs spots a little dog with excitement and hunger, waiting for him to defecate, and when the canine does, she throws herself to the ground and puts his fresh feces in her mouth. She proves, as the narrator (John Waters) states, that she is not only the filthiest person but also the filthiest actress in the world.

Waters's grotesque film goes far into the bizarre and the extreme, but it maintains a peculiar, even naïve endearment. "I've never just tried to gross you out—not even at the end of *Pink Flamingos*. I'm always trying to make you laugh first."[33] Although refraining from making overt political statements, Waters's films are not devoid of ideas. "I always have something to say, but I never get on a soapbox. The only way I can change how anybody thinks is to make them laugh. If I start preaching, they'll walk out."[34]

Some of Waters's films had premiered in Baltimore churches and later in that city's Senator or Charles Theatre. When they played in Provincetown, Waters himself proudly promoted the screenings on Commercial Street; as he remembers: "The Provincetown Bookstore would give me the whole window and I would turn it into a billboard.

We would go out in costume and hand out all the flyers for two weeks."[35]

Pink Flamingos premiered in late 1972 at the third Baltimore Film Festival, held on the campus of the University of Baltimore, where it played to sold-out audiences for three shows. The movie aroused particular interest among fans of underground cinema after the success of *Multiple Maniacs*, which had begun to be screened around that time in New York City and San Francisco. Later Waters's films were among the first to be picked up for distribution by New Line Cinema, established in 1967 by visionary lawyers and film lovers Bob Shaye and Michael Lynn. With few exceptions (*Cry-Baby* was released by Universal), New Line would produce and release most of Waters's pictures.

Giving middle-class audiences a shake-up, *Pink Flamingos* also had an effect on punk culture with its royal blue hairdos and half-shaved heads. In the 1970s, on Halloween night, youths could be spotted in the West Village, especially in the gay neighborhood of Christopher Street, imitating Divine and her cohorts. *Pink Flamingos* gained a loyal following—and repeat viewing—on the art-house circuit. Cherished by midnight moviegoers, it ran for years in New York and Los Angeles (I saw the film downtown as an undergraduate student at Columbia). Later on, *Pink Flamingos* was screened as a midnight movie at the Elgin Theater on Eighth Avenue in Chelsea (now the Joyce Theater).[36] Ben Barenholtz, the Elgin's owner, had been promoting midnight movies, like Alejandro Jodorowsky's *El Topo*, a 1970 film seen by and impacting all the directors in this book except for Terence Davies. Barenholtz felt that *Pink Flamingos* would do well with his audiences and showed it on Friday and Saturday nights. The movie soon built a cult of viewers, some of whom attended just to be in the company of the then a hip set—gay men. After awhile, the spectatorship broadened, and the picture became popular with rowdy working-class kids from the suburbs of New York and New Jersey. Many fans learned by heart the film's famous lines, which they recited at screenings, a phenomenon that would become closely associated with the 1975 *The Rocky Horror Picture Show*, the most popular midnight movie ever made.

As expected, the movie divided critics: it was called an abomination by some and an instant classic by others. Waters, just like Babs,

was not about to take a backseat to anyone in the battle of filth and bad taste. Most mainstream critics did not know what to make of the film. In a short, dismissive review, *Variety* described *Pink Flamingos* as "one of the most vile, stupid and repulsive films ever made." However, instead of being offended, Waters took the *Variety* review as a compliment, adding that *Pink Flamingos* might have been vile, all right, as *Variety* claimed, but that "it was joyously vile."[37] Negative reviews didn't deter Waters because "there was a cultural war going on—"It was Them versus Us."[38] He knew that critics who panned his work simply didn't get him and what he stood for. It's always been that way with Waters's work: "You just get it, or you don't. There's not much in the middle."[39]

Early public recognition reaffirmed Waters's commitment to his distinct brand of cinema. In 1975, *Pink Flamingos* was accepted into the permanent collection of the Museum of Modern Art, which has one of the world's largest film departments. However, while his reputation for excess enthralled the cognoscenti, it did not excite, to say the least, the executives of Hollywood's big studios. He later recalled that "*Pink Flamingos* is still the movie that gets me in the door, and then quickly thrown out the door."[40]

After this "succès de scandale," Waters lost several years in failed attempts to make a sequel to *Pink Flamingos* titled *Flamingos Forever*. Meanwhile, the number of fans of *Pink Flamingos* continued to grow with each successive showing, to the point where it became more than just a midnight movie. Significantly, of the directors in the book, Waters and, to a lesser extent, Almodóvar are the only cult figures, due to repeated showings of their early works. *Pink Flamingos* is the first and only Waters picture to wear the label proudly.

Waters's oeuvre has been associated with gay camp and gay humor, concepts that call for a more precise definition. In her well-known 1964 essay, Susan Sontag became the first scholar to define camp, calling it a phenomenon of pure aestheticism, based on artifice and stylization. Sontag observed that "things are campy not when they become old, but when we become less involved in them, and can enjoy, instead of being frustrated by the failure of the attempt."[41] She held that camp derives from the unpredictable effect of time on the interpretation of cultural products, from the view

that something could be perceived as aesthetically good precisely because it is awful. For Sontag, camp is disengaged and depoliticized because the obsession with style overrides concerns with the text's more serious contents.

However, as scholar David Van Leer pointed out, in depoliticizing camp, Sontag also de-homosexualized it.[42] She did not deal with the conditions that create and foster camp, such as the ostracizing of minorities and the oppression of subcultures, perpetuating their "invisibility" from the perspective of hegemonic culture. Minorities, be they racial (black and Latin) or sexual (gay and lesbian), often speak between the lines, reshaping ironically and radically the dialogues that their oppressors had invented in order to keep them in their place. Individuals (and groups) of minority status tend to find new modes of speaking to which the oppressors, whoever they are, have limited access or none at all.

Sontag also did not distinguish between camp that's innocent and camp that's deliberate and intentional. For her, pure camp is usually naïve and innocuous due to its outdated, retro nature. She and her followers have claimed that self-knowing camp is usually less satisfying because self-conscious and imitative camp is just regressive in its self-assertiveness. But this may not be the case, as Waters's work has shown. For this director, camp is a form of historicism viewed histrionically. In his movies, the camp strategy resurrects products of the past, focusing not so much on their origins as on their artifice, which is done through a heightened theatrical sensibility. Throughout his career, Waters has transformed famous (and infamous) movies and TV shows into something removed from their initial design and original meaning.

The brand of camp that prevails in Waters's output is what the scholar Barbara Klinger has called mass camp.[43] Media products qualify for camp enjoyment because they exhibit exaggerated exotica in their historical outdatedness. Mass camp depends on a thorough knowledge of pop culture and a familiarity with the conventions of established genres (e.g., Mae West comedies, Busby Berkeley musicals). Mass camp sensibility does not necessarily result in a coherent rereading of a film—it's more of a hit-or-miss sensibility. The viewers' interaction with a particular text always bears some effects, but the

effects may be temporary—that is, discernible only in the short run. Thematic and visual pleasures come in a sporadic manner as viewers dip in and out of a particular text, selecting specific moments: witty dialogue, quotable lines, lavish musical numbers, and physical appearances and costumes.

Gay camp usually relies on (or imitates) the hyperbole of movies and pop culture through overstated décor, fashion, and cross-dressing. In verbal terms, it's reflected in quotations, mimicry, lip-synching, gender inversion, put-downs, and witty puns. Gay camp is of real value to its practitioners because it enables them to demonstrate their insider status, their very cultural existence, and often their superiority over straight outsiders, who don't dig what they dig when they experience the same movie or TV show.

From the start, Waters politicized camp, using it as a deliberate assault on mainstream culture. He employed gay camp as a counter-cultural means, as an oppositional standpoint and active force. For him, camp attacks acceptable values, normal physical appearances, and conventional modes of behavior. It could be either a mild or a radical rejection of essential tenets of traditional aesthetics. Waters's brand of camp thrives on exaggeration, theatricality, and travesty, as is evident in the glorification of the characters in his texts and the particular actors who play them. The elements of his aesthetics are deemed cheap, sleazy, vulgar, and crude because the plots of his features transgress the bourgeois sense of decency and morality. Instead, they loudly extol bizarre and grotesque sexuality that's considered appalling by standards of middle-class taste.

Gay camp is manifest in most of Waters's films, intentionally and unintentionally. The components of gay camp include admiration for performers like Divine and the casting of movie stars who parody their own screen image, such as the gay actor Tab Hunter in *Polyester*, or the very straight Troy Donahue in *Cry-Baby*, or the eroticized Joe Dallesandro, a cult figure in works by Warhol and Morrissey. Waters's camp comedies are ambivalent about their subject and style, raising questions of what is being satirized and for what kinds of spectators. They are blatantly vulgar and deliberately crass, drawing on deviant sexuality as a source of humor and defying normative definitions.

What exactly has made *Pink Flamingos* a cult movie? The scholar Umberto Eco has shown that to qualify as a cult item, a movie doesn't have to be a work of art judged by high aesthetic standards.[44] He cites *Casablanca* and *Gone with the Wind*, which have assumed mythic cult status, though most critics would agree that they represent modest but not necessarily superlative aesthetic achievements—even by Hollywood yardsticks. For Eco, a cult movie is a "hodgepodge of sensational scenes strung together implausibly," with characters that are psychologically incredible and actors who act in a mannered way. The particular work must be loved, but it must also provide a completely furnished world so that its fans "can quote characters and episodes as if they were part of the beliefs of a sect, a private world of their own, a world about which one can play puzzle games and trivia contests, and whose adepts recognize each other through a common competence."[45]

The characters and subplots of a cult work tend to have archetypal appeal. A cult movie displays organic imperfections, which is why *Rio Bravo* is a cult movie, whereas *Stagecoach* is not, though both are accomplished generic works (Westerns), helmed by the legendary directors Howard Hawks and John Ford, respectively, and displaying commanding performances by John Wayne. In order to transform a work into a cult object, viewers must be able to unhinge it, to break it up, so that they remember only parts of it, regardless of their original relationship to the whole. Disjointed moments tend to survive as a disconnected series of images. Cult movies often display not one central idea but many ideas, and they do not exhibit a coherent philosophy or even structure. Hence, *Pink Flamingos* lives on—and is continuously revived—because of its rawness (primitiveness?) and disjointedness. Similar observations can be made about the musical-horror feature *The Rocky Horror Picture Show*, made at the time when Waters was at the height of his popularity, which was an artistic and commercial flop when first exhibited in legit movie houses.

Cult movies like *Pink Flamingos* exist and speak to one another independently of their authors' intentions. They provide proof that a particular film comes from other films and that once a film is made, it assumes an independent life of its own. Waters could not have anticipated that *Pink Flamingos* would become a cult movie. Nor did

Ridley Scott, in 1982, when he made *Blade Runner*, a noir apocalyptic tale that was not well received upon initial release and went on to become a cult movie despite negative critical response. It's worth noting that critical reaction to both *Pink Flamingos* and *Blade Runner* has also changed over the years into a more appreciative one, showing the shifting nature of criticism itself.

The notorious "doggie" finale of *Pink Flamingos*, as well as other scenes and lines, can be enjoyed for what they are, regardless of the particular place they occupy within the larger narrative. They work in the same way as two or three scenes from *Mommie Dearest*, starring Faye Dunaway as the emasculating Joan Crawford: the wire hangers, the axe, the physical fight between mother and daughter. These scenes can be easily removed from their original textual meanings, which explains why they have been playing over and over again in video bars frequented by gay men and savvy urbanites enamored of camp culture. The cult status of *Pink Flamingos* was confirmed in 1997, when for its twenty-fifth anniversary it received a limited theatrical rerelease and a new DVD version, now rated NC-17 by the Motion Picture Association of America (MPAA) and a more savvy and positive response from a new generation of critics. The new edition features an improved soundtrack, commentary by Waters, and several scenes deleted from the original cut.

In the first two decades of his career, Waters's identity had thrived on excess and exaggeration—on his wish, as he said semijokingly, for his own life to be "torn from the headlines." The *National Enquirer*, which he considers to be the ultimate barometer of fame in America, has informed his earlier sensibility.[46] His protagonists have shared their director's penchant for gaudy and lurid events. His fascination with crime and court trials is based on his belief that "when you do something horrible, you can't change it." "I think it's a matter of things being forbidden," he has repeatedly said. "That's part of the glory of being raised a Catholic. It makes you more theatrical, and the sex is always better 'cause it's dirty and forbidden."[47] Moreover, his moonlighting as a prison lecturer is a direct outgrowth of his attraction to the forbidden along with his undeniable service orientation.

* * *

Waters's next two features, *Female Trouble* (1974) and *Desperate Living* (1977), reinforced his outlaw reputation with their satiric skewering of middle-class suburbanism, the dominant mode of American life. Richer in ideas and better produced than *Pink Flamingos*, these films reflect a more coherent worldview, the elements of which would recur in his other movies.

It's a stretch to use the word *epic* in describing any of Waters's features, but due to its two-generational plot and character evolution, *Female Trouble* represents an epic of sorts. The tale follows the foibles and fables of one woman from juvenile delinquent to mother to dubious artist to outright criminal. It spotlights Divine in a dual role, as the headline-seeking outlaw and as her illicit welder-lover. Waters's original idea for a title was *Rotten Face, Rotten Mind*, though *Female Trouble* is more apt and catchy. Like *Pink Flamingos*, the affront to bourgeois morality relies on gross-out effects, but this film also displays sharper concepts and more acutely defined characters, resulting in a more biting and engaging satire.

Over the years, Waters has created screen characters with alliterative names, including Corny Collins, Donald and Donna Dasher, Fat Fuck Frank, Francine Fishpaw, Link Larkin, Motormouth Maybelle, Mole McHenry, Penny and Prudy Pingleton, Ramona Rickettes, Sylvia Stickles, Todd Tomorrow, Tracy Turnblad, Ursula Udders, Wade Walker, and Wanda Woodward. It has become a popular trivia exercise to guess the origins of his characters' names—Ursula Udders may be the easiest of the bunch. In *Female Trouble*, the heroine is DD, Dawn Davenport.

Holding up better than most of Waters's other films, *Female Trouble* has a shapelier narrative and a linear plot, attributes that are missing from most of his pictures. After the bold main titles, the text is divided into twenty-three segments: Youth, Cha Cha Heels, Dawn Meets Earl, Pregnant, Career Girl, Early Criminal, Aunt Ida, Lipstick Beauty Salon, Married Life, 5 Years Later, Dawn's Big Break, Gator's Goodbye, A Smashing Dinner Party, New Look for Dawn, Model of the Year, Taffy's Daddy, Show Business, A Painful Homelife, Superstar Nightclub, Dawn's Act, The Trial, Dawn's Big Day, and Final Curtain Call.

Set in 1960, the tale begins with Dawn as a juvenile troublemaker in a Baltimore all-girls school. In the first scene, the rebellious teenager

receives a failing grade and a sentence of essay writing for fighting, cheating, and eating in class, among many violations. On Christmas Day, when Dawn does not get the cha-cha heels she wanted, she breaks into a violent rage and pushes her mother into the Christmas tree. "I hate you! I hate this house! I hate Christmas!" she screams before storming out. Hitchhiking, Dawn is picked up by Earl Peterson (also played by Divine), a chubby man in an Edsel station wagon. Earl drives her to a dump where they have sex on a dirty mattress by the roadside. Sex in this and other Waters films is never depicted appealingly because in most cases it does not express love, passion, or desire—in sharp contrast to sexual acts in Almodóvar's oeuvre.

Realizing she's pregnant, Dawn demands money, but Earl tells her, "Go fuck yourself." Waters later joked that Divine had indeed done that because he played both roles. In 1983, another midnight cult movie, *Liquid Sky*, got attention for depicting model Anne Carlisle playing a sex scene with herself, but Waters always claimed to be the first! To grant it a semblance of realism, Dawn's birth giving scene was shot at the very end to take advantage of actress Susan Lowe's actual birth giving. The umbilical cord that Dawn cuts with her teeth was fashioned out of prophylactics filled with liver, showing the baby doused in fake blood.

Mocking the generic code of epic biopics, a title card announces "Dawn as Career Girl, 1961–1967," followed by a montage. To make ends meet, Dawn takes various jobs—waitress, dancer, hooker, and petty thief—but she is not good at any of them. Cut to 1968, when Taffy (Hilary Taylor), now age eight and already difficult, is subjected to a beating by her mother with a car antenna. When Dawn complains about her exhausting maternal duties, her mates, Chicklette (Susan Walsh) and Concetta (Cookie Mueller), suggest as a "solution" a new hairdo from the stylist Gator (Michael Potter). Occupying a prominent place in most of Waters's movies, hairstyle would become the very subject of his likable 1988 picture *Hairspray*. The particular hairdo chosen for a specific film always signals an ideological statement, not just a fashion trend.

Dawn becomes a client at the Lipstick Beauty Salon, owned by the Dashers, husband Donald (David Lochary) and wife Donna (Mary Vivian Pearce). A brief courtship by Gator leads to marriage,

but five years later the bliss is strained because Taffy (now played by Mink Stole) simply cannot stand the sight of Gator. When Taffy catches her parents in bed, Gator invites her to join them, which gives Taffy the occasion to deliver the movie's most-quoted line: "I wouldn't suck your lousy dick if I was suffocating and there was oxygen in your balls!" This line is addressed to a hairdresser (a typically gay profession in movies) who even lacks the style to be gay. In fact, Gator's obese Aunt Ida (Edith Massey) bemoans: "Honey, I wish you was queer; heterosexuality is a boring lifestyle," trying to get him to date boys.

Waters attempts to shock viewers for shock's sake—he was only twenty-seven when he made the picture, and the success of *Pink Flamingos* might have encouraged him to break other taboos. Upping the ante, *Female Trouble* contains frontal nudity with shots of Gator's penis in flaccid form, but the images are deliberately nonerotic. Fed up with Gator's cheating and bored by their sex—he penetrates her with hammers and pliers—Dawn decides to leave him. Seeking solace at the Lipstick Beauty Salon, she is urged by the diabolical Dashers to become a "glamorous guinea pig" in an experiment testing Jean Genet's theory that "crime equals beauty." It is noteworthy that in one way or another Genet has inspired all five directors in the book—each has made explicit or implicit references to the writer's oeuvre or his criminal career. Following their advice, Dawn obediently performs criminal acts, such as knocking her daughter unconscious with a chair, while not neglecting to pose for a photo shoot by the Dashers.

The plot piles up one contrived sequence after another—but with more concern for continuity of narrative and character than is the norm in Waters's pictures. Thus, Ida bursts into Dawn's house and disfigures her face with acid, but at the hospital, the hideous-looking Dawn is reassured that she is still pretty and needs no plastic surgery. Upon return, Dawn discovers that her home had been redecorated by the Dashers. Taffy pleads with her mother to disclose her father's identity, and she reluctantly does so. (It's probably a coincidence that this is the premise of Almodóvar's 1999 masterpiece, *All About My Mother*.) Visiting her drunkard father, who lives in a dilapidated house, he sexually assaults her, and she stabs him with a butcher knife. (This scene might have been inspired by *Peyton Place*, in which

Selena Cross, played by Hope Lange, kills her brutish stepfather after repeated rapes.)

Meanwhile, Dawn, unfazed, creates a nightclub act that includes jumping on a trampoline and wallowing in a playpen with dead fish. Waters was proud that Divine performed all the stunts, including the difficult flips on the trampoline, based on extensive training at the YMCA. When Taffy joins the Hare Krishna movement, sporting grotesque hair and outlandish outfits, Dawn cannot tolerate it and strangles her to death. Convinced that she has fully embraced Genet's philosophy, Dawn now sees beauty as an art form intricately born out of crime. The usual Waters exclamatory statement follows: "I framed Leslie Bacon! I called the heroin hot line on Abbie Hoffman! I bought the gun that Bremer used to shoot Wallace! I had an affair with Juan Corona! I blew Richard Speck, and I'm so fuckin' beautiful."

Screaming "Who wants to be famous? Who wants to die for art?" Dawn shoots into the crowds. Arrested by the police, she is put on trial, and the Dashers are granted "total immunity" in exchange for their testimony against her. The phonies claim to be shocked by Dawn's crimes, even though they were the ones to provide Dawn the axe that she uses to amputate Ida's hand. Found guilty, Dawn gets the electric chair, but not wasting time, she has a quick, casual affair in prison with another mate (Elizabeth Coffey).

True to her nature—and to Waters's worldview—Dawn perceives the execution akin to "winning an Academy Award," an act that will finally immortalize her. Strapped to the electric chair, Dawn deliriously renders her Oscar acceptance speech:

> I'd like to thank all the wonderful people that made this great moment in my life come true. My daughter Taffy, who died in order to further my career. My friends Chicklette and Concetta, who should be here with me today. All the fans who died so fashionably and gallantly at my nightclub act. And especially all those wonderful people who were kind enough to read about me in the newspapers and watch me on the TV news. Without all of you, my career could never have gotten this far. It was you that I burn for, and it is you that I will die for! Please remember, I love every fucking one of you!

Dawn's fantasy is fulfilled when her distorted face is shown in a freeze-frame as the end credits roll. Waters may have been paying tribute to François Truffaut's legendary freeze-frame of his alter ego as a boy at the end of *The 400 Blows*. In interviews, Waters has relished that final shot of Divine the same way he has the infamous doggie shot in *Pink Flamingos*, considering them as his most poignant stylistic touches.

In *Female Trouble*, Waters shows concern about the media's morbid fascination with lurid crimes, exploiting criminals for commercial reasons (TV ratings) by turning them into instant celebrities—never mind that he himself can be charged with perpetuating this trend by popularizing the notion in his films. Even so, when the movie came out, he was disappointed that many critics dwelled on the gross-out effects and grotesque characters rather than the film's satirical ideas. After seeing *Female Trouble*, Rex Reed, representing other film critics of his kind, groaned: "Where do these people come from? Where do they go when the sun goes down? Isn't there a law or something?"[48]

Waters has said that he wanted to caress with both needles and thorns the "uptown" viewers with his "downtown" underground sensibility. He knew that curious art-house denizens, wishing to demonstrate open-mindedness, considered it cool to watch *Pink Flamingos* and *Female Trouble* without walking out during the screenings. Hipsters have always regarded Waters's movies to be must-see events. But there were also spectators, known pejoratively as "the Bridge and Tunnel Crowd," who bothered to take the time and the train to see the movie. No doubt, in the 1970s, attending a Waters movie was a combination of cultural event and ideological statement, going way beyond the set of particular ideas and images that made up *Female Trouble* as a film.

Significantly, this movie was effective in expanding Waters's circle of fans, as the influential journalist Michael Musto attests: "I caught a double bill of *Pink Flamingos* and *Female Trouble* at Cinema Village. That double bill changed my life. It was punk. It was raunchy. It was outrageous. It was glamorous. It was exciting. I was vomiting and rolling in the aisles at the same time."[49] (Remember what Waters has said about vomiting?)

* * *

Billed as a lesbian melodrama about revolution, *Desperate Living*, the third film in the unofficial trilogy, was again disliked by most mainstream critics. Janet Maslin described the picture in the *New York Times* as "a pointlessly ugly movie that finds high humor among low life."[50] The credit sequence of this tale, in which again Waters ridicules Bourgeois manner, features a dead rat served on fine china at a fancily set dinner for one (perhaps homage to Bette Davis's notorious scene when she served a dead rat to Joan Crawford in Robert Aldrich's 1962 cult horror film, *What Ever Happened to Baby Jane?*). This sequence, which shows the hand of an offscreen woman, is the only visually elegant segment in a movie that's otherwise expectedly rude, crude, and gross.

This is the only feature that Waters made without Divine prior to the actor's death in 1988. By now boasting a reputation that went beyond Waters's films, Divine was touring in a live show, *The Neon Woman*, and couldn't fit the movie into his schedule. Another regular, David Lochary, was absent—but for another reason. Waters said, "The reason that David wasn't in *Desperate Living* is because of PCP. That's all there's to it, and he knows it too."[51] Sadly, Lochary died of a drug overdose during the film's production, and in the next several years other crucial members of the Dreamlanders passed away.

Desperate Living is the only lesbian picture in Waters's repertory and the most female-dominated: all the leads are played by women. Usually his protagonists, unlike those of the other directors in the book, are mostly males, especially after Divine's death. Mink Stole plays a neurotic housewife named Peggy Gravel, recently released from a mental institution but not ready yet to face the harsh reality of the outside world. (Almodóvar has a similar character, albeit a male, in several of his movies, including *Tie Me Up! Tie Me Down!*) In the first scene, the doctor protests that it's too early to release Peggy from the asylum, but her ever-optimistic husband insists that "mental health is just around the corner."

Early on, Peggy announces: "I have never found the antics of deviates to be one bit amusing." And, of course, the story that follows goes on to prove the opposite of her statement. When children accidentally hit a baseball through her window, she accuses them of

trying to kill her. When the phone rings and it's the wrong number, she hysterically asks, "How can you ever repay the thirty seconds you have stolen from my life?" Finding her two children—a boy and a girl—naked, playing doctor and patient, she accuses them of perversity. Descending the staircase with a cane, the grand dame exclaims, "What have I done to deserve this?" which, of course, is the title of Almodóvar's fourth feature.

Peggy's husband, Bosley (George Stover), who's always well dressed (in brown pants, jacket, and tie), tries to give her the requisite sedative, but she resists. Fighting back, she orders their obese black housekeeper, Grizelda Brown (Jean Hill), to help her kill him, and the latter all too willingly obliges, hitting Bosley with a broom until he collapses dead. The killing is also a form of revenge for Grizelda, who had earlier been caught by Bosley drinking his liquor and stealing his money.

Going on the lam, Peggy and Grizelda are arrested in the woods by a motorcycle policeman (Turkey Joe) just when Peggy protests to Grizelda how much she hates Nature because the trees are stealing oxygen from her. Weirder than they are, the cop is a cross-dresser—and an exhibitionist at that. He forces himself sexually on the women, demanding that they give him their underwear, which he sniffs with delight. He then orders them into exile in Mortville, a place ruled by the evil Queen Carlotta (Edith Massey). At Mortville, the women become associates of lesbian wrestler Mole McHenry (Susan Lowe), who wants to have a sex-change operation in order to please her lover, Muffy St. Jacques (Liz Renay). One of the few Waters films to use the structural device of flashbacks, *Desperate Living* has Mole and Muffy recount how and why they landed in Mortville. Muffy, who had once been married, was charged with the death of her baby when he was found in the fridge.

Mortville's outcasts represent a peculiar mix of notorious criminals, proud sex offenders, hunky black-leathered guys, and nudists. Eccentric to a fault (she's dressed in hot pink and needs to be carried to her assignments), the tyrannical Carlotta banishes her daughter, Coo-Coo (Mary Vivian Pearce), the heiress apparent, after Coo-Coo shamefully dates a garbage collector (George Figgs), a man beneath her station. When he's later killed by the queen's guards,

and Coo-Coo goes into hiding with her dead lover. Grizelda fights the guards and loses her life, and Peggy jois the queen in terrorizing her subjects, infecting them with rabies. The queen forces her denizens to eat cockroaches and dress and walk backwards. However, unable to take the abuse anymore, the populace overthrows Carlotta and executes Peggy by shooting in cold blood into her anus. To celebrate their freedom, they throw a lavish dinner party, in which Carlotta is served on a platter as a roasted corpse decorated with an apple in her mouth.

For this film, Waters recruited actors outside of his immediate circle. Liz Renay, a convicted felon and author of the memoir *My Face for the World to See*, which was referenced in *Female Trouble*, plays the crucial role of Muffy. Casting Renay marked the start of a trend in which the director employed both famous and notorious celebrities like Patricia Hearst and Traci Lords. Initially rejected for theatrical distribution in the United Kingdom, the movie was finally released there on video in 1990, after trimming the eyeball-gouging scene. *Desperate Living* became a cause célèbre after the Marilyn Manson band paid tribute to the film in its 1994 album, *Portrait of an American Family*. One of the album's tracks features a recording of Mink Stole shouting at the children: "Go home to your mother! Doesn't she ever watch you? Tell her this isn't some Communist daycare center! Tell your mother I hate her!"

The Byzantine-like plot of *Desperate Living* is laced with touches of cheap porno. The frontal nudity of men and women, and the sex scenes, are shockingly gross even by Waters's standards. Class and race barriers are banished when Grizelda and Peggy become lovers, and the scene in which the obese, fully naked Grizelda makes love to the skinny Peggy is still shocking in its aggression. Similar effects are generated when Queen Carlotta tells one of her guards, clad in black leather, to "f—k me hard" and the lad is doing that, like a dog. Waters himself later conceded that the problem with *Desperate Living* was that "everyone was insane and there was nobody for the audience to identify with."[52] Waters knew that his humor was always more poignant when placed in a broader context, when eccentric performers like Divine and Mink Stole are positioned against straighter, or at least "slightly more normal," individuals.

ACCESSIBLE SATIRES

Throughout his career, Waters had to walk a fine line; as he explained: "I'm certainly not going to make a Hollywood movie that will never be shown, but at the same time, I don't calculate, I write what I think is funny, I don't censor myself." Waters has not been willing to make a more mainstream film devoid of black comedy because it would then be "someone else's obsessions, not mine."[53] His agents don't even send him scripts by other scribes because they know that, like Almodóvar, he will direct only his own material. Waters has not developed acute technical skills, so his narratives, characters, and tone are far more important than their visual style or physical execution. Of the five directors in the book, he is the least technically adept, though in his defense it must be said that he has never aspired to be a skillful craftsman.

In the 1980s, Waters's films became less controversial and less risqué. Works such as *Hairspray*, *Cry-Baby*, and *Serial Mom* still maintain some outrageous elements but not the crass camp humor and shocking inventiveness of the earlier features. If the director has ceased to be subversive, it may be a natural result of his own aging and the softening of values that often goes along with that process. It's also harder to shock audiences anymore. Moreover, I suspect that deep down he shares many of the bourgeois values he had satirized—more than he is willing to admit. Unlike some Jewish comedians or filmmakers, such as Lenny Bruce and his contemporary Albert Brooks (*Lost in America*), Waters has never been an enraged agent or angry provocateur. Secretly, he may have wished for life to be as simple or naïve as that in *Leave It to Beaver*, a TV show he might have satirized too gently in his 1994 *Serial Mom*.

After the gross-out trilogy, Waters made a bid for wider acceptance with *Polyester*. By the standards of his previous work, the humor in *Polyester* is sedate, fluffy, and trivial. The film became notable for the presence of faded movie star and former teen idol Tab Hunter (the 1950s blond beefcake), who for decades had concealed his homosexuality, living a double life. It also introduced a cute gimmick, Odorama, a set of scratch-and-sniff cards that contained a range of stimuli matching the sensations experienced by Divine on screen.

Divine's Francine Fishpaw is a housewife whose life has deteriorated beyond recognition—it has become hell. Her husband, Elmer (David Samson), runs a porno theater that shows trash classics like *My Burning Bush*. A womanizer with a hairpiece and a belly, Elmer is involved in an open affair with his spoiled and childish secretary, Sandra (Mink Stole), who sports Bo Derek–style cornrow braids. Her values are expressed when she tells Elmer, "Children would only get in the way of our erotic lifestyle!" Francine has raised not one but two ungrateful teenagers. Dexter (Ken King) sniffs glue and stomps on women's feet, and Lu-Lu (Mary Garlington) is a brazen slut who hangs out with the overaged juvenile delinquent Bo-Bo (Stiv Bators), who says she's gleefully awaiting her next abortion. Francine's best friend, Cuddles (Edith Massey), is either insane or at least mentally challenged, deluding herself that she's still a debutante. Having inherited a fortune, Cuddles, a former maid, is driven around by a German chauffeur in a black limousine and is preoccupied with planning a grand ball for herself.

Francine's existence has become so miserable that even her dog commits suicide rather than witnessing her decline. But out of the blue, lightning strikes with the appearance of Todd Tomorrow (Hunter), a hunk clad in tight white pants driving a convertible. Francine throws herself into a torrid affair with the dashing beau. Tomorrow, the owner of a local drive-in theater, represents high culture to Francine because he shows art films by the French intellectual Margueritte Duras (author of *Hiroshima, Mon Amour*, directed in 1959 by Alain Resnais).

Sporadically amusing but not really foul or subversive, *Polyester* relied too much on "Odorama" for commercial appeal. Spectators were given a card with ten scratch-and-sniff patches to be smelled at key points in the action. Numbers flashing on screen indicated which specific scents should be used, ranging from roses to dirty sneakers. The score was another element meant to give the movie a distinctive feel. It consisted of romantic tunes sung by Hunter, singer Deborah Harry, and comedian Bill Murray, who was then popular on TV in *Saturday Night Live* and in a series of goofy film comedies with peers Harold Ramis and Dan Aykroyd.

Though sharply uneven, *Polyester* serves up some nasty fun, largely due to Divine's camp impersonation of an alcoholic matriarch of a supremely dysfunctional family that includes an adulterous porn-theater-owning husband, a son with a foot fetish, and a floozy daughter looking forward to having an abortion. For me, the film's two funniest set pieces involve a picnic in the country that goes uproariously wrong for Divine and Cuddles (Nature is always a target in Waters's films) and a bloody robbery that proves disastrously fatal for Divine's hypocritical and money-grubbing mother. Some critics suggested that as a comedy *Polyester* stinks rather than stings with its stench of farts and skunks. Though intended as an effort to get out of the midnight movie and the gay milieus, *Polyester* was a commercial failure. Hardcore fans were disappointed by Waters's compromised standards, though in his defense Waters quipped: "How could I have sold out? My movie stars a 300-pound transvestite and Tab Hunter!"[54]

Living from picture to picture, with long intervals in between, Waters is not the kind of director with three-picture deals. It took him a decade to learn how to play the game, how to get through the system. He always knew that his movies had to make some money so that he could continue to work: "I had to pay back the people who loaned me money, and eventually, I would ask them again. There's always that pressure."[55]

<p style="text-align:center">* * *</p>

After enjoying underground notoriety in the 1970s and spending nearly a decade of idleness in the 1980s, Waters experienced the sweet smell of success in 1988 with *Hairspray*, a surprise hit that, among many merits, introduced the public to the charms of comedienne Ricki Lake. Commercially successful, the film earned $8 million domestically, which is more than the combined box-office gross of all of his pictures until then. His first film in seven years, *Hairspray* deals with one of the few obsessions that was palatable to the studios. To achieve that, he altered his offensive, subversive style with a musical comedy that relied on faded stars and offbeat celebrities for camp pursuits. The first Waters film to receive a PG rating, *Hairspray* (one

of my three favorite Waters features) was suitable family fare, despite the weird hairdos. The lavish $2.6 million budget brought about changes in the working procedures; as Waters recalled, "It allowed for cappuccino in the editing room. I didn't have to pick up the cast in the morning. And when it rained, the cast got ponchos."[56]

Inspired by an essay in one of Waters's books, *Hairspray* dissects the arrival of racial integration in Baltimore through a local teenage program, the *Corny Collins Show*, based on the real-life *Buddy Deane Show*. In this sweet-tempered spoof, Lake plays Tracy Turnblad, a chubby teen who rockets to stardom as the new queen of the show. When Tracy's friend Penny Pingleton auditions for the show, she is too nervous and stumbles over her answers. Another girl who's black, Nadine, is excluded due to race—she is asked to attend the show's "Negro Day," the last Thursday of every month. Despite her weight, Tracy becomes a regular on the show, which infuriates the reigning queen, Amber Von Tussle, a mean, privileged classmate whose pushy stage parents, Velma and Franklin Von Tussle, own the Tilted Acres Amusement Park (based on Baltimore's Gwynn Oak Amusement Park). Things get worse when Tracy steals Amber's boyfriend, Link Larkin, and competes for the title of Miss Auto Show 1963.

Hired as a model for the Hefty Hideaway clothing store, Tracy is inspired to bleach and tease her hair into new styles. But at school, a teacher brands her look a "hair-don't" and sends her to the principal. Assigned to special education classes, Tracy meets black classmates, who are placed there to hold them back academically. Those students introduce Tracy to Motormouth Maybelle, an R&B record shop owner and host of the monthly "Negro Day." While Tracy learns new dances, Penny begins an interracial romance with Motormouth Maybelle's son, Seaweed. This horrifies Penny's tyrannical mother, Prudence, who imprisons her daughter at home in an effort to brainwash her into dating white boys.

By Waters's criteria, *Hairspray* is upbeat and optimistic: Tracy uses her new fame for the worthy cause of racial integration. The Von Tussles grow more defiant in their opposition to integration, plotting to sabotage the Miss Auto Show 1963 pageant with a bomb placed in Velma's bouffant hairdo. However, the Von Tussles are arrested after the bomb prematurely detonates, landing on Amber's head. Tracy, who

had won the crown but was disqualified for being in reform school, is pardoned by the governor, and in the joyous closure, she integrates the show by inviting everyone to dance.

Stretching her range, Divine is cast in two roles: Tracy's agoraphobic and overweight mother, Edna Turnblad, and the nasty male TV station owner, Arvin Hodgepile. The film is peppered with cameos of real-life celebrities, such as Palm Springs Mayor Sonny Bono and pop star Debbie Harry. As noted, Waters has appeared in some of his own pictures. In *Hairspray*, he ironically cast himself as Dr. Fredrickson, the bigoted psychiatrist quack who recommends electroshock therapy for Penny because she's in love with a black guy. (This horrific therapy is treated in a serious way in some of Todd Haynes's melodramas.)

But *Hairspray* is more than just a nostalgic romp filled with ratted hairdos and goofy hits. Based on Waters's watching, and occasionally appearing on, the *Buddy Deane Show*, its plot reveals the director's interest in the incendiary politics of style. When Tracy is radicalized by the school's all-white policy, she doesn't join the Weathermen; she begins ironing her hair. "When the straight-hair fashion first hit our neighborhood, it caused panic,"[57] Waters recalled. "Your whole values changed. Hair was politics. If you had ironed hair, you became a hippie, and if you kept your teased hair, you got married at twenty and had four kids."[58]

Hairspray was turned into a Broadway musical in 2002, becoming a hit and sweeping most of the Tony Awards. A film adaptation of the Broadway musical was released in July 2007 to positive reviews and commercial success, earning more than $200 million worldwide. However, it is for personal reasons that *Hairspray* assumes a special place in Waters's work—and his heart. This was Lake's first Waters feature and Divine's last. The scene in *Hairspray* when Lake and Divine come out of a beauty parlor was symbolic, sort of passing the torch from one generation of "divas" to the next. (Other founding members of Waters's troupe—Edith Massey, David Lochary, and Cookie Mueller—have also died over the past decade.)

* * *

An endearing sweetness has colored and tempered all of Waters's films since *Hairspray*. There was only a two-year gap between

Hairspray and *Cry-Baby*, Waters's next feature, which was less popular and less consequential than *Hairspray*. In depicting teen rebels and distraught parents, the director softened his jabs considerably—he might have played it too safe. Johnny Depp, then less well known, plays a 1950s teen rebel named Wade "Cry-Baby" Walker. To find the right actor for the role, Waters bought numerous teen magazines, all of which featured on their covers Depp, then a teen idol from the TV series *21 Jump Street*. Depp thought that the script was funny and strange and took the offbeat role to avoid being typecast as a TV teen idol. The feature's large ensemble includes some of Waters's regulars, such as Amy Locane and Ricki Lake, as well as many celebrities, such as Iggy Pop, Traci Lords, Kim McGuire, David Nelson, Susan Tyrrell, and Patty Hearst. Though not successful in its initial release, *Cry-Baby* later developed a small following and spawned a Broadway musical.

The movie is a parody of 1950s teen musicals, brought back into the limelight in 1978 in the John Travolta-Olivia Newton John musical *Grease*, which unexpectedly became a blockbuster and then a favorite at gay and straight festivals with its sing-along versions. At the center is a group of delinquents, the Drapes, and their interaction with the opponent subculture, the Squares. Call it *Romeo and Juliet* or *West Side Story* in Baltimore of 1954. "Cry-Baby" Walker, a Drape, and Allison Vernon-Williams, a Square, create upheaval by breaking taboos and falling madly in love. The comedy depicts the obstacles that the couple has to overcome and the impact of their affair on the larger community.

Members of the Drapes include Walker's teenage mom, his sister Pepper, the facially disfigured Mona "Hatchet Face" Malnorowski, the wild and free-spirited Wanda Woodward, and Milton Hackett, the nervous son of religious activists. Once again, the film's protagonist is different, if not a downright outcast: Cry-Baby's ability to shed a single tear drives all the girls wild. He invites Allison, a pretty girl tired of being a Square, to a party at Turkey Point, a local Drapes hangout, where she's relaxed enough to sing ("King Cry-Baby"). The couple's bond is based on a shared misery, their lives as orphans. Cry-Baby's father was sent to the electric chair, accused of being the "Alphabet

Bomber," a killer who bombed places in alphabetical order (airports, barber shops, etc.). As for Allison's parents, they used to take separate flights to avoid disastrous orphaning, should their aircrafts crash, until one day both of their planes went down at the same time.

Allison's jealous boyfriend, Baldwin, starts a riot, but Cry-Baby is wrongly accused of starting the fight and sent to jail, forcing Allison to return to the Squares. In the penitentiary, Cry-Baby endures a tear-drop tattoo with pride, telling the tattoo artist, Drape Dupree (Robert Tyree): "I've been hurt all my life, but real tears wash away. This one's for Allison, and I want it to last forever!" Allison's campaign for Cry-Baby's release forces Baldwin to admit that it was his grandfather who electrocuted Cry-Baby's father. Free of his past chains, Cry-Baby is now able to cry with both eyes.

The film is peppered with cameo appearances by celebrities and has-beens, in and out of the industry. Troy Donahue, a blond heart-throb of romantic melodramas (*A Summer Place* with Sandra Dee, *Parrish*), and Waters regular Mink Stole play Mr. and Mrs. Malnorowski, Hatchet-Face's parents, who sell cigarettes to the pupils. Porn star Joe Dallesandro, who made his name in Warhol and Morrissey films, and Joey Heatherton are ironically cast as Mr. and Mrs. Hackett, Milton's overzealous parents. David Nelson (Hope Lange's good and loyal boyfriend in *Peyton Place*) and Patricia Hearst play Mr. and Mrs. Woodward, Wanda's happy-go-lucky parents.

Waters's gleefully campy spectacle provided Depp a vehicle to lampoon his own pinup image. More technically polished than *Hairspray* but less focused, funny, or biting, *Cry-Baby* failed to reach viewers, despite Depp's charming performance. Ironically, Depp became a major star that same year, after appearing in Tim Burton's lyrical fable *Edward Scissorhands*, a Christmas release that was both a critical and a commercial success. Financed by Universal and getting the widest distribution of any Waters film to date, *Cry-Baby* was released in 1990 in 1,229 theaters. However, it grossed only $8.3 million, making it a box-office disappointment, given its big budget of $13 million. *Cry-Baby* was the second Waters film, after *Hairspray*, to be adapted into a stage musical. However, as expected, the critics compared it unfavorably to *Hairspray*, the 1988 film, the Broadway musical, and

the film version of the Broadway show, starring John Travolta in Divine's double role.

* * *

In the 1990s, Waters's work became more polished, reflecting the difference between a movie that costs $10,000 and one that costs $14 million, such as *Serial Mom*. Working with bigger budgets and movie stars, he is no longer an underground director. He hasn't had a movie playing the midnight circuit since *Pink Flamingos* and *Female Trouble*. In any event, the big midnight market, as it existed in the 1970s, declined rapidly and then disappeared altogether, a combined result of the VCR revolution (beginning in 1984) and the new technologies and social media.

After making a movie about every decade in which he has lived, Waters went back to more contemporary humor with a story that takes place in the "real" world. The result was *Serial Mom*, a likable but soft satire of suburbanism released in 1994. The director built into the film the affection that he and audiences must have felt for TV shows like *Leave It to Beaver* and *Ozzie and Harriet*. He wanted the viewers to fantasize about the offscreen lives of the characters in those shows—to speculate about them as "real" human beings. The movie is as much a satire of TV sitcoms as an ode to them. Juxtaposing bloody murders with Beaver backgrounds, *Serial Mom* reflects a compromise between Waters's early gross-outs and his new, more professional look. He aimed at courting mainstream audiences, a strategy that worked in *Hairspray* but failed in *Polyester*.

Kathleen Turner plays Beverly Sutphin, a fiercely devoted middle-class housewife, a Supermom in the mold of June Cleaver and Donna Reed (best known to American households from her popular TV show, *The Donna Reed Show*). Thriving at her chores, Beverly cooks meat loaves, keeps the house spic-and-span, and goes to PTA meetings—in short, she performs all the duties expected of a Good American Mom. Happily married to Eugene (Sam Waterston), a meek dentist, Beverly is ultrasensitive to her children's growing pains. Misty (Ricki Lake) is in college, but she is more interested in boys. High school senior Chip (Matthew Lillard) works at a video store where he cultivates an

appetite for horror flicks—the kind Waters himself adores. Behind the chipper façade of a suburban housewife, however, stands a serial killer: Beverly murders people who criticize or insult her family, taking the kind of action that's more Cleaver than Beaver.

The Sutphin family is having a normal breakfast when two police officers arrive to interrogate Beverly about mail threats and obscene calls received by their neighbor Dottie Hinkle. It turns out Beverly is the predator, punishing Dottie for stealing her parking space at the mall. Beverly's first murder occurs after a PTA meeting, during which Mr. Stubbins (John Badila), the math teacher, criticizes her son's fascination with violent horror films. Questioning the strength of the Sutphins as a family unit, Stubbins recommends therapy for Chip, and Beverly, terribly offended, sees no choice but to run him over. Later on, when Misty is upset after getting stood up by her date, Carl Pageant (Lonnie Horsey), and Beverly spots him with another girl (Traci Lords), she impales him with a fireplace poker. The Sterners get killed at their house while daring to have a chicken dinner— Beverly is an avid bird-watcher. When Betty Sterner (Kathy Fannon) opens the closet, Beverly stabs her with scissors and then topples an air conditioner onto her husband, Ralph (Doug Roberts).

Eugene grows suspicious of his wife when he uncovers disturbing items under their mattress, such as an autographed photo of Richard Speck, sent to Beverly from prison; an audiotape of Ted Bundy (voiced by John Waters); and a scrapbook of clippings of Jonestown and Charles Manson. At church on Sunday, the Sutphins are met with suspicion. Ironically, the sermon that day is "Capital Punishment and You." The service ends when a strange sound causes panic. Hiding from the police at her son's video store, Beverly overhears a customer, Mrs. Jensen, complaining to Chip about fees for failing to rewind her tape—she calls him "the son of a psycho." Beverly follows Mrs. Jensen to her home, and when the woman sings along to "Tomorrow" from the musical *Annie*, Beverly bludgeons her to death with a leg of lamb. (This is also the way that Carmen Maura kills her husband in Almodóvar's *What Have I Done to Deserve This?*)

Serial Mom is not as macabre as the deliciously nasty *Parents*, a visually stylish horror comedy directed by actor Bob Balaban, which coincidentally was released around the same time. Set in the 1950s,

Parents stars Randy Quaid and Mary Beth Hurt as the ideal, conformist American parents, defined by only one "minor" flaw, cannibalism. Their young son wonders where his parents get all the meat that they eat and what other devious stuff happens down in the basement.

With the obvious move toward the mainstream, Waters began to lose the subversive sensibility that had marked his underground films. As he disclosed: "In the old days, I wanted to make people nervous about what they were laughing at. In *Serial Mom*, there's a stream of good hearty laughs, but the nervousness is missing from the humor."[59]

The film's less original sequences deal with the media coverage of Beverly's trial and how the family exploits the case via agents, book rights, and TV movies. This theme had already been exploited in several Hollywood films, including Waters's own *Female Trouble* and, of course, Martin Scorsese's 1983 *King of Comedy*, a darkly humorous satire starring Robert De Niro as a fame-seeking sociopath who kidnaps a famous comedian (Jerry Lewis). But even in this section, there are genuinely funny moments, as when Mary Vivian Pearce (Waters regular who here plays an extra) asks Beverly to sign her book with "To a future serial mom."

For better or worse (I think the latter), *Serial Mom* reflects a middle ground between Waters's outrageous early works and the lighter tone of his later ones. He perceived *Serial Mom*, which was slightly edgier than *Hairspray* or *Cry-Baby*, as a way back to the R-rated territory, filtering his characteristic humor through a big Hollywood showcase. The picture helped the director feel the sweet smell of revenge. For him, *Serial Mom* was a subversive showcase not least because it played in neighborhoods that had scorned him, never before showing his movies.

For the first time in his career, Waters worked with a star of the caliber of Kathleen Turner, then at the height of her popularity after appearing in *War of the Roses*, opposite Michael Douglas, who had produced the pictures that put her on the map, *Romancing the Stone* and *The Jewel of the Nile*. Waters wanted the audience to like Turner as a heroine, not as a villainess, to the point where they wouldn't mind how many people she kills because it's all done in the name of an "honorable" cause, protecting the sacredness of the American nuclear family.

Though Turner plays her role with verve and gusto, some critics thought that Waters showed too much restraint in treating potentially subversive material, perhaps because of the double constraints of getting a bigger production budget than usual and casting a glamorous Hollywood star. Sensible spectators, however, could discern different kinds of suburbia in Waters's films: "*Polyester* was plastic-covered, an homage to bad taste, but the home in *Serial Mom* is not in obvious bad taste." Waters said that although he didn't want to live in that house, he did not hate it. Revisiting suburbia in his later work, he found it ironic that the new denizens liked his work: "It was their parents who hated me, but the generation that chased me out doesn't live there anymore."[60]

Self-reflexive, *Serial Mom* contains references to Waters's artistic influences. Images from films by Russ Meyer, Otto Preminger, William Castle, and Herschell Gordon Lewis are seen on TV sets throughout the tale. And as usual, celebrities like Patty Hearst, Suzanne Somers, Joan Rivers, Traci Lords, and Brigid Berlin make cameo appearances. Waters still cites *Serial Mom* as his prototypical and favored kind of picture, an offbeat comedy about Americans' obsession with serial killers, a film that delivers its ideas in a light, farcical way without being too gross, judgmental or messagy.

DECLINE, INEVITABLY

Made in 1998, *Pecker* is a pleasant but too slight and obvious tale of a working-class teenager who becomes a celebrity photographer in spite of himself. Shot in a Baltimore neighborhood known for its thick accent, this amiable but innocuous satire doesn't have much to say about the culture of celebrity, nor is it biting in the manner of previous efforts. Lagging behind the zeitgeist as far as what the public already knew about obsession with fame, *Pecker* induces some smiles, but as a Waters feature, it lacks distinction. It is more in the vein of the light and nostalgic *Cry-Baby* than the black and biting *Serial Mom*. With the exception of a few shots of rats having sex—a motif in Waters's work—and snippets of male strippers, the film is too tame and lame.

A congenial adolescent, Pecker is so named for his childhood habit of "pecking" at his food. He works in a sandwich shop, where he cultivates his hobby of snapping photos of his customers and their food. The likable protagonist is played by Edward Furlong, then riding high after making some popular action films, such as *Terminator 2: Judgment Day* with Arnold Schwarzenegger, and some well-received indies, such as *American Heart*, playing Jeff Bridges's son, and *American History X*, playing Edward Norton's brother. But his performance in this picture is stiff and disappointing, just like those of the other actors, largely because they are all representing types, given one-liners that they deliver in a monotonous way.

In tune with the abundance of dysfunctional families on the American screen, Pecker's family is dubbed "culturally challenged." All of its members are eccentrics of one kind or another. Mom (Mary Kay Place) dispenses fashion tips to the homeless clientele at her thrift shop. Pecker's older fag-hag sister, Tina (Martha Plimpton), hires go-go boys to dance at the local club, the Fudge Palace. His younger sister, Little Chrissy (Lauren Hulsey), suffers from eating disorders (she consumes too many sweets). Grandmother Memama (Jean Schertler), Baltimore's "pit beef" queen, engages in religious prayers with her statue of Mary, which can talk.

The unambitious Pecker stumbles into fame when his work is "discovered" by Rorey Wheeler (Lili Taylor), a savvy New York art dealer who becomes smitten with him. Never mind that his photographs are amateurish, grainy, and out of focus; they still strike a chord with New York's artsy-fartsy crowd. Soon there is a public exhibit, followed by instant fame. However, Pecker must learn the hard way the price of sudden stardom and overexposure. Turning into a sensation threatens to destroy his low-key lifestyle, which served as his inspiration in the first place. His new status also means that his buddy Matt (Brendan Sexton III) can't continue to artfully shoplift. His sweetheart, Shelley (Christina Ricci), who runs a laundromat, becomes distressed when the media label her a "stain goddess," mistaking her good-natured "pinup" poses for pornographic come-ons. Pecker's mother is no longer free to dispense fashion tips to the homeless. His grandmother is subjected to public ridicule when her talking statue is exposed in a national magazine. Tina is fired from her job as the

emcee of the gay bar because Pecker's photos reveal the habits of the club's sleazy patrons.

When his newfound fame disrupts the lives of his family and friends, Pecker decides to turn the tables on the art world by refusing to participate in a scheduled show at the Whitney Museum of Art. Instead, he forces the New York art elite to come to Baltimore to see his photos, which portray the same people that had disparaged his family in an unflattering light. In the last scene, interviewed about his future plans, he pauses for a second and then says, "I think I would like to direct a film." The character of Pecker may be a camouflage for the young Waters, and the whole movie can be seen as an allegory of Waters's own rise to fame, based on his fans catapulting him to cult status, perhaps for the wrong reason. However, the difference between Pecker and Waters is that the film's hero is modest and unassuming, whereas Waters was ambitious in his effort to shock viewers and establish a name for himself.

Waters tries to energize *Pecker* as a witty send-up of the contrast between Baltimore's blue-collar denizens and New York's sophisticated but phony art world. But he sentimentalizes his working-class characters, turning them into noble creatures corrupted by the middle-class values of upward mobility and monetary success. As a result, viewers are encouraged to feel superior to his characters. Aware that his narrative is ultraslight, Waters populates *Pecker* with the hottest indie actors at the time (Taylor and Ricci) and eccentric characters played by actual celebrities, by now a staple of Waters's work. Former beauty queen Bess Armstrong plays Dr. Klompus, a child services representative who prescribes Ritalin after misdiagnosing Little Chrissy with Attention-Deficit Hyperactivity Disorder. Patricia Hearst plays a society lady mostly seen adjusting her breasts in private and in public, and Waters regular Mink Stole is the precinct's captain.

Critical reaction to *Pecker* was mixed to negative, resulting in a commercial failure. Some reviewers described it as Waters's first stab at making a mainstream movie, which it was not. In his review, Roger Ebert pointed out that the main problem resides in the "tension between the gentler new Waters and his anarchic past."[61] For example, in the male strip bar, we keep waiting for the director to break loose and shock us, but he never does, except for a few awkward words.

Similarly, the miraculous statue of Mary could have provided comic possibilities, but it doesn't. The *San Francisco Chronicle* reviewer was kinder than most, finding the movie "never truly funny, but an amusing novelty, gaining strength from smart characterizations and sly cogency about the way people are exploited under the limelight of celebrity."[62]

* * *

After *Pecker*, Waters found himself in a tough, untenable position; he wanted to make more commercial films with bigger budgets and stars and yet maintain the edge and boldness he was known for. This dilemma is most evident in his next feature, made two years after *Pecker*. Basically a sketch overextended to the length of a feature, *Cecil B. Demented*, made in 2000, is one of Waters's weakest comedies. The most marketable element of the satire, very loosely based on the 1974 kidnapping of Patricia Hearst (allotted a cameo role in the film), is its high-profile cast, composed of many first-timers in a Waters picture: Stephen Dorff, Melanie Griffith, Alicia Witt, and Maggie Gyllenhaal. Unfortunately, they are all underutilized in slim and undernourished parts.

The otherwise sexy Melanie Griffith gives a terribly monotonous performance as the mean and snooty Hollywood star Honey Whitlock, kidnapped by terrorist filmmakers to star in their underground feature. The film's title (also the name of the protagonist, played by Dorff) alludes, of course, to the legendary dictatorial director Cecil B. DeMille, best known for his epic films, such as *The Ten Commandments*, directed as a silent in 1923 and then as an Oscar-winning sound film in 1956. Dorff's demented, self-styled guerrilla filmmaker, Sinclair-Cecil B., proudly sports a tattoo bearing the name of the controversial Hollywood director Otto ("The Terrible") Preminger, who notoriously broke some taboos in the 1950s with such films as *The Moon Is Blue*, which used the forbidden word *virgin*, and *The Man with the Golden Arm*, in which Frank Sinatra played a drug addict.

Based on a cute but silly idea, the cast and crew members boast tattoos of cool and offbeat filmmakers. Alicia Witt is Cherish the actress, flaunting a tattoo with the name of Andy Warhol. Adrian Grenier

plays Lyle the actor—with a tattoo of Herschell Gordon Lewis. Larry Gilliard Jr. is Lewis the art director—David Lynch. Maggie Gyllenhaal is Raven the makeup artist—Kenneth Anger. Jack Noseworthy is Rodney the hair stylist—Almodóvar. Mike Shannon is Petie the driver—Fassbinder. Eric Barry is Fidget the costume designer—William Castle. Zenzele Uzoma is Chardonnay the sound artist—Spike Lee. Erika Lynn Rupli is Pam the cinematographer—Sam Peckinpah. Harriet Dodge is Inah the producer—Sam Fuller. Some of Waters's regulars also appear in the picture: Mink Stole plays Mrs. Sylvia Mallory, and Ricki Lake is Libby, Honey's publicist. Kevin Nealon and Roseanne Barr play themselves, and Waters himself appears (uncredited) in a cameo as a reporter.

The terrorists represent a strange cross between cineastes who worship Andy Warhol and Underground Art and the Symbionese Liberation Army. Their value system encompasses a peculiar combination of highbrow culture and violent action. As misfits, they have branded themselves "kamikaze filmmakers," claiming the name of SprocketHoles.

Honey is a Hollywood star whose screen image is that of a sweet, sensitive woman, but she's actually a mean bitch who uses profanities and makes unreasonable demands. While in Baltimore to promote her film, she is kidnapped just as she concludes her phony remarks. Held captive in an abandoned theater, she is told by Cecil that he needs a star for his next film. At first, the resistant Honey plays her scenes with no emotion, but when Cecil demands better work, she renders an over-the-top performance, which, of course, pleases him.

The crew runs around town shooting scenes in actual (unapproved) locations with innocent bystanders and crashes a luncheon hosted by the Baltimore Film Commission. In a gunfight between the crew and the police, Cecil is wounded. Turning herself in, Honey is taken away by the police, but later she is retrieved by the terrorists. As she becomes more comfy—possibly developing Stockholm syndrome—she watches a TV special about her life, in which her former husband (Eric Roberts) and others testify to her rudeness. Realizing that escape would just take her back to the Old Hollywood that already hates her, she declares herself "Demented Forever," burning a brand into her arm in a rite of passage.

The group invades the set of the sequel to *Forrest Gump*, which is shooting in Baltimore. Some of Cecil's crew members are killed in a gunfight, and the survivors seek refuge in a porn movie house. After filming the final scene at a local drive-in, the SprocketHoles begin to perform sex in public. The police arrive, and in an act of self-sacrifice meant to grant Honey freedom, Cecil sets himself ablaze. However, touched by the affection of her new fans, Honey becomes fully committed to the SprocketHoles in their effort to destroy the film industry and its homogenized products.

After the first reel, *Cecil B. Demented*, which is contrived and movie-ish in the first place, runs out of ideas and energy. Amateurish, it looks like a retro home movie, with the actors goofing around and winking at the audience and at themselves. Lacking real bite and failing to shock, the comedy is underdeveloped in terms of narrative and characterization. Though shockingly granted a budget of $10 million, it's also sloppy in technical execution, representing the kind of movie that Waters used to make at the beginning of his career.

Given a limited release by Artisan Entertainment in August 2000, as counterprogramming to the summer's blockbusters, *Cecil B. Demented* was dismissed by most reviewers—it is my least favorite Waters film. Some critics felt that, with this presumably black comedy, Waters was biting the hand that feeds him. Unfortunately, the movie offers only a mildly amusing look at the underside of the industry, a subject that's been treated in funnier, more poignant ways in countless other satires. The verdict was that, by the standards of both Waters and American pop culture at the beginning of the new millennium, the parody failed to shock. It was not spiked with sufficient nasty laughs and did not contain enough twisted ideas to merit the genre of a parody. Rather, it assumed the shape of a pastiche, a self-conscious homage by the middle-aged Waters to the young Waters. An artistic and commercial flop, the film cleared only $500,000 at the domestic box office and slightly more in foreign countries.

* * *

Billed as America's first carnal-concussion comedy, *A Dirty Shame*, made in 2004, provided further proof that Waters was losing his edge.

He seemed unable to find suitable subjects to address the shifting pulse of American pop culture, which was getting quirkier, more liberal, and farther left of center. Going out of its way to be rude in signaling sexual anarchy, *A Dirty Shame* is a movie with a sleazy mind and a generous heart but a cold (or no) soul. Waters decided to make the film after discovering several sexual slang terms on the Internet, which helped him to clarify the terminology in his film. Set in the Harford Road area of Baltimore, *A Dirty Shame* tells the story of a horny horde of "sex addicts" who invade a blue-collar neighborhood, to the dismay of its "neuter" residents.

Sylvia Stickles, played by popular TV personality Tracey Ullman, is a grumpy and repressed middle-aged woman married to a dull husband, Vaughn (Chris Isaac). Her routine day consists of running the family's Pinewood Park and Pay convenience store and preparing meals for her exhibitionist daughter, Caprice (Selma Blair), a go-go dancer with enlarged breasts, known to her fans as Ursula Udders. (Get the reference?) Nudity and disorderly conduct lead to Caprice's detention in the apartment of Sylvia's mother-in-law, above the Stickleses' garage, thus giving the neighbors access to the family's secrets. When Sylvia gets into a freak accident that injures her head, a raunchy tow-truck driver named Ray-Ray Perkins (Johnny Knoxville) rushes to her aid. A sexual healer, he brings out her flaming cauldron of hidden lust. No longer a prude, Sylvia begins to view the world through hypersexual eyes. Vaughn is shocked by his wife's resurgent libido, and when he sees her raunchy "hootchy-kootchy" dance in a nursing home, he knows that something is wrong.

Meanwhile, Sylvia's mom, Big Ethel (Susanne Shepherd), already up in arms about the liberties taken, decides to fight back. Supported by her sex-hating neighbors, including Marge the Neuter (Mink Stole), she leads the battle for "Neuter Normality." It is noteworthy that even some of the actors were shocked by the language. Veteran stage actress Shepherd was unfamiliar with Waters's work and had no idea what to expect. Horrified by what she had to say as Big Ethel, she became so distraught that she began to cry at the first reading of the script. She tried to quit the project, and Waters had to use his charm and powers to persuade her to stay.

Sylvia, burning with desire, is not alone in eroto-mania. Head injuries have brought forth a flock of sex addicts who infiltrate the entire community, from the post office and the police to the Park and Pay. Ray-Ray's disciples, an aggregate of bizarre fetishists, plan to take over Harford Road, signaling a new age of erotic bliss. But Sylvia's torrid night out at the Holiday House biker bar is cut short by a second head injury, after which her raging libido is snuffed out like a candle. To help Sylvia deal with her "runaway vagina" and reclaim her sexual sobriety, the Stickleses turn to a doctor and a twelve-step program.

Having seen the "Promised Land," Ray-Ray and his followers will not abandon their sister to erotic anorexia. With joyous cry of "Let's Go Sexin'!" they set out to rescue Sylvia and liberate the community. In the final battle, Big Ethel and the neuters make a last stand against the sex addicts. As the struggle spreads around, head injuries multiply, and sexual miracles continue to happen. Sylvia's hitherto dull marriage is jump-started by bold erotic acts that announce a dawn of sexual awakening.

Among the film's nice touches is the renewed bond between Sylvia and her daughter, Caprice, even if it takes a sexual concussion to bring them closer together. "I'm a cunnilingus bottom," Sylvia tells her daughter. For a while, it's fun to observe Ullman running around with a prosthetic busom, torn between carnal rapture and self-castigation, and venting at the tyranny of the axis of evil. As a frumpy hausfrau twitching with lust, she horrifies the residents of her mother-in-law's retirement home. However, in terms of acting, the film's revelation is Johnny Knoxville, whose charisma, sexy look, and cool attitude are suitable for the erotic evangelist. Long-term collaborator Vincent Peranio created a tawdry version of blue-collar suburbia, and the vintage score of bawdy, double-entendre-laden nuggets includes "The Pussy Cat Song," "Hump-a Baby," "Tony's Got Hot Nuts," "Eager Beaver Baby," and "Itchy Twitchy Spot."

The first sight of Ray-Ray shooting semen out of his head onto the camera is hilarious, but the more the sex addicts talk about their hang-ups, the more harmless and unfunny they become as screen characters. If anything, A Dirty Shame, meant to be raucously gritty, is not wicked or kinky enough. Ebert, an otherwise ultragenerous critic, panned the film: "There is in showbiz something known as 'a bad

laugh.' That's the laugh you don't want to get, because it indicates not amusement but incredulity, nervousness or disapproval. *A Dirty Shame* is the only comedy I can think of that gets more bad laughs than good ones."[63]

Unfortunately, *A Dirty Shame* doesn't take advantage of Ullman's talent for showing the eccentricities of kooky American women in the way that *Serial Mom* served Kathleen Turner so well. Structurally and technically, *A Dirty Shame* is messy, and most of the jokes are hit-or-miss, sort of a camouflage for a nonexistent plot. Archival footage of hootchy dancers and other period eroto-maniacs that is inserted into the tale is sporadically fun to watch. But overall, the art scheme and digital work—horny squirrels and fornicating flora—are cheesy and childish, even by design. The sex-related buzzwords flashing at intervals on screen are diverting only up to a point; *A Dirty Shame* is not only monotonous and repetitious, it also leaves a bad taste after viewing.

More ribald than Waters's recent milder output, *A Dirty Shame* was slapped by the MPAA with NC-17, which was no surprise, given that every imaginable sexual proclivity is catalogued. When Waters asked the MPAA what needed to be cut in order for the film to get an R rating, they replied that "after awhile, we just stopped taking notes"; if everything they objected to was cut, only ten minutes of the film could have been approved for distribution. It was then and there that New Line decided to release it with an NC-17 rating, which is usually the kiss of death at the box office, though in this case the movie would have failed with any kind of rating. Released in September in 133 venues, the film claimed a meager box office gross of $1.3 million, resulting in a big loss for New Line.

There are two versions of the movie, a full, uncensored version and "The Neuter Version," a heavily edited R-rated cut sold at Blockbuster, Walmart, Best Buy, and other store chains. The R-rated version lacks most of the profanities in action and dialogue, including references to "sex toys." A scene in which two characters stand naked in their doorway is replaced by one in which they are clothed. Waters considered this cut to be "essentially for brainless people and 'really weird collectors.'"[64] To its credit, Netflix later streamed the picture's uncensored NC-17 version. However, rather strangely, it's the censored

version that played on LOGO, a cable channel specifically targeted at gay viewers.

Only a few critics lauded the film's unashamed vulgarity in expressing people's latent urges to talk freely about their sexual desires and practices, praising Waters for drawing on the liberating power of comedy as a genre; most others dismissed it. When the movie came out, Waters's mother asked, "What's this one about?" "Sex addicts," he said. "Oh, maybe we'll die first," his mother quipped. For the most part, his parents' reaction was like that of many other conservative spectators. Waters said that "it took a lifetime of my parents to getting used to my odd-duck sensibility, and being proud of it."[65]

Although Waters is now a household name, his signature taste level still proves to be an obstacle to getting his projects made. He was planning to make *Fruitcake*, a Christmas movie for children about meat thieves, starring Johnny Knoxville and Parker Posey. The shoot was scheduled to begin in November 2008, but the backing fell through, despite Waters's genuine belief that the concept was broad and accessible. In a recent interview, Waters pointed out that "independent films that cost $5 million are very hard to get made. I sold the idea, got a development deal, got paid a great salary to write it, and now the company is no longer around, which is the case with many independent films these days."[66]

TRASHY CAMP: END OF AN ERA?

In his earlier pictures, Waters satirized both Hollywood's ideals of glamour and the liberals' ideals of hipness and chic—in other words, the limits of "good" taste. In his later pictures, he satirized all-American institutions such as suburban life, bourgeois marriage, the nuclear family, and motherhood (Momism). Some of the grotesqueries prevail in his later work, but his recent, more tender sensibility has been more cuddly than cutting.

The changing demographics and the rapidly shifting pop culture have worked against Waters's enjoying a continuous, thriving career. As he recalled: "People my age who are now running the studios saw my films, especially *Pink Flamingos*, in college, so it isn't really

something I have to battle anymore."[67] Waters, who's now in his late sixties, seems to have lost his edge and audacity in tackling controversial, hot-button issues, opting instead for gentler satires about rather familiar topics. Time and history have diluted the extremities of his work. He represents an underground phenomenon co-opted into the mainstream, an initially shocking career gradually rendered more palatable. The director himself has acknowledged that the golden age of trash is over because there are no more taboos to break. His battle to redefine the parameters of taste and to restructure American culture by broadening its range has been triumphant. In fact, the struggle was so successful that, ironically, it might have ended his career.

Understandably, Waters is nostalgic for the 1970s—before independent film became institutionalized as an industry with its own structure, financial backing, distribution, and stars. As I have shown in my book *Cinema of Outsiders*, independent film of the past decade does not so much run against Hollywood as parallel to it; it's a small industry—but an industry nonetheless.

Asked to define his style, Waters said: "With all the directors I like, you can spot their style even if there are no credits on the film, because they take you into their world. It's visibly identifiable, and it's like no one else's. That to me is a good director, even if you don't want to go in their world."[68] And so, instead of repressing his uniqueness, Waters embraced it, waving it like his personal version of the American flag.

When Waters's directing prospects declined, acting became a more creative outlet for him. He appeared, puffing on a cigarette, in a short announcing that "No Smoking" is permitted in the theaters. It was shot for the Nuart, a Landmark Theatre in Los Angeles, in appreciation for its years of showing *Pink Flamingos*. The featurette ran before his film and before the midnight screenings of *The Rocky Horror Picture Show*. He played the paparazzo Pete Peters in 2004's *Seed of Chucky* and a minister in *Blood Feast 2: All U Can Eat*, a sequel to one of his favorite films, directed by his idol Herschell Gordon Lewis. In 2007, Waters became the host ("The Groom Reaper") of *Til Death Do Us Part*, a program on America's Court TV network that dramatizes soured marriages ending in murder.

Waters is also the author of several respected books. A collection of old stories and some new ones was published as *Crackpot: The Obsessions of John Waters*. His book *Shock Value* included several previously printed articles. He has written essays for *Rolling Stone*, *American Film*, and *National Lampoon*. Waters has also advocated the parole of former Manson family member Leslie Van Houten, to whom he devoted a chapter in his book *Role Models*, published in 2010.

Art may represent Waters's new, more viable passion. He has been making artworks and installations that are exhibited in international museums. He considers his artwork, just like his movies, to be conceptual, in which the presentation is more important than the craft. In 2004, the New Museum in New York City presented a retrospective of his artwork curated by Marvin Heiferman and Lisa Phillips. More recent exhibitions include *Rear Projection* in April 2009 at the Marianne Boesky Gallery in New York and the Gagosian Gallery in Los Angeles. The pieces are often humorous, such as "Rush," a supersized, tipped-over bottle of poppers (nitrite inhalants), which are used to enhance dance energies on the disco floor and sexual activities afterward. "Hardy Har," a photo of flowers, squirts water at anyone who traverses a taped line on the floor.

Ironically, Waters is the richest artist represented in this book, due to royalties from his movies and their Broadway adaptations. He mainly resides in his hometown of Baltimore, the setting of his films, but he also owns properties in San Francisco and a home in Provincetown. Instantly recognizable by his trademark pencil-thin moustache, he has sported this look for decades. Provincetown's residents continue to marvel at his friendliness and penchant for storytelling—he is a grand raconteur. He loves riding his bike on Commercial Street (the town's main street), wearing a jacket and a bowtie and greeting fans and visitors with a big smile on his face.

To the extent that a distinguished filmmaker is an artist who creates an idiosyncratic milieu, Waters has proven that he is a director to be taken more seriously, having fulfilled important ideological and cultural functions in the 1970s and 1980s. Kathleen Turner, the star of *Serial Mom* (the director's most commercial picture), has summed up his influence most succinctly: "John is probably a genius. Quite frankly, you don't create your own genre and an international

audience that are completely outside the system—and in spite of the Hollywood system—unless you have one hell of a lot of talent."[69] In 2007, *This Filthy World*, Waters's touring one-man show, was made into a feature film directed by Jeff Garlin. The show was so successful that he now tours with its sequel, *This Filthy World II*. He also presented a TV series, *Movies That Will Corrupt You*, for TV's gay-friendly cable network, Here! He is a regular presence at the Spirit Awards, which he has hosted in the past. At the March 1, 2014, ceremony, the hosts paid a special tribute to him on the occasion of the fiftieth anniversary of his short *Hag in a Black Leather Jacket*. Not many filmmakers, mainstream or independent, can claim such longevity.

Waters is the most idiosyncratic filmmaker among the artists in this book, but there are serious doubts about whether he will be able to make another feature film. With his directorial career all but over, he continues to cultivate his reputation and maintain his status as an iconic celebrity in various extra-filmic endeavors. With the exception of Almodóvar, the other directors—Van Sant, Haynes, and especially Davies—are immediately and directly associated with filmmaking; they are figures that few people would recognize in public or ask for autographs. Gifted in many fields, Waters has channeled his creativity into acting in films, traveling with his stage show, lecturing on campuses and other places, creating conceptual art. Writing books has become his most cherished and enjoyable activity; as he attested, "I can probably be more completely myself when writing a book, because book editors don't say, 'you have to play it to Peoria in a shopping mall.'"[70]

Waters is the least specifically definable of the book's directors. A recent column described him as "simultaneously 'The Pope of Trash' for his Baltimore-based films *Pink Flamingos* and *Female Trouble*; a darling of Broadway for the stage adaptations of *Hairspray*; an X-rated holiday tradition for his traveling show *A John Waters Christmas*; and the unlikeliest fan of Justin Bieber, whom he would like to enlist for a special Christmas edition of *To Catch a Predator*.

Despite a solid body of work, Waters knows that he will always be remembered as the director of *Pink Flamingos*—"The day I die it will be in the first paragraph of my obituary." While recognizing that it is not his best film, he realizes that the movie "helped make

trash more respectable, and it lasted longer than I ever would have imagined. I still meet young kids who have just seen it and they react with the same disbelief that their parents did the first time."[71] Looking back, Waters has said: "I believe life is nothing if you're not obsessed. I only think terrible thoughts, I do not live them. Thank God, I am not my films. If audiences can laugh at my twisted ideas, what's the great harm? I had a goal in life, I wanted to make the trashiest pictures in cinema history. Thanks so much for allowing me to get away with it."[72]

JOHN WATERS FILMOGRAPHY

1970 *Mondo Trasho*
1971 *Multiple Maniacs*
1972 *Pink Flamingos*
1974 *Female Trouble*
1977 *Desperate Living*
1981 *Polyester*
1988 *Hairspray*
1990 *Cry-Baby*
1994 *Serial Mom*
1998 *Pecker*
2000 *Cecil B. Demented*
2004 *A Dirty Shame*

CONCLUSION

GAY DIRECTORS—WHO'S LOOKING AND HOW?

THERE IS no one model of gay authorship or a single pattern of gay sensibility to fully describe the work of the five directors in my book. Although Pedro Almodóvar, Terence Davies, Todd Haynes, Gus Van Sant, and John Waters didn't invent gay-themed cinema, they have played overarching roles in making it more explicit, accessible, and acceptable. Gay directors no longer have to hide away on screen and off. There is much less coded and condemnatory treatment of gays—in front of or behind the camera—than there was when they began their careers in the 1970s and 1980s. Gay directors, in fact, may have the advantage of being partially liberated from the pressures that culture exerts on straight directors to conform their films to mainstream notions of male domination and female subordination.[1]

The greatest challenge in writing this book was to balance my necessarily critical and detached approach with my passionate admiration for all of these directors' accomplishments. I have avoided the issue of the directors' private lives, an interesting subject worthy of serious biographers but not particularly relevant to the scope of my book. I once asked Almodóvar what kind of lifestyle he leads. Pausing for a brief second, he said: "My life is dominated by work. I have dedicated all my time to the profession. I would love to enjoy an intense

sex life and adventures, like those of my characters, but I am totally surrendered to work, perhaps because I have to justify that I am a self-made man."[2] Work has consumed the lives of all five filmmakers, showing utmost dedication to their careers, which they perceive as a calling. "I like to work, that's when I'm the happiest," John Waters has repeatedly said. "I'm like a workaholic. When there isn't any project getting on, it gets boring."[3]

Nor have I dealt with the directors' level of comfort with their own homosexuality, which is variable. Almodóvar has acknowledged: "Every artist needs to have *secrets*. Secrets enrich your life, and they add riches to your work, but secrets can become asphyxiating. A prime example is handling homosexuality. You don't have an obligation to talk about this, but you have an obligation to face it yourself, otherwise you are condemned to a very painful life."[4] And painful it has been in the case of Terence Davies, who, by his own account, has suffered from being homosexual. What matters to me as a scholar is the reality that all five are openly gay (though they came out at different ages and phases of their lives) and the channels through which they have expressed their sexuality in their films. This is based on my belief that, ultimately, the film—or any artwork—is more important than the psychology and motivation of the artist behind it.

In examining these directors, I have not adopted any particular theory. I have used the more general concept of gay, rather than queer, based on my assumption that queer suggests more radical political positions on gender, desire, and sexuality. Moreover, surveying the literature, I have read several essays that raise the question of the extent to which queer may be a hipper, cooler, all-pervasive term for what used to be known as gay studies up to the 1980s.[5]

What unifies a diverse volume like *Gay Directors, Gay Films?* is its comparative perspective and methodological strategy. My project was motivated by a theoretical interest in nonnormative expressions of gender and sexuality that are still considered "deviant" from the viewpoint of mainstream society and the dominant culture, despite the progress made in accepting alternate lifestyles and same-sex marriage. Jointly, the five directors have been prime carriers of innovative aesthetics within the realm of cinema. Each director has made personal films that have challenged societal taboos, particularly in the

areas of sex and gender. Their commitment to individuality is driven less by a need to be irreverent or a disregard for authority than by a genuine interest in changing reality, on screen and off. Their work is based on the shared belief that there always should be on-screen representation of the "marginal" aspects of society.

Instead of going from a general theory to a particular film, I have taken the opposite direction, going from a particular work to a more general framework, constructing in the process the director's distinctive vision and unique sensibility. While analyzing the films (individual trees) of each director chronologically and placing them in the social-historical contexts in which they were made, some interesting patterns (woods or forests) emerged. *Gay Directors, Gay Films?* describes the work of five influential directors who have largely enjoyed successful careers inside and outside mainstream cinema. I have tried to address the tensions between the directors' singular visions and the narratives they have made. It's what auteurist critic Andrew Sarris has referred to as a film's "interior meaning" in his seminal book *The American Cinema: Directors and Directions*.[6]

My reading of the films in this book is not "alternative" or "subcultural" but a legitimate reading standing alongside other kinds of readings. This reading shows that each director has created a distinctive way of looking at the world—a weltanschauung—and each is aware of this fact. Almodóvar has said: "The main difference among directors is their private reality. I think one auteur is different from another because he has his own morality, but when I say morality, I don't mean ethics. It's just a private point of view. I mean you can see a film by Luis Buñuel and you know exactly that it belongs to Buñuel, because it's just a way of thinking."[7]

All five directors qualify as auteurs from both a thematic and a stylistic standpoint. For example, most of Van Sant's films, whether explicitly or implicitly gay, deal with outsiders and outcasts, observed from a detached and nonjudgmental perspective. He has been consistently attracted to American youths—their confusion, alienation, and disturbance. In his best work, he has illuminated what it means to be an outsider living on the periphery of society. His films have centered on unusual characters seldom seen in mainstream cinema: hustlers (*Mala Noche*, *My Own Private Idaho*), thieves

and junkies (*Drugstore Cowboy*), a fame-obsessed murderess (*To Die For*), violence-driven high schoolers (*Elephant*), and a troubled, suicidal youth (*Last Days*).

Though the five do not share the same worldview, their sensibility has been influenced by some similar experiences as outsiders, even when they do not make gay-themed films. The insecurity and ambiguity built into their status as outsiders, especially in the first decade of their careers, has had a strong impact in shaping their creative filmmaking. All five are aware of this; as Van Sant has said, "We are all mavericks and relish our positions as such."[8] It often takes outsiders, gay directors included, to see societal manners and mores with greater complexity and deeper subtlety.

All five directors have subscribed to postmodernism in its most general meaning, a concept guiding them to move beyond coherence of form and unified structure, due to the increasingly incoherent reality we live in and the rapidly differentiated culture we experience. Celebrating the end of "serious meaning," they recognize that all art forms, high and low, share a community of images and sounds that generate meanings even if they don't relate to some objective or external reality. They also realize that the new technologies and social media have rendered subjectivity permeable and changeable. Like other independent-minded directors, they have embraced two tenets—self-conscious aesthetics and political (or sexual) militancy—that are anathema in Hollywood, where these concepts have meant financial risk, if not utter failure.

Like all postmodern artists, the five directors have broken down narrative and aesthetic boundaries. However, thus far, they have all operated within the national-state model. Almodóvar's work is accessible and popular all over the world, but he is still very much a Spanish director whose screen characters, themes, and motifs are grounded in the specificity of Spanish culture. Unlike many foreign directors (most recently, even Chinese and Korean filmmakers, such as Chen Kaige, Wong Kar-Wai, and Zhang Yimou), Almodóvar has resisted tempting offers to go Hollywood or direct a movie in the English language.

Of the five, Davies is the most critical of Hollywood; as he recently said, "It's difficult when you are not in the mainstream. We are

culturally and politically a lap dog of America. We will swallow every-
thing from America. If we're not careful in 20 years' time we'll have no
culture at all. The language is despised. But we need to be protected,
not ossified."[9] Moreover, though his work is grounded in British his-
tory, he is also critical of his own national cinema: "It's stultifying to
hear that another Jane Austen adaptation is being made. If that's all
we can do we should maybe just stop."[10]

None of the gay directors is truly religious in the traditional sense
of the term, though the work of Almodóvar, Davies, and Waters can-
not be understood without considering their strict upbringing and
then rebellion against their oppressive Catholic backgrounds. For all
five directors, cinema is the ultimate mode of personal expression.
For Davies and especially for Almodóvar, cinema is also the psycholo-
gist's couch and the priest's confessional. But the cinema created by
Davies and Almodóvar is universal, transcending nationality without
renouncing the specificity of its culture, be it Britain's Liverpool or
Spain's Madrid.

Though three of the directors are graduates of film schools, with
the possible exception of Haynes, none of them is intellectual or cere-
bral. Perhaps not coincidentally, Haynes is the youngest (fifty-four)
of the clique and also a student of semiotics at Brown University. No
director has worked exclusively in the indie sector or mainstream Hol-
lywood. Some, like Van Sant, have gone in and out of the indie milieu
with varying degrees of success. All five are intensely individualistic
directors, but they are also capable of adapting themselves to various
genres and different styles. Almodóvar, for example, has effectively
meshed the proclivities of European high art with the demands of
Hollywood popular entertainment without losing his idiosyncratic
approach.

Thematically and stylistically, none of the directors has attempted
to hide the medium's unique formal devices in his work; au contraire,
they have rejoiced in playing with or against them. All of them, espe-
cially Haynes and Almodóvar, have experimented with revisiting and
revising the more closed and stable elements of classic Hollywood
cinema. All five men have dealt with erotic desire, sexuality, and gay
characters, but they have exhibited different approaches to their
themes. The only commonality is their belief in continually breaking

taboos and challenging their viewers' expectations, both narratively and visually.

Each of the five directors has been associated with particular actors over a long period of time. For example, Waters developed and enjoyed crucial collaborations with Divine, Mink Stole, and the Dreamlanders. Almodóvar was inspired by and built the career of Carmen Maura in the 1980s and then did the same with Marisa Paredes and Penélope Cruz from the 1990s onward. Agustín, Almodóvar's younger brother and producer, is the only figure to have appeared in all of his pictures. Haynes has cast Julianne Moore in several of his features. Van Sant has worked with two Matts (Dillon and Damon), the Afflecks (Ben and Casey), and the Phoenixes (River, Rain, and Joaquin). I have explored the relationship between the directors and their frequent actors, who often function as the filmic equivalent of a theater repertory company. These particular actors have served as effective expressions of their directors' innermost concerns and feelings. Almodóvar has said this about his actors: "In my films there's always someone new. But I do like having an artistic family, like a stable repertory, which is sincere and concrete."[11]

As noted, the acting in Waters's earlier films is deliberately grotesque and restricted, though later on, working with Kathleen Turner and other accomplished performers, the acting has become subtler and more realistic. In his focus on youth-oriented stories, Van Sant has largely cast young, often inexperienced and nonprofessional actors. The most subtle and professional acting is to be found in the films of Almodóvar, due to his perception of actors as "the special effects of my films." Known for his rigorous mise-en-scènes, in which the actors (not objects or décor) are central, he has paid attention to the minute details of acting, guiding his performers in terms of voice, facial expression, gestures, body position, and body movement. He loves actors because, as he has said time and again, "It's impossible for them to lie to me when I'm directing them. I ask the actors to be completely naked in their emotions."[12]

Specific physical settings within which their stories take place have defined the work of all five directors: Waters and Baltimore, Almodóvar and Madrid, Davies and Liverpool, Van Sant and Portland, and Haynes and Los Angeles. In Almodóvar's oeuvre, Madrid and

La Movida have shaped his narratives and characters, manifest in the colorful streets, beauty parlors, coffee shops, night clubs, taxi cabs, and nonstop music.

As members of minority subcultures, the gay filmmakers have revealed within their narratives anxieties, tensions, and ideological cracks (holes in a pattern) that are both personal and collective. They have often imbued seemingly conventional genre films with a multiplicity of meanings; on the surface, the old patterns are maintained, but beneath the surface, the patterns are challenged, reinvented, and discredited.

Almodóvar's work was explored from feminist and gay perspectives, although not neglecting historical factors. The contours of his work are shaped by the politics and culture during the end of Franco's dictatorship and right after his death. Almodóvar has placed special emphasis on the libidinal pleasures of individuals' bodies and their sex organs. His characters are driven by a relentless pursuit of love and pleasure, not of power, status, or money. In his universe, there is no pain without pleasure, and vice versa, no pleasure without pain.

Haynes has created a masterful mise-en-scène of middle-class suburbia, depicted as both strange and attractive by the entry of foreign or alien forces. He constructs spaces whose stability is fragile, always threatened by various outsiders. Haynes's characters, more complex and multinuanced than those constructed by Waters or Van Sant, are formed by social contexts that can barely contain them. He asks his viewers to respond to the vagaries of history, urging them to engage in readings different from those offered by the dominant cinema.

Of the five directors, Almodóvar has devoted the most attention to the articulation of sexuality, raising the question in film after film of how desire is rendered visible in narrative film. The essential questions of who is looking at whom, in what context, and to what effect run through most of his films. Dealing with cinema's most risky issues—voyeurism, fetishism, sexuality, and violence—he has challenged classic Hollywood cinema's notions of male gaze—specifically, the ideas that the spectator-voyeur is necessarily male and that female exhibitionism is always the object of male gaze. He has met that challenge by creating narratives in which the protagonists are homosexuals, bisexuals, lesbians, transvestites, and transsexuals, all

of whom have served as objects of desire and all of whom have been subjected to both female and male gaze.

From the beginning, Almodóvar's goal has been to move toward greater visual explicitness in sexual matters, to remove blinders from cinema when it comes to sexual imagination and sexual action. The most stylishly elegant of the filmmakers, he allows entry into his world through rich mise-en-scènes, composition, lighting, camera movement, color coding, and editing, elements that provide viewers with perceptual patterns that go beyond his own perceptions and those of his protagonists.

Almodóvar may or may not have read Michel Foucault on sexuality, but his work certainly validates the French scholar's theories of sexuality as a historically specific organization of desire and power, or, to put it differently, the idea that desires, identities, and practices do not line up and match neatly. Almodóvar, like the French theoretician, has shifted the focus from sexual identities to sexual practices. The figures in his work cannot be reduced simply to the two categories of homosexuals and heterosexuals. The transvestites, transsexuals, and transgenders in his films cannot be understood simply in terms of names, labels, or assumed identities. Ultimately, sexual practices are more consequential than gender-driven definitions of gay or straight. In shifting the focus to practices, he has unsettled sociological assumptions, contesting the supposedly stable relationship among sex, gender, desire, and sexual practice. In his work, there are diverse configurations of identities, desires, and practices that go beyond the labels of homosexual and heterosexual.

Van Sant has deliberately fragmented the mise-en-scène and perceptual location in his films, demanding that viewers pay attention to their various parts. He has refused to provide spectators the comfort of stable emotional placement. In his films, the mise-en-scène is never totally accommodating. Unlike Almodóvar's characters, Van Sant's have no homes or security, resulting in their habitation of transitional spaces—thus, the prevalence of the road/journey motifs. The antiheroes in his films live in perpetual states of anomie marked by confused identities and self-destructive violence.

The sociopolitical and cultural contexts of the three American figures (Waters, Van Sant, and Haynes) and the Spaniard Almodóvar are

vastly different from those of their elders. This contemporary cohort has reacted to timely social factors such as the AIDS crisis, the debates over "political correctness" in the arts, and the tension between the "queering" of American culture on the one hand and the surrounding conservative climate on the other—especially the homophobia that prevailed during the retro (and reactionary) Reagan era.

Their work has benefited from the rise of the gay movement, which prompted a revisionist perspective toward gay cinema. They have also profited from the rising prominence of gay film festivals, which first started in San Francisco in 1976. Almost every city in the United States has a gay film festival, and some more than one—bearing standard names, such as LGBT, or more original ones, such as Los Angeles's OutFest. Van Sant's entire career owes its existence to the repeated showings in festivals of *Mala Noche*, his breakthrough 1985 feature. It took four years for the movie to get a legitimate (if limited) theatrical exhibition, by which time many industry players had heard about Van Sant through the festival circuit. At the moment, gay festivals, like other film festivals, are flourishing across the country, though it remains to be seen how important they will be in the second decade of the millennium, due to the changing patterns of movie viewership.

The prevalent conflation of sexism and homophobia in the "woman's director" designation is pertinent to the understanding of four of the five filmmakers. A predilection for prominent and sympathetic female protagonists is a distinctive feature of four directors; the exception is Van Sant, whose work doesn't include many women. Yet no member of this quartet has been labeled a woman's director in the restrictive (and punitive) way that describes George Cukor, Hollywood's best-known gay director. As I have shown in my biography of Cukor, Master of Elegance, there are more prominent female figures in the work of Alfred Hitchcock or Michelangelo Antonioni's than in Cukor's, but neither Hitchcock nor Antonioni was ever described as a woman's director, whereas Cukor was—largely because he was gay.

Historically disenfranchised and maligned gay men tend to identify with other marginalized and oppressed groups: ethnic minorities, individuals of color, and women. Most gay directors, including this particular quintet, have experienced some form of oppression,

even if it is not identical to the oppression faced by women. There are therefore significant links between gay men and women, grounded in the historical marginalization of both groups. Gay filmmakers, like other minority members—and women are a minority culturally, if not statistically—share an ideological construction as victims.

There are not many women in Van Sant's work, not even in secondary roles. *Even Cowgirls Get the Blues* and *To Die For* are his only pictures featuring female protagonists. In *Drugstore Cowboy*, two members of the quartet are females, but the focus is on one male, Bob Hughes. Van Sant has shown strong empathy for male outsiders. "Directors have to fall in love with their lead characters, because the lead character is the spokesman for the universe the director is creating,"[13] he once joked. "When we're casting guys, there is the extra conflict of interest of falling in love with them, but I don't allow that to happen. In France, directors say they have to make love to their actors, but they're French, and I'm more Calvinist."[14]

Due to his conservative upbringing and repressed personality, Van Sant has shied away from depicting sexuality in a graphic way—in sharp contrast to Almodóvar. Van Sant has acknowledged that

> a gay director who is directing a straight sex scene is removed, which helps. He can objectively see what the dynamics of the two characters are. But when you're making movies, it's like designing and building. If you're designing a room and you're gay, there are some things that will be affected—maybe the shape of the room, the interior decoration. But when you're talking about just getting people through doors with the right kind of perspective, your sexuality doesn't necessarily apply. A sex scene is architecturally rendered by the filmmaker. The actual sexuality of the characters is the last thing you come in contact with.[15]

Viewed historically, each director, having begun his career in the 1970s or 1980s, had to deal with gay liberation (especially in the case of Waters and Almodóvar) and later on with the culture of AIDS and the unfortunate consequences of discrimination and rampant homophobia. Van Sant and Haynes have made specific movies dealing with AIDS as well as other movies that are allegories of AIDS. Nonetheless,

the work of Almodóvar, Haynes, and Van Sant (but much less so that of Davies and Waters) cannot be fully understood without taking into an account AIDS and its impact on our culture.

All five directors have had to contend with the restrictions of political correctness as an ideology and a practice. Throughout his career, Almodóvar has had to deal with repeated charges of exploiting rather than illuminating the sociocultural elements of rape, which his adversaries claim occurs in too many of his films. But I don't recall many critics complaining that there are "too many murders" or "too many villains" in Hitchcock's films. Almodóvar's detractors seem to disregard the fact that each rape is vastly different from the others, depending on the text's circumstances and tone. The rape in *Tie Me Up! Tie Me Down!* cannot be placed in the same category as the rapes in *Talk to Her* and *The Skin I Live In* because they serve different narrative, dramatic, and emotional purposes. Similar observations can be made about the use of drugs in Almodóvar's films, which can provide the source of humor, as in *Dark Habits* and *Women on the Verge of a Nervous Breakdown*, but also the source of illness, tragedy, and devastation, as in *All About My Mother*, *Bad Education*, *Volver*, and *The Skin I Live In*.

All five filmmakers have spoken against reductionism—namely, the reduction of gay artists (and gay screen characters) to sexuality as the single, or most prominent, aspect that defines their personalities. They have also refused to reproduce dominant stereotypes of homosexuals, such as the Sissy, the Suicidal Youth, the Gay Psychopath, the Seductive Androgyne, and the Bisexual. Instead, they have tried to present "more real" or "realistic" gay men and lesbians. They realize, as Anneke Smelik has suggested, that for straight viewers, using old, negative stereotypes confirms prejudice and that for gay spectators, their use might encourage fear, self-hatred, and anger.[16] On the other hand, these directors also realize that presenting only positive images is not the solution and that images of gays and lesbians cannot be seen as simply "true" or "false." *Gay Directors, Gay Films?* has focused on the social contexts and the conditions under which various entertainment institutions have created, maintained, and perpetuated ideological and cinematic stereotypes that gay directors have set out to challenge and abolish.

Aiming to establish connections between gays and other marginalized minorities, Haynes destabilizes the division between dominant and subordinate individuals by disturbing the usual space allotted to "others" in society's broader structure. Like Almodóvar, he avoids any form of labeling because labeling permits those in power to feel secure and to perpetuate the status quo by drawing boundaries that separate those who have from those who have not.[17] Moreover, to label is to judge, and to judge is to limit the range of possibilities of his characters and the range of interpretations of his viewers. No character in his films can be adequately understood or fully contained through sexual labeling; in most cases, socioeconomic status is more important as a defining criterion. He empowers his disenfranchised individuals in fantasy worlds, which they create apart from their oppressors. In *Poison*, nothing that the jail's wardens do can prevent the prisoners from engaging in imaginative sexual intercourse (a plot device that served as a climax in Martin Sherman's Holocaust drama, *Bent*). In *Velvet Goldmine*, Arthur rehearses in his imagination the bold declaration of his sexuality to his parents.

Haynes qualifies as a queer filmmaker in the traditional as well as the new sense of the term. As Justin Wyatt has suggested, Haynes's oeuvre is queer by being unusual, strange, and disturbing,[18] but in my view, it's also queer in its deconstruction of gay identities and its reconstruction of gay subcultures. His formal experimentation is based on his belief that the greatest function of film (and any art) is to provoke, to disturb, and to unsettle. Like Almodóvar (and David Lynch before him), by making the familiar unfamiliar and the ordinary extraordinary, Haynes has helped viewers see the unusual yet still beautiful elements in our everyday lives.

Four of the five directors (the exception is Van Sant) have dissected the screen role of the housewife, working-class and middle-class, Spanish, British, and American. Almodóvar said early on in his career, "If I want a heroine, I prefer a housewife, whose world is much more interesting as a social commentary as well as melodrama," though he admitted that every class and group (including yuppies) has its charms and eccentricities. His preoccupation with the role of the housewife reflects his own background, a rural family with a strong matriarch moving to the metropolis and fighting for survival. Years

later he acknowledged the impact of similarly themed Italian neo-realist features—specifically, *Rocco and His Brothers*, Luchino Viscon-ti's 1960 masterpiece. "I tried to adopt a sort of revamped neorealism with a central character that's always interested me: the housewife and victim of consumer society."[19]

More than other directors, Almodóvar and Haynes have exposed the sociocultural mechanisms that construct gender roles, but they have done it in different ways. A postmodern intellectual, Haynes has dissected gender analytically from a deconstructive academic standpoint, whereas Almodóvar has done it more intuitively. Both directors have struck a blow against the monolithic accumulation of patriarchal film conventions by critiquing gender stereotypes, but Haynes has done it via serious melodramas, whereas Almodóvar has tackled those issues in various genres: satires, farces, comedies, melodramas, film noir, and even horror-thrillers.

The family institution has been of central concern to all five direc-tors. "As a subject, the family never fails and never disappoints," Almodóvar said. "I found that when I shot *What Have I Done to Deserve This?* people began looking at me with different eyes, sort of 'he's modern but also sensible.' The family is always first-rate dramatic material."[20] Though phrased differently, Van Sant has expressed a similar opinion: "Families are interesting stuff. The dynamics of whatever family you have is an orientation that you apply to the out-side world. Maybe it's just the most interesting thing that I know."[21]

Van Sant and Haynes have not said much about the impact of their birth mothers on their lives and careers, but Almodóvar, Davies, and Waters have, and Almodóvar's worship of his mother is also reflected in his casting her in major roles in his pictures until she died. In his features, Almodóvar has analyzed the complex dynamics of three-generational families, a clan absent from most American films (and reality). Reflecting his own background and the family tradition in Spain, extended families, including patriarchal and matriarchal grandparents, abound in his oeuvre.

There is also more concern with the relationships between siblings, be they two brothers, two sisters, or brother and sister, He acknowl-edged: "I love the sense of fraternity, and I have always enjoyed mov-ies with siblings. Warren Beatty being beaten up in the parking lot for

watching his sister's loss of honor in *Splendor in the Grass*. . . . Thrilling Harry Dean Stanton in *Paris, Texas* and his silent visit to brother Dean Stockwell."[22] And he does not shy away from depicting the camaraderie between female siblings (*Tie Me Up! Tie Me Down!* and *The Flower of My Secret*) as well as the rivalry between male siblings (most manifest in *What Have I Done to Deserve This?* and *Bad Education*).

Van Sant's work differs radically from that of Almodóvar (and Waters) in that his protagonists either are products of broken families or have no biological families at all. On one level, *My Own Private Idaho* is the sad tale of two surrogate brothers in search of a missing mother. For Van Sant, newly formed families, based on shared lifestyle or occupation, are far more significant than birth families. In *Mala Noche*, the Mexican drifters form sort of a community of hustlers. In *Drugstore Cowboy*, we meet Bob's mother only once; and the surrogate family that the four drug addicts establish is far more significant. If families of procreation are seldom seen in Van Sant's work, it's because his protagonists are high schoolers or adolescents, too young to have families of their own.

I had met the late French director François Truffaut several times through my friendship with critic Michel Perez. In a spontaneous moment of chutzpah, I once asked Truffaut if the state of French gay cinema would have been different if one of the leaders of the New Wave (Alain Resnais, Eric Roehmer, François Truffaut, Jean-Luc Godard, and Jacques Rivette) had been homosexual. After a moment of pause, he said hesitatingly, in French, "probablement." I do believe that French cinema would have included more openly gay directors and queer films had there been a tradition of gay cinema. Marcel Carne could not afford to be explicitly gay, but elements of gay gaze prevail in his best work (*Children of Paradise*). Even Andre Techine had to be "cautious" in the climate of the 1970s, and made his most personal film (*Wild Reed*) in 1994. Indeed, it took a whole generation for a major, openly gay French director, such as the accomplished François Ozon (*Swimming Pool, 8 Women*), to make strongly personal films unabashedly. Incidentally, Ozon was included in my initial research design but was eliminated due to restrictions on this book's scope and length.

Despite variability of nationality and social class, all five have been influenced, directly or indirectly, by the same artists and filmmakers, which demonstrates the universal power of art. Call it the Anxiety of Influence among gay directors, to borrow Harold Bloom's concept. I have discussed in some detail the thematic and stylistic impact of Douglas Sirk's melodramas on the features made by Almodóvar and Haynes. More specifically, the directors have all read in high school or college what Almodóvar has referred to as "the damned poets," like France's *enfants terribles* Arthur Rimbaud and Jean Genet, creators of radical works of literary density. It's not a coincidence that the directors have all watched and then studied Genet's *Un chant d'amour*. Almodóvar recalled: "In high school, we of course didn't hear about Rimbaud or Genet, but I knew very soon that there was something interesting in them and read them on my own."[23]

Though none of the quintet has defined himself as an overtly political filmmaker, say, in the sense that Oliver Stone is, they have all engaged in sexual politics—in the power relationships between men and women, men and men, and women and women. Domination and subjugation, freedom and control—these are terms that apply to all of them. Critics of Almodóvar have charged that he makes political references in a frivolous and gratuitous way, to the point of trivializing politics by using it for comedic purposes. Those critics have raised the allusions to Shiite terrorism in *Labyrinth of Passion* and *Women on the Verge of a Nervous Breakdown* and the war of genocide in the former Yugoslavia in *Live Flesh* and *The Flower of My Secret*. In response, Almodóvar has claimed that his target audience, the younger generation in Spain that came of age in the 1980s, is more interested in seeking pleasure and happiness than in politics per se. Challenged to take a clearer political position, he said: "I've never been a member of a political party because I need to keep my independence. But I'm very much on the left. In films, it's not necessary for characters to talk about politics. The politics is implicit in the story." And though he does not define himself as an overtly political filmmaker, he has readily acknowledged that all of his films "carry a political commentary" and that just exploring the lives of housewives is "already a political statement."[24]

Along with sexual politics, the political denominator shared by these filmmakers can be called the politics of aesthetics. All five have contributed to the democratization of on-screen representation, taking characters that have been (at best) marginal and putting them center stage. They have taken minority subcultures (racial, sexual, or criminal) and made them more mainstream by creating stories in which homosexuals, transvestites, transgenders, drug addicts, and criminals play the leads, occupying unashamedly and unapologetically the center rather than the periphery of the narrative.

For example, Waters has gone way beyond his heroes—Jack Smith, Andy Warhol, and Paul Morrissey—in redefining the politics of taste. Warhol had placed several of his sexy models and hunky studs (such as Joe Dallesandro) at the center of his films, but it was Waters who made a legitimate star out of the 300-pound transvestite Divine and a household name out of cute if chubby Ricki Lake. Individually and collectively, this quintet has revolutionized film and popular culture by redefining their range and parameters. I doubt that the stage and movie musical versions of *Hairspray* would have been possible without Waters's pioneering movie twenty-six years ago. That said, the five directors are not alone and not the first ones—they stand on the shoulders of giants, and credit should be given to such iconic gay figures as Oscar Wilde, Jean Genet, Jean Cocteau, William Burroughs, Tennessee Williams, Truman Capote, and others.

My book has made strong statements about the artistic merits of seventy films, but they are not final assessments. My critical approach is not exhaustive but necessarily partial—yet hopefully useful in shedding light on the work of five talented directors. I have deliberately avoided overall evaluations of what the directors have accomplished because they still have many years of creative work ahead of them. With the exception of Waters, who has not made a film in a decade, the directors are still working. Their careers are still in progress, evolving in unanticipated ways—due to changes of the film industry and society at large as well as inevitable shifts in their own personalities and artistic sensibilities.

Finally, I do hope that the films made by the five directors in the future will justify a second, updated version of *Gay Directors, Gay Films?*

NOTES

Note: To avoid repetition, my interviews with the directors with the Hollywood Foreign Press Association are designated as HFPA.

INTRODUCTION

1. Russo (1981).
2. Mulvey (1975).
3. For a discussion of the new approaches, specifically gay and queer studies, see Corber and Valocchi (2003) and Hanson (1999).
4. Branigan (1992).
5. See Doty (1998) for the importance of different interpretations.

1. PEDRO ALMODÓVAR

1. Russo (1988).
2. Quoted in Besas (1985:216).
3. Ibid.
4. Quoted in Kinder (1987:35).
5. Author interview with Almodóvar, Hollywood Foreign Press Association (HFPA), Los Angeles, October 19, 2004.
6. Kinder (2008:277).
7. Author interview with Almodóvar, HFPA, Los Angeles, October 17, 2002.

8. Ibid.
9. Ibid.
10. Russo (1988:63).
11. Almodóvar, production notes for Volver.
12. Author interview with Almodóvar, HFPA, Los Angeles, October 19, 2004.
13. Torres (1982:111).
14. Harguindey (1984).
15. Mackenzie (2002): 155.
16. Author interview with Almodóvar, HFPA, Los Angeles, September 19, 2006.
17. Author interview with Almodóvar, HFPA, Los Angeles, September 29, 1999.
18. Schnabel (1995:94).
19. Rouyer and Vie (1988:72).
20. Ibid.
21. Allinson (2001).
22. Kinder (1987:41).
23. Ibid.
24. Pasolini was assassinated in 1975; Truffaut died in 1984, Tarkovsky in 1986, and Kieslowski in 1995.
25. Pally (1990:x).
26. "Tie Me Up! Tie Me Down!" 1991. *New York Post*, December 17.
27. Pally (1990:85).
28. Agustín, Almodóvar's younger brother, has been the executive producer of his films ever since 1988 and is the only person to appear as an actor in small parts in all of his movies.
29. Alberich and Aller (1984).
30. Kinder (1987).
31. The division of Almodóvar's career into phases is based on my criteria and doesn't follow other classifications, such as those of Allenson (2001) or Smith (1994).
32. Besas (1985:216).
33. Ibid.
34. Author interview with Almodóvar, HFPA, Los Angeles, October 17, 2002.
35. Ibid.
36. Francia and Perucha (1981).
37. Heath (1981).
38. Most of Almodóvar's characters have already met randomly or by coincidence, sometimes as children and sometimes as adults, in private or public spaces.
39. See, for example, Gary Giddins's review in the *Village Voice*, January 23, 1990. As noted, Almodóvar's films were not released in the United States in the chronological order in which they were made.
40. *La Religieuse* has been adapted several times for the big screen—most notably, in 1966 as *The Nun*, directed by French New Wave leader Jacques Rivette

and starring Anna Karina and Liselotte Pulver, and in 2013 as *The Nun*, starring Isabelle Huppert.

41. Russo (1988).

42. Francia and Perucha (1981).

43. Author interview with Almodóvar, HFPA, Los Angeles, December 14, 1991.

44. Lehman (1993:9–10).

45. "All About My Mother." 1999. *New York Post*, December 17.

46. Almodóvar, in production notes for *Matador*.

47. Kinder (2008:282).

48. Ibid., 283.

49. Paul Berenson. 1993. "Gender Bender." *Time Out* .

50. Mackenzie (2002).

51. Author interview with Almodóvar, HFPA, Los Angeles, October 16, 1995.

52. Kinder (1987).

53. Russo (1988).

54. Clark (1988).

55. Pally (1990).

56. Almodóvar's commentary for the DVD editions of *Matador* and *Law of Desire*.

57. Author interview with Almodóvar, HFPA, Los Angeles, November 15, 1988.

58. Ibid.

59. Almodóvar, in production notes for *Women on the Verge of a Nervous Breakdown*.

60. Pauline Kael. 1988. "Women on the Verge of a Nervous Breakdown." *New Yorker*, November 18.

61. Almodóvar, in production notes for *Women on the Verge of a Nervous Breakdown*.

62. Author interview with Almodóvar, HFPA, Los Angeles, October 19, 2004.

63. Scott (2002).

64. *Tie Me Up!* generated a lot of stir due to the controversy that arose when it was slapped with the rating of NC-17, the kiss of death at the box office.

65. Rouyer and Vie (1988).

66. "Tie Me Up." 1990. *New York Times Magazine*.

67. Author interview with Almodóvar, Berlin Film Festival, February 10, 1990.

68. *Mildred Pierce* is one of Almodóvar's most favorite Hollywood films and inspired several of his own films. He said that *High Heels* is a melodrama with a parallel film noir story, like *Mildred Pierce*. Haynes remade the 1945 film into a TV mini-series (see chapter 3).

69. Russo (1988).

70. Author interview with Almodóvar, HFPA, Los Angeles, September 29, 1999.

71. Rape is a theme that appears in more than half of Almodóvar's movies.

72. Author interview with Almodóvar, HFPA, Los Angeles, October 19, 2004.

73. Paul Smith. 1996. "High Heels." *Sight and Sound* X (February).

74. Author interview with Almodóvar, HFPA, Los Angeles, October 17, 2002.
75. For comparisons of *Live Flesh* and the source material on which it is based, see Smith (1994).
76. Author interview with Almodóvar, Cannes Film Festival, May 17, 1999.
77. Gender role-play is theoretically developed by Judith Butler in her poignant 1990 book *Gender Trouble*, though I doubt that Almodóvar has read it.
78. Author interview with Almodóvar, HFPA, Los Angeles, September 29, 1999.
79. Llauradó (1983).
80. Ibid.
81. Almodóvar, quoted in Smith (1994:176).
82. Author interview with Almodóvar, HFPA, Los Angeles, October 17, 2002.
83. Ibid.
84. Mackenzie (2002).
85. Author interview with Almodóvar, HFPA, Los Angeles, September 19, 2006.
86. Author interview with Almodóvar, Cannes Film Festival, May 12, 2004.
87. Ibid.
88. Author interview with Almodóvar, HFPA, Los Angeles, October 19, 2004.
89. The box-office gross of *Bad Education* in 2004 was less than half that of *All About My Mother* or *Talk to Her*.
90. Almodóvar, production notes for *Volver*.
91. Ibid.
92. Author interview with Almodóvar, HFPA, Los Angeles, October 19, 2006.
93. Almodóvar, in production notes for *Volver*.
94. Author interview with Almodóvar, Cannes Film Festival, May 18, 2006.
95. Author interview with Almodóvar, HFPA, Los Angeles, September 19, 2006.
96. Almodóvar, in production notes for *Volver*.
97. Kinder (1987).
98. Almodóvar, in production notes for *Volver*.
99. Author interview with Almodóvar, HFPA, Los Angeles, September 19, 2006.
100. Ibid.
101. Author interview with Almodóvar, Cannes Film Festival, May 18, 2006.
102. Almodóvar, in production notes for *Volver*.
103. Author interview with Almodóvar, HFPA, Los Angeles, September 29, 1999.
104. Wesley Morris. 2013. "I'm So Excited Review." *Grantland*, June 28.

2. TERENCE DAVIES

1. Davies, in production notes for *The Deep Blue Sea*.
2. Author interview with Davies, Cannes Film Festival, May 20, 2008.
3. Quart (2009). This is the best analysis of this documentary.
4. Ibid.

5. Michael Koresko. 2014. Commentary: *The Long Day Closes: In His Own Good Time*. Criterion DVD Collection.
6. Johnny Ray Huston. 2008. "Miserable to Be Gay: Terence Davis." *San Francisco Bay Guardian*, February 20.
7. Koresko (2014).
8. Jim Ellis. "Davies, Terence." In *An Encyclopedia of Gay, Lesbian, Bisexual, Transgender, and Queer Culture*.
9. Quart (2009).
10. Ibid.
11. Clarke (2011).
12. Paul Farley. 2000. *Distant Voices, Still Lives*. London: BFI Modern Classics.
13. Ibid.
14. Author interview with Davies, Toronto Film Festival, September 12, 1992.
15. For excellent analysis of the score, see Thomson (2007).
16. Rene Pol Nevils and Deborah George Hardy. 2001. *Ignatius Rising*. Baton Rouge: Louisiana State University Press.
17. Stephen Holden. 1995. "Neon Bible," *New York Times*, October 2.
18. Barry Walters. 1996. "Neon Bible." *San Francisco Examiner*, July 10.
19. "Interview with Terence Davies." 2002. *Time Out*.
20. Rob Nelson. 2001. "The House of Mirth," *City Pages*, February 21.
21. Review of *The House of Mirth* by Edith Wharton. 1905. *New York Times*, October 15.
22. Scott Marshall. 1996. "Edith Wharton on Film and Television: A History and Filmography." *Edith Wharton Review*.
23. Jeffrey Meyers. 2004. Introduction to *The House of Mirth* by Edith Wharton. New York: Barnes and Noble.
24. Mildred Pierce as a screen type and *Mildred Pierce* as a classic woman's film and a quintessential film noir have inspired and/or are referenced by all five of the book's directors. Haynes has actually remade the film as an HBO mini-series in 2011.
25. Review of *The House of Mirth* by Edith Wharton. 1906. *New York Times*, March 3.
26. Davies's commentary for the DVD edition of *Of Time and the City*.
27. Quart (2009).
28. Author interview with Davies, Cannes Film Festival, May 20, 2008.
29. Quart (2009).
30. Ibid.
31. Ibid.
32. Ibid.
33. Koresko (2014).
34. Davies, in production notes for *The Deep Blue Sea*.
35. Author interview with Davies, Toronto Film Festival, September 2011.
36. David Denby. 2012. "Deep Blue Sea." *New Yorker*, March 26.

37. Author interview with Davies, Toronto Film Festival, 2011.
38. Ibid.
39. Davies, in production notes for *The Deep Blue Sea.*
40. Ibid.
41. Terence Davies. 2011. *The Deep Blue Sea.* London: Nick Hearn.
42. J. Hoberman. 2012. "The Inner Light of Terence Davies," *New York Times,* March 23.
43. Author interview with Davies, Cannes Film Festival, May 2008.

3. TODD HAYNES

1. Wyatt (1993), has written the most thorough analysis of Haynes.
2. Ibid.
3. Kruger (1987:107–108).
4. For a discussion of the New Queer Cinema, see Levy (1999:chap. 12).
5. Anderson (1992).
6. Author interview with Jennie Livingston, Toronto Film Festival, September 12, 1992.
7. McKenna (1994).
8. Ibid.
9. Levy (1999).
10. Anderson (1992).
11. Wyatt (2011).
12. Jennings (2011).
13. Vaughn (1998:18).
14. Although *Homo* is partially inspired by Genet's *The Miracle of the Rose,* Haynes has also acknowledged the influence of two other Genet novels, *Our Lady of the Flowers* and *The Thief's Journal.*
15. For a good analysis of the film, see Jane Giles. 1991. *The Cinema of Jean Genet: Un chant d'amour.*
16. Jonathon Green and Nicholas J. Karolides, eds. 1990. *Encyclopedia of Censorship.* New York.
17. Ibid.
18. James (1991).
19. Hoberman (1991).
20. Wilmington (1991).
21. Author interview with Todd Haynes, HFPA, Los Angeles, June 1, 1995.
22. Sterritt (1995).
23. Manohla Dargis. "Endangered Zone: With *Safe* Director Todd Hayness Declares His True Independence." *Village Voice,* July 4, 1995.
24. Wyatt (1993).

25. Ibid.
26. Grossman (2005).
27. Next to *Far from Heaven*, *Safe* is Haynes's most critically acclaimed film, currently holding an 84 percent approval rating on the Rotten Tomatoes website.
28. Luis Buñuel has served as an influential figure for Almodóvar in terms of surreal and irrational narratives and for Haynes, who borrowed the idea of different actors playing the same part from the Buñuel's 1974 *The Phantom of Liberty*.
29. Author interview with Haynes, HFPA, New York, March 2011.
30. Ibid.
31. Ibid.
32. Ibid.
33. Author interview with Kate Winslet, HFPA, New York, March 2011.
34. Author interview with Haynes.
35. Haynes, in production notes for *Mildred Pierce*.

4. GUS VAN SANT

1. Hofler (1998).
2. Ibid.
3. Author interview with Van Sant, Toronto Film Festival, September 10, 1991.
4. Graham Fuller. 1994. *Interview Magazine* (June).
5. Stempel (2000).
6. Parish (2000:112).
7. Ibid.
8. Hofler (1998).
9. Parish (2000:49).
10. Ibid., 165.
11. Handelman (1991).
12. Fuller (1994).
13. Parish (2000:165).
14. Kristin McKenna (1989). *Los Angeles Times*, December 7.
15. Hoberman (1989).
16. Hofler (1998).
17. Parish (2000:56).
18. Pauline Kael. 1989. *New Yorker*, October 30.
19. Peter Rainer. 1989. *Los Angeles Times*, December 1.
20. Hinson (1990).
21. David Ansen. 1989. "Drugstore Cowboy." *Newsweek*, October 23.

22. Peter Travers. 1989. "Drugstore Cowboy." *Rolling Stone*, October 19.
23. Fuller, Interview with Van Sant, My Own Private Idaho (1993).
24. Paris (2000).
25. Ibid.
26. Paul Andrews. 1990. *Seattle Times*, September 9.
27. Kael (1989).
28. Author interview with Van Sant, Toronto Film Festival, September 8, 1989.
29. Terrence Rafferty. 1991. *New Yorker*, October 7.
30. Fuller (1993).
31. Ibid.
32. Interview with Van Sant, *Premiere Magazine*, October 1991.
33. Fuller (1993).
34. Parish (2000).
35. Fuller (1993).
36. Limitations of space do not permit me to discuss those features.
37. Hartl (1995).
38. John Powers. 1995. "To Die For." *Vogue*, September.
39. Ibid.
40. Janet Maslin. 1995. "To Die For." *New York Times*, September 27.
41. Emanuel Levy. 1997. "Good Will Hunting." *Daily Variety*, December 11.
42. Author interview with Gus Van Sant, HFPA, Los Angeles, November 29, 2000.
43. Emanuel Levy. 2000. "Finding Forrester." *Daily Variety*, December 15.
44. Author Interview with Van Sant, Locarno Film Festival, August 7, 2002.
45. Chautard (2003).
46. Author interview with Harris Savides, Los Angeles, August 6, 2009.
47. Adams (2008).
48. Author interview with Van Sant, Cannes Film Festival, May 2005.
49. Adams (2008).
50. It took Van Sant a whole decade after the death of Cobain, who was found dead at his Washington home on April 8, 1994, to come to terms with this painful event and make a film about it.
51. Sam Adams. 2008. Los Angeles Times, March 9.
52. For a good discussion of the documentary, see Levy (1999:chap. 12).
53. Justin Chang. 2011. "Restless." *Daily Variety*, May 13.
54. Matt Damon appears in a small part in *Finding Forrester*.
55. Author Interview with Van Sant, HFPA, New York, December 10, 2012.
56. Ibid.
57. D. K. Holmes. 1989. "Gus Van Sant." *Pacific Northwest*, August.
58. Adams (2008).
59. Ibid.

5. JOHN WATERS

1. Levy (1999).
2. Frank DeCaro. 1994. "Diving in New Waters." *Newsday*, April 11.
3. Crow (1994).
4. Waters, quoted in Ives (1992:15).
5. Crow (1994).
6. Waters (1995:27).
7. MacDonald (1982).
8. Ives (1992).
9. *Time Out New York*, April 1997.
10. James Egan. 2011. "Where Will John Waters Be Buried, March 9, 2010." In *John Waters Interviews*, ed. James Egan. Jackson: University Press of Mississippi.
11. Shulman (2009).
12. Michael Franco. 2007. "Love and Frogs: Dating John Waters." *PopMatters*, February 14.
13. Waters (2005).
14. Goldstein (1988).
15. Pela (2002).
16. "John Waters Interviews Little Richard." 2010. *The Guardian*, November 28.
17. Ibid.
18. Goldstein (1988).
19. Fields and Lebowitz (1973).
20. Ibid.
21. MacDonald (1982).
22. Ives (1992).
23. Peary (1997).
24. Ives (1992).
25. Ibid.
26. Ibid.
27. Pela (2002).
28. Ibid.
29. Fields and Lebowitz (1973).
30. Ibid.
31. Waters's commentary in the documentary *I Am Divine.*
32. Ives (1992)
33. Postel (1977).
34. Ibid.
35. Ives (1992).
36. Hoberman and Rosenbaum (1991).
37. Levy (1999).

38. Ibid.
39. Crow (1994).
40. MacDonald (1982)
41. Sontag (1966).
42. Van Leer (1995).
43. Klinger (1994).
44. Eco (1984).
45. Ibid.
46. Levy (1999)
47. Chute (1981)
48. Rex Reed, quoted in Levy (1999).
49. Michael Musto. *Village Voice.*
50. Janet Maslin. 1977. "Desperate Living." *New York Times*, October 15.
51. Waters (2005).
52. Postel (1977)
53. Author Interview, HFPA, Los Angeles, July 27, 2000.
54. MacDonald (1982).
55. Peary (1997).
56. Goldstein (1988).
57. Ibid.
58. Ibid.
59. James Grant. 1994. "He Really Can't Help Himself." *Los Angeles Times*, April 10, 1994.
60. Brooks (1982).
61. Roger Ebert. 1998. "Pecker." *Chicago Sun-Times.* September 25.
62. Peter Stack. 1998. "Pecker." *San Francisco Chronicle.* September 25.
63. Roger Ebert. 2004. "A Dirty Shame," *Chicago Sun-Times*, September 24.
64. Waters's comments for different DVD versions of *Cecil B. Demented.*
65. Michael Franco. 2007. "Love and Frogs," PopMatters.com.
66. Author interview with John Waters. 2003. Provincetown, MA, June 19.
67. Ibid.
68. DeCaro (1994).
69. Luaine Lee. 1994. "John Waters Weirdness Runs Deep." *Daily News*, April 12.
70. Tasker (2011).
71. Ives (1992).
72. Nina Metz. 2010. "John Waters Loves Christmas," *Chicago Tribune*, December 3.

CONCLUSION

1. Personal conversation with noted Canadian film critic Robin Wood, who has discussed this aspect in his work.

2. Author interview with Almodóvar, Hollywood Foreign Press Association (HFPA), Los Angeles, October 19, 2004.
3. Postel (1977).
4. Mackenzie (2002).
5. See Hanson (1999).
6. Sarris (1968).
7. Author interview with Almodóvar, HFPA, Los Angeles, September 29, 1999.
8. Author interview with Van Sant, HFPA, Los Angeles, August 1, 2003.
9. Clarke (2011).
10. Ibid.
11. Author interview with Almodóvar, HFPA, Los Angeles, September 29, 1999.
12. Rouyer and Vie (1988).
13. Parish (2000:149).
14. Ibid.
15. Ibid., 151.
16. Anneke Smelik. 1998. "Queer Studies." In *Oxford Guide to Film Studies*. New York: Oxford University Press.
17. Wyatt (2011).
18. Wyatt (1993).
19. Author interview with Almodóvar, HFPA, Los Angeles, October 19, 2004.
20. Author interview with Almodóvar, HFPA, Los Angeles, September 19, 2006.
21. Parish (2000).
22. Kinder (1988).
23. Author interview with Almodóvar, HFPA, Los Angeles, October 19, 2004.
24. Celestine Bohlen (1998), in a *New York Times* interview with Pedro Almodóvar.

SELECT BIBLIOGRAPHY

Adams, Sam. 2008. "Cautiously Eyeing the Mainstream." *Los Angeles Times*, March 9.

Alberich, Enrique, and Luis Aller. 2004. "Pedro Almodóvar: Cinema in Evolution." In *Pedro Almodóvar Interviews*, ed. Paula Willoquet-Maricondi, 26–31. Jackson: University Press of Mississippi.

Allinson, Mark. 2001. *A Spanish Labyrinth: The Films of Pedro Almodóvar*. London: I. B. Tauris.

Almodóvar, Pedro. 1992. *The Patti Diphusa Stories and Other Writings*, trans. Kirk Anderson. London: Faber & Faber.

——. 1996. *Women on the Verge of a Nervous Breakdown*. London: BFI.

——. 1997. *The Flower of My Secret*. London: BFI.

Allon, Yoram, Del Cullen, and Hannah Patterson, eds. 2001. *Contemporary North American Directors*. London: Wallflower.

Anderson, John. 1992. "Out There Struggling." *Los Angeles Times*, August 23.

Appleford, Steve. 2007. "This Filthy World." *Los Angeles CityBeat*, October 11.

Arroyo, Jose. 1992. "La ley del deseo: A Gay Seduction." In *Popular European Cinema*, ed. Richard Dyer and Ginnette Vincendeau, 31–46. London: Routledge.

——. 1996. "The Auteur and the National Cinema." *Tesserae* 2, no. 2: 269–274.

——. 1998. "Live Flesh." *Sight and Sound* (May).

——. 1999. "All About My Mother." *Sight and Sound* (September).

——. 2011. "Pedro Almodóvar." In *Fifty Contemporary Film Directors*, ed. Yvonne Tasker. London: Routledge.

Atwell, Lee. 1979. "Word Is Out and Gay U.S.A." *Film Quarterly* 32, 2: 17–25.

Aufderheide, Pat. 1990. "The Domestication of John Waters." *American Film* 15, no. 7 (April): 32–37.

Barrios, Richard. 2003. *Screened Out: Playing Gay in Hollywood from Edison to Stone Wall*. New York: Routledge.

Bennetts, Leslie. 1982. "The New Realism in Portraying Homosexuals." *New York Times*, February 21.

Berube, Allan. 1990. *Coming Out Under Fire: The History of Gay Men and Women in World War Two*. New York: Free Press.

Besas, Peter. 1985. *Behind the Spanish Lens: Spanish Cinema Under Fascism and Democracy*. Denver: Arden Press.

Bloom, Harold. 1997. *Anxiety of Influence: A Theory of Poetry*. New York: Oxford University Press.

Bohlen, Celestine. 1998. "Pedro Almodóvar: Spain's Freest Spirit Gives Maturity a Try." *New York Times*, January 18.

Branigan, Edward. 1992. *Narrative Comprehension in Film*. New York: Routledge.

Bronskie, Michael. 1984. *Culture Clash: The Making of Gay Sensibility*. Boston: South End Press.

Brooks, Claude Thomas. 1982. "Waters: '... I've Always Tried to Sell Out.'" *In Motion Film and Video Production Magazine*: 20–23.

Burston, Paul. 1993. "Gender Bender." *Time Out London*: 2–9.

Butler, Judith. 1993. *Bodies That Matter: On the Discursive Limits of Sex*. New York: Routledge.

Canby, Vincent. 1991. "Poison." *New York Times*, April 5.

Carroll, Kathleen. 1991. "Poison." *New York Daily News*, April 5.

Castellet, George Cabello, Juame Marti-Olivella, and Guy H. Wood, eds. 1995. *Cine-Lit II: Essays on Hispanic Film and Fiction*. Portland, OR: Portland State University.

Caughie, John. 1992. "Becoming European: Art Cinema, Irony and Identity." In *Screening Europe: Image and Identity in Contemporary European Cinema*, ed. Duncan Petrie, 32–44. London: BFI.

Chauncey, George. 1993. *Gay New York: Gender, Urban Culture and the Making of the Gay Male World, 1890–1940*. New York: Basic Books.

Chautard, Andre. 2003. "Shooting Without Answers." *Los Angeles Times*, October 19.

Chua, Lawrence. 1989. "I Love My Dead Gay Son." *Village Voice*, December 5.

Chute, David. 1981. "Still Waters." *Film Comment*. 26–32.

Clark, Tim. 1988. "Pedro Almodóvar: Desperado Living." *Time Out* xx (November): 58–61.

Clarke, Donald. 2011. "Interview with Terence Davies." *Irish Times*, November 25.

Cook, Pam, and Philip Dodd, eds. 1993. *Women and Film: A Sight and Sound Reader*. London: Scarlet.

Cooper, Dennis. 2004. "John Waters." *BOMB Magazine*, no. 87 (Spring): 22–29.

Corber, Robert J. 1996. *In the Name of Social Security: Hitchcock, Homophobia and the Political Construction of Gender in Postwar America*. Durham, NC: Duke University Press.

Corber, Robert J., and Stephen Valocchi, eds. 2003. *Queer Studies: An Interdisciplinary Reader*. Malden, MA: Blackwell.

Corrigan, Timothy. 1991. *A Cinema Without Walls*. New Brunswick, NJ: Rutgers University Press.

Creekmur, Corey K., and Alexander Doty, eds. 1995. *Out in Culture*. Durham, NC: Duke University Press.

Crow, Tom. 1994. "A Face Only a Serial Mom Could Love." *Los Angeles Village View*, April 14.

Dargis, Manohla. 1995. "Endangered Zone: With *Safe* Director Todd Haynes Declares his True Independence. *Village Voice*, July 4.

Davies, Terence. 2011. *The Deep Blue Sea*. London: Nick Hearn.

De Lauretis, Teresa. 1988. "Sexual Indifference and Lesbian Representation." *Theater Journal* 40 (May).

——. 1991. "Queer Theory: Lesbian and Gay Sexualities—An Introduction." *Difference* 3, no. 2.

Deleyto, Celestino. 1995. "Postmodernism and Parody in Pedro Almodóvar's Mujeres al borde de un ataque de nervios." *Forum for Modern Language Studies* 31, no. 1: 49–63.

D'Émilio, John. 1983. *Sexual Politics, Sexual Communities*.

Denby, David. 2004. "In and Out of Love," *The New Yorker*, November 22: 84–89.

Denby, David. 2012. "The Deep Blue Sea." *The New Yorker,* March 26: 79–80.

D'Lugo, Marvin. 1991. "Almodóvar's City of Desire." *Quarterly Review of Film and Video* 13, no. 4: 47–65.

——. 1991. *The Films of Carlos Saura*. Princeton, NJ: Princeton University P ress.

Donapetry, Maria. 1999. "Once a Catholic: Almodóvar's Religious Reflections." *Bulletin of Hispanic Studies* 76: 67–75.

Doph, Dennis. 1990. "Inside Gus." *New York Native*, February 12.

Doty, Alexander. 1998. "Queer Theory." In *The Oxford Guide to Film Studies*, ed. John Hill and Pamela Church Gibson, 146–150. New York: Oxford University Press.

Duggan, Lisa. 1992. "Making It Perfectly Queer." *Socialist Review* 22, no. 1: 11–32.

Dyer, Richard. 1990. *Now You See It: Studies on Lesbian and Gay Film*. New York: Routledge.

Dyer, Richard, and Ginnette Vincendeau, eds. 1992. *Popular European Cinema*. London: Routledge.

Eco, Umberto. 1984. "Casablanca: Cult Movies and Intertextual Collage." *SubStance*, 14, no. 2: 3–12.

Edwards, Gwyne. 2001. *Almodóvar: Labyrinths of Passion*. London: Peter Owen.

Egan, James, ed. 2011. *John Waters: Interviews*. Jackson: University Press of Mississippi.

Elder, Robert K. 2011. *The Film That Changed My Life*. Chicago: Chicago Review Press.

Ellis, Jim. 2007. *Encyclopedia of Gay, Lesbian, Bisexuals, Transgender*.

Eng, David. 1995. "Fractured by Voices: Technologies of Gender in Pedro Almodóvar's Mujeres al borde de un ataque de nervios." In *Cine-Lit II: Essays*

on Hispanic Film and Fiction, ed. George Cabello Castellet, Juame Marti-Olivella, and Guy H. Wood, 146–154. Portland, OR: Portland State University.

Epps, Brad, and Despina Kakoudaki, eds. 2009. *All About Almodóvar*. Minneapolis: University of Minnesota Press.

Evans, Peter. 1993. "Almodóvar's Matador: Genre, Subjectivity, and Desire." *Bulletin of Hispanic Studies*.

Fields, Danny, and Fran Lebowitz. 1973. "Pink Flamingos & the Filthiest People Alive." *Interview* (May): 14–15, 40–41.

Fischer, Lucy, ed. 1991. *Imitation of Life*. New Brunswick, NJ: Rutgers University Press.

Fox, David J. 1990. "They Found Out How Tough a Sell AIDS Really Is." *Los Angeles Times*, May 13.

Francia, Juan I., and Julio Perez Perucha. 1981. "First Film: Pedro Almodóvar." *Contracampo* 18 (September).

Fuss, Diana, ed. 1991. *Inside/Out: Lesbian Theories, Gay Theories*. London: Routledge.

Gaiman, Neil, and Kim Newman. 1985. *Ghastly Beyond Belief*. New York: Arrow.

George, Bill, and Martin Falck. 1974. "The Late Show Presents the Divine World of John Waters." *The Late Show*.

Gever, Martha, Parmar Pratibaha, and John Greyson. 1993. *Queer Looks: Perspectives on Lesbian and Gay Film and Video*. New York: Routledge.

Glatt, John. 1995. *Lost in Hollywood: The Fast Times and Short Life of River Phoenix*. New York: Primus.

Gledhill, Christine. 1987. *Home Is Where the Heart Is: Studies in Melodrama and the Woman's Film*. London: Routledge.

Gold, Richard. 1989. "Van Sant's Hard Sell." *Variety Weekly*, October 11.

Goldstein, Patrick. 1988. "Director John Waters Teases 'Hairspray.'" *Los Angeles Times*, February 25.

Goldstein, Richard. 2002. *The Attack Queer*, London: Routledge.

Grant, James. 1994. "He Really Can't Help Himself." *Los Angeles Times*, April 10.

Green, Jonathon and Nicholas J. Karolides. 2005. *Encyclopedia of Censorship*. New York: Facts on File.

Grossman, Julie. 2005. "The Trouble with Carol: The Costs of Feeling Good in Todd Haynes's *Safe* and the American Cultural Landscape." *Other Voices* 2, no. 3.

Hall, Stuart. 1992. "European Cinema on the Verge of a Nervous Breakdown." In *Screening Europe: Image and Identity in Contemporary European Cinema*, ed. Duncan Petrie, 15–53. London: BFI.

Handelman, David. 1991. "Northwest Passage." *Rolling Stone* (October 31).

——. 1997. "Auteurs Turned Authors." *Harper's Bazaar* (October).

Hanson, Ellis, ed. 1999. *Out Takes: Essays on Queer Theory and Film*. Durham, NC: Duke University Press.

Harguindey, Angel S. 1984. "Pedro Almodóvar: Grab the Fame and Run." *El Pais*, September.

Hart, Lynda. 1994. *Fatal Women: Lesbian Sexuality and the Mark of Aggression.* Princeton, NJ: Princeton University Press.

Hartl, John. 1995. "Gus Van Sant: Exploring New Territory." *Seattle Times*, October 5.

Hattenstone, Simon. 2006. "Bigmouth Speaks Again," *The Guardian*, October 20.

Haynes, Todd. 1998. *Velvet Goldmine*. New York: Hyperion Books.

Heath, Steven. 1981. *Questions of Cinema*. Bloomington: Indiana University Press.

Henderson, Jonathan. 2011. "Children, Madonna & Child, Death & Configuration." *Cinelogue*, January 25.

Higginbotham, Virginia. 1988. *Spanish Film Under Franco*. Austin: University of Texas Press.

Hinson, Hal. 1989. "Drugstore Cowboy." *Washington Post*, October 27.

——. 1990. "Mala Noche." *Washington Post*, June 15.

Hirschenberg, Lynn. 2004. "The Redeemer," *New York Times Magazine*, September 5.

Hoberman, J. 1989. "Drugstore Cowboy." *Village Voice*, October 10.

——. 1991. "Independents: Poison." *Premiere* (February).

——. 2012. "The Inner Light of Terence Davies." *New York Times*, March 23.

Hoberman, J., and Jonathan Rosenbaum. 1991. *Midnight Movies*. New York: Da Capo.

Hochman, David. 1995. "Gus Van Sant: Q&A." *US Magazine* (November).

Hofler, Robert. 1998. "Good Will Hunting." *The Advocate* (March 31): 15–19.

Holmes, D. K. 1991. "All About Gus." *Willamette Week*, November 10.

Hopewell, John. 1986. *Out of the Past: Spanish Cinema After Franco*. London: BFI.

——. 1991. "Art and a Lack of Money: The Crisis of the Spanish Film Industry." *Quarterly Review of Film and Video* 13, no. 4: 113–122.

Huston, Johnny Ray. 2008. "Miserable to be Gay," *San Francisco Bay Guardian*, February 20.

Ives, John G. 1992. *John Waters*. New York: Thunder's Mouth Press.

James, Caryn. 1991. "Politics Nurtures Poison." *New York Times*, April 14.

James, Nick. 1998. "American Voyeur." *Sight and Sound* (September): 8–10.

Jay, Bernard. 1993. *Not Simply Divine!* London: Virgin Books.

Jeffries, Stuart. 2011. "Terence Davies: Follow Your Hormones," *The Guardian*, November 11.

Jennings, Ros. 2011. "Making Movies That Matter: Christine Vachon, Independent Film Producer." In *Fifty Contemporary Film Directors,* ed. Yvonne Tasker, 353–361. London: Routledge.

Kennedy, Lisa. 1989. "Lianna Massey Eats Pussy." *Village Voice*, December 5.

Kinder, Marsha. 1987. "Pleasure and the New Spanish Mentality: A Conversation with Pedro Almodóvar." *Film Quarterly* 41, no. 1 (Fall): 33–44.

——, ed. 1997. *Refiguring Spain: Cinema/Media/Representation*. Durham, NC: Duke University Press.

——. 2009. "All About the Brothers." In *All About Almodóvar*, ed. Brad Epps and Despina Kakoudaki, 267–294. Minneapolis: University of Minnesota Press.

Klinger, Barbara. 1994. *Melodrama and Meaning: History, Culture, and the Films of Douglas Sirk*. Bloomington: Indiana University Press.

Koestenbaum, Wayne. 1993. *The Queen's Throat: Opera, Homosexuality and the Mystery of Desire*. New York: Simon and Schuster.

Kruger, B. 1987. "Into Thin Air: Karen Carpenter Superstar." *Artforum* 26, no. 4: 31–37.

Kuryla, Mary, and Holly Willis. 1994. "Brisky Business." *Moving Pictures*, May 13.

Lally, Kevin. 1988. "Hairspray Gets a Shocking PG as Waters Looks Back to 1962." *Film Journal* (February–March).

Laskawy, L. 1991. "Poison at the Box Office: An Interview with Todd Haynes." *Cineaste* 18, 38–39.

Lehman, Peter. 1994. *Running Scared: Masculinity and the Representation of the Male Body*. Philadelphia: Temple University Press.

Leroy, J. T. 2000. "What Price Hollywood?" *Filmmaker Magazine* (Summer).

Levy, Emanuel. 1994. *George Cukor: Master of Elegance*. New York: William Morrow.

——. 1999. *Cinema of Outsiders: The Rise of American Independent Film*. New York: New York University Press.

——. 2003. *All About Oscar: The History and Politics of the Academy Awards*. New York: Continuum International.

——. 2009. *Vincente Minnelli: Hollywood's Dark Dreamer*. New York: St. Martin's.

Llauradó, Anna. 1983. "Interview with Pedro Almodóvar: Dark Habits." *Dirigido por* 108 (October): 17–25.

MacDonald, Scott. 1982. "John Waters' Divine Comedy." *Artforum* (January): 52–60.

Mackenzie, Suzie. 2002. "All About My Father." *The Guardian*, August 17.

Mayne, Judith. 1993. *Cinema and Spectatorship*. New York: Routledge.

McCourt, James. 2003. *Queer Street: Rise and Fall of an American Culture, 1947–1985*.

McKenna, Kristine. 1994. "Crossover Hopes: Can 'Fish' and 'Priscilla' Find the Mainstream?" *Los Angeles Times*, July 10.

Merck, Mandy. 1993. "Lianna and the Lesbians of Art Cinema." In *Perversions: Deviant Readings*, 162–176. London: Routledge.

Meyer, Morris. 1994. *The Politics and Poetics of Camp*. London: Routledge.

Meyer, Thomas J. "Gus Van Sant," *New York Times Magazine*, September 5, 1991.

Milstead, Frances, Kevin Heffernan, and Steve Yeager. 2001. *My Son Divine*. New York: Alyson.

Montano, Alicia G. 1999. "Almost All About Almodóvar." *Fotogramas & Video* (May): 88–95.

Mulvey, Laura. 1975. "Visual Pleasure and Narrative Cinema." *Screen* 16, no. 3: 6–18.

——. 1987. "Notes on Sirk and Melodrama." In *Home Is Where the Heart Is: Studies in Melodrama and the Woman's Film*, ed. Christine Gledhill. London: BFI.

——. 1989. *Visual and Other Pleasures*. Bloomington: Indiana University Press.

Mundy, John. 2006. "Singing Detected: Blackpool and the Strange Case of the Missing Television Musical Dramas." *Journal of British Cinema and Television* 3, no. 1: 59–71.

Nandorfy, Martha J. 1993. "Tie Me Up! Tie Me Down!: Subverting the Glazed Gaze of American Melodrama and Film Theory." *Cineaction* 31 (Spring–Summer): 39–45

Natale, Richard. 1993. "AIDS as Metaphor." *Los Angeles Weekly*, August 16.

Nevils, Rene Pol, and Deborah George Hardy. 2001. *Ignatius Rising*. Baton Rouge: Louisiana State University Press.

Noh, David. 1996. "Almodóvar's Secret." In Paula Willoquet-Maricondi, ed., *Pedro Almodóvar Interviews*, 119–125.

O'Neill, E. 1994. "Poison-ous Queers: Violence and Social Order." *Spectator* 15, no. 1: 9–29.

Pacheko, Patrick. 1995. "The Sound of Two Men Kissing." *Los Angeles Times*, July 30.

Padva, Gilad. 2014. "Claiming Lost Gay Youth, Embracing Femininostalgia: Todd Haynes's *Dottie Gets Spanked* and *Velvet Goldmine*." In *Queer Nostalgia in Cinema and Pop Culture*, 72–97. London: Palgrave Macmillan.

Pally, Marcia. 1990. "The Politics of Passion: Pedro Almodóvar and the Camp Esthetic." *Cineaste* 18, no. 1: 81–91.

Parish, James Robert. 1993. *Gays and Lesbians in Mainstream Cinema*. Jefferson, NC: McFarland.

——. 2000. *Gus Van Sant: An Unauthorized Biography*. New York: Thunder's Mouth Press.

Peary, Gerald. 1997. "John Waters in Baltimore." *Provincetown Arts Magazine*.

Pela, Robert. 2002. *Filthy: The Weird World of John Waters*. New York: Alyson.

Petrie, Duncan J, ed. 1992. *Screening Europe: Image and Identity in Contemporary European Cinema*. London: BFI.

Postel, Louis. 1977. "An Interview with John Waters." *Provincetown Magazine*.

Preston, Paul. 1986. *The Triumph of Democracy in Spain*. London: Routledge.

Quart, Leonard. 2009. "Remembering Liverpool: Of Time and the City." *Cineaste* 34, no. 2: 37–45.

Rich, B. Ruby. 1992. "A Queer Sensation." *Village Voice*, March 24.

——. 2013. *New Queer Cinema*. Durham, NC: Duke University Press.

Riemenschneider, Chris. 1995. "Just Another Girl-Gets-Girl Story." *Los Angeles Times*, June 25.

Roddick, Nick. 2008. "The King of Cannes," *London Evening Standard*, May 23.

Roen, Paul. 1994. *High Camp*. San Francisco: Leyland.

Rosenbaum, Jonathan. 1989. "Distant Voices, Still Lives," *Chicago Reader,* August 18.

Rothman, Cliff. 1998. "Playing Straight with Gays." *Los Angeles Times*, April 19.

Rouyer, Philippe, and Claudine Vie. 1988. "Interview with Pedro Almodóvar." *Positif* 327.

Russo, Vito. 1981. *The Celluloid Closet: Homosexuality in the Movies*. New York: Harper and Row.

——. 1988. "Man of la Mania: Spanish Director Pedro Almodóvar." *Film Comment* 24, no. 6 (November–December).

——. 2012. *Out Spoken: The Vito Russo Reader—Reel One* and *Reel Two*. 2 vols. New York: White Crane Books.

Sarris, Andrew. 1968. *The American Cinema: Directors and Directions*. New York: Da Capo.

Savage, J. 1991. "Tasteful Tales." *Sight and Sound* (October): 15–17.

Schnabel, Julian. 1992. "Interview with Pedro Almodóvar: High Heels." *Interview* (January): 92–96.

Scott, A. O. 2002. "The Track of a Teardrop, a Filmmaker's Path." *New York Times*, November 17.

Sedgwick, Eve Kosofsky. 1993. *Tendencies*. Durham, NC: Duke University Press.

Segal, Lynne, and Mary McIntosh, eds. 1992. *Sex Exposed: Sexuality and the Pornographic Debate*. New Brunswick, NJ: Rutgers University Press.

Shulman, Randy. 2009. "Waters World." *Metro Weekly*, December 3.

Smelik, Anneke. 1998. "Gay and Lesbian Criticism." In *The Oxford Guide to Film Studies*, ed. John Hill and Pamela Church Gibson, 135–147. New York: Oxford University Press.

Smith, Paul Julian. 1992. *Laws of Desire: Questions of Homosexuality in Spanish Literature and Film, 1960–1990*. New York: Oxford University Press.

——. 1994. *Desire Unlimited: The Cinema of Pedro Almodóvar*. London: Verso.

——. 1997. "Pornography, Masculinity, Homosexuality." In *Refiguring Spain: Cinema/Media/Representation*, ed. Marsha Kinder, 178–195. Durham, NC: Duke University Press.

Sontag, Susan. 1966. "Notes on Camp." In *Against Interpretation and Other Essays*. New York: Farrar, Straus and Giroux.

Stabiner, Karen. 1982. "Tapping the Homosexual Market." *New York Times Magazine*, May 2.

Stempel, Penny. 2000. *River Phoenix: They Died Too Young*. Philadelphia: Chelsea House.

Stephens, Chuck. 1995. "Gentlemen Prefer Haynes." *Film Comment* (July–August): 21–29.

Sterritt, David. 1995. "Director Avoids 'Safe' Route with New Movie." *Christian Science Monitor*, July 25.

Stevenson, Jack. 1996. *Desperate Visions: The Films of John Waters and the Kuchar Brothers*. London: Creation.

Straayer, Chris. 1996. *Deviant Eyes, Deviant Bodies: Sexual Re-Orientation in Film and Video*. New York: Columbia University Press.

Strauss, Frederick. 2006. *Almodóvar on Almodóvar*. London: Faber and Faber.

Studlar, Gaylyn. 1987. "Midnight S/Excess: Cult Configurations of 'Femininity,' and the Perverse." In *The Cult Film Experience*, ed. J. P. Telotte. Austin: University of Texas Press.

Talens, Jenaro, and Santos Zunzunegui, eds. 1998. *Modes of Representation in Spanish Cinema*. Minneapolis: University of Minnesota Press.

Tasker, Yvonne, ed. 2011. *Fifty Contemporary Film Directors*. London: Routledge.

Taylor, Clarke. 1986. "New Films Treat Gays as a Matter of Fact." *Chicago Tribune*, March 12.

Taylor, Ella. 1992. "Call Me Irresponsible." *Los Angeles Weekly*, August 21.

Telotte, J. P., ed. 1987. *The Cult Film Experience*. Austin: University of Texas Press.

Thompson, Anne. 1992. "Sophisticated Ladies." *Los Angeles Weekly*, September 24.

Thomson, David. 2010. *A Biographical Dictionary of Film*. New York: Knopf.

Thomson, David. 2007. "Sound and Fury: Terence Davies." *Sight and Sound* (April): 17–21.

Torres, Maruja. 1982. "Pedro Almodóvar: Life in a Bolero." *Fotogramas & Video* x (May): 9–14.

——. 1995. "Interview with Pedro Almodóvar: The Flower of My Secret." *El Pais*, September.

Triana Toribio, Nuria. 1996. "Almodóvar's Melodramatic Mise-en-Scène: Madrid as a Setting for Melodrama." *Bulletin of Hispanic Studies* 73, no. 2: 21–26.

Troyano, Ela. 1994. "Interview with Pedro Almodóvar: Kika." *BOMB Magazine* (Spring): 102–109.

Vachon, Christine. 2006. *A Killer's Life: How an Independent Film Producer Survives Deals and Disasters in Hollywood and Beyond*. New York: Simon and Schuster.

Vachon, Christine, and David Edelstein. 1998. *Shooting to Kill*. New York: Avon.

Van Leer, David. 1995. *The Queering of America*. New York: Routledge.

Van Sant, Gus. 1992. *108 Portraits*. Santa Fe, NM: Twin Palms.

——. 1993. *Even Cowgirls Get the Blues and My Own Private Idaho*. Boston: Faber and Faber.

——. 1997. *Pink*. New York: Anchor/Doubleday.

Vernon, Kathleen. 1993. "Melodrama Against Itself: Pedro Almodóvar's What Have I Done to Deserve This?" *Film Quarterly* 46, no. 3: 39–45.

Vernon, Kathleen, and Barbara Morris, eds. 1995. *Post-Franco, Postmodern: The Films of Pedro Almodóvar*. Westport, CT: Praeger.

Wallace, David. 2006. *Exiles in Hollywood*. Pompton Plains, NJ: Limelight Editions.

Warner, Michael, ed. 1993. *Fear of a Queer Planet*. Minneapolis: University of Minnesota Press.

Waters, John. 1981. *Role Models*. New York: Dell.

———. 1988. *Trash Trio: Three Screenplays of John Waters.* New York: Vintage.

———. (1987) 2003. *Crackpot: The Obsessions of John Waters.* Reprint, New York: Scribner.

———. (1981, 1995) 2005. *Shock Value: A Tasteful Book About Bad Taste.* Updated edition, New York: Thunder's Mouth Press.

Williams, Linda. 1991. *Hard Core: Power, Pleasure, and the Frenzy of the Invisible.* Berkeley: University of California Press.

Willoquet-Maricondi, Paula, ed. 2004. *Pedro Almodóvar Interviews.* Jackson: University Press of Mississippi.

Wilmington, Michael. 1991. "Poison." *Los Angeles Times*, May 17.

———. 1992. "Lust, Crime Unite Doomed Teen-Age Lovers in Swoon." *Los Angeles Times*, September 25.

Wright, Elizabeth, ed. 1992. *Feminism and Psychoanalysis: A Critical Dictionary.* New York: Oxford University Press.

Wyatt, Justin. 1993. "Cinematic/Sexual Transgression: An Interview with Todd Haynes." *Film Quarterly* 46, no. 3: 2–8.

———. 1998. *Poison.* Trowbridge, England: Flick Books.

———. 2011. "Todd Haynes." In *Fifty Contemporary Film Directors*, ed. Yvonne Tasker. London: Routledge.

Young, Jamie Painter. 2000. "Demented at Heart." *Backstage West*, August 3.

INDEX

8½, 50
20th Century-Fox, 135
21 Jump Street, 306
108 Portraits, 200
400 Blows, The, 297

Abraham, F. Murray, 243
Abril, Victoria, 56, 61
ACT-UP, 163
Act Up! 233
Adams, Jane, 263
Affleck, Ben, 236, 237, 330
Affleck, Casey, 234, 330
Age of Innocence, The, 141
Ages of Lulu, The, 60
AIDS, 38, 110, 163, 165, 178, 213, 220, 225, 232, 257, 258, 333, 334, 335
Aimee, Anouk, 191
Akerman, Chantal, 175, 246
Alberti, Maryse, 198
Aldrich, Robert, 298
Alice Doesn't Live Here Anymore, 193
Alice in Hollywood, 204

All About Eve, 80, 81
All About My Mother, xvii, 12, 31, 56, 76–83, 89, 93, 99, 100, 104, 105, 114, 295
All That Heaven Allows, 80, 157, 161, 186
Allen, Edward, 171
Allen, Woody, 1, 38, 108, 197
Almodóvar, Agustin, 6, 330
Almodóvar, Pedro, xvii, 1–117, 119, 120, 122, 129, 166, 180, 201, 202, 206, 219, 224, 229, 294, 295, 298, 325, 328
Altman, Robert, 38
Amadeus, 243
American Cinema: Directors and Directions, The (book), 327
American Heart, 312
American History X, 312
American Playhouse, 167
American Psycho, 268
amour fou, 46, 47, 61, 103, 105, 208
Andersen, Bibi, 43
Anderson, Gillian, 122, 123, 142, 144
Anderson, Lindsay, 155

Angelopoulos, Theo, 246, 247
Anger, Kenneth, 203, 273, 277
Anna Karenina, 154
Antichrist, 226
Antonioni, Michelangelo, 10, 64, 102, 330
Apartment, The, 9
Apparatus Productions, 162
Arden, Eve, 92
Arsenic and Old Lace, 94
Artisan Entertainment, 316
Ashbourne, Lorraine, 128
Ashby, Hal, 189
Ashcroft, Peggy, 151
Asphalt, Jungle, The, 51
Assassins: A Film Concerning Rimbaud, 162, 172
Atame! (Tie Me Up! Tie Me Down!), 54–60
Atkine, Feodor, 61
Austen, Jane, 329
Autumn Sonata, 62
Avenue, 212
Aviator, The, 193
Aykroyd, Dan
Azorin, Eloy, 77

Bad Education, 3, 5, 12, 23, 42, 47, 89–93, 95, 109
Badila, John, 309
Baez, Joan, 191
Bale, Christian, 180, 183, 191
Baltimore, Maryland, 269, 270
Banderas, Antonio, 11, 22, 36, 49, 54, 56, 110
Bannen, Ian, 133
Barber, Samuel, 157
Bard College, 162
Bardem, Javier, 72, 108
Bardot, Brigitte, 28
Barenholtz, Ben, 287
Barranco, Maria, 52
Basic Instinct, 166

Basketball Diaries, The, 213
Batman, 183
Bators, Steve, 302
Bausch, Pina, 83, 88
Beat Generation, 206, 268
Beatnik, 207
Beatles (Fab Four), 146
Beaton, Cecil, 26
Beatty, Warren, 41, 337
Beckett, Samuel, 246
Bell, Martin, 222
Belle de jour, 106
Bellissima, 101
Benning, James, 162
Benton, Thomas Hart, 140
Bergen, Candice, 54
Bergman, Ingmar, 273
Bergman, Ingrid, 62, 91
Berkeley, Busby, 289
Berlanga, Luis Garcia, 8
Berlin, Brigid, 311
Berlin Film Festival, 60
Bernal, Gael Garcia, 90, 93
Bertolucci, Bernardo, 10, 251
Bill and Ted's Excellent Adventure, 222, 227
Birds, The, 256
Bisset, Jacqueline, 54
Black, Dustin Lance, 257
Blackboard Jungle, 231
Blade Runner, 292
Blair, Selma, 317
Blake, William, 251
Blanchett, Cate, 189, 189, 197
Blood for Dracula, 221
Blood Wedding, 10, 80
Bloom, Harold, 339
Blue Jasmine, 197
Blue Velvet, 14
Bogart, Humphrey, 85
Boise, Idaho, 286
Bonnie and Clyde, 165
Bono, Sonny, 305

Bowie, David, 161
Boorman, John, 132–33, 223
Bottoms, Timothy, 248
Bound for Glory, 189
Bowie, David, 180
Bowling for Columbine, 248
Boxing Helena, 59
Boyle, Danny, 183
Boyz n the Hood, 220
B-Picture, 4, 56
Bracco, Lorraine, 229
Bradell, Maurice, 276
Brakhage, Stan, 162
Brando, Marlon, 219
Branigan, Edward, xv
Breakfast at Tiffany's, 91
Breaking the Waves, 238
Brecht, 246
Brel, Jacques, 43
Bresson, Robert, 246
Bride of Frankenstein, The, 174
Bridges, Jeff, 312
Brief Encounter, 157
Bringing Up Baby, 48
Broadbent, Jim, 158
Broken Embraces, 50, 103–9
Brolin, Josh, 260, 261
Brooks, Albert, 301
Brown, Barry, 276
Brown, Rob, 240, 244
Browning Version, The, 151
Brown University, 162
Bruce, Lenny, 301
Bryant, Anita, 260
Buddy Deane Show, 304, 305
Bunuel, Luis, 8–9, 12, 64, 189, 285, 327
Burroughs, William S. Jr., 204, 206,
 212, 215, 235, 268, 271
Burton, Tim, 307
Bush, George W., 257

Cafe Muller, 83
Cain, James M., 144, 160, 194, 193–7

Caine, Michael, 242
Caldwell Davis Ad Agency, 204
Callas, Maria, 273
Camara, Javier, 83, 114
Camp, 10–11, 288–90
Canalejas, Lina, 25
Cannes Film Festival, 121, 158, 201, 219,
 233, 246, 248, 250, 261, 266, 278
Canto, Toni, 78
Capote, Truman, 8, 80, 91, 278
Caravaggio, 165
Carax, Leos, 226
Carillo, Mari, 25
Carlisle, Anna, 294
Carmen, 10
Carne, Marcel, 92
Carol, 198
Caron, Leslie, 271
Carpenter, Karen, 161
Carpenter, Richard, 163
Carroll, Jim, 213
Casablanca, 85, 291
Cassavetes, John, 141
Castle, William, 311
Cat on a Hot Tin Roof, 6, 20
Catholic, 1, 3, 90, 122, 146, 148
Cecil B. Demented, 314–16
Celebration, The, 243
Celluloid Closet, The, xiii
Chang, Justin, 263
Chaplin, Charlie, 130, 246
Chaplin, Geraldine, 84
Chekhov, Anton, 146
Children, 123–4
Chimes at Midnight, 223
China Syndrome, 265
Chinatown, 101
Choose Me, 212
Christmas, 27, 125, 127, 270, 294
Christopher Street, New York, 287
Cinderella, 271
Cinema of Outsiders (book), 321
Citizen Kane, 104, 181, 190, 202

City of Night, 222
Civil War (Spanish), 13, 20
Clark, Larry, 213, 230
Clarke, Alan, 247
Clarkson, Patricia, 185
Cleaver, June, *308*
Close Encounters of the Third Kind, 46
Cobain, Kurt, 250, 251
Cobo, Eva, 36
Cobo, Yohana, 94
Coffey, Elizabeth, 296
Collette, Toni, 181
Columbine High School, 247-48
Conner, Bruce, 203
Connery, Sean, 240, 244
Cooeyate, Doug, 207
Coppola, Francis Ford, 214
Corman, Roger, 213
Corny Collins Show, 304
Cortes, Joaquin, 71
Crawford, Joan, 51, 81, 102, 194, 298
Cronenberg, David, 235
Cross, David, 192
Cruz, Penelope, 11, 72, 77, 94, 99, 103, 107, 108, 330
Cry-Baby, 305-308
Cukor, George, xiii, 26, 71, 102, 229, 330
Cult movie, 291-2
Cunningham, Merce, ix
Cunningham, Michael, 11
Curtis, Jackie, 276
Curtiz, Michael, 194

Daisy Kenyon, 144
Daldry, Stephen, 11, 197
Dali, Salvador, 7
Dallesandro, Joe, 226, 276-77, 290
Damon, Matt, 201, 236, 237, 239, 264, 330
Danner, Blythe, 152
Darien, Connecticut, 202, 218
Dark Habits, 5, 20, 25-29
Darling, Candy, 276

Davies, Terence, 3, 4, 5, 118-59, 287, 325, 328-29
Davis, Bette, 53, 82, 298
Davis, Viola, 185
Day, Doris, 125
Day-Lewis, Daniel, 127
Dean, James, 214
Death and Transfiguration, 123-24
Death Valley, California, 244, 245
De Beauvoir, Simone, 170
Dee, Sandra, 63, 187, 307
Deep Blue Sea, The, 119, 121, 143, 150-58
De Falla, Manuel, 10
Demme, Jonathan, 110
Deneuve, Catherine, 106
De Niro, Robert, 310
De Palma, Brian, 4
de Palma, Rosy, 54, 58, 63
Depp, Johnny, 307
Derek, Bo, 302
Desperado, 110
Desperate Living, 298-300
Deulen, Eric, 248
DeWitt, Rosemarie, 264
Diane Linklater Story, The, 282
DiCaprio, Leonardo, 213, 239
Dietrich, Marlene, 283
Dillon, Matt, 212, 214, 234, 330
Diner, 279
Dirty Shame, A, 269, 316-18
Discipline of D.E., The, 204
Distant Voices, Still Lives, 122, 126-34
Divine, 102, 274, 279, 283, 294, 298, 300, 304-5, 307, 308, 330
Do the Right Thing, 219, 220
Dolan, Xavier, 233
Dolce Vita, La, 46, 189
Donahue, Troy, 290, 307
Donna Reed Show, The, 308
Dorff, Stephen, 314
Dottie Gets Spanked, 172-73
Double Indemnity, 9, 37, 90, 194
Douglas, Ileana, 235

Douglas, Michael, 310
Down by Law, 212
Dreamers, The, 251
Dreamlanders, 273, 279
Driver, Minnie, 238
Drugstore Cowboy, 212–20
Duel in the Sun, 38
Duenas, Lola, 94, 107, 114
Dunaway, Faye, 101
Durang, Christopher, 26
Duras, Margueritte, 302
Durrenmatt, Friedrich, 91
Dylan, Bob, 161, 188, 192–93

Eastwood, Clint, 257
Easy Riders, 213
Eat Your Makeup, 274
Ebert, Roger, 313
Eco, Umberto, *291*
Educating Rita, 242
Edward II, 165
Edwards, Blake, 91
Edward Scissorhands, 307
Eggar, Samantha, 59
Eggers, Dave, *264*
Ekberg, Anita, 46
El amor brujo (*The Bewitched Love*),
 10
El pais, 22, 84
El Topo, 287
Elephant, xvii, 247–50
Elephant (BBC), 247
Elgin Theatre, 287
Eliot, T.S., 122, 146
Ellis, Bret Easton, 268
Ellsworth, Barry, 162
Emerald Forest, The, 223
Engels, Friedrich, 146
Epstein, Robert, 258
Erice, Victor, 48
Erin Brockovich, 265
Escoffier, Yves, 239
Even Cowgirls Get the Blues, 228–30

Eyes Without a Face, 109
Exterminating Angel, The, 285

Fabian, Alice, 191
Fairy tale, *111*
Fairy Queen, The, 83
Fannon, Kathy, 309
Far from Heaven, 31, 160, 183–88
Fassbinder, Rainer Werner, 1, 273
Faster, Pussycat! Kill! Kill!, 273
Feast, Michael, 181
Feldman, Andrea, 277
Fellini, Federico, 10, 46, 50, 64, 189, 273
Female Trouble, 293–96
Fernandez, Adolfo, 84
Ferrero, Jesus, 37
Figgs, George, 299
Fine Line, 230
Fire in the Bowels, 7
Fitzgerald, Ella, 129
Fitzpatrick, Leon, 231
Flaming Features, 275–76
Flaubert, Gustave, ix
Flesh, 276
Flesh for Frankenstein, 221
Flores, Rosario, 84
Flower of My Secret, The, 5, 6, 9, 12,
 54, 81
Focus Features, xvii, 184, 265
Fogle, James, 212
Folland, Alison, 234
Fonda, Peter, 213
Fontana de Trevi, 46
Ford, John, 223, 291
Foreign Language Film Oscar, xvii
Forque, Veronica, 31, 63
Forth, Jane, 277
Foster, Jodie, 237
Foucault, Michel, 332
Four Quartet, The, 122
Fox Searchlight, xvii
Franco (General), 9, 16, 331
Franco, James, 259

Frankenstein, 109, 112
Frears, Stephen, 118
Friedberg, Mark, 196
Friedman, Bob, 258
Frohnmayer, John E., 169
Frost, Alex, 248
Fuegos en las enranas (Fire in the Bowels), 7
Furlong, Edward, 312

Gainsbourg, Charlotte, 191
Galano, Cam, 221
Garbo, 102, 154
Gardner, Ava, 6, 64
Garfield, John, 195
Garland, Judy, 121
Garlington, Mary, 302
Garnett, Tay, 195
Gavin, John, 63
Gaynor, Gloria, 59
gazpacho, 53, 106
Genet, Jean, 168–72, 190, 246, 273, 295
George Cukor, Master of Elegance (book), *ix*
Gere, Richard, 189
Gerry, 244–47
Giant, 6
Gibson, Mel, 3
Ginsberg, Allen, 233
Girl Can't Help It, A, 14
Girls and Suitcases, 105
Glen or Glenda, 273
Godard, Jean-Luc, 10, 189
Go Fish, 164
Golden Globes, xvii
Gomez, Fernan, 8
Gomez, Jose Luis, 107
Gone with the Wind, 20, 139, 291
Graduate, The, 237
Graham, Heather, 214
Grease, 306
Great Expectations, 137
Greenwood, Bruce, 192

Griffith, Melanie, 110, 314–15
Guardian, The, 126
Guess Who's Coming to Dinner 217
Guillen, Fernando, 48
Guinness, Alec, 136
Gummo, 232, 239
Gun Crazy, 165
Guthrie, Woody, 190
Gyllenhaal, Maggie, 314

Hag in a Black Leather Jacket, 273
Hairspray, 303–5, 307
Hallellujah Now, 118
Hamer, 4
Hamilton, George, 33
Handel, George Frideric, 148
Hanks, Tom, 110, 166
Happiness, 263
Happy Go Lucky, 158
Happy Organ, The, 204
Hardcore, 223
Hardwicke, Catherine, 255
Harold and Maude, 262
Harry, Debbie, 305
Hart, John, 167,
Harvey, Rodney, 221
Hawkins, Sally, 158
Hawks, Howard, 4, 48, 291
Hay, Louise, 178
Hayden, Sterling, 51, 81
Haynes, Todd, xvi, 2, 4, 5, 119, 120, 129, 156, 160–99, 202, 206, 218, 305, 325
Haysbert, Dennis, 184
Hays Code, 165
Hayworth, Rita, 92
HBO, 160, 247, 249
Hearst, Patricia, 300, 306, 307, 311, 313
Heath, Steve, 21
Heche, Anne, 239
Hedaya, Dan, 235
Hedwig and the Angry Inch, 251
Heiress, The, 157
Hendersen, Sarah, 231

Henderson, Jonathan, 124
Henry, Buck, 237
Henry V, 223
Hepburn, Audrey, 91, 102, 106
Herranz, Miguel Angel, 31
Herrmann, Bernard, 90
High Heels, 61–64, 13
High Hopes, 146
Highsmith, Patricia, 197
Hill, Jean, 299
Hippie, 206
Hirsch, Emile, 260, 302
His Girl Friday, 48
Hitchcock, Alfred, 4, 9, 11, 12, 49, 90,
 102, 106, 165, 239–40, 256, 333
Hitler, Adolf, 132
HIV, 78, 198
Hoberman, Jim, 207
Hoffman, Dustin, 237
Holbrook, Hal, 264
Holden, Stephen, 141
Hold Me While I'm Naked, 278
Holden, William, 130
Holy Motors, 226
Homar, Lluis, 103
Home from the Hill, 33
Hollywood, 167, 196
Homophobia, 4, 167
Hope and Glory, 132–33
Hopkins, Miriam, 53
Hopper, Dennis, 213
Hopper, Edward, 140
Hopper, Henry, 262
Horsey, Lonnie, 309
Hours, The, 11, 188
House of Mirth, The, 119, 141–45
Houseman, A. E. *146*
Houston, Beverle, *162*
Howard, Bryce Dalla, 263
Howard, Ron, 263
Howards End, 141
Howl, 206, 233
Hudson, Rock, 186

Hughes, John, 219
Hulsey, Lauren, 312
Human Beast, The, 92
Human Voice, The, 48, 81
Hunt, Martita, 137
Hunter, Kim, 41
Hunter, Tab, 290, 301, 302, 303
Hunter, Tim, 253
Hurt, Mary Beth, 310

Idiots, The, 226
Iglesias, Alberto, *7*
I Love Lucy, 173
Imitation of Life, 62–63, 80, 81, 161, 184
I'm Not There, 161, 188–93
I'm So Excited, 12, 113–16
In the Name of the Father, 127
Irish, 147
Isaac, Chris, 317
I Spit on Your Grave, 273
I Will Survive, 59
Izzard, Eddie, 181

James, Henry, 144
Jamon Jamon, 72, 99
Jarmusch, Jim, *212*
Jarman, Derek, *165*
Jay and Silent Bob Strike Back, 237
*Jeanne Dielman: 23 Quai du Commerce
 1080 Bruxelles*, 175
Jewell of the Nile, The, 310
JFK, 166
Jodorowsky, Alejandro, 289
Joe, Turkey, 299
Johnny Guitar, 51, 81
Johnson, Celia, 157
Jones, Debi, 128
Jones, Jennifer, 38, 130
Joyce, James, 146
Junkies, 213

Kael, Pauline, 51, 219
Kafka, 228

Kaige, Chen, 328
Kalin, Tom, 164, 166
Kar-Wai, Wong, 10, 328
Keaton, Buster, 246
Keaton, Diane, 247
Kelly, Gene, 121
Keith, Penelope, 152
Kennedy, Jackie, 274
Kennedy, John F., 274
Kent State Massacre, 213
Kerouac, Jack, 206
Kerr, John, 31
Kiarostami, Abbas, 246
Kidman, Nicole, 233, 236
Kids, 213, 230–233
Kier, Udo, 221
Kieslowski, Krzysztof, 10, 106
Kika, 31, 64–68
Killing, The, 51
Kinder, Marsha, 4
King, Ken, 302
King of Comedy, 236, 310
Klinger, Barbara, 289
Knoxville, Johnny, 317, 320
Kohner, Susan, 63, 64, 187
Korine, Harmony, 232
Krasinski, John, 264
Kristofferson, Kris, 193
Kubrick, Stanley, 178
Kuchar brothers (George and Mike), 203, 273, 277
Ku Klux Klan, 140, 272

Labyrinth of Passion, 21–25, 86
Lacan, Jacques, xiv
Lachman, Ed, 188, 196, 197
La Comedia Madrilena, 7
Lady from Shanghai, The, 92
Ladykillers, The, 136
Lake, Ricki, 102, 303–4, 305, 308
La Mancha, Spain, 5, 97, 101
Lamont, Nicholas, 135
La Movida Madrilena, 7, 90, 330

Lampreave, Chus, 25, 97
Landscape in the Mist, 246
Lange, Hope, 295, 307
La rosa del azafran, 7
Last Tango in Paris, 38
Laura, 90
Law of Desire (La ley del deseo), 41–47, 50, 81, 89
Lean, David, 137, 157
Leave Her to Heaven, 90, 107
Leave It to Beaver, 301, 308
Ledger, Heath, 191
Lee, Peggy, 147, 148
Lee, Spike, 212, 214, 220
LeGros, James, 195, 214
Leigh, Janet, 239
Leigh, Mike, 118, 146
Leigh, Vivien, 41, 152, 154
Leisen, Mitchell, *xiii*
Leiter, Saul, 197
Lelouche, Claude, 191
Less than Zero, 219
Letter from an Unknown Woman, 157
Levinson, Barry, 279
Lew, Jason, 263
Lewis, Herschell Gordon, 273, 278, 311
Lewis, Jerry, 14, 123, 310
Life magazine, 270
Lightfield's Home Videos, 233
Lili, 271
Lillard, Matthew, 308
Limelight, 130
Lindstrom, Pia, 62
Line, Helga, 22
Linney, Laura, 142, 143
Liquid Sky, 294
Little Man Tate, 237
Liu, Dan, 254
Live Flesh, 72–76, 99
Liverpool, 121, 122, 145, 146, 147, 329
Living End, The, 164, 165
Livingston, Jennie, 164
Loach, Ken, 118

Locane, Amy, 306
Locarno Film Festival, 121
Lochary, David, 273, 279, 280, 284, 294, 298, 305
Loden, Barbara, 41
Lowe, Susan, 294
London, 180
Lonesome Cowboy, 276
Long Day Closes, The, 122, 126, 134–37
Longtime Companion, 167, 258
Lorca, Federico Garcia, 80, 81
Lords, Traci, 300, 306, 309, 311
Lords of Dogtown, 255
Loren, Sophia, 100
Loritz, Katia, 30
Los Angeles Film Critics Association (LAFCA), xvii, 243
Los Angeles Times, 248
Los Goliardos, 7
Lost in America, 301
Love, Courtney, 252
Love Is a Many Splendored Thing, 130
Love on the Run, 102
Lovers on the Bridge, 226
Loves of Ondine, The, 276
Love Story, 262
Lowe, Susan, 299
Lumet, Sidney, 235
Luna, Bigas, 48, 60, 99
Luna, Diego, 260
Lutherville, Maryland, 270, 279
Lynch, David, 1, 59, 215, 271, 336
Lynch, Jennifer, 59
Lynch, Kelly, 212, 214
Lynn, Michael, 287
Lynne, Sherry, 162
Lyons, James, 171, 198

McCormack, Leigh, 135
McDormand, Francis, 264
McGregor, Ewan, 180
McGuire, Kim, 306
McKinney, Luaren, 255

McNamara, Fabio, 19
MacMurray, Fred, 92, 194
Madonna and Child (short film), 123
Madonna and La Pietà, 45, 224, 226
Maelcum, Malcolm, 271
Magnani, Anna, 48, 81, 101
Magnificent Ambersons, The, 136, 137
Maguire, Vincent, 129
Mahler, Gustav, 148
Making Love, 166
Mala Noche, 165, 168, 206–12, 327, 333
Malone, Dorothy, 98
Man and a Woman, 191
Mansfield, Jayne, 14
Man Who Loved Women, The, 102
Marnie, 106
Marquez, Gabriel Garcia, 8
Martick's, 271
Martinez, Fele, 90
Martinez, Juan, 31
Martinez, Nacho, 36
Masculine Feminine, 189
Maslin, Janet, 236, 298
Massey, Edith, 279, 281, 284, 295, 298, 305
Masterpiece Theater, 142
Masurca Fogo, 88
Matador, 19, 23, 35–41, 50, 57, 110
Maura, Carmen, 11, 15, 16, 25, 30, 33, 41, 45, 48, 89, 97, 100, 102, 106, 309
Mawdsley, Phillip, 124
Mawra, Joseph P., 273
Maxwell, Larry, 170
Maynard, Joyce, 233
Meeks, Edith, 171
Meet Me in St. Louis, 121, 132
Mekas, Jonas, 203, 277
Melin, Marina, 274
Memento, 196
Mercer, Johnny, 129
Merchant-Ivory, 141
Method Acting, 227
Meyer, Russ, 278, 311

Meyers, Jonathan Rhys, 180
MGM, 121
Midnight Cowboy, 277
Mildred Pierce, 90, 92, 94, 144, 160,
 193–98
Miles, Sylvia, 277
Milk, 257–61
Miller, Arthur, 107
Miller, Glenn, 139
Miller, Jack, 255
Mills, Danny, 284
Minnelli, Vincente, xiii, 4, 31, 32
Miramax, 55, 182, 232
mise-en-scene, 4
MIT, 237, 241
Mitchum, Robert, 33
Mittweg, Rolfe, 223
Mole People, The, 273
Molina, Miguel, 43
MoMA (Museum of Modern Art),
 29, 203
Momsen, Taylor, 255
Mondo Trasho, 279–80
Monroe, Marilyn, 28, 106, 107
Montez, Maria, 275
Montgomery, Mona, 274
Moon River (song), 91
Moore, Juanita, 63, 186
Moore, Julianne, 160, 173, 179, 184, 188,
 191, 197, 239, 330
Moore, Michael, 248
Moran, Pat, 273, 279
Morita, Pat, 229
Morris, Wesley, 116
Morrissey, Paul, 168, 226, 275
Mortensen, Viggo, 239, 281
Moulin Rouge, 183
MPAA, 319
Mr. Tambourine Man (song), 192
Mueller, Cookie, 279, 294, 305
Multiple Maniacs, 280–81
Mulvey, Laura, xiv
Munch, Christopher, 163

Murray, Bill, 302
Musky, Jane, 243
Musto, Michael, 297
My Burning Bush, 302
My Fair Lady, 26
My New Friend, 204
My Own Private Idaho, 44, 165, 220–28,
 327
Myrbach, Felicien de, 146
Mystic River, 257

Naked, 158
Naked Lunch, 206
NC-17 (rating), 55, 232
national cinema, 328–29
National Enquirer, The, 292
National Film School (UK), 123
National Society of Film Critics, The
 (NSFC), 219
Natural Born Killers, 236
Nazi, 248
NC-17, 319
NEA (National Endowment for the
 Arts), 169
Nelson, Blake, 253
Nelson, David, 306, 307
Ne me quitte pas (Jacques Brel song),
 43
Neon Bible, The, 119, 122, 137–41
Neon Woman, The, 298
Nepomniaschy, Alex, 177
Network, 235
Nevins, Gabe, 253
New Age, 176, 179
New Line Cinema, 221, 284, 287, 319
Newman, Paul, 20
New Queer Cinema, 164–67
New Wave, 338
New Yorker, The, 219
New York Film Critics Circle (NYFCC),
 xvii, 62, 123, 184
New York Film Festival (NYFF), 29, 109
New York Times, The, 236, 298

Nichols, Mike, 237
Night of the Living Dead, 236
Nightmare Typhoon, 204
No Exit, 98
Norman, Susan, 170
Norma Rae, 265
North Country, 265
Norton, Edward, 312
Novas, Tamar, 104
Now Voyager, 157
Nuart, 321
Nymphomaniac, 38
Nysmayer, Ron, 166
NYU, 273

Obama, Barack, 172
O'Donnell, Chris, 241
Odorama, 301–2
Of Time and the City, 126, 135, 145–50
O'Hara, Scarlett, 20
Old Acquaintance, 53
Olga's House of Shame, 273
One, Two, Three, 9
On the Road, 206
Ordinary People, 237
Oscar (Academy) Award, 62, 83, 108,
 127, 132, 152, 158, 164, 182, 184, 188,
 201, 237, 243, 248, 257, 258, 265, 296
Oskarsdottir, Valdis, 243
O'Sullivan, Terry, 125
Oswald, Lee Harvey, 274
Outsiders, The, 214
Over the Edge, 214
Owens, Ayse, 135
Ozon, Francois, 338
Ozzie and Harriet, 308

Pacino, Al, 241
Palindromes, 190
Palme D'or, 219, 246, 248
Panic in Needle Park, 213
Paquin, Anna, 243
Paradigm of the Mussel, The, 41

Paranoid Park, 253–57
Paredes, Marisa, 11, 25, 61, 77, 110, 330
Parents, 309
Paris, Texas, 41, 338
Parish, James Robert, 227
Parker, Laurie, 212
Parker, Michael, 221
Paris Is Burning, 163
Parrish, 307
Parting Glances, 258
Pascual, Cristina Sanchez, 25
Pasolini, Pier Paolo, 10, 227
Passion of the Christ, The, 3
Pasztor, Beatrix Aruna, 239
Pat Garrett and Bill the Kid, 189, 193
Patty Diphusa, 7
*Patty Diphusa y otros textos (The
 Patty Diphusa Stories and Other
 Writings)*, 8
Pearce, Guy, 196
Pearce, Mary Vivian, 272, 274, 279, 284,
 294, 299, 310
Peck, Gregory, 38
Pecker, 311–14
Peckinpah, Sam, 189, 193
Pena, Candela, 77
Penn, Sean, 201, 257
*Pepi, Luci, Bom and other girls on the
 heap*, 6, 14–21
Peppard, George, 33
Perenio, Vincent, 279
Perfidia, 139
Perez, Michel, 338
Perkins, Anthony, 239
Perlman, Max, 215
Peranio, Vincent, 318
Personal Best, 166
Peter Pan, 172
Peyton Place, 6, 296, 307
phallic, 56
Philadelphia, 110, 164, 166
Phoenix, Joaquin, 330
Phoenix, Rain, 228, 229, 330

Phoenix, River, 203, 227, 240, 253, 330
Piano, The, 243
Pill, Alison, 261
Pink, 200, 240
Pink Flamingos, 282–92, 321
Pitchlynn, Robert Lee Bob, 221
Pitt, Brad, 239
Pitt, Michael, 250
Place, Mary Kay, 312
Playboy magazine, 271
Plimpton, Martha, 312
Point Break, 227
Poison, 160, 165–73
Poitier, Sidney, 217, 231, 242
Polanski, Roman, 101
Polyester, 290, 301–3
Poncela, Eusebio, 36
Pop, Iggy, 180, 306
Pope (Church), 7
Pope, Dick, 158
Portland, Oregon, 162, 207
Portillo, Blanca, 94, 104
Posey, Parker, 320
Postlethwaite, Pete, 127
Postman Always Rings Twice, The, 194
Potemkin (aka *Battleship Potemkin*), 273
Potter, Dennis, 133–134
Potter, Michael, 294
POV, 12, 56, 86, 124, 152, 155, 220, 225, 230
Powell, Sandy, 182,
Powers, John, 234, 235
Prada, 81
Preminger, Otto, 311
Pretty in Pink, 219
Prieto, Rodrigo, 107
Prince of Tides, The, 166
Promised Land, 264–66
Proust, Marcel, 159
Provincetown, MA., 274, 278, 286
Psycho, 90, 95, 239–40, 256
Pulitzer Prize, 11, 241

Pulp Fiction, 229
Pussy on a Hot Tin Roof, 278

Quaid, Dennis, 184
Quaid, Randy, 310
Queen and Country, 133
Queer Cinema, xvi
Quinn, Anthony, 91

Rabal, Francisco, 57
Rachmaninoff, 157
Rain Man, 279
Rains, Claude, 85
Rapper, Irving, xiii
Rattigan, Terrence, 150, 151
Ray, Nicholas, 51, 214, 231, 253
Raymond, Jon, 194
Razzie Award, 240
Read, Lou, 276
Reader, The, 194, 196
Reagan, Nancy, 212
Rear Window, 49, 241
Rebel Without a Cause, 214, 219, 231, 253
Rechy, John, 222
Red, 106
Redford, Robert, 237
Redgrave, Michael, 151
Reed, Donna, 308
Reeves, Keanu, 206, 222, 227, 228
Remar, James, 215
Remley, Rob, ix
Renay, Liz, 299, 300
Renderer, Scott, 171
Renoir, Jean, 92
Reservoir Dogs, 10
Resnais, Alain, 302
Restless, 261–64
Revhy, John, 271
Reynolds, Debbie, 136
Ricci, Christina, 312
Rice, Ron, 203
Rich, Mike, 242
Rich, Ruby B., 167

Rich and Famous, 54, 71
Richards, Bea, 217
Richardson, Tony, 155
Richert, William, 221
RIDA (Rhode Island School of
 Design), 203
Rimbaud, Arthur, 190
Rio Bravo, 222, 291
Rivers, Joan, 311
River's Edge, 253
Robbins, Tom, 228
Roberts, Doug, 309
Roberts, Eric, 315
Robinson, John, 248
Rocco and His Brothers, 337
Rocky Horror Show, The, 18, 287, 291, 321
Rodriguez, Robert, 200
Roman Candles, 273
Romancing the Stone, 100, 310
Romeo and Juliet, 306
Room with a View, A, 141
Rope, 165
Rosen, Jeff, 188
Rossellini, Roberto, 48, 62, 81
Roth, Ann, 197
Roth, Cecilia, 21, 28, 77, 114
Rowlands, Gena, 82, 140, 141
Rudolph, Alan, 212
Running on Empty, 222
Russo, James
Russo, Vito, *xiii*
Ryan, Meg, 233

Safe, 160, 173–180
Saliva Films, 284
San Fernando Valley, 160
San Francisco Chronicle, The, 314
San Juan, Antonia, 77
Sarris, Andrew, ix, 327
Sartre, Jean-Paul, 98, 170
Saura, Carlos, 10, 48, 80
Savides, Harris, 243, 247, 249, 250, 266
Scarwid, Diana, 140

Scent of a Woman, 241
Schlesinger, John, 155
Schneider, Romy, 82
Schrader, Paul, 223
Schwarzenegger, Arnold, 312
Scorpio Rising, 273
Scorsese, Martin, 1, 141, 182, 193, 223,
 236, 261, 310
Scott, A.O., 55
Scott, Ridley, 292
Screen International, xvii
Sea Inside, The, 104
Sea of Trees, The, 267
Searchers, The, 223
Secrets & Lies, 158
self-reflexive, 4, 87, 189
Separate Tables, 151
Serial Mom, 308
Serna, Assumpta, 19, 36
Serrano, Julieta, 19, 49
Sevigny, Chloe, 231
sex, lies, and videotape, 219, 228
Sexton, Brandon III, 312
Seyrig, Delphine, 175
Shakespeare, 222
Sharp, Jeff, 167
Shatz, Leslie, 251
Shaye, Bob, 287
Shearer, Norma, 102
Shepard, Sam, 222
Shepherd, Susanne, 317
Sherman, Martin, 336
She's Gotta Have It, 212
Shrinking Man, The, 86
Skarsgaard, Stellan, *238*
Skin I Live In, The, 12, 46, 54, 109–13
Silence of the Lambs, The, 166
Silva, Eva, 15
Singing Detective, The, 133–34
Singin' in the Rain, 121, 132
Singleton, John, 220
Sirk, Douglas, 4, 9, 63, 80, 98, 156, 171,
 184, 186

sissy (as stereotype), 31
Sister Mary Ignatius Explains It All for You, 26
Skyfall, 72
Smith, Geraldine, 276
Smith, Jack, 275
Smith, Kate, 282
Smith, Kevin, 237
Smith, Paul Julian, 74, 77, 81
Snake Pit, The, 280
Soderbergh, Steven, 200, 219, 228, 266
Solondz, Todd, 190
Somers, Susanne, 311
Sontag, Susan, 289–90
Sony Pictures Classics, xvii, 116, 179
Soul, Maelcum, 274
Speedway Junkie, 233
Spielberg, Steven, 4, 46
Spinners, The, 147
Spirit Awards, 322
Splendor in the Grass, 6, 41, 63, 338
Spring Breakers, 232
St. Elmo's Fire, 219
St. Mark's Church, 273
Stagecoach, 291
Stamp, Terence, 59
Stand by Me, 222
Stanton, Harry Dean, 41, 338
Stanwyck, Barbara, 92, 194
Starke, Michael, 130
Stepford Wives, The, 177
Stewart, Missy, 239
Stockwell, Dean, 41, 338
Stole, Mink, 273, 281, 284, 295, 298, 300, 302, 313, 317
Stoltz, Eric, 142
Stone, Oliver, 166, 236, 258
Stover, George, 299
Streetcar Named Desire, A, 41, 77, 79
Streeter, Tim, 207
Streetwise, 222
Streisand, Barbra, 166

Sundance Film Festival, 160, 164, 169, 173, 244
Suicide, The, 162
Summer Place, A, 307
Sunset Boulevard, 9, 277
Superstar: The Karen Carpenter Story, 160, 162–3
Swanson, Gloria, 277
Swift, Paul, 281
Swoon, 163

Talk to Her, 12, 38, 83–89, 108, 114
Tammy, 136
Tarantino, Quentin, 4, 10, 200, 229
Target, 116
Tarkovky, Andrei, 10
Tarnation, 233
Tarr, Bella, 246
Tashlin, Frank, 4, 9, 14, 18, 48
Taste of Cherry, 246
Taylor, Elizabeth, 6, 20
Taylor, Hilary, 294
Taylor, Lili, 312
Taxi Driver, 223, 261
Tea and Sympathy, 31
Teenage Lust, 213
That Obscure Object of Desire, 189
Therese Raquin, 92
Terrence Davies Trilogy, The, 123–25
Third Man, The, 104
Thomas, Dylan, 145
Three of Hearts, 164, 166
Threesome, 164
Thurman, Uma, 229
Tie Me Up! Tie Me Down! 12, 54–60, 109, 298
Tierney, Gene, 107
Time Out (UK), 126, 141
Times of Harvey Milk, The, 223, 258
To Die For, 233–36, 254
Toledo, Guillermo, 115
Toole, John Kennedy, 122, 37–138

Toronto Film Festival, 121, 124, 150, 230
To Sir with Love, 242
Trash, 276–7
Travolta, John, 306, 308
Trip, The, 213
Troche, Rose, 163, 164
Trueba, Fernando, 48
Truffaut, Francois, 10, 102, 297, 338
Tudors, The, 183
Turner, Callum, 133
Turner, Kathleen, 100, 308, 310, 319, 330
Turner, Lana, 62–63, 81, 195
TV Movie of the Week, 263
Two or Three Things I Know About Her, 189
Tyree, Robert, 307
Tyrrell, Susan, 306

UFO, 46
Ullman, Tracey, 317, 319
Un chant d'amour, 168, 273
USC, 162

Vaccaro, John, 275
Vachon, Christine, 162, 182
Van der beek, Stan, 203
Van Leer, David, 289
Van Sant, Gus, xvii, 2, 5, 44, 162, 200–67, 271, 325
Vargas, Manuela, 71
Variety, ix, xvi, 164, 263, 272, 288
VCR Revolution, 308
Velvet Goldmine, 180–83
Venice Film Festival, 222
Vera Drake, 158
Verhoeven, Paul, 166
Vertigo, 90
Vicky Cristina Barcelona, 108
Vidal, Gore, 278
Vidor, King, 38

Vietnam War, 191, 213
Village Voice, 179, 207, 277
Vincente Minnelli: Hollywood's Dark Dreamer (book), ix
Visconti, Luchino, 101, 227
Visit of the Old Lady, The, 91
Vitti, Monica, 102
Volver, 5, 12, 93–103, 108
Von Sternberg, Josef, 283
Von Triers, Lars, 38, 226

W, 258
Waiting for Godot, 246
Walsh, Susan, 279, 294
Warhol, Andy, 8, 168, 202, 221, 273, 275, 315
War of the Roses, 310
Wasikowska, Mia, 262
Watermelons, Dem, 162
Waters, John, 4, 12, 13, 17, 102, 123, 202, 266, 268–324, 325, 326
Waterston, Sam, 308
Watson, Anthony, 135
Waves, The, 118, 123
Wayne, John, 222, 291
Where'd She Go? 204
Weinstein, Harvey, 182
Weinstein Company, The (TWC), 189
Weisz, Rachel, 123, 150
Welles, Orson, 92, 104, 136, 181, 202, 223
Wesker, Arnold, 155
West, Mae, 289
Weston, Celia, 186
West Side Story, 306
Whale, James, xiii
Wharton, Edith, 122, 142
What Ever Happened to Baby Jane?, 298
What Have I Done to Deserve This?, 12, 29–35, 94, 99, 309
Whishaw, Ben, 190
Whitaker, Stella, 272

Wild One, The, 219
Wild Tigers I Have Known, 233
Wilde, Oscar, 180
Wilder, Billy, 4, 9, 37, 194, 277
Wildman, Donald E., 169
Williams, Dean, 128
Williams, Robin, 238, 239
Williams, Michelle, 192
Williams, Tennessee, 6, 20, 77, 271
Will Success Spoil Rock Hunter?, 14
Wilroy, Channing, 284
Winslet, Kate, 194, 195
Winslow Boy, The, 151
Witt, Alicia, 314
Wizard of Oz, The, 215, 271
Woman Under the Influence, A, 141
Women, The, 229
Women on the Verge of Nervous Breakdown, 12, 16, 47–5, 55, 81, 106
Written on the Wind, 80, 98
Wood, Evan Rachel, 196

Wood, Natalie, 6, 64, 214
Woodlawn, Holly, 277
Woodward, Joanne, 142
Woolf, Virginia, 8, 118
World War II, xi
Wyatt, Justin, 336
Wyler, William, 59
Wyman, Jane, 186

X-Files, The, 122

Yeoman, Robert, 218
Yost, Daniel, 212
You Can Heal Your Life, 178
YouTube, 163

Zabriskie, Grace, 215, 221, 226, 228
Zarzo, Manuel, 26
Zedd, Nick, 277
Zola, Emile, ix
Zorro films, 110